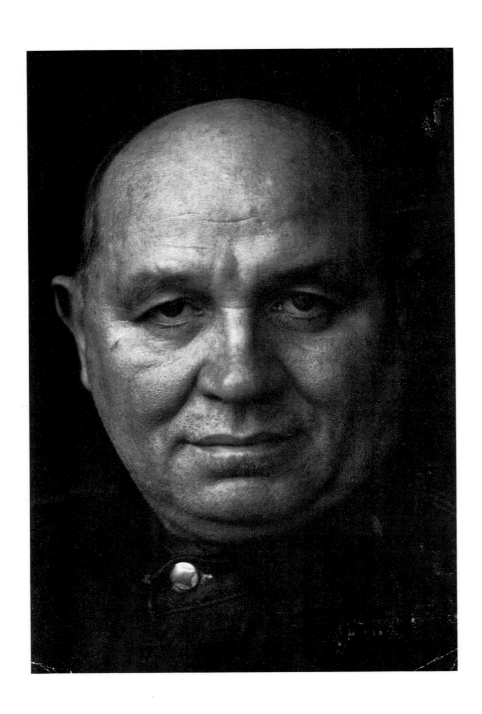

Romare Bearden

BEARDEN

HIS LIFE & ART

BY MYRON SCHWARTZMAN

FOREWORD BY AUGUST WILSON

HARRY N. ABRAMS, INC. PUBLISHERS NEW YORK

FOR JUDITH AND MAX

Editor: Beverly Fazio
Designer: Raymond P. Hooper
Rights, Reproductions, and Photo Research: Neil Ryder Hoos

Frontispiece: Romare Bearden, c. 1970. Photograph by Sam Shaw

Library of Congress Cataloging-in-Publication Data
Schwartzman, Myron.
 Romare Bearden: his life and art / Myron Schwartzman.
 p. cm.
 Includes bibliographical references.
 ISBN 0–8109–3108–7
 1. Bearden, Romare, 1914–1988. 2. Afro-American artists—
Biography. I. Title
N6537.B4S39 1990
709′.2—dc20
[B] 90–30729
 CIP

Published in 1990 by Harry N. Abrams, Incorporated, New York
A Times Mirror Company

Printed and bound in Japan

Portions of the text previously appeared, in altered forms, in *Artforum* and *Callaloo: A
Journal of African-American Arts & Letters*

The extract from "Adolescence" by W. H. Auden is reprinted from *Collected Shorter Poems
1927–1957* by W. H. Auden with permission of Random House, Inc.

The extract from *A Moveable Feast* by Ernest Hemingway is reprinted with permission of
Charles Scribner's Sons, an imprint of Macmillan Publishing Company. Copyright © 1964
by Mary Hemingway

Editor's notes: "Conversations" that appear throughout this book were edited from a series of
interviews between Bearden and the author that took place from 1982 to 1987. All artwork is
by Romare Bearden unless otherwise noted

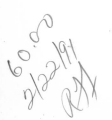

CONTENTS

DA

PREFACE

In 1984, about two years after I began writing this book, a woman whose father had worked with Romare Bearden for the Department of Social Services in the late 1940s sent me a letter describing her memories of Bearden. Actually, one of her own earliest memories of *anything*, it turned out, had to do with Bearden. Her father had taken her to a Bearden opening when she was no more than four years old. "I remember walking up a flight or two of narrow stairs, up to a room with many people—I have an impression of many knees and of looking at the paintings—and of a nice man I assume was Mr. Bearden, smiling at me. There was this aura of something *special* about him. . . . "

That memory touched a chord. Although I was more than a good bit older than she when the writer Albert Murray first introduced me to Bearden at the Cordier & Ekstrom gallery in 1978, I had a reaction that was in some ways similar to hers. He struck me as taller somehow and even more substantial than his 5′11″, 210-pound frame would warrant, smiling with a gaze in his hazel green eyes that was at the same time congenial, approachable, yet detached and distant—and there was a decidedly special aura about him. Although Bearden was a remarkably fair-skinned black American, he was also what the writer Albert Murray had called an *Omni-American*—part frontiersman, part Cherokee, part Southerner, part urbane Harlemite, and part blues-idiom hero, fully capable of improvising his way through the briarpatch. He was a man whose presence charged a room with intelligence, not that he ever put on any airs: he had no need to.

In fact, if I'd had to imagine the least likely of artist's studios in which Bearden would create the baptisms, conjur women, Delta blues guitarists, and Mecklenburg, North Carolina, interiors that filled the collages I had seen in museums, galleries, and books, it would have been the lone room on the third floor of an office building in Long Island City where I found him waiting for me every Tuesday morning, with his blue coveralls ("RB" written on the pocket) and soft felt cap. Our ritual was unchanging: in all seasons but summer, I would bring hot tea with lemon, a half-sugar for Romare, a sugar-and-one-half for myself.

After a few sips of tea and some small talk, I would set up the tape recorder on the small round table near the door of the studio. Romare would invariably ask me if I wanted to plug the machine into an outlet, and

whether I needed an extension cord to make this easier. I would invariably thank him and tell him that the machine used batteries. Then we would begin, and talk for the next hour or so—he was open to any subject. Every few minutes the screeching of the Flushing elevated's wheels would override the conversation with an unspeakable din so loud that it always made that portion of tape nearly indecipherable, but none of this fazed Romare. He was imperturbable, speaking out of some inner place, undisturbed by the world's noises. It still seems to me that no matter where he lived and worked, Bearden had somehow arranged to be near trains, bodies of water, or birds.

Five or six pigeons would perch on the outer sill of the window almost on cue, and Bearden would greet and feed them. He called them his doves. I quickly saw that the animals he often used in his collages—doves, roosters, and cats—were neither abstract icons nor childhood memories, but familiar daily presences, either in New York or St. Martin, where he spent several months of the year. When I visited Romare and his wife, Nanette, in St. Martin, fighting cocks strutted and crowed on the patio, while the Beardens' cats remained curled up in the shade of the dining room. As he and I climbed the stone steps to his studio, lizards darted out of our path while birds seemed suspended in flight among the mountains, the clouds, and the bay.

Sometimes after we finished an interview, Bearden would take out a lunch he had brought for me. This too was unchanging: ham and cheese. I don't eat ham, so I would tell him my appetite wasn't great for meat that day, give him the ham, and keep the cheese. He invariably saved the ham for his cats, Tuttle (Tutenkhamen), Mikie (Michelangelo), and Rusty (Rustum, the mighty Persian hunter). It was a soft, anachronistic, and thoroughly delightful ritual in which reminiscences of Southern (his) and Russian (mine) parlors were thrown headlong into the middle of a disused industrial section of Queens. We continued this way for several years.

Bearden hadn't worked at an easel since the 1940s. He created his collages on masonite board laid flat on a work table surrounded by scraps of paper, various oils and temperas, inks, benzines, and brushes. On the opposite wall, bookshelves filled with hundreds of books and sheaves of papers stood beside a gigantic bin filled with slides, photostats, old watercolors, sketches, posters, lithographs, rolled-up Arches paper—a seeming chaos. Bearden knew where everything was, although sometimes he could find it in seconds while at other times he couldn't seem to locate it no matter how hard he tried. At those times, I was struck by the thought that in some deep recess of his mind he wasn't *ready* to find it.

For me, he was never simply the subject of a biography: he was teacher, friend, spiritual father, grandfather, and finally a legacy of words and images to be sifted and distilled for posterity.

On the wall above his work table, Bearden had written out a line from Wordsworth's preface to the *Lyrical Ballads*. The quotation read: "He is the rock of defense of human nature, an upholder and preserver, carrying everywhere with him relationship and love." This is the essence of who Bearden was and of what he achieved in his life and art.

FOREWORD

In 1965, as a twenty-year-old poet living in a rooming house in Pittsburgh, I discovered Bessie Smith and the blues. It was a watershed event in my life. It gave me a history. It provided me with a cultural response to the world as well as the knowledge that the text and content of my life were worthy of the highest celebration and occasion of art. It also gave me a framework and an aesthetic for exploring the tradition from which it grew. I set out on a continual search for ways to give expression to the spiritual impulse of the African-American culture which had nurtured and sanctioned my life and ultimately provided it with its meaning. I was, as are all artists, searching for a way to define myself in relation to the world I lived in. The blues gave me a firm and secure ground. It became, and remains, the wellspring of my art.

In 1977, I made another discovery which changed my life. I discovered the art of Romare Bearden. I was then a thirty-two-year-old poet who had taken his aesthetic from the blues but was unsure how to turn it into a narrative that would encompass all the elements of culture and tradition—what Baldwin had so eloquently called "the field of manners and ritual of intercourse" that sustains black American life. My friend Claude Purdy had purchased a copy of *The Prevalence of Ritual,* and one night, in the Fall of 1977, after dinner and much talk, he laid it open on the table before me. "Look at this," he said. "Look at this." The book lay open on the table. I looked. What for me had been so difficult, Bearden made seem so simple, so easy. What I saw was black life presented on its own terms, on a grand and epic scale, with all its richness and fullness, in a language that was vibrant and which, made attendant to everyday life, ennobled it, affirmed its value, and exalted its presence. It was the art of a large and generous spirit that defined not only the character of black American life, but also its conscience. I don't recall what I said as I looked at it. My response was visceral. I was looking at myself in ways I hadn't thought of before and have never ceased to think of since.

In Bearden I found my artistic mentor and sought, and still aspire, to make my plays the equal of his canvases. In two instances his paintings have been direct inspirations. My play *Joe Turner's Come and Gone* was inspired by Bearden's *Mill Hand's Lunch Bucket*, a boardinghouse setting in Pittsburgh. I tried to incorporate all of the elements of the painting in the play, most notably the haunting and brooding figure at its center, whom I named Herald Loomis. The names of the characters, Seth and Bertha, were taken from another Bearden painting, *Mr. Seth and Miss Bertha*. The title of my play *The Piano Lesson* was taken from a painting of the same title.

I never had the privilege of meeting Romare Bearden. Once I stood outside 357 Canal Street in silent homage, daring myself to knock on his door. I am sorry I didn't, for I have never looked back from that moment when I first encountered his art. He showed me a doorway. A road marked with signposts, with sharp and sure direction, charting a path through what D. H. Lawrence called the "dark forest of the soul." I called to my courage and entered the world of Romare Bearden and found a world made in my image. A world of flesh and muscle and blood and bone and fire. A world made of scraps of paper, of line and mass and form and shape and color, and all the melding of grace and birds and trains and guitars and women bathing and men with huge hands and hearts, pressing on life until it gave back something in kinship. Until it gave back in fragments, in gesture and speech, the colossal remnants of a spirit tested through time and the storm and the lash. A spirit conjured into being, unbroken, unbowed, and past any reason for song—singing an aria of faultless beauty and unbridled hope.

I have often thought of what I would have said to him that day if I had knocked on his door and he had answered. I probably would just have looked at him. I would have looked, and if I were wearing a hat, I would have taken it off in tribute.

August Wilson
Saint Paul, Minnesota

THE OLDEST OF PLACES • 1911–1923

What is it?
I'm trying really to remember
The clock has stopped
Now I can never know
Where the edge of my world can be
If I could only enter that old calendar
That opens to an old, old July
and learn what unknowing things know...

Romare Bearden

CAROLINA INTERIOR: CHARLOTTE ROOTS

H. B. and Rosa Kennedy, Bearden's great-grandparents, on the porch of their corner home, Charlotte, N.C., c. 1920

Picture a Carolina interior, one of the bedrooms in the corner home of Romare Bearden's great-grandfather, Henry B. Kennedy, in Mecklenburg County at 401 South Graham Street, Charlotte, North Carolina, on the sunny, 75-degree morning of Saturday, September 2, 1911. There, Romare was born, the only child of Bessye and Howard Bearden. He was delivered by Dr. James A. Pethel. Perhaps Romare's great-grandmother, Rosa Kennedy, was in the room to make sure all went well. One can imagine Howard downstairs in the front parlor, nervously waiting while Rosa came out periodically to assure him that everything would be all right. Quite possibly, Henry, or H. B. as he was better known, tried to seem unperturbed as he tended his grocery store next door, having told Rosa to let him know the moment there was news.

Now extend the collage. Add a window to the room, and paint a landscape there. Three houses farther south on Graham Street, all of which belong to H. B. Kennedy, are a train trestle and a railroad bridge going up to the main station on Trade Street. The station was on a main artery of the Charlotte, Columbia & Augusta Railroad, a formidable interurban system running down to Columbia, South Carolina. Steam locomotive trains whistled, sending the hens in H. B.'s backyard coop momentarily aflutter. On the other side of the railroad bridge on Graham Street stands the block-long Magnolia Mill. The humming drone of the machines starting up in the morning fills the

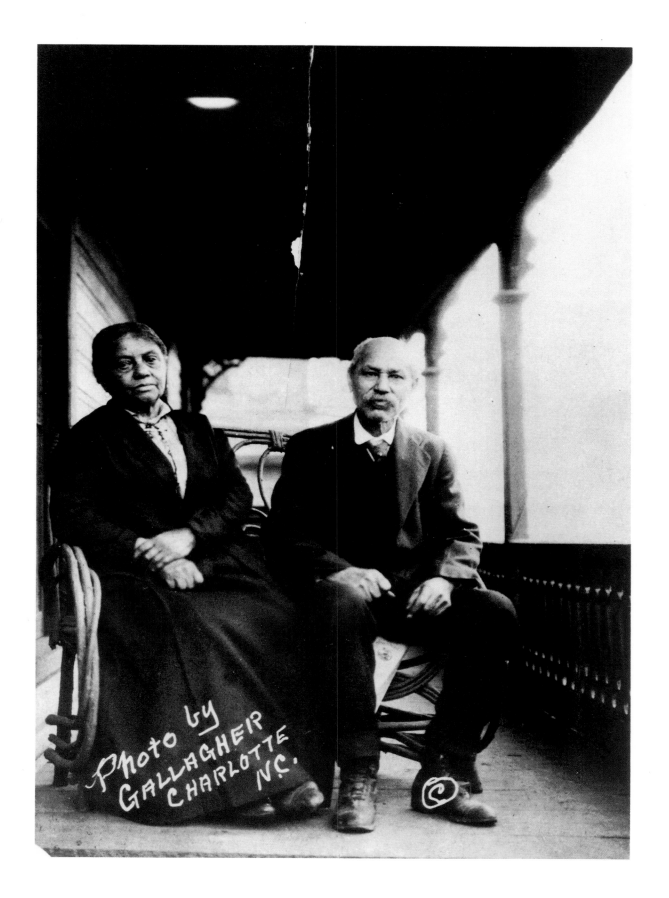

Third Ward. Lining the streets for blocks are huge wagons, piled high with burlap sacks filled with raw cotton to be weighed and graded. Farm children sit atop the wagons.

But the landscape in this Carolina interior should be simple; it cannot contain all of this detail. Make it a steam engine running across a sunlit field.

A photograph taken not long after the turn of the century shows Romare Bearden's paternal great-grandparents seated on a braided cane seat on the porch of their home at the corner of South Graham and Second streets. H. B. Kennedy is clearly the *paterfamilias*. With vested suit, tie slightly loosened, and the corner of one collar splayed on his lapel, he sits with his legs apart, his boots planted firmly on the porch floor. He is fair-skinned, of medium height, with a handlebar moustache and with thick eyebrows over penetrating eyes that look straight at the photographer. The most prominent gesture in his carriage is the position of his hands. The right is loosely clenched in a fist; the left rests loosely over his left thigh. He is a self-made man, a hard-working property owner, part of a generation born into slavery that by 1890 formed the Negro middle and upper classes of Charlotte. He had little time or opportunity to obtain a formal education: like many men of his generation, he went straight to work during Reconstruction, channeling his energies into business and family. While he may be less in the limelight than Charlotte's black churchmen, newspapermen, and politicians, he stands every inch as tall as they.

His wife, Rosa, sits to his right. H. B. gives the impression that he dresses this formally only when he has to; Rosa, on the other hand, appears poised and at ease in her Sunday best, a full, dark suit and dress of cotton voile, probably with a taffeta underskirt. Her blouse is of fine material, with a rounded collar echoing her large, softly featured face. She is darker complected than her husband, with short hair, prominent eyebrows, and soft eyes. Altogether, she is fuller and softer than her husband. They are a study in contrasts: Rosa's left hand rests upon her right wrist, her shoes are next to one another, and she rests against the back and side of the seat. H. B. is poised forward, as if ready to stand.

Henry B. Kennedy was born in Chester, South Carolina, in January 1845, almost certainly into slavery. According to the family monument he erected in Pinewood Cemetery in Charlotte, his mother was Jeraline Oates, who died on January 22, 1864, almost certainly still in slavery. Jeraline Oates's husband, Charles Oates, died, according to the date on the monument, on April 22, 1832. That is mysterious. Clearly, the man H. B. Kennedy chose to commemorate as "Father" (that is the word on the monument) died thirteen years before his birth.

Kennedy married Rosa Catherine Gosprey in 1863, when he was eighteen and she was sixteen. A tombstone near that of H. B. and Rosa in Pinewood Cemetery was erected in memory of one Elizabeth Gosprey, who was born in 1814 and died in August 1898. Elizabeth's relationship to Rosa is uncertain; she may have been her mother or her aunt. According to the 1900

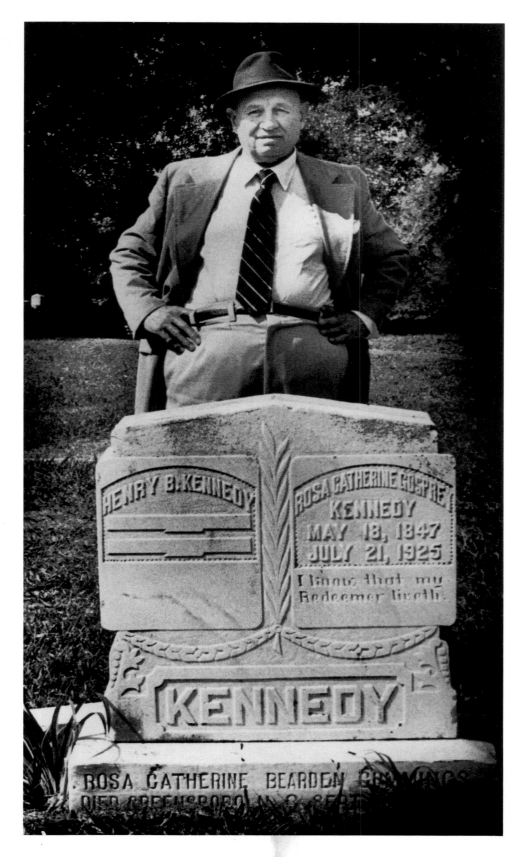

Bearden at Pinewood cemetery in 1980. *Charlotte Observer*

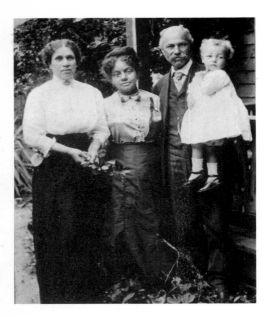

Above: Bearden with H. B. and
Rosa Kennedy and
grandmother, Rosa Catherine
(Cattie) Bearden, 1912

Opposite, top: Bessye Bearden

Opposite, middle:
Richard Howard Bearden

Opposite, bottom: Bearden's
sketch of H. B. Kennedy's
house and yard in Charlotte,
N.C., where he was born, as
well as store and adjoining
rental houses owned by
Kennedy. 1985. Pen and ink on
graph paper

census, H. B. and Rosa Kennedy's only child, Rosa Catherine (Cattie) Kennedy, was born in 1865.

During this period, the Kennedys were employed as servants of Dr. Joseph Wilson, Woodrow Wilson's father. Dr. Wilson was a Presbyterian minister who lived and taught in Columbia at the time. Woodrow, born in 1856, when the family lived in Staunton, Virginia, would have been an adolescent in the South Carolina household where the Kennedys worked, and he later attended Davidson College near Charlotte for a year in 1873 prior to his entering Princeton in 1875.

There is no question that during Woodrow Wilson's first term of office (1913–17), H. B. Kennedy basked in the presidential light. A booklet issued in Charlotte in 1915 to celebrate fifty years of Emancipation, for instance, mentions him as one of Charlotte's prominent citizens, alongside bishops, physicians, and a former United States consul to Sierra Leone. "Mr. Kennedy," the booklet says, "is now using the chair that was formerly used by Dr. Wilson before President Wilson was born."

Sometime in the 1870s, Kennedy brought Rosa and Cattie to Charlotte, where he was employed as a mail agent for the Charlotte, Columbia & Augusta Railroad. He must have saved every penny, because by April 5, 1878, according to the Grantee and Grantor books at the Office of the Registrar of Deeds, Mecklenburg County, he paid $100 down on a total of $425 for a quarter-acre parcel of land and several houses at the corner of Graham and Second streets. The Charlotte City Directory shows that in the 1880s, H. B. Kennedy went from the position of homeowner (of a four-room wood-frame house with kitchen) and mail agent for the CC & A Railroad, to landowner of the adjoining parcel, grocer, and wood merchant.

During the next ten years of wheeling and dealing, most often using one or another piece of property as collateral, Kennedy established himself as a respected member of Charlotte's upper-middle class. The 1900 census shows that at age fifty-five, H. B. Kennedy owned his home, the grocery store at 403 South Graham Street, and two small houses next to that.[1] He had a total of four boarders at the time, all hotel waiters by trade.

H. B. Kennedy's move to Charlotte and his success there were by no means isolated phenomena: his prospering career in the last two decades of the nineteenth century coincided with what was, relatively speaking, a window of opportunity for black people in Charlotte and Mecklenburg County that lasted from about 1880 to 1920. Kennedy's move to Charlotte had been part of a wave of black migration in the 1870s that doubled the city's black population in ten years.

Since the 1960s, deprivation of civil rights, Jim Crow ordinances, and the entire attendant apparatus of segregation have been widely understood in the United States. What is far less commonly known is that in a city like Charlotte, in the years between the end of the Civil War and the turn of the century, an entire generation of men like Romare Bearden's great-grandfather was able to fashion a limited but highly significant version of the American dream. Starting with less than nothing, owned by other men, they became

able to vote, get elected or appointed to office, wield some political power, and buy and sell property. There were blacks on the Charlotte Board of Aldermen, for instance, from 1868 through 1893. Some black men became ministers, doctors, lawyers, or teachers, while others entered the work force as skilled laborers. They established churches, hospitals, schools, newspapers, and libraries in their community.

The blacks' continuing success took place despite, or as one Charlotte historian has suggested, perhaps because of a virulent White Supremacy campaign in the election of 1898 and the pivotal election of 1900, which effectively disenfranchised black voters in North Carolina. Like a tree that had been allowed to take root in good soil and grow for twenty years, the black community of Charlotte was able to consolidate its gains and to prosper for at least another generation, even in the withering atmosphere of Jim Crow.

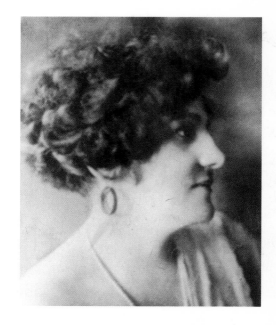

CHARLOTTE MEMORIES

Four generations of Kennedys and Beardens were living in North Carolina when Romare was born: his paternal great-grandparents, H. B. Kennedy and Rosa Catherine Gosprey Kennedy; his grandmother Rosa Catherine Kennedy Bearden (Cattie), whose husband Richard (Romare's grandfather), a grocer and harness maker, had died in 1891; two of Cattie's three children—Romare's Uncle Harry and his father, Richard Howard Bearden (his Aunt Anna had married Dr. Bullock, a medical practitioner, and moved to Greensboro)—and his mother, Bessye. Bearden was baptized at the Episcopal Church of St. Michael and All Angels on November 19, 1911, according to the church's records. One of the witnesses was Mrs. Anna Alston, widow of the former rector of St. Michael's, Primus P. Alston, who had died in 1910.[2] Later, Romare's Uncle Harry married Anna, establishing a family tie between the Beardens and Alstons; the Alston children, Rousmanière, born in 1902, and Charles ("Spinky"), born in 1907, were to become significant friends, as well as cousins by marriage, of the child.[3] The baby was named Fred Romare Howard Bearden, after Fred Romare (pronounced Rō-mǝry, with the accent on the first syllable), a childless friend of H. B. Kennedy's from Joplin, Missouri.

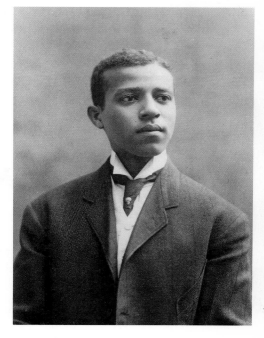

Both of Romare's parents were college-educated. Howard for a time attended Bennett College in Greensboro, where he went out for the football team. Like many Southern black men who could find no employment near home, he had gone North to find work. In Atlantic City, he met Bessye Johnson Banks. Bessye had been born in Goldsboro, North Carolina, but had been raised and educated in Atlantic City, where she lived with her mother, Carrie, and her stepfather, George T. Banks. Bessye attended Hartshorn Memorial College in Richmond, Virginia, and was graduated from Virginia Normal and Industrial Institute in Petersburg.

The two made a fine-looking couple. Howard was a handsome, even dashing young man. He was thinner and a full head taller than Bessye, who was fulsome but not at all fat, quite beautiful, and had fair, almost Italianate features and a direct, outspoken temperament to match. They courted, fell in love, and were married in Philadelphia in 1910 by the Rev. John

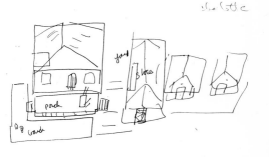

Logan. Soon thereafter, Howard brought Bessye home to Charlotte.

Romare's parents settled in with the Kennedys and remained in Charlotte for several years. In his earliest years, Romare attended church at St. Michael's with his parents. He had light, blond hair parted in the middle and blue eyes. Rousmanière Alston remembers Bessye striding up the aisle of St. Michael's holding her son by the hand not long after he had begun to walk. "Romare was toddling after her, and she smiling graciously, and very proud of him. He had a fancy little bonnet that looked just like a girl's and he looked like a little girl walking up St. Michael's church!" At St. Michael's, Howard was one of two organists, and Bessye taught, probably English, at the

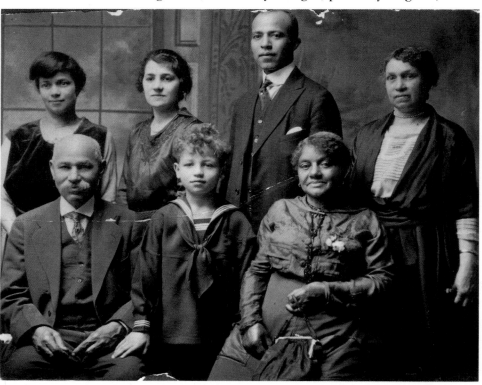

Romare surrounded by his great-grandparents; standing from left, his aunt Anna, mother and father, and grandmother Cattie, c. 1917

church's school. During her years in Charlotte, Bessye did all the things traditionally expected of women. Rousmanière recalls that Bessye was handy with her fingers, adept at knitting and crocheting.

H. B. Kennedy seems clearly to have tried to get Bessye and Howard to settle down in Charlotte. He took Howard into the business (even cross-listing the store in the 1914 city directory with Howard's name in boldface type) and added a bathroom and a telephone (again listed in Howard's name) to the house. Yet even H. B. Kennedy, rooted and still prospering in Charlotte, could not convince Howard and Bessye Bearden, the college-educated parents of his great-grandson, to remain in the South for very long: they moved to New York City when Romare was about three years old. The decade following the passage of the notorious suffrage amendment to the state constitution shows what amounts to a reversal of the black population's growth in the 1870s, when Romare's great-grandparents had settled in Charlotte. Lacking

any real political clout, subject to the pervasive indignity of Jim Crow and the lack of good professional opportunities, young black people, especially women, would have felt constricted by life in Charlotte. In the new century, the white population of the city more than doubled, from 10,940 in 1900 to 22,262 in 1910; meanwhile the black population grew by only 4,000, from 7,151 in 1900 to 11,752 in 1910. By 1910, the white population of Charlotte was almost twice the size of the black population. By the end of the next decade, blacks represented only one-third of the population in both city and county.[4]

One specific incident, which Bearden was told about much later, likely contributed to his parents' decision to leave Charlotte. On a shopping trip in a predominantly white section of Charlotte, Bessye left Howard to watch Romare, while she stepped into a store. Howard separated himself slightly from Romare, perhaps to look into a store window. When he walked toward his son, people became suspicious at the sight of a brown-skinned man approaching what could easily have been taken for a white child. At that moment, Bessye came out of the store. She was furious with Howard for straying from Romare's side, even for a moment.

Years later, after Romare and his parents had moved to New York and were summering in Charlotte with the Kennedys, his father had a run-in with the police that he would describe over and over again. Walking down Graham Street one night, Howard was stopped by a detective and asked where he was from. When Howard answered that he was from New York, he was taken in for questioning and detained in jail overnight. Romare recalled, "My father woke me up around dawn and told me to get my clothes on, we were going back to New York. My great-grandparents were upset, but my father wouldn't tell them what had happened. Later he told me. It was something he often talked about."

Between the two parents, Bessye probably had an easier time coping with prejudice. She was forthright, articulate, and, as a woman, perhaps perceived as less of a threat than a black man. When she spoke out against injustice—as she often would in later years—people made it their business to listen. Howard, who was darker skinned, felt prejudice just as keenly and became as angry at it as did Bessye, but was less outspoken and far less the public personality.

In New York, Howard found that good employment was difficult to secure. By 1917–18, with Romare enrolled in a city elementary school, Howard found work as a steward for the Canadian railroads on a special train that made a run between Edmonton, Alberta, and Moose Jaw, Saskatchewan. About a year later, Bessye and Romare joined Howard in Moose Jaw, where the family remained for about a year after the end of World War I. Romare was eight or nine years old at the time, and attending the equivalent of second or third grade in Moose Jaw.

These were itinerant years for Romare. Even after the Beardens took the long train ride back to New York to take up permanent residence in Harlem in 1920, locating secure employment was problematic for both parents. Romare spent his fourth-grade year in Pittsburgh with Bessye's moth-

er, Carrie Banks. The family also summered with the Kennedys in Charlotte now and again until Rosa Kennedy's death in September 1925.

RED CLAY

Charlotte remains part of a South embedded in a history in which nothing is forgotten, least of all family, lineage, and land. It is a city that has literally been paved over, but one whose past, nevertheless, lies just beneath the surface of its glass-and-steel skyline.

The generations are layered almost geologically, like strata. Time has collaged them, bonding the generations so tightly that in the canvas we call memory, the illusion of temporal depth has disappeared, leaving the flat, two-dimensional surface of the picture plane. It is a process analogous to Bearden's art. As for the artist himself, there is little question about the manner in which one struggles to give form and meaning to chaos. That struggle takes place on the canvas. Romare Bearden stood in Pinewood Cemetery in 1980 near the graves of most of his family. "It's all down under the earth here—that's Charlotte," he commented. It was a quick visit. As he stood near the graves of his Aunt Anna and his Uncle Harry, he was asked if he had any thoughts of his own mortality. "No," Bearden answered, "just to living." He might have added, "just to painting."

Bearden spent enough time in the South as a child to etch it indelibly in his memory. Compared with other artists who left their native cities relatively early in life but who kept them vivid in their imaginations (Picasso, Chagall, Joyce), Bearden seems singular in having internalized much of the subject matter of his art by the time his memory was fully formed.

Many of Romare's earliest memories found their way into his art. In one of what are known as his *Mecklenburg County* collages, *Morning of the Rooster* (1980), male and female principles—rooster and woman, sun and tree, sky and earth—combine to establish a world wrested from time and change.

Intermeshed with Romare's recollections of those early summers in Charlotte, fleshing out the painting, are the memories of Rousmanière Alston, who was some nine years older than Romare.[5] Rousmanière has little recollection of the Alston family's house at 398 South Graham Street where she lived until she was about five, but she remembers clearly the look of the four corners and the Kennedy house, diagonally opposite her own, with its elongated kitchen. To enter the grocery store from the Graham Street entrance used by the customers, you had to walk up five or six steps. H. B. Kennedy stocked the usual staples found in a grocery of the era, and would give Rousmanière a bottle of soda water each time she went there. Later, Rousmanière recalls, when the Alstons moved to a large home a block and a half away at 416 West 3rd Street between Mint and Graham, Rosa Kennedy would bake a braided, challah-like bread, take a short cut through the alley that separated the properties, "and hand it to me through our back window."

Among Romare's playmates was Rousmanière's brother Charles "Spinky" Alston, who was about four years older than he. The two

Morning of the Rooster. 1980. From the *Mecklenburg County* series. Collage on board, 18 x 13¾″. Private collection

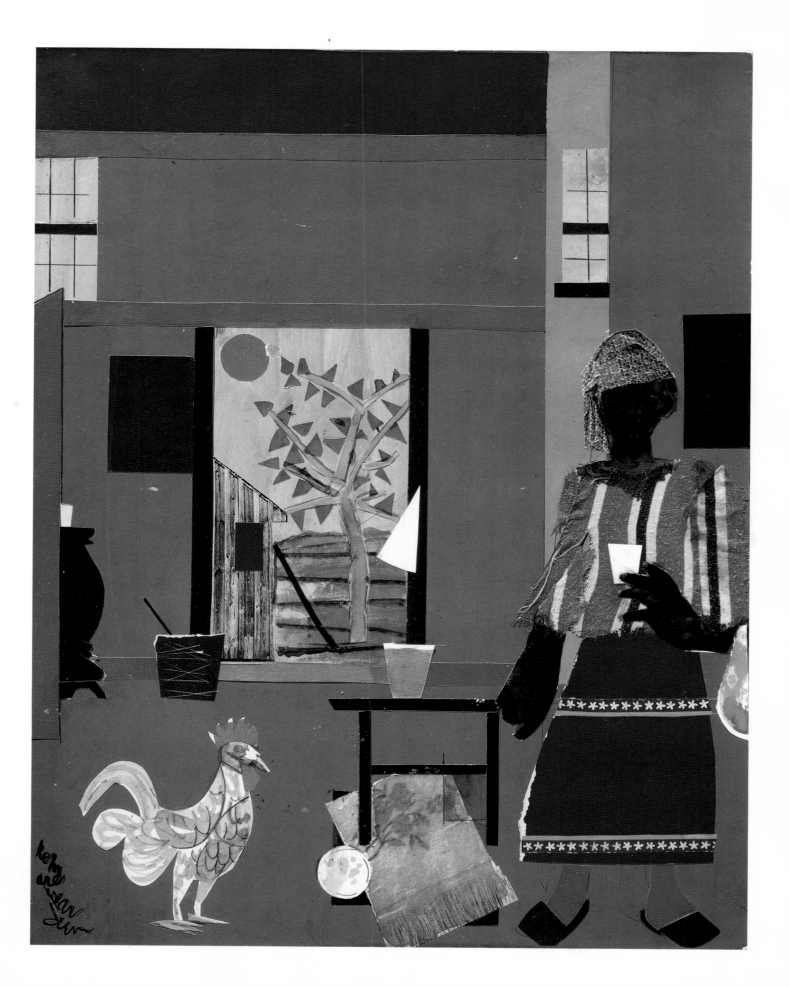

played ball on the steep stone stairway leading up to the front door of the old Charlotte branch of the United States Mint, Romare probably keeping to the lower steps as he watched Spinky's antics. Spinky was to become an artist himself, and he and Romare were close friends for many years in New York City.

Love of art and music pervaded the extended family. Both H. B. and Cattie dabbled in art. H. B.'s painting of Custer's Last Stand hung in the grocery store, and Cattie's drawings included a portrait of Abraham Lincoln. Bearden would later find his first mentor in Bessye's mother, Carrie Banks, who told him how to simplify his earliest efforts in art. Charles Alston was making sculptures out of Charlotte's red clay before he left for school in New York.

Musically, the families were equally adept. Along with his work as St. Michael's organist, Howard was a good pianist whose favorites were church hymns and sentimental songs. (Later, in the Bearden apartment in Harlem, there was a grand piano that Howard shared with the likes of Fats Waller and Duke Ellington, friends who often stopped by.) Romare's Uncle Harry was a devotee of opera who also played the pianola; his Aunt Anna was a church organist in Greensboro and taught both piano and organ there. Anna's daughter Mabel had a beautiful soprano voice and took her Mus. B. degree at Howard University.

Rousmanière also remembers how much Romare loved to watch the trains go by. He would have seen or heard them pass all day and through the night, even in his sleep. In Rousmanière's young years, children would sometimes take a walk down to the Southern Railroad station on West Trade Street to see the trains come in, especially those Rousmanière calls the

Sunset Limited. 1978. From the *Profile/Part I: The Twenties* series (Mecklenburg County). Collage on board, 15½ x 20¼". Private collection

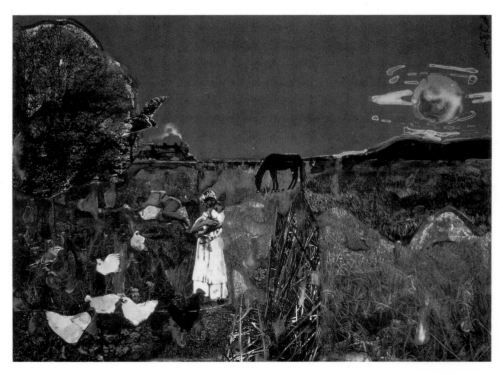

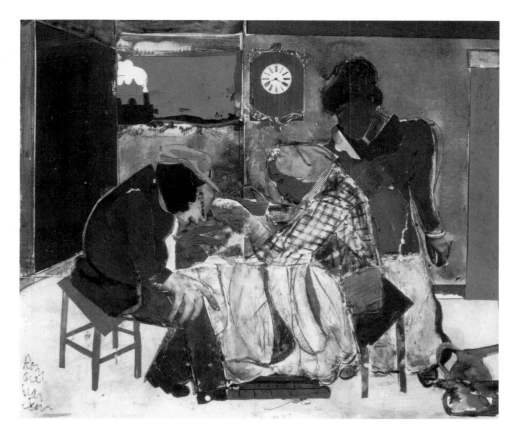

Sunset Express. 1984. Collage on board, 13 x 13″. Collection of The Asheville Art Museum, Asheville, N.C.

"special trains," the numbers 37 and 38. Mornings, it was the 37, the New York and Atlanta Special that came down through Charlotte at 10:00 A.M.; evenings, it was the 38, coming back up at 7:30 P.M. headed for Washington, New York, and points north. One can imagine the look of that train, with its big gunmetal blue steel locomotive, coal car, day cars, Pullman drawing-room sleeping cars, dining car, and parlor observation car. Within a fifteen-minute period each morning starting at 10:00, a child could have seen the 37, the New York and New Orleans Limited, and the United States Fast Mail coming through northbound. It would have been wondrous to go to the main platform, whether it was to meet a relative or just to see the trains and hear the conductor shout out the names of those destinations: "New York and Atlanta Special boarding for Asheville, Atlanta, and Macon. Haaawll . . . Haboouaart!"

Many years later, it would be just such trains, carrying people to magic, mysterious places, that Romare would remember in collage after collage with titles such as *Watching the Good Trains Go By* (1964), *Sunset Limited* (1978), *Southern Limited* (1976), *Evening Train to Memphis* (1976), and *The Afternoon Northbound* (1978). Beneath a collage called *Daybreak Express* (1978) the memory is written out: "You could tell not only what train it was but also who the engineer was by the sound of the whistle."

Bearden remembered attending school briefly in Charlotte when he was a boy, and thought it was the Myers Street School. Nobody left in Charlotte can verify this. Still the memory was there: a collage like *School Bell*

Above: *Daybreak Express*. 1978.
From the *Profile/Part I: The
Twenties* series (Mecklenburg
County). Collage on board,
10 x 15″. Private collection

Right: *The Train*. 1974. Collage
on paper, 15¼ x 19¼″. Estate
of William H. Van Every, Jr.,
Charlotte, N.C.

Left: *Southern Limited*. 1976. Collage, 18 x 24″. Private collection

Below: *School Bell Time*. 1978. From the *Profile/Part I: The Twenties* series (Mecklenburg County). Collage on board, 29¼ x 41″. Kingsborough Community College, C.U.N.Y.

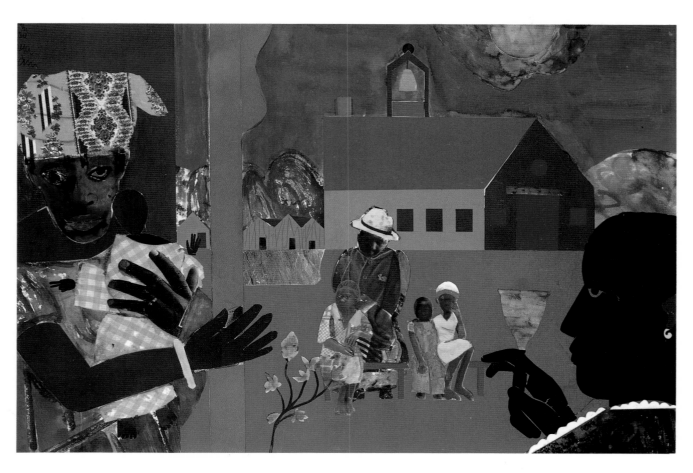

Time (1978), part of a *Mecklenburg County* series, shows a teacher ringing a bell that echoes a large school bell displayed prominently atop a barnlike school building. The collage carries the narrative "Once it was mid-September again, it was back to Miss Pinkney and books, blackboards, rulers and fingernail inspection." The Myers Street School had just such a bell, and it was a wooden, three-story building. But with the mind of a mathematician, Bearden himself would point out that by itself, that proved nothing. Many schools, he would say, had such bells. Nobody left in Charlotte who went to school at the time can remember a Miss Pinkney. None of that is the point. Bearden was remembering, "re-remembering," and re-creating. His mind was at play, and he was talking about the archetypal ritual of passage rung in by the bell at the start of the new school year.

Bearden was of two minds about the past. On the one hand, he was as rigorously analytical as any skeptic, and he had the training of a mathematician and philosopher. On the other, there were the memories, the ghosts that made themselves known if he allowed them to walk through his paintings. The people and places in Bearden's memory became elemental to his art. "One day, these people came walking into my work and seemed to know just where to go within the painting." He chose to let the mysterious remain a mystery.

In an autobiographical statement for the Archives of American Art, Bearden wrote that one of his earliest visual recollections was of a beautiful tan, orange, and brown tiger lily he saw in his great-grandfather's garden when he was a boy of nine or ten: "Each day I would go and look at that flower; but one Sunday I found it gone, and only a green stem trembling in the air like a small garter snake. My [great-]grandfather saw my concern. He told me that my [great-]grandmother had worn it to church. Then he said, "Don't worry, this is good soil and next year your tiger lily will be back once again."[6] The salient themes are all there in the anecdote: the childhood entrancement with a beautiful object, its destruction, and his urgent desire to retrieve it.

TRAINWHISTLE BLUES GUITAR: LUTHERVILLE AND NEW YORK

In one of Bearden's collages, *Childhood Memories* (c. 1966), a blind guitar player is led by a little boy holding a rose. The memory re-created there is a window on his years as a youngster in New York City with deep ties to grandparents in Charlotte, Lutherville, and, later on, in Pittsburgh.

One "old old July" in the early 1920s, he visited his grandmother Cattie in Lutherville, Maryland, a rural town near Baltimore. Cattie was a teacher and a preceptor at Bennett College in Greensboro, North Carolina, where her daughter Anna lived. Long after Richard P. Bearden's death, she had married Charles Cummings, a Methodist minister who had a parish in Baltimore and Lutherville. Cattie had moved there with him.

In Lutherville, Romare knew a Mrs. Johnson, whose grandmother had been born into slavery and whose baking tins had been made by a slave blacksmith. Mrs. Johnson's culinary specialty, passed down the genera-

tions, was a watermelon cake fashioned so expertly that it was difficult to tell from the real thing. She placed "seeds" of chocolate hardened in an icy stream in a red batter, painted the top with melon stripes, and added a transparent sugar icing as the final touch. This Southern *pièce de résistance* was in great demand among the rich white families who lived or vacationed in Lutherville's fine old houses. Each Saturday morning he was in Lutherville, Romare delivered the cakes for Mrs. Johnson.

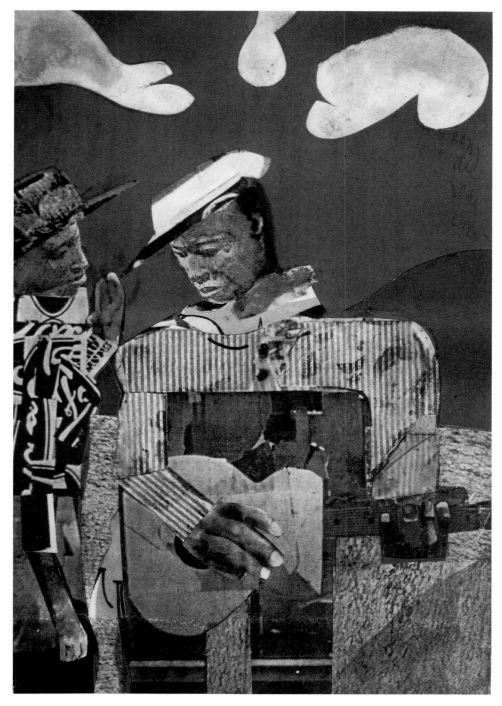

Guitar Executive. 1979. From the *Jazz* series. Collage on board, 9 x 6″. Courtesy Sheldon Ross Gallery, Birmingham, Mich.

Her husband, E. C. Johnson, was a locally famous blind guitar player and folksinger. One Saturday, E. C. accompanied Romare as the boy delivered the watermelon cakes in a little wagon. As always, he had his guitar, Romare recalled.

When the two started out this Saturday, Mrs. Johnson gave the boy a pail, telling him that if he picked some blackberries on the way home, she would bake him a nice pie. "Along the way, Mr. Johnson held my free hand and strummed on the guitar with his right hand. After I had left the last cake and started back, I saw a good clump of blackberries a little ways off the road. I went with my pail to pick the berries and Mr. Johnson sat on an old tree stump and began to play his guitar. The music was strange to me and not like the church hymns, or the blues, or any of the popular songs that I knew. Finally I asked Mr. Johnson what was the music he was playing. He said, 'Oh, I don't know; I'm just wandering over the chords, just as if the wind was moving my fingers.' It was fine listening to Mr. Johnson's music and picking the full ripe berries. I felt very good and I picked a beautiful rose I saw growing wild that I thought would please my grandmother."

E. C. Johnson's music may have been strange and beautiful, but his visits were unwelcome to all but the boy who led him. E. C. was a latterday Tiresias who knew everybody's business. He had a dream about anyone he could get Romare to corral, and the dream was consistently calamitous: "Oh, Mrs. Jones, I dreamt last night I saw you lying in that coffin just as plain," he would say; "The casket was just so nice." And finally the kicker: "How are you feeling, sister? I mean, you better take care of yourself, because I dreamt about you last night."

As Bearden told it, when people saw the guitarist coming, they scattered. "So there he was and he'd be strumming on his guitar. It was kind of out of a Greek play—leading the blind soothsayer. The little boy leads him in and he makes a dire prediction for the city."[7]

Bearden sifted the details of this childhood memory so that the listener was given a new perspective with each retelling. What in one interview sounded like an extended recipe for watermelon cake sounded, in another, like a jazz musician riffing first on one phrase, now another. He "called and recalled" these same images in different ways: the blind guitar player, the boy, the wild rose. He did collages of a woman named Maudell Sleet time after time, for instance. "Each time it's different: I mean the facial characteristics. I wouldn't recognize her as the same woman one for the other, but it's faithful to my memory."

Guitar players sound their folk blues in dozens of Bearden's collages. These musicians, together with other recurrent motifs of railroad trains, or roosters voyeuristically observing bathing women, not only suggest the idiomatic particularity of the landscape Bearden remembered, but also act as metaphors and icons in the terrain of his artistic vision. Of the two collages in particular that contain guitarists Bearden associated with E. C. Johnson— *Guitar Executive* (1979) and *Childhood Memories*—the latter is the more striking due to its juxtaposition of rural Southern memory and big-city setting. The

Farewell to Lulu. 1981. From the *Profile/Part II: The Thirties* series. Collage on board, 18 x 14″. Collection Dr. and Mrs. Herbert Ross, New Rochelle, N.Y.

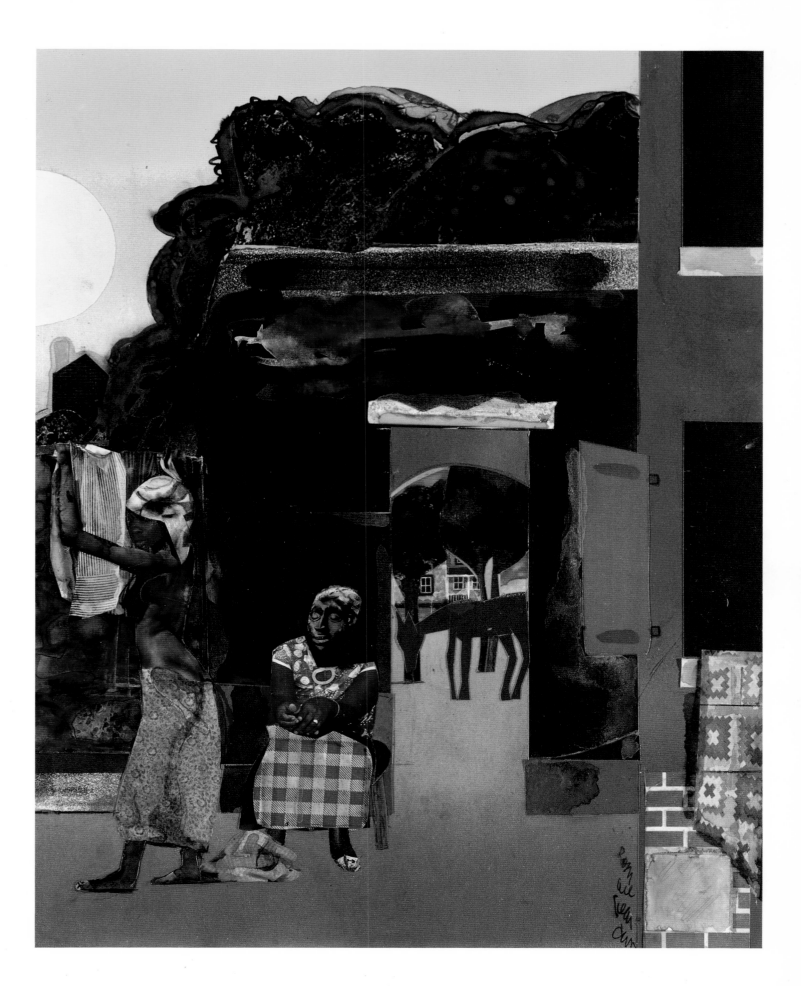

guitar player and little boy stand before a cobblestone crossroad filled with New York City traffic and the anonymous pedestrians of the metropolis. Pulling together all these elements is a gigantic eye-clock in the upper center of the collage, unblinking, giving its own version of the city's time.

SCHOOL BELL TIME: HARLEM

Childhood Memories is also a visual metaphor for Romare's early school years, when his life must have felt displaced, divided between the Julys of visits with his great-grandparents, his grandmother Cattie, and his Aunt Anna on the one hand, and the Septembers of New York City public school on the other.

When the family first moved to New York about 1915, they lived on West 53rd Street with a great-aunt of Howard's, Rosa Kennedy's sister Anna. While Romare was still of preschool age, they moved to 130th Street, where a Mrs. Austin rented rooms. By the time Romare was ready to enter public school, Howard and Bessye had found an apartment at 173 West 140th Street at Lenox Avenue, where they would live well into the next decade.

This apartment overlooked a large lot extending all the way from Lenox to Seventh Avenue and from 139th to 140th streets.[8] The lot was a kind of improvised park, a natural playground for children and adults. A hill, composed almost completely of old glacial rock, fronted Seventh Avenue. Inside the lot there were trees, winding trails, small ponds, and even a cricket field near Lenox Avenue. Here, emigrées from the West Indies played on Sunday afternoons. During July and August in the mid-1920s, a wooden floor was laid on a flat top section of the hill, and from under a large tent called "The Garden of Joy" jazz floated on the still humid evening air.

In 1917, Romare had been enrolled at P.S. 5 on 141st Street and Edgecombe Avenue. Except for the year spent in Moose Jaw, Canada, and the next spent completing fourth grade with his maternal grandmother in Pittsburgh in 1920–21, he would receive his entire elementary school education and the first two years of high school in New York. He completed high school in Pittsburgh from 1927 to 1929.

Like Harlem itself in the first two decades of the century, P.S. 5 was multiethnic. Most of the pupils were Irish, Jewish, and Italian; only a small percentage were black. A number of students, all of whom wore similar uniforms—blue pants and blue shirts—were called "The Home Boys." They were from the Hebrew Orphan House, then situated a bit west of Lewisohn Stadium. At the stadium, teams from City College played football, baseball, and lacrosse, and on summer evenings, one could hear wonderful symphonic music, often for free.

At that time, the system "tracked" the students in both elementary and high schools, reserving the academic track for the brightest and placing the others in slower classes or on a vocational track. Romare did well enough to skip an entire year from the end of sixth grade to 8A1, the most advanced class, when IQ tests were first given. But then he suddenly found himself teetering dangerously near classification as prime "shop material,"

even as a potential truant. At first, it all seemed like Percy Cramer's fault. And perhaps, to an extent, it really was.

Percy and Romare were the only two black children in the class, and Percy was a cutup who loved to have fun. The two boys, whose families were neighbors, were seated together and were perceived as trouble-makers by their teacher. "I don't know whether we kids would *sense* that she didn't like us, but for some reason, we would always go out of class to wrestle and play." Inevitably, report card time came around. "This woman gave Percy the lowest mark I imagine ever given in the New York City public school system. If there was A + on down, and D was bordering on failure, I think I got B-, D-, D-, and Percy got X, Y, and Z!"

Bessye, by this time secretary of the school board (the first black woman to hold that position in New York City), nearly went apoplectic when she saw her son's report card. The next day, she went over to P.S. 5 to see the principal, who called Romare up from class and began to question him about what he read. "I remember one of the books was Charles Lamb's adaptations of Shakespeare's plays. He asked me about this, other things, some arithmetic." It became clear that Bessye's position—that Romare was not stupid, that she fed him properly, that his grades couldn't be *this* bad—was quite reasonable. And so the teacher was asked to come up.

" 'He's a very smart boy, but it's just that Percy Cramer, he's so bad, he's so disruptive,' the teacher said. 'Well then, why'd you sit my boy next to him, if he's so bad?' Bessye asked her." Then the teacher said that they were the only two colored boys in the class, and she knew both families were acquainted. "And well, my mother hit the ceiling, and they both lit into the teacher. So then I stayed, and I didn't have much trouble after that."

Harlem was changing year by year as the migration of black people from the South proliferated. The hill fronting Seventh Avenue by the play lot opposite the Bearden apartment was blasted, and the lot was leveled so that stores, apartment houses, and P.S. 139 could be built on the site.[9]

Later, Romare was transferred to the new P.S. 139, along with many other students from P.S. 5, and completed the last half year of eighth grade there. He was in the school's first graduating class, when he was about twelve years of age.

Romare went on to two of De Witt Clinton High School's annexes. The school had so many pupils that in consecutive years, there were about five annexes in various parts of the city; one of these was far west on 53rd Street, another was located on 116th Street. In the year and a half that Romare attended Clinton, he never made it to the main building.

By now, Romare was thoroughly accustomed to life in New York City. But his memory continued to cling to an old July, when E. C. Johnson sat him down on a tree stump to explain how his sound came from the wind moving through his fingers over the guitar strings.

OF MECKLENBURG, MEMORY, AND THE BLUES

A COLLAGIST'S MUSIC LESSON

Autumn Lamp (Guitar Player). 1983. From the *Mecklenburg Autumn* series. Oil with collage, 40 x 31″. Private collection

During the time of this interview, dating in large part from March 1983, Bearden was working on a series of works set in his birthplace, Mecklenburg County. Most of these collages are referred to in this interview by Bearden's working titles, which often changed once the pieces were finished. I saw them go from nothing but a ground of colored Arches paper on masonite board to completed collages. Bearden was moving toward a new way of handling collage: in some of these pieces, he stripped away more elements than he allowed to remain and painted a great deal of the surface in oil colors.

I very rarely saw him struggle with a collage. But *Autumn Lamp,* with its country guitarist, guitar, and lamp, did not come easily. Watching it change over a period of several weeks reminded me of the awe I felt listening to Bud Powell, Max Roach, and George Duvivier perfect Bud's composition "Un Poco Loco," a classic of jazz improvisation. In three successive recorded takes, the careful listener can hear the gropings, the hesitancies, the quickening, and then the precise point at which all the elements suddenly jell and the improvisation takes flight. Bearden himself likened the struggle to jazz: "You do something, and then you improvise." As Claude Monet observed of Edouard Manet, Manet always wanted his canvases to have the air of being painted at a single sitting, but often he would scrape down what he had executed during the day. He kept only the lowest layer, which had great charm and finesse, on which he would begin improvising. In this sense, for Manet, a painting was never absolutely finished; at some point, he relinquished it.

That was the way Bearden struggled with *Autumn Lamp.* At a certain point in the process of composition, he placed a denim shirt on the guitarist, "and then I knew when I put these denim sections in that it had a kind of set to it." But by the time *Autumn Lamp* was relinquished, the only fabric remaining was a small section at the upper part of the guitarist's shirt surrounding his square chin. His guitar is at rest on his thigh; his long hands are at rest one on top of the other. There is a wise smile on his lips and in his knowing eyes. He—like Romare—has played.

Bearden had just returned from Baltimore, where he saw his completed mosaic *Baltimore Uproar* unveiled in the mezzanine of the Laurens Street metro station, a neighborhood where the strains of jazz bands could once be heard long into the night, and where Billie Holiday spent her early years.

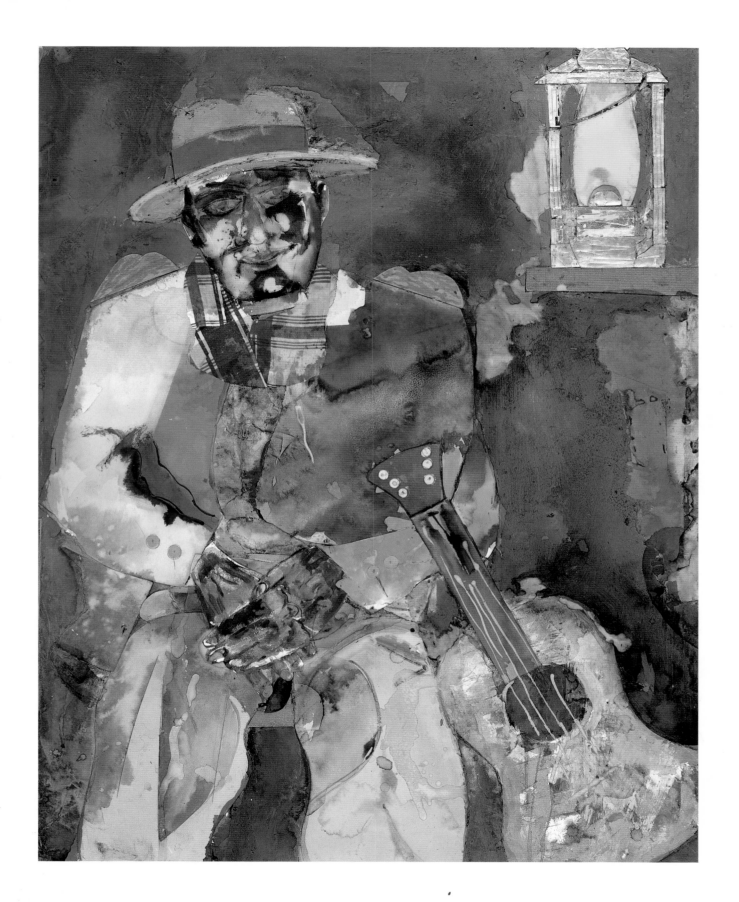

MS: I picked up a Baltimore newspaper yesterday in Times Square, hoping that the ceremonies on the opening of your big mosaic for the Laurens Street subway mall would be covered. There it was! I guess this was the area of Baltimore near Billie Holiday's birthplace, and the paper has a good photo of the mural, with the singer and the big band wailing behind her. In the accompanying story, the reporter wrote that you used to visit your grandmother Cattie when you were in Baltimore as a boy. Were you allowed to go out in the evening late enough to catch any music when you were that young?

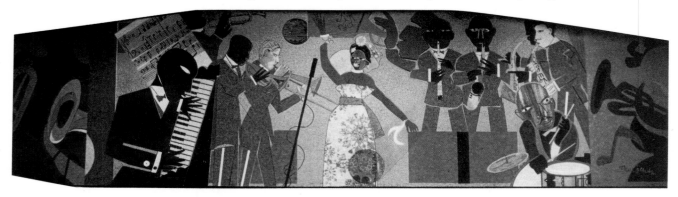

Baltimore Uproar. 1983. Ceramic and glass tile, 15 x 40′. Upton subway station, Baltimore. Photograph by James Kelmartin

RB: No I wasn't. You had people at that time—they had records, but they weren't too fond of playing jazz, especially religious people. . . . Then when I was there Tuesday, driving into and back from Baltimore, there was the turnoff to Lutherville, and I would have liked to have gone in to see what the devil it looks like now. . . . I know it's all changed.

MS: Probably like Charlotte. Now, you superimposed Ellington, and Ellington's music, on that scene. So I just wanted to ask you about when you first heard Duke's band.

RB: In the thirties. He played in the Cotton Club, but no Negroes were allowed in the Cotton Club. But the Cotton Club shows would come to the Lafayette Theatre, I think twice a year, and you would see the whole show, the dancing and things, and Duke's band would play there.

MS: What are your memories of the band, and the performance?

RB: I had a cousin, still living, Aida, and she was very friendly with Ruth Ellington, as I still am. And the three of them—Aida, Ruth Ellington, and Lena Horne—were schoolgirls together. Later on, Duke did play at the Savoy, when that opened. But he was mostly at the Cotton Club or touring.

MS: Al Murray writes that Ellington bought one of your first works.

RB: Yes. I had a show at Kootz right after World War II. Ellington bought an oil, maybe it was religious. Fats Waller bought something when I was first in school, but I don't think because of any interest in art. He just came by here— I was living at 154 West 131st Street. He did a lot of music for Connie's Inn and the Lafayette, and they would hear this lyricist, Andy Razaf, who was always in and out of the house, and he just bought that—you know, a couple of dollars—to help me. I was just getting my first lessons.

MS: I want to ask you about the two *Profiles*, the twenties (1978) and the thirties (1981). You had said when we talked last time that the idea of a profile

was Mr. Ekstrom's, following the Calvin Tompkins profile for *The New Yorker*. Was it also his idea to include those little narrative descriptions beneath the collages?

RB: Yes. Right on the gallery wall. I said, "Mr. Ekstrom, you can't do this, you'll wreck your wall." He said, "I'll repaint it."

MS: What were your impressions of that method of display. Did you like it?

RB: Yes, it was rather effective, then. We're so used to graffiti these days. . . .

MS: For you, were those little capsules of statements written on the wall—do you think of them as part of the work, the collage? Or were they extraneous to it, somehow explanatory, or parallel?

RB: Since it was a profile, I was talking about remembrances, and actual people—actual people but not photographs of them. You know, like Maudell Sleets. I've done her about two or three times; and each time the facial characteristics are different: I wouldn't recognize her as the same woman one for the other, but it's all right for my *memory*, because I'm *recalling* this thing. . . .

MS: Each collage could surely have stood on its own . . . and in a way to read that description as what the collage means, limits what's happening in the collage.

Above left: *Sunset and Moonrise with Maudell Sleet*. 1978. From the *Profile/Part I: The Twenties* series (Mecklenburg County). Collage on board, 41 x 29″. Private collection

Above right: *Maudell Sleet's Magic Garden*. 1978. From the *Profile/Part I: The Twenties* series (Mecklenburg County). Collage on board, 10⅛ x 7″. Private collection

RB: Well, now that the people who have bought these things—they have 'em on their walls!

MS: And the descriptions have gone their separate ways!

RB: You see, this is also not just painting; it was a history of something that's gone, and people should know about. Now, hanging in a museum, for instance, that [historical element] is not there.

[We went on to discuss the series, *Mecklenburg Autumn*, on which Bearden was still at work. He'd completed six or seven of the collages by then, but one of them, structurally the tightest, had stuck in my mind, and I wanted to see it again. Bearden took out all of the completed collages which were stacked in a corner of the studio: he named them as he set them side-by-side on the floor against the bookcase. He loved to do this when he had finished a number of pieces, and he named them with pride, although some of the titles have been changed since that day. He set *The Piano Lesson* right next to us so that we could see it easily as we talked about it. In it, a stern teacher stands over her pupil, her finger pointing didactically, while the young student performs intently. The structural formality of the collage suggests the internal logic of Mondrian's work. At the same time, Bearden's use of the metronome as a recurrent triangular motif made me think of Matisse's *Piano Lesson*, 1916, while the figures of teacher and student and the ornamentation at the top of the piano and on the music to its left suggest Matisse's more naturalistic *Music Lesson*, 1917. These allusions notwithstanding, Romare's flower-patterned aeolian window, the chandelier, the furniture, the piano, and each detail of costume are unmistakably from a Southern parlor.]

MS: Could you please describe how you started on this canvas, what triggered the idea for it, and how you began.

RB: Well, I began with these kind of colors that I painted on the masonite. This is the masonite underneath there, where you see the brown. Then this is a very fine Arches paper, acid-free. Sometimes you find that Goya, Manet, some of the Old Masters painted on what they called red or brown bolas grounds, and they would let this play through in their paintings; and sometimes this ground was used for the shadows—they'd almost leave it. I've seen some of Goya's paintings where the underneath ground predominated over half the painting, and then he would, say, weave a certain blue color here and then develop those things that he wanted to be highlighted. This was an Italian technique from the Venetian painters—Tiepolo, Veronese, Tintoretto painted very much in that way. So I let the ground play through. And then what I put on there—the things I lay down—I try to put in proportion to the overall size—in the same ratio. And then in this, I did something that I don't usually do. You see I tipped it to lay the piano in a kind of perspective going this way, and to compensate for that I had to . . . bring things back on the frontal plane—you see the blue?— because this is going this way and the other blue is for that reason: to carry you back to the front. And sometimes I do that if it's going to bring it right back to the frontal plane, so that the things are more or less flat.

MS: In your *Piano Lesson*, what materials are there?

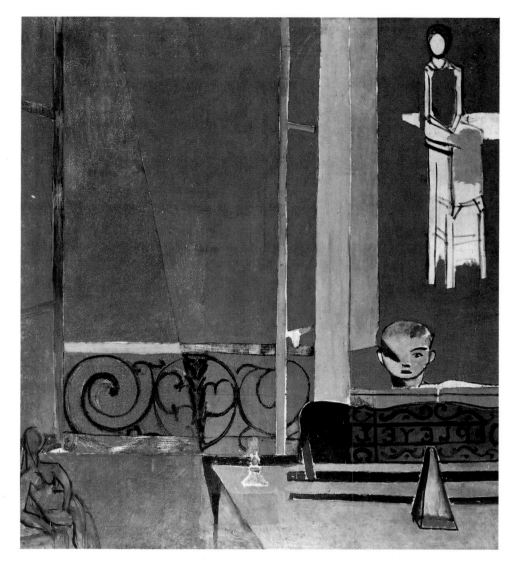

Henri Matisse. *The Piano Lesson.* 1916. Oil on canvas, 96½ x 83¾". Collection, The Museum of Modern Art, New York. Mrs. Simon Guggenheim Fund

RB: Cloth, actual wood, to make those tables, paint—you see the dress of the young lady, painted—and other things I've found: the metronome, the picture that they would have on the wall is painted, and a lot of the windows in those days in the South would have those ornaments, little stained glass windows; and then the lamps, the sideboard.

MS: Did you sketch at all on the masonite board?

RB: No, I very seldom do. Sometimes I'll take a piece of charcoal and just indicate something, but I didn't here. When I do sketch, it's just the starting point for something.

MS: Do you keep materials for collage? Fabrics? . . .

RB: Yes. I have some fabrics here that I asked my wife to go and buy in a shop near home.

MS: And do you keep a picture file from magazines?

RB: I have some magazines. For instance, you see the old Singer sewing machine. I had an old Sears Roebuck catalogue of the turn of the century, or

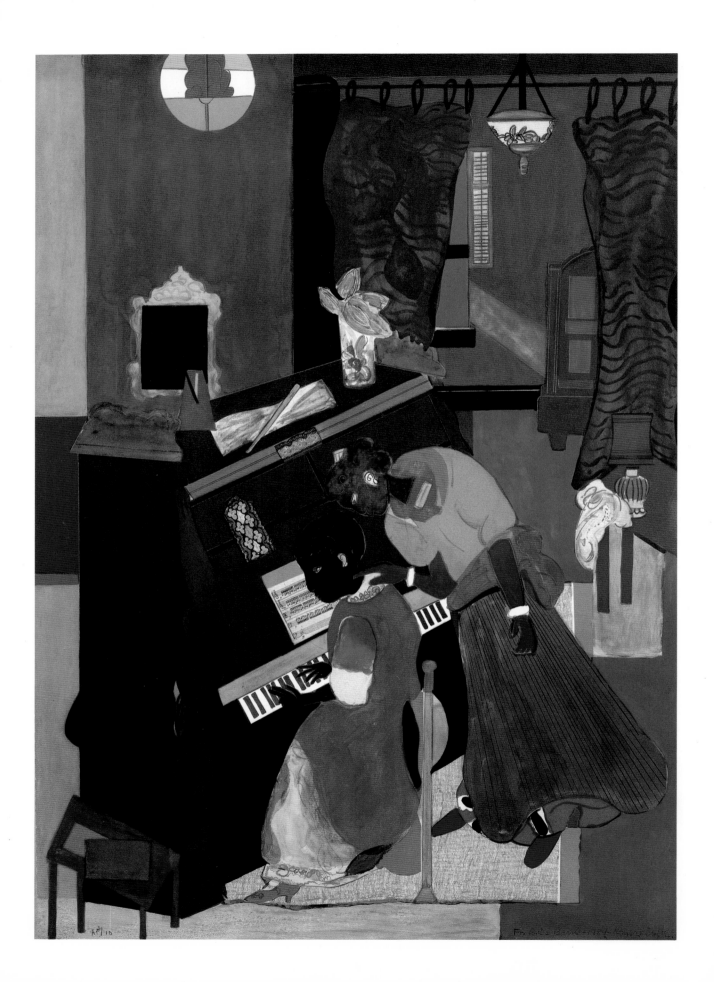

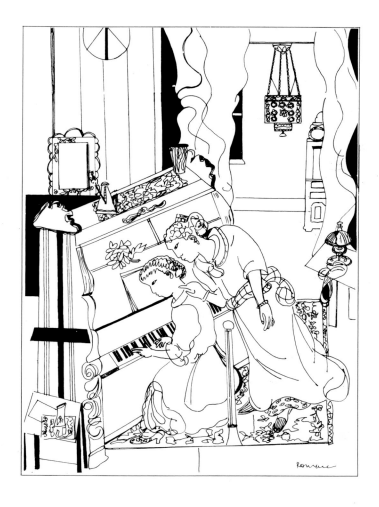

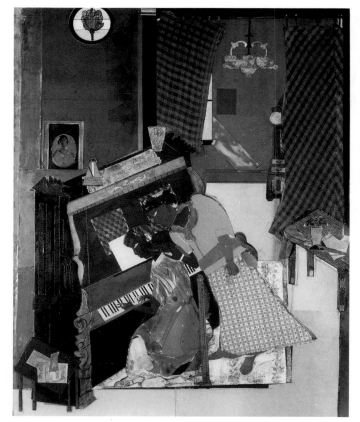

Opposite: *The Piano Lesson.* c. 1984. Silkscreen, 29¼ x 20¼". Private collection

Above left: Maquette for silkscreen of *The Piano Lesson.* c. 1984. Ink on tracing paper, 19½ x 14". Private collection, New York

Below left: *The Piano Lesson.* 1983. From the *Mecklenburg Autumn* series. Oil with collage, 40 x 31". Private collection

the first decade. I took the representation from an advertisement, because it was hard to carry the full memory of something like that in your mind. But the other things that I put in. . . . They had the old Chinese lamps that they had hanging down. So I took a [picture of a] Chinese vase, and cut it into the shapes of those old lamps, and put it in.

MS: So it gets improvisational. Like you're playing as you go; not all preconceived: some things happen in the process.

RB: Well, it's like jazz; you do this and then you improvise. You know Manet (I think) said, "A painting isn't finished; sometimes you get on the surface." He meant, "Well, you've got it under control." Maybe sometimes a third of the way through, I'll say, "I *know* this is coming out." You get that feeling that the thing is going to be all right. And other things you just have to surrender. As my friend Carl Holty used to say, "Don't close your picture too quickly; keep it open until the very last, and that gives you room to maneuver." You reach a point when all the elements seem to focus, so that the colors and the forms will set. And at that point you can relinquish the painting.

You know I had a time with the *Guitar Player* [finally titled *Autumn Lamp*]. I had other ideas, and then improvised it. It just wasn't setting right to me. I had it in another way with the denim cloth shirt on, and then I knew when I put these denim sections in, it had a kind of set to it. I don't know how I can define that. He just seemed to be sitting in the picture right.

MS: When you reached the point when it wasn't setting right with you, where it seemed like a cul-de-sac, did you fight it? Or did you decide to push on?

RB: To take another tack . . . I stayed with that canvas. Sometimes you just have to surrender something, but I stayed with it, and finally it came through.

MS: What triggers the series, Romie?

RB: Well, the memories are just there; they're just really with me. It's strange, the memories are there. For instance, you see the Vermeer [reproduction of *The Concert*] up there on the wall? I'll say, "Well, I saw something like this; this used to be so-and-so." Because I guess art is made from other art. Yes, I've been in places like this; I've gone in with the same kind of stillness, and the light coming in from this source.

Those people [of Vermeer's time] moved on, and the people from Mecklenburg have come in there; they stayed a while and now there is something else.

MS: Let's explore the theme of relationships. What does it mean to you in painting?

RB: In discussing relationships, we have to consider many disparate factors, or seemingly disparate factors, in the way a painting is put together, such as scale, space, line, and so forth. And the idea of my thinking is that everything has a certain correspondence with one another. For instance, a Chinese painter, in the classic days, when he looked at the rocks and the trees, felt a certain oneness with them. And he was, himself, although painting it, *part* of the landscape which he was painting. He looked upon the large tree, let us say, as a father tree, the others as his children; the largest mountain, perhaps, as a father mountain, or a mother, and smaller, children mountains. So he imbued

nature with these human concerns. Since he was relating them in a family way, they would be his own, personal concerns. In this way he was able, at the very beginning, to think of the relationships in his painting because of his relationships with a family. And I think this is one of the most important things that Matisse talks about—the relationships, how one does things—and it changes. I was talking with Holty once, and he said, "Titian had to juggle about twelve balls in doing one of his paintings, because he had to think of perspective, volume, historical concerns, where the king or the Virgin Mary had to be centered as the most important figure . . . historical concerns, not so much what the artist of today bothers with. But while Titian is juggling twelve balls, maybe Picasso or Matisse juggles four. But they must be the exact right ones."

In the Cloisters I saw some old Spanish frescoes, and I thought—Picasso. In the icons, and in African sculpture, they bring everything to a very beautiful shape. So long as you can get everything in a nice shape, the picture will be all right—you're just shaping it, not worrying so much about the anatomy. If you do that and it all moves in the right rhythms, you have a painting. We get deceived so much by appearances. You sometimes just have to forget about that, because you are working in another world here. And so you could easily take these [canvases] as being completely nonrepresentational.

Take Vermeer's drawings—you turn them upside down, and there's real, great abstraction. The wrinkles in the clothes, for instance; you turn the drawing upside down, and you see something else, the great relationships. This is the abstracting of things. People think abstraction means that you don't have figurative objects in a work. So a more accurate word is "nonrepresentational" rather than "abstract," because Poussin, Ingres are great abstractionists.

MS: So this canvas is not, per se, about a music lesson, it's just as much about the relationships of rectangles and the composition of the whole . . .

RB: Yes, but it's the music lesson. The mechanics are hidden.

MS: Do you listen to music while you work?

RB: I turn on Columbia's station, WKCR, at about twelve o'clock—*Out to Lunch* is on from twelve to three. I listen to that, and then I can listen to classical. I don't care for rock 'n' roll. I like some of the old blues, and the classics—Bach, Buxtehude, Respighi, Vivaldi—the precision of it. Carl Holty loved Mozart. I haven't got quite the feeling for that great composer. And then I would like some of the French, way back; the Romantic composers.

MS: Could you pinpoint how the music enters into your work? In other words, does it take your mind away, when you want it to, or does it help the flow?

RB: It's hard to delineate these things, because there is always—what does Walter Pater say—that "all art aspires to resolve itself to the condition of music"? Which he felt was the greatest of the arts, and perhaps it is. Delacroix said that painting is the *rarer* art. There is this type of thing. To a Buddhist, all things are one and related.

MS: When you do a canvas like any of these, there are many processes, some of which have to do with simply cutting paper, or applying paper, or coloring

the paper, which you could think of as mechanical and possibly stopping the flow of the work. Does that happen? Or does the mechanical part of the process sustain the creative part by breaking it up? What I'm really asking you is where the energy comes from.

RB: Well, I know what you're saying. Von Clausewitz, who wrote a book, *On Warfare,* [1833] said the solution to a battle is really simple. The only thing is that there are so many choices. So the flow isn't as it is in music, where it is continuous. You have chaos—not in the sense of anarchy, but in the sense that things have to be resolved. And in your painting, it's the last thing, the resolution of these things, as the *relation*, the relating of these things one to the other—for instance, the inverted and repeated metronome in *The Music Lesson*. This is the solution to the battle, or what Manet meant by "getting on the surface."

MS: For me, this is really what a music lesson is like: the diagonals, and the

teacher and the student really have to do with the way a teacher really is with a student; the severity of that woman, perhaps.

RB: No jazz was allowed in her parlor! And her big favorite was MacDowell's "Ode to a Water Lily."

MS: How do you keep the element of surprise moving in your work? Or is "surprise" an appropriate word?

RB: I think so. In Chinese paintings, probably the greatest of paintings, you'll find—and I sometimes try to do this—an open area, or open space, which allows the onlooker to enter the painting and find his own surprises in it. They always refer to the "open corner" of Chinese painting.

MS: With all the different elements you've got to struggle with in one of these collages, how do you know it's all going to come together in the end?

RB: I felt that the *Guitar Player* just wasn't right. It took about two weeks getting him to "set" right. As a writer, you've felt that maybe this paragraph needed to be restructured. . . . God, after a while, if you don't have that feeling—it's hard to describe it—the most important parts you just have to feel your way on faith. It's akin to religion. You can't say, "I believe it," because it can be challenged. If you have faith, who can say anything about it?

MS: Right. Right. Do you find the trip to the studio from your home, the physical relocation, refreshing?

RB: It's not *refreshing*—it gives you another aspect. If you have your studio right where you live, you're always jumping up at night: you want to paint, and you start wrecking things. Also, if you're working intensely—composing a piece of music, or writing a novel, painting, or whatever art you're in—about three hours is enough for anyone. Say if I'm painting a mural, and let's say I want the sky painted in like this. I figure the gentleman who comes in to help me could do that, with a roller, if I'm doing something huge. That isn't the same thing. You're doing something mechanical then. But in the *composing* of this, in the *thinking* of that, I think if you're working intensely, with great intensity, you'll tire after three hours. Because with the invention of the machine, and in modern life—and it will be more so now, with the computer— man's patience was annihilated. And so now everywhere in the world—down in the islands, and everywhere—people are looking at television. And it's geared to the half-hour look, with breaks. In a half hour, you go to get something, a glass of beer, or whatever. So it's no longer like Van Eyck, that you sit down [for long periods]. The modern world has stripped us of that. The machine made work easier, but as the French poet [Paul] Valéry said, with the invention of the machine, man's capacity for patience was destroyed.

 I went to see those unicorn tapestries at the Cloisters, with all those hundreds of different flowers that people knew the names of—"Let's put an elderberry bush here," and so on. And it's all integrated into this thing. You see, if you took Picasso, Matisse, Braque, Cézanne—all the great painters of this century—they couldn't do that. They are great painters who did something else. I'm not saying they wouldn't do something equally as great, but that type of thing, that called for infinite patience, modern man, or man at this time, is not capable of.

Bearden during an interview at his Long Island City studio, 1983. Photgraph by Mimi Wlodarczyk

We are going into a different time, not an age. When men first went to the moon, this was frightening. Looking at this dead planet, they were glad to get back to earth; it had looked so beautiful out there, like some diamond or precious stone in space. Now you have kids shooting down alien space invaders in video arcade games: no more cowboys and Indians. I'm not saying this is right or wrong, but it certainly seems to be the direction our world is heading in. Charlotte and Mecklenburg County was no booming metropolis when I was a little boy. When they turned on the machinery in the Magnolia Cotton Mill, you'd hear it all over Charlotte. All this is gone, and the people are gone, and the people who *thought* that way are gone. So I imagine that all of this must affect style, in art.

MS: So you're saying in the sense that art registers the contemporary sensibility, no artist would do a work like the unicorn tapestries any longer.

RB: *Could* do it! They would try, but they *couldn't* do it. Which is why you can't forge things. When you look at a Vermeer, you can see those big eyes, and things . . . and the fact that he may have used the same kind of paints, or glazes, or whatever, as Van Gogh did, isn't the thing. [In making] all art, as

Goethe (I think) said, you're always *bound* to your time by one or two of its greatest faults. Now, there is a painting by Ingres, who is so classical, and this man is proposing to a young lady, and he's on his knees, and she's so overcome that she has dropped the book she was reading, which is hanging up here in the air! You see, he was overcome by the Romantic sensibilities of his time in this particular thing. Watteau, in the century before, in the Romantic beginning, wouldn't have made that error. And certainly Ingres didn't in his drawings. But he was just overcome by that time. You see it links it right in to that time. And by the same token, artists are presented with certain problems at a particular time. Coming out of the so-called Dark Ages, in Europe, the painters were interested in knowing the world, as well as being artists, you see. So Titian, with somebody in his workshop, drew the anatomical drawings for Vesalius's book on anatomy. You wouldn't ask Picasso now to do something like that. Or some of Dürer's drawings herald the beginning of botanical illustration. So in that period, the painter or sculptor walked hand in hand with the scientist. That lasted for a short time: Leonardo exhuming bodies, dissecting them . . . they don't do that anymore.

RB: In the overall format of the painting, the 'A' which you see here, this rectangle, is pretty much in the same ratio as the entire work. Since I depicted a piano that was making a thrust from the left part of the picture, moving on to a kind of perspective toward the right, I had to compensate for that dark area back of that kind of a box rectangle of the piano, to hold it on the flat surface. The rectangle is completely flat, and tips into the box and tends to hold the piano back into the flat picture plane. Now 'C' is a movement in the drapes that moves through the piano onto the teacher's dress. You see, it's holding. You might say this is all one continuing movement down, from the drapes right on through the teacher—a straight flat movement.

 Now at the bottom of the piano, if you'll notice, there is a rug. And the rug is set into a rectangular relationship that encloses the teacher and moves across to the young girl. This (I'll call it 'D') also holds the picture flat to the picture plane. There is another movement: the end of the back of the chair on which the young girls sits, which again is straight up and moves again to hold the flat picture plane. The drape on the far side, which comes down to the picture, is curvilinear and picks up the curves in the drape to the left of it. I'll put two arrows to show that.

 There is a picture, or a mirror, above the piano, and again, it's in the same overall ratio as the entire picture itself. I think these are the main aspects. Coming out of the drape on the right-hand side there is a little cabinet (I'll call that 'E') that again accentuates the up and down movement of the picture. There is a baseboard which is in the same movement directly across as this black line; this black movement is in back of the piano, you see, if we trace it across, which again holds to the flatness of the picture.

 So I think, without going any further that you'll see what I'm talking about, trying to get volume through the contrasting movements of planes while still trying to hold the flatness of the picture plane.

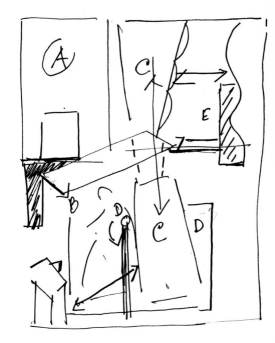

Bearden's diagrammatic drawing of *The Piano Lesson.* Ink on paper

MILL HAND'S LUNCH BUCKET
• PITTSBURGH IN THE 1920S

*I think the artist has to be something like a whale, swimming
with his mouth wide open, absorbing everything until he has
what he really needs. When he finds that, he can start to make
limitations. And then he really begins to grow.*

—Romare Bearden[1]

In 1947, inspired by his reading of the journals of
Eugène Delacroix, Romare Bearden began to keep
a journal of his own. He was in his thirties and had
been drawing and painting seriously for ten years.
A striking journal entry for September likens the artist's creative struggle to a
worker's capacity to endure intense pain: "Imagine a factory whistle blowing
through your spine, and consider how long you could stand this shrill discor-
dance," Bearden wrote. "This is in effect tantamount to the effort of intense
creation. The greater artists have been able to stand this whistle and steam
blowing their insides apart a little while longer than the others. A mechanic
can step up the revolutions of a motor and listen with his head almost in the
bearings for the engine defects. Likewise the great artist can destroy form after
form, constantly seeking the unique twist that will appear in the end as if he
owned the entire array of shapes and colors."[2]

Bearden wanted this godlike omniscience in his art, and he
seemed poised to withstand the "factory whistle" blowing through his spine to
achieve it. The image he chose to convey the shrieking intensity of the artist's
life was no romantic literary commonplace. Rather, his metaphor was drawn
directly from his own experiences of the Pittsburgh steel mills.

Bearden's earliest memories of the steel mills date from
1920, the year he spent in Pittsburgh in the fourth grade. He lived with his
maternal grandmother, Carrie, and her husband, George Banks. The couple
ran a boardinghouse in Lawrenceville, a steel mill neighborhood of the city.

That year began an era of great migration of Southern black
workers to the industrial cities of the North, coupled with a substantial wave of
European emigration to America. Lawrenceville and areas like it were focal
points: there was so much work in the mills that laborers might be trucked
north from Georgia or Mississippi and put to work immediately on the gigantic
blast furnaces and assembly lines. Romare would see a truck bringing twenty
or twenty-five men up from the South. Since the workers needed a place to

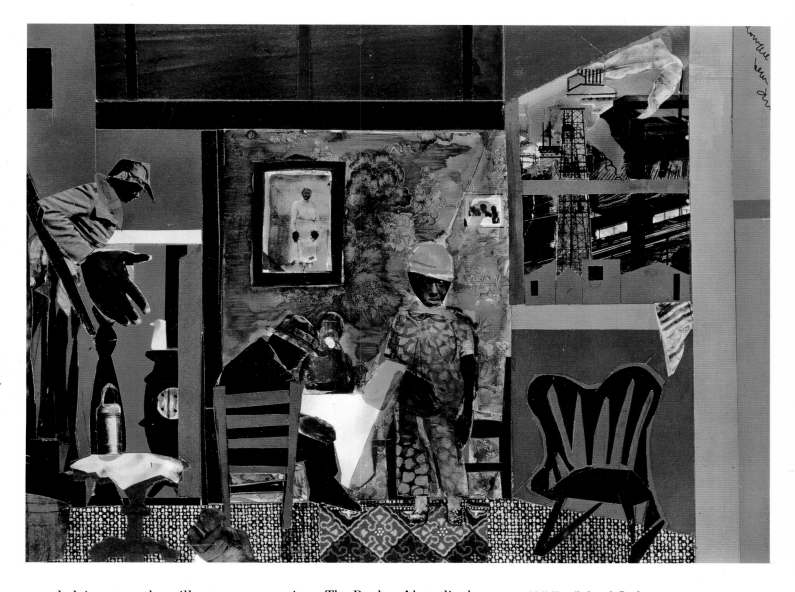

Mill Hand's Lunch Bucket.
1978. From the *Profile/Part I:*
The Twenties series (Pittsburgh
Memories). Collage on board,
13¾ x 18⅛". Private collection

stay, lodgings near the mills were at a premium. The Bankses' boardinghouse had a large dining room and kitchen on the ground floor, individual rooms for several men on the ground and second floors, and two large dormitory-style rooms on the third floor, where up to twenty men slept on cots. Each floor had a single bath that ran continuously on Saturdays. There was no time for anything but work and sleep during the week. The men worked eight-to-twelve-hour shifts five days a week and a half day Saturday for the then-stupendous wage of $40 or $50 weekly. The mills operated continuously, and the shifts worked through the night. The factory-owners' great fear was of a strike, for if the furnaces had to be shut down for any length of time, they would crack and have to be rebricked.

From his grandmother's boardinghouse on Penn Avenue, Romare could see the flames and smoke and hear the screaming factory whistles signaling shift's end and the constant bass roar of the furnaces. It was so

hot working near the hearths that the men disregarded the warnings about burns, shed their asbestos clothing, and stripped down to the waist so that they could withstand the ordeal. "When the furnace doors opened," Bearden recalled, "that flame would lick out like a burning snake's tongue and hit 'em. They were always getting scorched."[3] Romare's grandmother would rub the men down with cocoa butter at the end of their shift.

Bearden evoked this milieu in a collage entitled *Mill Hand's Lunch Bucket* (1978). In an interior framed by rectangles, a central group of three (perhaps a mother, father, and child) surrounds a dining table. The eye is drawn, however, to the outsize hand of the young mill worker wearing an asbestos coat and hat reaching for a lunch bucket perched on a table, as he descends a stairway. To the right, a window looks out on a steel-mill landscape behind a row of shanties: railroad tracks, chimneys, and a cloud of smoke emerging from a gigantic furnace fill the scene. The narrative, written on the gallery wall beneath the collage when it was first exhibited at Cordier & Ekstrom, read, "The mills went 24 hours a day with three 8-hour shifts."

Later, in 1927, when his grandparents had moved to East Liberty, another Pittsburgh neighborhood farther away from the mills, Romare once again lived with them while he completed high school. One summer, when he was fifteen or sixteen, Romare and a friend got jobs in a big mill run by U.S. Steel. They were put on the night shift. The mill was so large that it had its own trolley, which ran the two young men out to their assigned furnace. Now he was exposed to the flames directly. "It was hot in the summer there anyway," he recalled, "but just opening the door to where you were going was like opening the furnace to hell." They couldn't take it and asked for a new assignment the next day. The pair were transferred to a crew coating the top of the mill with a black paint that grew unbearably hot. Once again the two young men asked to be reassigned. They were then given a job moving steel products from the mill to a nearby barge. The two youngsters proved no match for the job: on one occasion, Romare lost control of the steel he was rolling toward the barge and went into the canal with it.

Next Romare was given a job as a "chipper" and told to chip the imperfections out of the steel with a diamond-headed hydraulic drill whose vibrations rumbled through the kidneys and heart. If the worker slipped, he lost a toe. Bearden lasted as a chipper about as long as it took him to come to that realization.

Miraculously, he was kept on at the mill long enough that summer to be assigned a job he could perform. After the hellish furnace doors, the broiling roof, the murky canal waters, and the body-wracking drill, Romare was assigned to a two-man Bessemer furnace that produced a very high grade of surgical steel, using tungsten fired at very high temperature. The man Bearden helped was so strong he could negotiate the entire process alone, except for the final step, which involved sorting the finished products for transport to locations throughout the country. This man was barely literate, so Romare invented a simple system using the letters of the alphabet—"A" for Albany, "B" for Buffalo, "C" for Chicago—that allowed him to complete the

Bearden's schematic drawings of three floors of his maternal grandmother's boardinghouse in Lawrenceville, Pa. (above) and of placement of boardinghouse in relation to immediate neighborhood and puddling mill. Ink on graph paper

Drawing of small section of
Penn Ave. in Lawrenceville.
Ink on graph paper

process. The mill inspectors congratulated the furnace operator on fixing up his operation, and Romare was able to complete the summer at the mill.

Thus, twenty years later, the metaphor Bearden chose in his 1947 journal to evoke the artist's struggle to create was not at all abstract; it came from the layers of memory, of experience. He had lived it all, long before he was twenty years old.

SPRING WAY

Bearden's periods of residence in Pittsburgh left him with other memories than those of the mills, some no less vivid and, in a sense, no less scorching. His initiation into the mystery of sex took place relatively early, and, as he recounted it, the scene could have come out of *Huckleberry Finn.*

Romare and his friend Joey, both about ten years old, were standing on water barrels right beneath the bedroom window of the Ice Cream Lady's house on Penn Avenue. The old woman and her daughter ran a kind of candy store, where they sold homemade ice cream. For three or five cents, you could get anything from a cone to an overstuffed ice cream sandwich.

Joey, the son of Hungarian immigrants and something of a rascal, had a crush on the Ice Cream Lady's daughter, whom Bearden recalled clearly: "She was a *big* Amazonian woman who looked like she stepped out of a Rubens painting." The daughter, for her part, was sweet on a worker from a

nearby puddling mill, an Eastern European immigrant, like many who worked in the Lawrenceville mills.[4] He looked like one of Rubens's men. "The fellow was so strong that he could put out his arm and we could chin on it. It was like a tree branch. 'Come on, boys,' he'd say, and hold out his arm for us."

When the Ice Cream Lady died, her daughter continued to run the store by herself. The girl was always asking Romare or Joey to run over to the notions store across the street: "Go and ask Mr. Hungerford to give me a pitcher," she would say. When they went into Mr. Hungerford's shop, he would say, "I just gave her a pitcher last week—what does she want a pitcher *now* for?" but he would always give them one to take back to the girl, who would reward them with ice cream. Mr. Hungerford may have been perplexed, but he continued to give the girl what she asked for. It seemed to Romare that he wanted to marry her. At worst, he must have thought, she was a klutz who was always dropping things.

Finally, the boys resolved to unravel the mystery of the Ice Cream Lady's daughter and her puzzling, continual need of new pitchers. They asked her when the puddling mill worker would be there. "Oh," she said, "he's a little late, especially on Friday." So Romare and Joey went in the evening around to the back. Having delivered pitchers to her there before, they were familiar with the position of the barrels and the windows, which were painted an opaque green. Joey made a scratch on one of the panes and Romare on another, so they both could see through. Romare was stunned.

"It terrified me—ever since—of women! He would lift her up and they'd laugh and pound away until they were like to break the bed. And then they'd stop for a while and start up again, tearing up the place! I said to myself, 'My God, is *that* what you have to do to a woman?' That's why she was *always* needing things. They were having a good time, and something would break. And the place was wrecked! She'd say, 'Go see Mr. Hungerford, tell him I need a pitcher,' and Mr. Hungerford would say, 'What, again?' "

Bearden's recalled terror notwithstanding, the anecdote is revealing of his temperament, and prophetic of his later perspective as an artist. From an early age, nothing human was alien to him; he saw it with wide-open, intelligent eyes. "He was a kid down the alleyway from the whorehouses," says Sam Shaw, the photographer and film director whose friendship with Bearden began in the mid-1930s. "He saw things that shocked him, but he took it; that's what life was about. He was a kid that observed all this. And in the end, it's related to his art: he portrayed women with terrific elegance, never degrading them, and understanding the degradation that women go through. But he also had a world view of the evils and the elegance of man."[5]

Bearden was seeing life's seamier side from within the protective shield of religious, concerned, black, middle-class family life. It simultaneously fascinated him and left him awestruck, a reaction that would emerge in his art. His sensuous nudes at the bath, for instance, are attended by grandmother figures, while at the same time male symbols—roosters, dogs, bulls, bordello piano players, country guitar players, or steam engines—look on, play on introspectively, or steam by. It is the rare collage (*Railroad Shack*

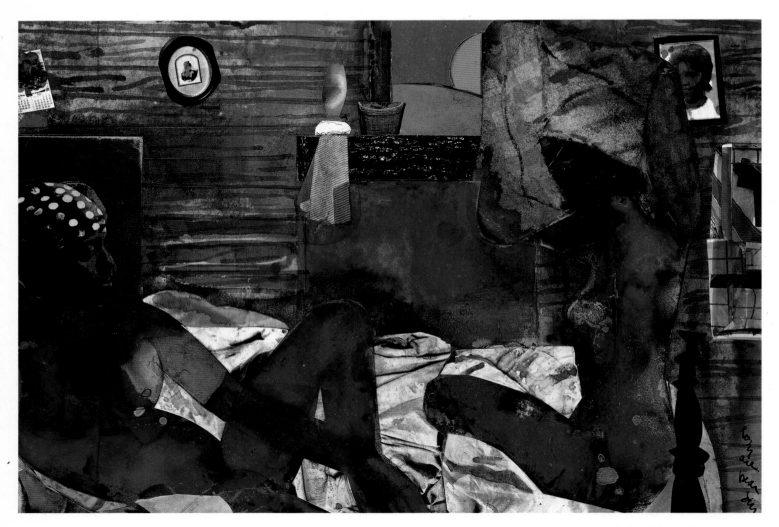

Railroad Shack Sporting House.
1978. From the *Profile/Part I:*
The Twenties series
(Mecklenburg County). Collage
on board, 11¾ x 16⅝". Private
collection

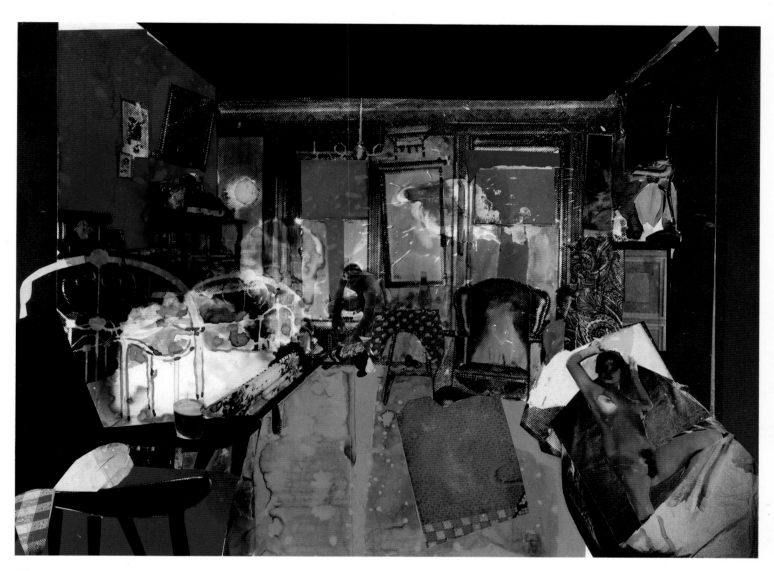

Electric Evening. 1976. Collage
on board, 18 x 24″. Collection
Sam and Sophie Pearlstein,
Southfield, Mich.

Sporting House, 1978, is one; *Electric Evening*, 1976, another) that depicts a man and woman preparing to make love.

Lawrenceville was also the "time of Eugene," a crippled boy who first came around to the backyard of Romare's grandmother's boarding-house one day in the summer of 1926. Romare was shooting marbles with his cousin Charlie and his friend Dennis. Eugene stood there silently, braces on both his legs, staring at the three boys. First Dennis hit him, then Romare and Charlie joined in until Romare's grandmother saw the goings-on from the kitchen window and came out with her broom to break up the scuffle. She carried Eugene into the house and he became their friend.

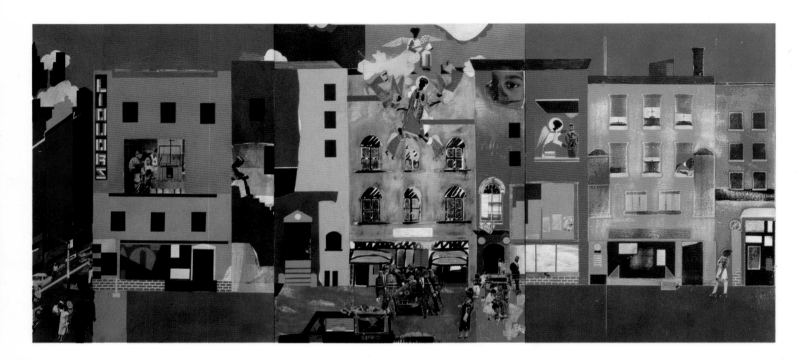

Eugene took to hanging around Carrie's house, and spent lots of time making erotic drawings on sheets of brown paper. They fascinated Romare, who had never seen anything like them before. One drawing was of a house of prostitution not far from where they lived, run by a woman named Sadie. Romare knew it because it was part of his newspaper route; he and his friends liked to go into Sadie's parlor because the scene was so interesting, especially the piano player off in a side room, cigarette dangling from his mouth as his hands stroked the keyboard in different rags and barrelhouse blues. Eugene had drawn Sadie's house with the facade cut away. Somebody had shot a pistol, and the bullet was shown going all through the house. The bullet went through women on top of men, and women, dressed in only high-gartered stockings, dancing with men, and down through the ceiling into the front parlor. There stood Sadie with her pocketbook open, and the bullet had turned into coins and was dropping into her pocketbook.[6]

Romare's grandmother had set up a table in Romare's room, where Romare took impromptu daily drawing lessons from Eugene, just trying to copy what he did. After about a week, Carrie wanted to see what the boys had accomplished. She took one look and, scandalized, grabbed all the drawings and threw them into the furnace. Where, she asked, had Eugene ever seen anything like this? Eugene lived at Sadie's, he answered, and his mother worked there. That night, after giving the boys dinner, Romare's grandmother took them to Sadie's door, confronted Sadie, and told her she was taking Eugene home to live with her. She sent the boys up to Eugene's room on the top floor to get his belongings, and Eugene showed Romare how you could look

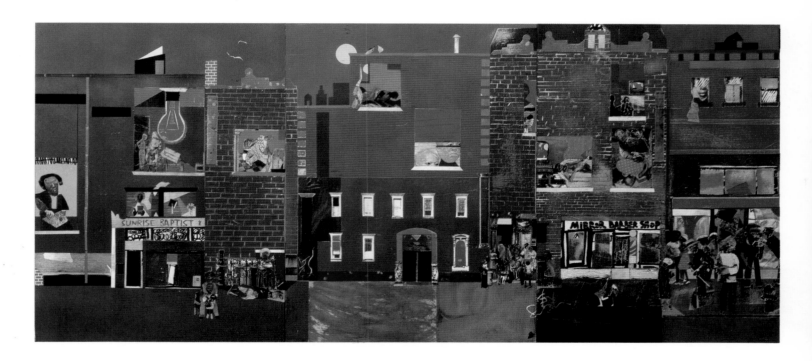

down through the cracks in the floor into the room below.

Eugene moved into the boardinghouse, bringing with him the pigeons and doves he kept as pets. For the next year, his mother would visit him at Romare's grandmother's house every Sunday. They sat in the front parlor, near an old German clock Romare hated to look at: its inscription read: "Every Hour Wounds. The Last One Kills."[7] Eugene stopped drawing when he left Sadie's (as did Romare, until much later) and died about a year later. During his short life, he had inspired Romare to learn to draw, and his influence was deep and lasting. "Lautrec would have loved him," Bearden said, "because he had that kind of an eye."

In one of his best-known collages, *The Block* (1971), Bearden juxtaposes a funeral, an Annunciation, and a group of shops at street level, while in the brownstones above, the facades have been shorn away to reveal scenes of the kind Romare had seen in Eugene's brown paper drawings

The Block. 1971. Collage of cut and pasted paper and synthetic polymer paint on masonite; six panels, 48 x 216″ overall. The Metropolitan Museum of Art, New York. Gift of Mr. and Mrs. Samuel Shore

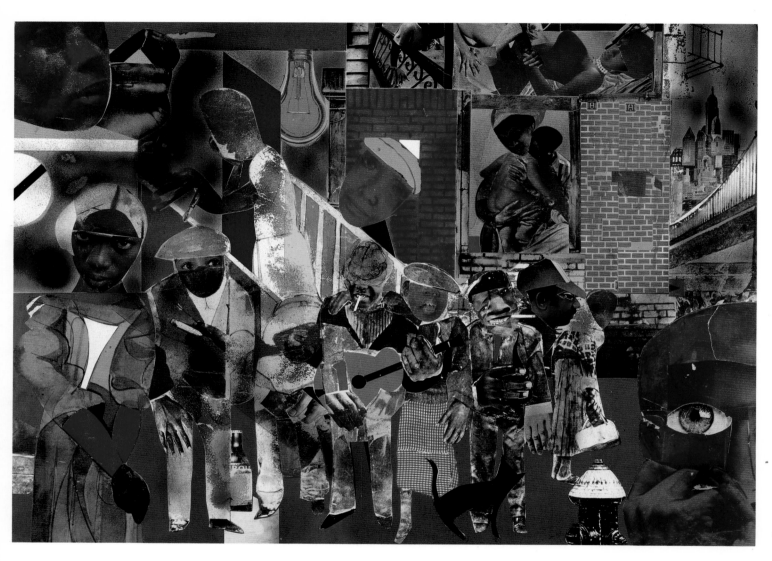

The Street. 1975. Collage on board, 37½ x 51″. Courtesy Sheldon Ross Gallery, Birmingham, Mich.

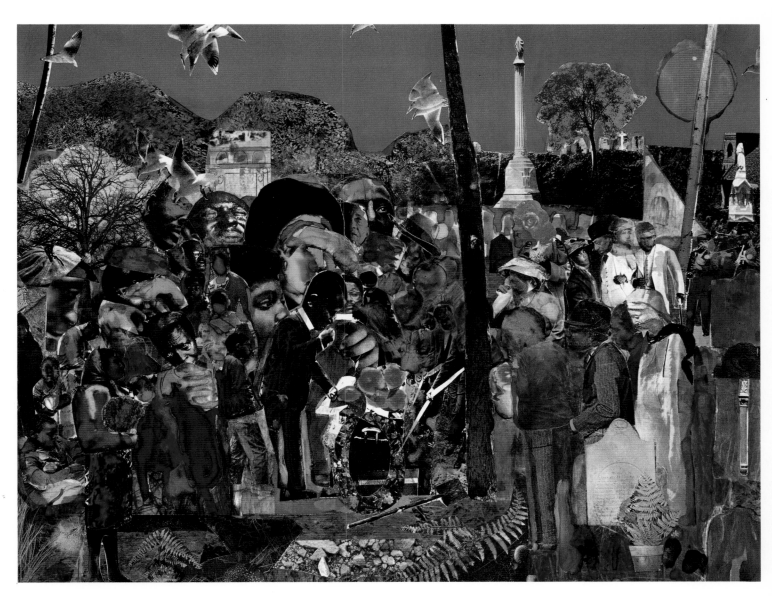

Farewell Eugene. 1978. From
the *Profile/Part I: The Twenties*
series (Pittsburgh Memories).
Collage on board, 16¼ x 20½".
Private collection

almost half a century earlier. The brownstones themselves, their various colors tracked vertically side by side, create the overall effect of a piano keyboard.

In a later version of one of his original "Projections," the monumentally enlarged photomontages that marked the beginning of Bearden's work in collage in the early 1960s, he again remembered Eugene. The 1964 projection is named *The Street*. In the more recent 1975 collage version, large, masklike faces anchor the bottom right and upper left of the picture, a bridge occupies the upper right, the face of a boy tilted diagonally is near the center, and a guitar player establishes the central group of figures. But now, as if the viewer could penetrate the tenement wall, Bearden established three rectangularly framed interiors—a figure, seen from above, ascending a stairway; a couple embracing; and a mother holding her baby.

Farewell Eugene (1978), part of the collage series "Profile/Part I: The Twenties," is Bearden's remembrance of Eugene's funeral. The collage is filled with the faces of mourners at the cemetery, with orange-red flowers on the casket echoed by a similarly colored disk of sun cut by a bare, angular tree, the flower in a woman's hair, and flowers held by a mourner. Eugene's doves flutter about the mourners.

After Eugene's death, while Romare was completing high school in Pittsburgh, he won two poster contests with the help of his grandmother. The first was sponsored by a local movie theater to capitalize on the spate of war films following World War I. It had been held to advertise a film called *The Big Parade*, starring John Gilbert. Romare researched the subject thoroughly—a lifelong habit—and filled his first sketch with images of World War I tanks, cannonry, soldiers, Big Bertha, and airplanes. Carrie took one look and assured him that he would never win without simplifying: "Why don't you just have the shell holes there, and have this wounded soldier, and Uncle Sam picking him up and saying 'Forward!' Romare followed the advice and won the grand prize: $25 and a year's pass to the movie theater.

The second contest was for a city-wide cleanup campaign. With its pervasive mills, Pittsburgh was known as "Smoky City," and Romare could remember days there when the white shirt he put on in the morning was gray with soot by afternoon. Again his library research was fruitful, turning up images of Bessemer converters, open-hearth furnaces—the whole apparatus of steel manufacturing. Romare's grandmother told him simply to "make it Mrs. McCarthy," a neighbor who chased Romare and his friends off her marble stoop with a broom and then ordered them back, if they had left even a scrap of litter, to "Pick it up!" Romare got a puzzled Mrs. McCarthy to model for him with her broom, put in the inevitable three-word caption, and won the contest.

From 1927 through his graduation in 1929, Bearden attended Peabody High School in East Liberty. Each day he would walk to school from the house on Collins Avenue. He liked the school, especially the chemistry classes, but the teacher he remembered most sharply was a Miss Ealey, who taught English. Bearden kept the grammar text Miss Ealey used, *Wooley's English Grammar*, perhaps out of sheer masochism, for the lessons were excruciating to him. The class was made to diagram and parse sentences end-

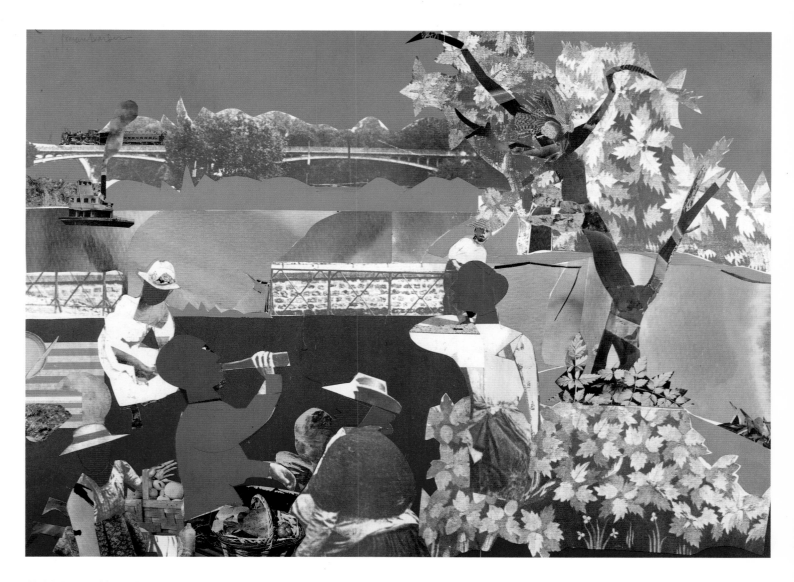

Shiloh Baptist Church Picnic.
c. 1965–66. Collage, 30 x 40″.
Private collection

lessly. "So, month after month, this modifies this, that modifies that; we learned everything that would inhibit a person who actually wanted to *write* something. And double negatives! And split infinitives! But anyway, it was good; in that sense it was very thorough."

Bearden showed more interest in sports than English grammar during his high school years. He went out for the Peabody High football team but did not make it as a regular; he threw the discus as a member of the track team, and could doubtless have made the baseball team if he had cared to. Once, the baseball team was training on a field alongside the track where Romare was practicing his discus throw. The ball got away; it was way out of the ballfield. The players hollered to Romare to toss them the ball. "I was way out, past the outfielders. So I threw the ball to the second baseman, straight in, on a low line." The ball players were awed, and the coach asked Romare to pitch for the team, but he declined. He preferred sandlot games, where they could play *serious* ball, then carouse. The huge lot where Romare played most of his baseball had a big bakery on one side. "We'd go there in the evenings and the girls who worked in the bakery would throw us down cakes. Or we'd leave school and go to the movies—I think it was eleven cents. A lot of the kids had secondhand Fords they had bought for $25 or $30, painted all up, and drove to school. And so it was a lot of fun, football in the fall, going to basketball games in winter, and baseball in spring and summer. There was always something."

Romare's grandmother had no particular interest in sports or art and had trouble spelling words properly. Growing up in the South, she had had little chance to go to school and went to work instead. But she had a taste for simplicity, an unerring instinct for the telling gesture, and an eye for good graphics.

If Romare's first artistic inspiration had come from an unlikely source in Eugene, and his first critiques from an equally unlikely source in Carrie (who had, after all, burned Eugene's drawings), his "scholarship money" toward the freshman year of college came from the most incredible source of all—a man who knew his way around Pittsburgh's underworld and who took pride in subscribing to the newspaper of the Ku Klux Klan.

Bearden remembered his benefactor as a Mr. Druett. He distributed electrical refrigerator systems and also had a concession with Brunswick records, which he had delivered to various record shops around the city. In addition, Mr. Druett ran bootleg liquor in from Canada and owned a nightclub on a lake. More than this, Romare did not need or want to know. But he worked for Mr. Druett during one summer in the late twenties.

Druett was a paradoxical character. Although he knew that Romare was black (he knew Romare's cousins Charlie and Erroll, who were very brown-skinned), he would hold the KKK newspaper out before Romare and say, "This is America, boy; this is the real thing here—real America." He was as vengeful toward those who crossed him as he was generous to those he considered loyal. In short, he was a smaller-city paradigm of the tough men of the era, an era in which Owney Madden, one of the chief proprietors of the

Cotton Club, was driven around New York in a bulletproof Duesenberg.

Romare helped wash and simonize Druett's cars. Another of his jobs was to get Druett's wife, who had a sweet tooth, fixed up with candy. "She didn't like a bar, she liked *boxes* of candy." Fifty cents would buy a great deal of candy at the time, and for a dollar you could get a big box of chocolate candy, or a pound of caramels. Romare would go around to various candy stores in search of the very best for Mrs. Druett, who would "sit in the back of the automobile and eat candy all day."

Above the garage, on the second floor, Friday nights were devoted to "smoker movies," the pornography of the time. The place would be packed. (Druett himself had little taste for art, either in film or graphics. When Bearden showed him the prizewinning poster he had done for *The Big Parade*, Druett thought that was all right, but he told Romare that he thought the greatest artist in the world was Budd Fisher, who drew "Mutt and Jeff.")

Druett offered Romare a job at his lakefront club outside Pittsburgh for the summer. Romare's grandmother, unaware of the precise nature of the work, voiced no objection. Before the full season began, around Decoration Day, Romare would be driven to the resort, rent out canoes on the lake, then come into the nightclub until 5 P.M., when he would be driven home. During the season proper, he stayed all weekend.

"He'd come and take me on Friday, and I would go out there and stay. They sold whiskey. Of course, this was during Prohibition, but he was in this group that ran name-brand whiskey in from Canada. Once they asked me if I wanted to go to Canada to make the whiskey run, but I said no."

In the nightclub, Bearden's job was to stand at the back at a counter where the waiters picked up ice, soft drinks, and liquor. His real value, however, lay in the fact that he was so young and innocent-looking, because it was he who held the big money. The customers would pay the waiters, who gave the money to Romare. Druett had instructed Romare to put anything over $200 in his pocket rather than in the cash register.

Druett's relationship with the police was typical of the Prohibition era. "The motorcycle police would always come and knock on the window around ten-thirty or eleven at night, and they'd give them their drink through the window." One weekend night, when Druett was away, a scene took place that could have come straight from a gangster movie.

"This man came in, I remember, in the summer heat with a derby hat on and asked to make a reservation for six. When they said yes, he said the cars would be right there. When they came back, the men had pistols and shotguns. Everybody had to get off their seats, get up against the wall. Then they took the women's jewelry; they were fainting and screaming. They took the men's money, watches, and their rings had to come off.

"And then they came to me. It was 'Hands up!' Then the man looked at me and said, 'Put your hands down, kid. How much is in that thing?' " Romare gave him the $200 limit that was in the till. "Then he said, 'Gee, ain't doin' no business tonight?' I was scared of getting shot or something, to tell him my pockets were down here with the money. So he took what

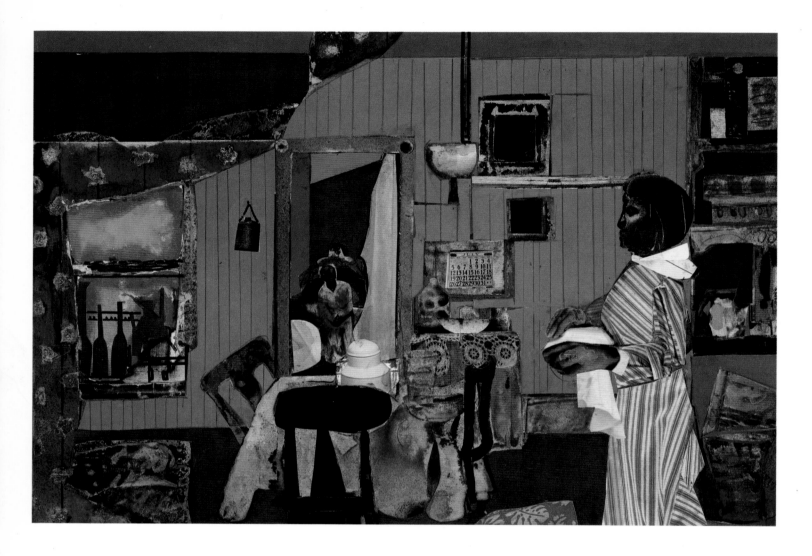

Allegheny Morning Sky. 1978. From the *Profile/Part I: The Twenties* series (Pittsburgh Memories). Collage on board, 10⅛ x 14½″. Collection Mr. and Mrs. M. Gutner, North Woodmere, N.Y.

was in the register and said, 'Give me a few bottles of whiskey.' He put some in his pockets, and a couple in his hand, and then they left."

During all of this, Romare heard the noise of the motorcycles and knew it was the police. They must have had a healthy instinct for survival, because there was no knocking at the window until after the mobsters had left. "I guess the cops looked in and saw what was happening, because two or three minutes after they were gone, the police came up and said, 'What's happened here?' Druett wasn't there, so they called him, and he came. He asked what they looked like, but the police couldn't help, so Mr. Druett thanked them and took care of it himself. He made certain calls, asked, 'And what did they look like?' And he said, 'Oh, those are guys from Detroit.' And I think about a week later, he made calls to Detroit, Cleveland, to know who they were. And they took care of that whole thing themselves. I don't know all the details—I didn't *want* to get into that."

When Romare handed the mobster all the money he was still holding in his pockets, Druett was overcome with gratitude. "And you know,

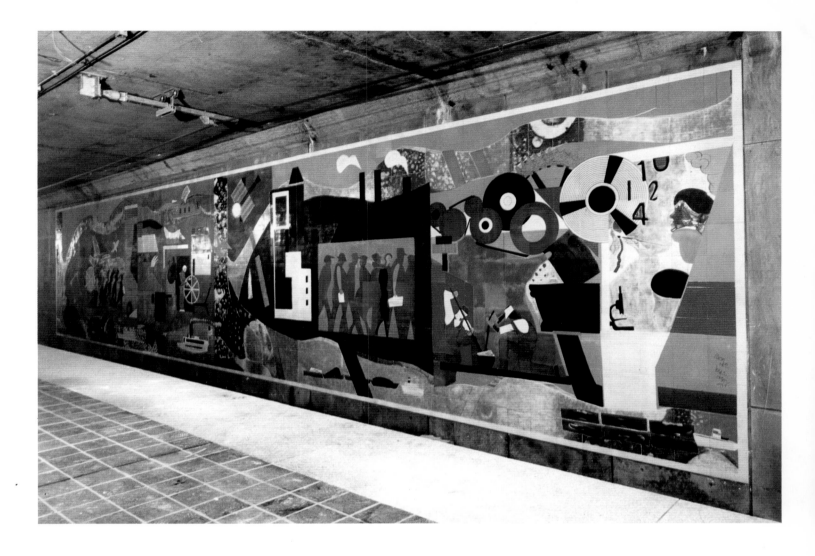

he gave me enough for my first year in college. I left him to go to school; I left Pittsburgh."

Some ten years later, when Bearden returned to Pittsburgh to write an article about the strike in the area called "Little Steel," he described streets like Spring Way in reportorial, almost Dickensian phrases: "It is difficult to get accurate figures, but roughly 75,000 Negroes are employed in the steel industry. They have migrated to the steel areas from the South, have little education, and a great deal of their life centers around the church. In the larger cities, they live in narrow, ancient, cobble-stoned alleyways, flanked on both sides with densely packed houses."[8]

Bearden photographed Spring Way for his article. The photograph echoes the description accurately enough. But to a boy in his adolescence, Spring Way—with its warehouse, machine shop, junkyard, the sawmill where Joey's father worked, and the Ice Cream Lady's store—was deserving of its lyric name. For Bearden, Spring Way was far more than a cobble-stoned alleyway. It was a passage from boyhood to youth.

Pittsburgh Recollections. 1984. Ceramic tile mural composed of 780 tiles (made by Bennington Potters, Inc.), 60 x 13′. Gateway Center "T" Station, Pittsburgh Allegheny Rapid Transit Authority

CHAPTER 2

THE EAGLE FLIES ON FRIDAY:
HARLEM IN THE 1930s

When I was a little boy, I was in a theater. The lights went on, the show was stopped, and the manager came out. He had everyone rise and played "The Star-Spangled Banner" because Lindbergh had just flown the Atlantic and had landed in France. When we came out, people were shouting, walking on their hands; it was like Armistice day, people were going wild. And I remember George M. Cohan's "Lucky Lindy, the Eagle of the USA." Everybody was playing that song. But then the greatest poem written on that flight was done at the Savoy: the Lindy hop—the dancers throwing the girls, their skirts billowing—you realize that everything it did in that way was the essence of flight. So sometimes we tend to look in the book store or the museum for our history, while neglecting other aspects of it.

—*Romare Bearden*[1]

Above: *Sandwich Man—8th Avenue*. 1930s. Ink and conté on paper, 6¹⁵⁄₁₆ x 3¼". Schomburg Center for Research in Black Culture, Art and Artifacts Division, The New York Public Library

Opposite: *Untitled*. 1930s. Oil and gouache on canvas, 60 x 50". Collection Leonard Bates, New York

Romare was a youngster of fifteen when Charles Lindbergh landed *The Spirit of St. Louis* in Paris. "In the spring of '27," F. Scott Fitzgerald wrote, "something bright and alien flashed across the sky." There was no chance for a prolonged adolescence, either for Romare or the country. Five years later in spring 1932, Charles Lindbergh, Jr., was kidnapped, and his body found two months later on the Lindbergh estate; 13 million people were unemployed; tens of thousands of homeless children wandered the streets of New York City; marches by the jobless on manufacturing sites throughout the country were met with beatings, mass arrests, and in some cases, by machine gun fire. Franklin Delano Roosevelt, running for president, pledged a "New Deal."

In early 1933, during the "first hundred days" of the new administration, unemployment stood at 25 percent of the work force, and soon rose to one-third. In 1937 after Roosevelt was reelected with 61 percent of the vote, as against 57 percent in 1932, unemployment had dropped to 13 percent, but it rose again in 1938 to 18 percent during the "Roosevelt recession."

While artists in the 1930s found themselves part of the proletariat by virtue of the bond of unemployment, the art of the period was far from a monolithic response to the Depression. Artistic currents of the 1920s continued to exert their influence. Alfred Stieglitz's "291" gallery, which closed in 1917, had pioneered in introducing modernism to America, championing the work of Georgia O'Keeffe, who first exhibited there in 1916; Arthur Dove, who had his first one-artist show there in 1912; Marsden Hartley, who

had his first one-artist show there in 1909; and John Marin, who had one-artist shows there from 1910 to 1917.

The Regional artists, Thomas Hart Benton, Grant Wood, and John Steuart Curry, all with roots in the Midwest, by and large rejected European modernism and sought a rural, agrarian vocabulary of images with which to place themselves in what William Carlos Williams had defined as "The American Grain." The arrival of the Mexican muralists Diego Rivera, José Clemente Orozco, David Alfaro Siquiros, and others beginning in 1927 not only stimulated the interest in mural painting but gave American Regionalists a clear notion of art that had drawn its imagery from indigenous, traditional

forms. Benton's early murals commissioned for the New School for Social Research (1930) and the Whitney Museum of American Art (1932) were, in Milton W. Brown's estimation, clearly satirical and outspokenly critical of American society.[2]

Stuart Davis, like Thomas Hart Benton at an earlier time, studied in Paris. He too created a peculiarly American montage, but used a completely different artistic vocabulary. Davis excelled in abstraction that explored the analogies between avant-garde art and American jazz, exploiting the use of vivid color and the rhythms of American life. Davis would have an enormous influence on Bearden in the early 1940s.

The art current particular to the 1930s can be divided into at least three distinct categories. The American Scene painters, Charles Burchfield and Edward Hopper, deriving from the Ashcan School, had by the 1920s created new images of American life. Hopper's cityscapes especially were cold and clinical, isolated. The Urban Realists of the 1930s, themselves deriving directly from the Ashcan School, took the stance of sympathetic observers of the daily life surrounding them. The 14th Street School, which included Reginald Marsh, Isabel Bishop, Raphael and Moses Soyer, and Kenneth Hayes Miller, took its name from the fact that all of these artists lived or had studios near Union Square and used its life—its bums, soapbox orators, and unemployed—as subject matter for their art.

Overtly political subject matter was left to the Social Realists, whose art was more a political weapon. These artists included Ben Shahn, William Gropper, and Philip Evergood. Shahn had worked as Diego Rivera's assistant on the Rockefeller Center mural of 1932–33, *Man at the Crossroads*, which was ordered destroyed prior to its completion because of its overtly revolutionary subject. George Grosz's savage political cartoons influenced Gropper, who drew cartoons until the mid-1930s when he began to work on canvas. And Grosz's teaching at the Art Students League drew Bearden there.

The government's Work Progress Administration/Federal Arts Project commissions created yet another variety and style of 1930s realism, felt especially in murals for public buildings. The policy was that the artist was to represent a specifically American subject. Here the numbers of works allocated to hospitals, schools, libraries, and post offices tell the tale: about 200 murals, 2,100 sculptures, 12,000 easel paintings, and 750,000 prints.[3] By 1936 the WPA/FAP had given work to more than 4,000 artists, who by the 1940s had produced over 20,000 murals, easel paintings, sculptures, and graphics for New York State alone.[4]

Therefore, despite the enormous privation and suffering it brought, the Depression eventually energized the arts in New York City, particularly music and painting. The eagle would fly in many forms: as the image symbolizing vast infusions of federal monies into various WPA projects by 1935; as the Walter Page/Benny Moten Swing machine that, in 1932, roared its hungry way out of Kansas City in 4/4 time and that, by 1937, opened at the Apollo Theater as Count Basie's orchestra with singers Jimmy Rushing and Billie Holiday; and by the end of the 1930s, as the alto saxophone player

Fountain Pen Sketches. 1930s.
Ink on paper, 8¼ x 5¾".
Schomburg Center for Research in Black Culture, Art and Artifacts Division, The New York Public Library

Charlie Parker, whose dazzling solo flights made his nickname "Bird" seem prophetic of his genius.

Fortunately, the Depression, during which he spent his young manhood, toughened Bearden but did not coarsen him. In a pattern that was to repeat itself throughout the decades to come, Bearden returned to places he had been and to people he had known or studied with, now with new eyes and a deepened awareness of social, aesthetic, and human issues.

In 1937, for example, he went back to Lawrenceville, Pennsylvania. Now on assignment for the journal *Opportunity*, he interviewed steelworkers, both black and white, plant foremen, and employers in the cluster of mills called "Little Steel" that sprawled east, west, and southward from Pittsburgh. Bearden's article appeared in the aftermath of a particularly virulent strike. As Bearden described it, "The strikers were intimidated and beaten by company thugs, aeroplanes were used to fly food to the men who remained in the Republic Mill, vigilantes and other flag-waving organizations were formed in the Little Steel towns, back-to-work movements were initiated, and all this was accompanied by furious anti-CIO propaganda."

Bearden's vantage point, and the title of his article, was "The Negro in 'Little Steel.' "[5] He analyzed the sometimes negative reaction of black steelworkers toward the union, underscored the sources of racial tension between mill workers, and concluded that although the strike at Little Steel had been broken, there was hope for organized labor; as for the black man, he wrote, "His own leaders from out of the ranks must be developed. The outworn patterns of his thinking must be recreated." What made Bearden's reporting admirable was his thorough understanding of the processes of steel manufacture, the levels of skill involved in various jobs within the mill, and the process of apprenticeship by means of which a worker could raise himself in the ranks, especially as all of these considerations affected race relations among the workers. He had, after all, been there.

Bearden must have thought twice about taking on the assignment, even though it was a reasonable way of spending time near his high school stomping grounds, for his mother was the New York editor of the most influential black newspaper in the country, the *Chicago Defender*. With the great migration of Negroes to cities like Chicago, New York, and Pittsburgh in the 1920s, newspapers like the *Chicago Defender*, which had a condensed weekly national edition, the *Pittsburgh Courier*, the *Norfolk Journal and Guide*, the *Baltimore Afro-American*, and the *Amsterdam News* were all sold in Harlem in those days.

The national edition of the *Defender* had news from around the country, and Bessye Bearden covered many of the events along the East Coast, particularly Harlem society news. "I would go to a baseball game, because she had tickets for that, and I would write something myself about the National League at that time, and she'd fix it up. Then she had, let's say, a Paul Robeson concert, or a political event, and the social column."

When Romare was in his teens, Bessye had managed the ticket office at the Lafayette Theatre. Later, she went to work for a real-estate

firm run by a man named Payton with offices on 141st Street between Seventh and Lenox avenues, and for many years was in charge of the New York office of E. C. Browne, a Philadelphia real-estate firm. Her interest in politics began early, when a Mr. MacNeil, who had a position with the city as inspector of markets, especially the Eighth Avenue Market in Harlem from 140th to 145th streets, got Bessye involved in Democratic party politics. The family was then living at 173 West 140th Street, and for a short time, until he was joined by his wife, MacNeil lived with the Beardens. Another influential political acquaintance in Harlem was Ferdinand Q. Morton, who had studied at Harvard and had become a Civil Service commissioner. Morton was to become one of the Democratic Party leaders in Harlem.

The Bearden household was always large, including, at one time or another throughout the late 1920s and 1930s, Bessye; her husband, Howard; Romare; Romare's cousins Eddie and Charlie; Charlie's mother, Clara; and a number of Siamese cats. While Romare loved Bessye, he thought that he might have had an easier time of it with Clara. "I was better with my mother's sister, my aunt Clara. She was much softer: 'The little boy wants to paint; let him do that,' she would say. But my mother could *straighten* them up, Eddie and Charlie, like a drill sergeant. I could get along with my mother, but for me, I didn't need 'the whip.'"

Bessye had her own charisma. She was a complete extrovert, an intensely social person whose home was the focal point for gatherings of personalities from many worlds—politics, journalism, show business, and the arts. As is commonly the case with extroverts, Bessye disliked solitude. Once Bearden came home to find his mother in bed, crying. "My father happened to be out. So I said 'What's the matter? You're sick.' She replied 'No, I'm by myself!' "

By the time the Beardens moved to a third-floor apartment at 154 West 131st Street, Bessye's parlor had become a hub of activity in Harlem. She had always been a person who knew how to get something accomplished quickly and effectively. Whether the need involved fund raising for a political campaign or rounding up talent for a benefit performance for the Children's Aid Society, Bessye was the person to see.

Romare rarely saw Bessye read, except the newspapers. As he remembers, "She had a good mathematical mind, but her thing was people. She was on every kind of committee; she'd come home and then right out she'd go." Since 1922 she had served as secretary to School Board 15; later, when the district's designation was changed to District 12, she was elected chairman of the board.[6] She had helped form the women's auxiliary of the local Negro Democratic Club and later worked to organize the Negro Women's Democratic Club. Every week, she attended meetings of the NWDC. Eventually Bessye became national treasurer of the Council of Negro Women and a member of the executive board of the New York Urban League.

Bessye's close friend in Democratic party politics was Mary McLeod Bethune, who had founded Bethune-Cookman College, Daytona Beach, Florida, with $1.50, and later became its president. Mary Bethune was

The handwritten labels in the drawing read: 7th Avenue, Tree of Hope, FAT RIGHT, CONNIES INN, DRUG STORE, Muzzie Anderson's, Restaurant, Safayette Theater, 132nd S, R Rytman Club, BACK Stage Lafayette, 131 St, 134, to Lenox Ave

founder-president of the National Council of Negro Women, vice-president of the NAACP, and president of the National Association of Colored Women's Clubs and of the American Teachers' Association.

In the early 1940s, Bessye introduced Eleanor Roosevelt and Mary Bethune at a benefit for Bethune-Cookman College at the Golden Gate Auditorium on Lenox Avenue and 142nd Street. Romare had previously accompanied Mrs. Roosevelt from the Bearden house to a girls' school in Harlem where she was to speak. "She asked me, 'Would you like to go?' So I said, 'All right.' Romare felt sure there would be a chauffeur-driven limousine waiting outside the door. Instead, the First Lady and Romare walked to the subway and rode it up to the school. When Mrs. Roosevelt entered the school and walked down the aisle, "it was all these hands, reaching to touch her."

Dr. Aubré de L. Maynard, the first black person to be admitted to an internship in surgery at Harlem Hospital in 1926 and senior in charge of the surgical service when he first met Bessye, was temperamentally akin to her in his absolute refusal to tolerate racial bigotry. Dr. Maynard had come to Harlem-wide attention as the result of a racial incident at the hospital. A white resident from the South was chief of obstetrics. As senior in surgery, Maynard was obliged on one early morning to summon a white physician who slept near the Southern doctor. The Southerner, annoyed with Maynard for having disturbed his sleep, accosted him in the cafeteria and, after some words, threw a glass of water at him. Maynard wisely kept his temper in check. Then he wrote to the all-white Board of Directors demanding that the chief of

obstetrics be disciplined. After a hearing, the Southerner was dismissed from Harlem Hospital, losing his residency. Newspapers serving the black community, particularly the *Amsterdam News*, carried the story for weeks.

Bessye Bearden first met Dr. Maynard when she went to Harlem Hospital and told him how proud she was of his victory. Dr. Maynard recalled, "She was a community leader, a very, very wonderful community leader. She was a very beautiful and highly intelligent woman who fought with all her heart and soul for those who needed help."[7]

Because she had faith in his wisdom and stability, Bessye consulted Dr. Maynard often in the ensuing years. "She used to come to my office with a lot of problems concerning the community, sometimes concerning her husband, and sometimes concerning Romare. 'No matter what happens to me,' she always maintained, 'I want you as long as Romare is alive to be his friend and to be his guide. You have the stability that Romare needs. Romare is all right but sometimes he gets a little shaky.' It was not so much instability as the fact that Romare had not yet found himself. Romare was never a fool. He was very rugged. But at that stage in his life he was unsure that he could go through with art, and he didn't think for a moment that he was going to make a living out of art, although he did later on."

Although Bessye had worries that she shared privately with friends like Dr. Maynard, her household never reflected them. For Romare, "The house was just like a revolving door with people coming in and out. Fats Waller came up with his lyricist, Andy Razaf—they were always by the house. Paul Robeson; Chandler Owens, who had a magazine called *The Messenger*; George Schuyler." (Schuyler, a journalist on the staffs of *The Messenger*, *The Crisis*, and the *Pittsburgh Courier*, had published *Black No More* in 1931, a wonderful, wildly outrageous satirical novel.)

From a front window of the Bearden apartment, one could see a passageway that led straight to the backstage entrance of the Lafayette Theatre, a large building with a marquee on Seventh Avenue between 131st and 132nd streets. Near the Lafayette stood the Tree of Hope, the great elm around which all the performers would gather in the evening. Entertainers who were out of work would go through the ritual of touching the trunk for luck. In back of a drugstore near the Lafayette was Muzzy Anderson's, which Bearden recalled as "a gambling place where all of the entertainers and others went to play cards, gamble, and so forth." On the same side of Seventh Avenue, toward the corner of 131st Street, was an entrance, going downstairs, to Connie's Inn, which, like the Cotton Club, had black entertainers playing to an all-white clientele.

On the corner of Seventh Avenue with an entrance on 131st Street stood the Bright real-estate office, run by a good friend and schoolmate of Fats Waller's. Since Mr. Bright was himself of some girth, it was no accident that the two friends were known to everyone as Fats Bright and Fats Waller. Bright leased the basement to the Immerman brothers, Connie and George. A large rehearsal hall occupying an entire floor above the office was used by entertainers on the night before performing at the Lafayette, and had at one

Shopping 7th Avenue. 1930s. Ink and conté on paper, 6½ x 4¼". Schomburg Center for Research in Black Culture, Art and Artifacts Division, The New York Public Library

time served as a drill hall for the Fifteenth Regiment, a kind of National Guard regiment of black soldiers who had fought in World War I.

The block on which the Bearden apartment was situated was lined on both sides of the street by neat, well-kept brownstones. The brownstone at 154 West 131st enjoyed the reputation of being the nicest of all.

From her appointment to the position in 1935 to her death in 1943, Bessye Bearden spent the balance of her life working as deputy collector for the Third New York Internal Revenue District. In the interim, whether in her home life, politics, Harlem high society, or newspaper work, Bessye remained a vigorous, outspoken woman. If the family went to a theater on 125th Street with a Negro section in the balcony, Bessye would raise hell and sit exactly where she wanted to. Arguments between Bessye and Howard took place often, and in full view of Romare. "They would *really* have some arguments, especially because my father drank. When we were living at 114th Street, she would go to the bar where my father drank, and all the men would say, 'Here comes Dewey!' (the prosecutor who made his reputation cracking down on racketeering). And my mother would say to him: 'Come on, you have to go home now!'" According to Bearden's cousin Edward Morrow, who shared a room with him in the Bearden household after his graduation from Yale, Bessye was known to punctuate these words by flinging Howard's pajamas at him. Bessye's directness was matched only by her considerable charm and Ellingtonesque ease in society. Eddie remembers that her usual way of greeting people was "Hey, baaby!" (she would prolong the vowel) and, since Romare was her only child, the conversation would eventually turn to the question: "What can you do for *my* baaby?"[8]

As for Bessye's "baby," Romare spent the first half of the Depression decade in college. He spent some part of his freshman year at Lincoln University, a historically black, all-male university in Pennsylvania with a decidedly academic orientation, then transferred to Boston University, a milieu more to his liking, not only because he had friends in the area, but because the curriculum was more amenable.

Bearden's two years as a student at Boston University were marked by a short but significant stint as a star pitcher for the varsity team. Though he tended to downplay his talent as a baseball player, Bearden kept a certificate of merit awarded him by Boston University in 1931 on a wall of his Canal Street home until the end of his life. They were, after all, heady days. During two summers, Bearden pitched for the Boston Tigers, a Negro team that would play semipro exhibition games against such teams as the House of David (a bearded group from the Midwest, patriarchal at least in appearance), the Pittsburgh Crawfords, and the Kansas City Monarchs. In the years before Jackie Robinson broke the color barrier in baseball, crowd-stoppers, some of whom were of the caliber of the legendary Leroy "Satchel" Paige (Judy Johnson or "Cool Papa" Bell, for instance), barnstormed around the country playing the National or American Negro League circuits, and in the off-season playing exhibition games as far afield as Puerto Rico or Cuba. Bearden even pitched against Paige (Paige, who pitched three hundred shutouts and fifty no-hitters

prior to joining the Cleveland Indians, won). Once, Mickey Cochrane, a graduate of Boston University who caught for the Philadelphia Athletics, brought some of his teammates up to Boston for an exhibition game against the University team. In that game, Bearden gave up only one hit, a home run, to Al Simmons. Reportedly, Connie Mack, the Athletics' owner, offered Bearden a substantial bonus and a chance to join the major leagues if he were willing to pass for white, but Bearden refused the offer. In his second season, Bearden was "fooling around" on third base when a grounder was hit out of play. He moved to field it, but the ball hit his right thumb, tearing off the nail. That held up his pitching for a while and allowed him time to think. He saw no real future for himself in the game as things then stood for Negro players, and he was becoming increasingly interested in drawing.[9]

"I had done some cartoons for the Boston University *Beanpot*. [But] I wanted to be in New York." For Bearden, New York represented a hub of energy, a chance to develop his drawing style. It would also give him an opportunity to earn some money by selling his work to the many magazines that published drawings while he completed his degree. So Bearden left baseball and Boston University, transferring to New York University under the name of Howard Bearden in 1932. Back home at the family apartment in Harlem, he took the subway to and from classes in Washington Square.

As an undergraduate student at NYU, Bearden showed a flair for cartooning. His drawings for the *New York University Medley*, some of which bore the signature "Romare," began to appear in December 1933, and he became art editor in 1934. The *Medley* was a monthly humor magazine whose format closely approximated that of *The New Yorker* (a cover drawing, feature essays, and a good number of captioned humorous drawings). For the most part, Bearden's drawings for the *Medley* were derivative of various *New Yorker* cartoonists' signature styles: light, bantering, and urbane. His subjects were almost always white. On only one occasion did his drawing address the situation of blacks in the Depression. An April 1934 cartoon shows three blacks in a bar, one in the center angrily holding up a barber's razor. The caption reads "Dis razor ain't been a bit of good . . . since dat time I shaved wid it." (Unlike that of the razor, the cutting edge of the cartoon's double entendre was sharp enough.) He so liked drawing for the magazine that he continued to contribute to it after completion of his degree. His cover drawing for the October 1935 issue (in front of a blackboard filled with equations, a smiling mathematics professor reads from his notes to a class of sleeping students) appeared after he was graduated with a B.S. degree in mathematics in June 1935.

Bearden became a friend of Elmer Simms Campbell, the first black cartoonist to be published in all the large magazines. Later, Bearden had cartoons published in several of the big magazines of the day, including *Life, Judge, College Humor,* and *Collier's*. Academic life at N.Y.U. was much more interesting to Bearden than it had been at Boston. His matriculation in mathematics, a discipline he enjoyed and one for which he had a natural aptitude, was integral to his mother's hope that Romare would go on to medical school, but Bearden himself was becoming increasingly interested in art.

Cover drawing from NYU *Medley*, Oct. 1935. Courtesy of New York University Archives

"8:30, AND MY SECRETARY IS LATE AGAIN!"

"DIS RAZOR AIN'T BEEN A BIT OF GOOD . . . SINCE DAT
TIME I SHAVED WID IT."

"Of course, Rivera's approach is different."

"Morris is becoming very conservative lately."

About a year after his graduation from NYU, Bearden followed Elmer Campbell's suggestion and entered the Art Students League to study with George Grosz, the German expatriate and master of corrosive political satire whose masterpiece of drawings and watercolors, *Ecce Homo*, had been suppressed in Germany. Bearden had come to know about Grosz as early as the summer of 1932, when Grosz taught briefly at the League just after emigrating to the United States. Campbell, already an established artist in his own right, was attending Grosz's weekly "crits" at the League. Bearden, just back in New York from Boston, dropped in at the League a few times. Later, when Bearden became Grosz's student for a year and one-half in 1936–37, Grosz commented that Campbell was a very good draftsman, but that he had gotten just what he wanted from the League class and no more. In Bearden's assessment, "Campbell always kept in mind that he was a cartoonist and illustrator, and that he wanted to perfect his drawing in that sense. He wasn't to be a Dürer or an Ingres, but he was a very clean and professional workman." For Campbell, even in the midst of the Depression, the work paid and was steady. Later, Bearden recalled, Campbell was rather disappointed when his young friend didn't want to do any more cartoons or attempt to be an illustrator. "You'll run into a lot of tribulation," Campbell warned Bearden, "because you don't have enough of a Negro middle class to buy or sustain what you're doing." There was, of course, truth in what Campbell was saying.

At the League, Grosz familiarized Bearden with some of the master draftsmen of the past—Ingres, Hans Holbein, Dürer—and his interest in cartooning naturally led him to study the work of some other great satirical draftsmen, such as Daumier and Forein. Bearden was so obsessed by the work of Brueghel that his friends at the League called him "Pete." More importantly, Grosz gave Bearden a sense of control over his materials. "When I started studying with Grosz," Bearden told Henri Ghent in an interview for the Archives of American Art, "unlike the other students who usually were very tight I would draw all over the paper. And Grosz said, 'Now look, I want you to just draw the model's hand, or maybe just the face. Just use the whole paper and draw it here because I want you to really observe.' And this is what I did. . . . And then I did watercolors; I had never painted in oil."[10]

While studying with Grosz, Bearden was earning such money as a political cartoonist could in mid-Depression for the nationally distributed *Baltimore Afro-American*. He contributed weekly for nearly two years from late September 1935 to May 1937. As good an example as any of Bearden's draftsmanship in those years was a group of sketches of the Eighth Avenue Market in New York, subtitled "Sketches from an Art Student's Notebook by Romare Bearden," published in *Opportunity* in January 1935. They were the product of the kind of notebook Grosz had suggested Bearden keep as early as 1932. One of them, simply titled *Dispossessed*, depicts a woman surrounded by all of her belongings—rocking chair, rolled-up rugs, kerosene lamp, buckets, and dressers—in front of a stairway leading up to a tenement. Another drawing, with an equally self-explanatory title, is *Apple Woman*. Bearden's work in gouache of the later 1930s was similar in theme. One of the only

Drawings from *The Medley* (NYU). Clockwise from above left: "8:30, and My Secretary Is Late Again," January 1934; "Dis Razor Ain't Been a Bit of Good . . ." April 1934; "Of Course, Rivera's Approach Is Different," May 1935; "Morris Is Becoming Very Conservative Lately," March 1935. All Courtesy of New York University Archives

Shall Mob Rule Continue as the Expression of Southern Justice?

"The Ghost Walks"

examples of his work in gouache that survived a fire in the family apartment at 114th Street is entitled *Soup Kitchen*.

Bearden's work for the *Baltimore Afro-American* appeared on the editorial page. "I remember I did one on Hitler, and that got the most comment. There was a statement of Talleyrand's to Napoleon. He said, 'Sir, you can conquer a nation with bayonets, but you can't sit on it.' This was Tallyrand's advice when Napoleon was intending to make himself emperor. So I had Hitler sitting on these bayonets; that was before the outbreak of World War II."

One can discern Grosz's teaching in the increasing maturation of Bearden's work for the *Afro-American*. He could of course speak and draw what was on his mind with far greater latitude than had been possible during his NYU *Medley* days. More importantly, he was taking greater risks with his draftsmanship, using single images to fill the frame, playing with distortions of scale, and using the white space to strengthen the image he drew. These techniques were in a sense an early precursor of his collage work of the 1960s. In a drawing published June 20, 1936, for instance, a Southern red-neck with crazed eyes, pointed teeth, an ammunition belt slung across his chest, a pouch with a swastika on his back, a rifle, and a lynch rope strides

toward the viewer. His outsize boot marches across the word "Dixie," away from a hillside filled with crosses. The title is *The Watch Dog*, and the headline reads "Why Stay in Dixie?" At its best, Bearden's was work worthy of Grosz's *Ecce Homo*.

The political winds blew strongly leftward among artists throughout the 1930s, gaining momentum until late 1939 with the signing of the Nazi-Soviet nonaggression pact. Bearden's place in the political arena can be inferred not only from his political cartoons, but also from the nature of his friendships and family life. Among blacks, Bearden's friend and fellow artist Norman Lewis held radical political opinions. Claude McKay, the Jamaican-born poet who would become Bearden's neighbor and close friend when he moved into his first studio in 1940, had quit his post as associate editor of *New Masses* in a dispute in 1932 with the editor, Michael Gold (author of *Jews Without Money*). Among whites, Romare's friend Sam Shaw, with whom he would later draw from the model in the 1940s, had become art director of *The Daily Worker* at age twenty. Shaw's opposite number at *New Masses* was the great modernist Ad Reinhardt. According to Shaw, all the cartoonists for *The New Yorker* drew for these publications under pseudonyms, with the exception of Peter Arno, "so the others occasionally drew cartoons in Arno's style."

Above left: "Why Stay in Dixie?" *Baltimore Afro-American*, June 20, 1936. Courtesy of The Afro-American Newspapers Archives and Research Center

Above right: "Lincoln Freed the Slaves in 1863?" *Baltimore Afro-American*, Dec. 19, 1936. Courtesy of The Afro-American Newspapers Archives and Research Center

Bearden also maintained close friendships with Maxwell T. Cohen, a radical lawyer in Harlem; and with Walter Quirt, a painter who rejected Social Realism in favor of Surrealism and who was quite active in the John Reed Clubs and the Artists' Union. At the same time, Bearden was well aware of mainstream New Deal Democratic politics in Harlem. Like his mother, he hated bigotry and injustice, considered the 1930s Supreme Court racist, thought blacks should finally free themselves of the GOP yoke, and was a humanist—far too much a humanist to embrace Marxism. That, it seems in retrospect, is the key: Bearden was never on-stage in the political arena, but he was always an intellectually curious, enlightened, and aware member of the audience.

In May 1935 and throughout the summer, discussions were held by a group of artists intent on forming an artists' congress. Stuart Davis (who would later become Bearden's mentor and friend) became executive secretary of the group, which grew from twenty to fifty-six artists by August. During this time, various drafts of a Call for the American Artists Congress were written. The final manifesto was hammered out by a committee including Davis; Aaron Douglas, the presiding black artist of the elder generation; Hugo Gellert; and Ben Shahn. The planning committee met regularly at the American Contemporary Artists Galleries (ACA).[11]

The intent of the Congress must be understood against the background of the changing political strategy of the American radical left. From 1928, the year Michael Gold assumed editorship of *The New Masses*, to 1935, when Georgi Dimitroff's speech at the Seventh World Congress of the Communist International in Moscow spelled out the concept of the "Popular Front" against Fascism, the official party line had been "hard," elitist, anti-intellectual. The party now took a "soft" line: it turned from the unremitting Marxist critique of capitalism as the enemy of socialism, to a broad-based, worldwide war against fascism and for the preservation of culture. There was a new benign and indulgent interest in radical writers and artists, Communist or not.[12] Editors such as Stanley Burnshaw resolved "to drive away no one who can be turned into a friend of the revolutionary movement." Even in 1934, the American Communist Party resolved that one of its "immediate tasks" was "to bring intellectuals into closer contact with the working class."

The planning committee for the American Artists Congress decided that membership should be limited to "artists of standing" by virtue of an important exhibition, award, or other professional achievement. New members would be ratified by vote of a majority of the members present. In November 1935, the call for the first meeting was published.

Among the 379 artists from various mediums (including painting, sculpture, printmaking, and photography) who signed the call were Berenice Abbott, Milton Avery, Peggy Bacon, Ben Benn, Ahron Ben-Schmuel, Margaret Bourke-White, Byron Browne, Paul Burlin, Alexander Calder, Stuart Davis, Aaron Douglas, Mordechai Gorelick, Adolph Gottlieb, Harry Gottlieb, William Gropper, Chaim Gross, Sargent Johnson, Rockwell Kent, Julien Levi, Isamu Noguchi, Walter Quirt, Philip Reisman, Ben Shahn, Meyer Shapiro, Moses and Raphael Soyer, William Steig, Joseph Stella,

"Shall This Continue to be the Plight . . ." *Baltimore Afro-American*, April 3, 1937. Courtesy of The Afro-American Newspapers Archives and Research Center

"Shall This Continue to Be the Plight of Colored Labor?"---

James Johnson Sweeney, and Max Weber. The list was a virtual Who's Who of artists who had made their reputations in the 1920s as well as those who would become the avant-garde of the 1940s. [13]

All but 41 of the 401 members attended the opening public session at Town Hall in New York City on February 14, 1936, to hear Lewis Mumford's opening address, with the addition of a delegation of twelve from Mexico (including Orozco and Siqueiros) and many guest delegates. Stuart Davis, the national executive secretary, characterized the followup sessions at The New School for Social Research through February 16 as "daily jam sessions."

At the public session, Aaron Douglas, as patriarch among painters of the Harlem Renaissance, kept to the idea of presenting a united stance to the world, but his remarks had a cutting edge: "If there is anyone who does not understand Fascism let him ask the first Negro he sees in the street. . . . One of the most vital blows the artists of this congress can deliver to the threat of Fascism is to refuse to discriminate against any man because of nationality, race, or creed." At the same time, Douglas not only took to task the exclusion of serious Negro art from America's major art institutions, but also warned against exploiting the Negro as subject by making him "a kind of proletarian prop, a symbol, vague and abstract." Toward the end of his talk, Douglas took note of those Negro artists who had "here and there arrived at a fair mastery of the painter's craft": "Of all the Negro artists, H. O. Tanner is the best known; William Johnson, Hal[e] Woodruff, and Archibald Motley are possibly the most accomplished of our younger painters. Among our young artists of sound talent and definite promise are Wells, Porter, Alston, Bannarn, Hardwick and Bearden. The well known cartoonist E. Simms Campbell, the recent winner of Hearst's contest, is at present our most successful artist. In sculpture Sargent Johnson, Richmond Barthe and Augusta Savage have done important work." [14]

In Harlem a year earlier, Bearden had attended a meeting of some forty-five black artists at the 135th Street Y.M.C.A. This marked the beginning of the Harlem Artists Guild. Formally established by the sculptor and teacher Augusta Savage (arguably the most influential artist in Harlem by 1934), Elba Lightfoot, Charles Alston, and others, the Guild was instrumental in exerting pressure to increase the number of black artists on the WPA/FAP program. [15] Norman Lewis, one of Savage's protégés, became treasurer of the Guild, which swelled to eighty members, including Bearden, Selma Burke, Beauford and Joseph Delaney, and Gwendolyn Knight. [16] The Guild's efforts led to the establishment in 1937 of the Harlem Community Art Center in a loft at 290 Lenox Avenue and 125th Street with eight thousand square feet of studio space. Savage was named its first director, and Eleanor Roosevelt attended the opening ceremonies. Among Savage's students, some of the most influential were Knight, the twin brothers Morgan and Marvin Smith (who began as painters and later became photographers and filmmakers), Ernest Crichlow, and William Artis. (In 1939–40, Morgan and Marvin Smith opened a studio at 139 West 125th Street, a block from Bearden's first studio; a year

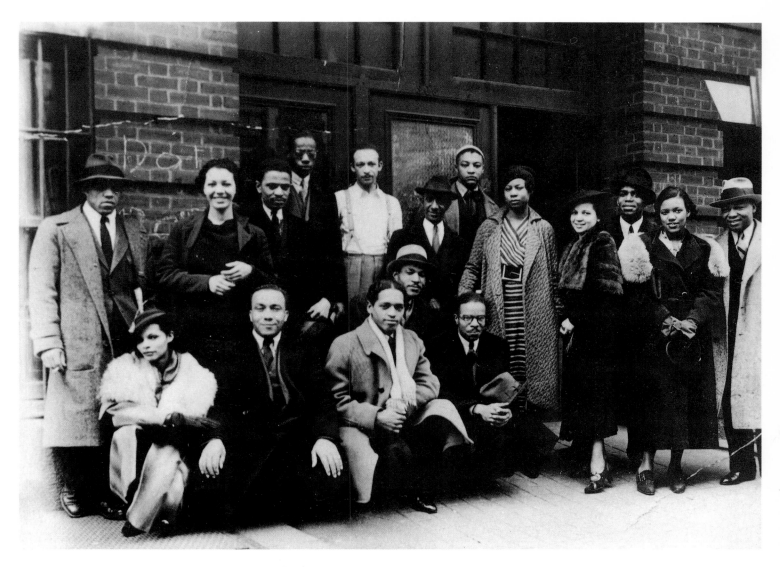

after that, they would help Bearden's mother find Romare a space above theirs in the Apollo Building.)[17]

At the American Artists Congress, Aaron Douglas had really gone far beyond naming individual talents: he had identified the moving forces behind a network of art-educational forces in Harlem. Not only had he made significant reference to Augusta Savage, but in naming the younger black generation of "sound talent and definite promise," Douglas had also listed the core group of Harlem's "306," a wide-ranging and quite informal group of artists, writers, and musicians who gathered at the West 141st Street studios of painter Charles Alston and sculptor Henry ("Mike") Bannarn. "306" grew out of the WPA Federal Art Project, instituted under Harry Hopkins in 1935 to create jobs for artists, writers, and people connected with the theater. The project subsidized the studios as teaching and work spaces, and continued even after the project closed down in 1943. By that point, over two million students had attended WPA art classes nationally.

Members of the "306" group at 306 West 141st Street, mid-1930s. Front, from left: Gwendolyn Knight, Edgar Evans, Francisco Lord, Richard Lindsay, Fred Coleman (holding hat); back, from left: Ad Bates (wearing hat), Grace Richardson (model), James Yeargans, Vertis Hayes, Charles Alston (in white shirt), Cecil Gaylord, Silas Glenn, Elba Lightfoot, Selma Day, Ronald Joseph, Georgette Seabrooke, O. Richard Reid. Photograph by Morgan and Marvin Smith

This opportunity for free instruction affected the painter Jacob Lawrence, for example, quite directly. As a boy, he had first studied with Alston at Utopia House—a settlement house that provided day-care, hot lunches, and an after-school arts and crafts program. Bearden remembered this community center as a big brownstone at 130th Street off Seventh Avenue. Alston ran the program while completing a master's degree at Columbia University. Alston then became the director of the Harlem Art Workshop, with facilities in the 135th Street Public Library. Lawrence studied there under Alston from 1932 to 1934, followed Alston when a WPA Harlem Art Workshop was established in the latter's studio at 306 West 141st Street, and continued to study, now with both Alston and Bannarn, from 1934 to 1937.[18] For a few dollars weekly, Lawrence kept a space in Alston's studio until 1940. Since Alston was also Harlem director of the WPA mural project, artists assigned to the project came to "306" to report to him.

The ground floor of the three-story building at 306 West 141st, a former horse stable, had been converted to a commercial establishment. The Harlem Art Workshop was on the second and third floors. The second floor contained a large work space, with easels, work tables, cabinetry, and supplies. Upstairs, on the third floor, were living quarters. Throughout the building, the odor of the ground-floor's first tenants, the horses, could be noticed, a decade after their departure for other pastures.[19]

Bannarn and, to a lesser extent, Alston refined their sculpting techniques under the tutelage of Ahron Ben-Schmuel, another of the regu-

Romare Bearden, Norman Lewis, Ad Bates

lars at "306." Ben-Schmuel had enormous strength, which he had developed
by working with granite and other hard stone as a carver of tombstones early in
his career. He was also quick to anger. Ben-Schmuel taught sculpture to the
youngsters at "306." Bearden remembered one time when: "He gave instruc-
tions on how to build modeling stands. When he came, no one had done it
[properly]—they had little fruit stands, or boxes. He got so mad he took a
hammer and smashed them all. He had a terrible temper. But he was a great
help to Alston and Bannarn in their carving techniques and methods. Aaron
liked Mike Bannarn very much [and] he was very fond of Ad Bates."[20]

 Bates, a furniture maker, dancer, and model at the Art Stu-
dents League, rented the front studio upstairs. His brother Len, also a cabinet-
maker and model at the League, lived in the middle apartment from 1936 to
1937 and again with his wife, Myrtle (who was Langston Hughes's assistant for
a time), from 1939 to 1942. The back apartment was Spinky Alston's.

 In the late 1930s, the writer Ralph Ellison, who had come
up to New York from Tuskeegee Institute, where he had studied trumpet and
classical composition, became a regular. Here, Jacob Lawrence remembers
meeting Richard Wright, Langston Hughes, Alain Locke, and Ellison. Ellison
himself took over Len and Myrtle Bates's apartment in the early 1940s.

Twenty-five years later, Ellison recalled the nature of Bearden's art in that era:

During the late Thirties when I first became aware of Bearden's work, he was painting scenes of the Depression in a style strongly influenced by the Mexican muralists. This work was powerful, the scenes grim and brooding, and through his depiction of unemployed workingmen in Harlem he was able, while evoking the Southern past, to move beyond the usual protest painting of that period to reveal something of the universal elements of an abiding human condition. By striving to depict the times, by reducing scene, character and atmosphere to a style, he caught both the universality of Harlem life and the "harlemness" of the national human predicament.[21]

In essence, "306" was a microcosm of the rich artistic life of Harlem which flourished during the Depression. Bearden's friend Jacob Lawrence, who was by then about eighteen years old, remembers "306" as a wonderful place, "an extension of the art community as a whole."[22] The older generation included such artists as Savage, Douglas, and O. Richard Reid and writers Langston Hughes, Countee Cullen, Claude McKay, and Gwendolyn Bennett. Among the younger artists and writers who came to "306" regularly were Bearden, Lawrence, Crichlow, Lewis, Knight (who later married Lawrence), James Yeargins, Robert Blackburn, Frederick Coleman, Ronald Joseph, Richard Lindsay, Francisco Lord, and Walter Crispus. The writer William Attaway and his sister, the actress Ruth Attaway, who were from Chicago, became part of the group, and later the choreographer Katherine Dunham, also from Chicago and an acquaintance of the Attaways, would drop in. Len Bates remembers poker games between the Attaways, his brother Ad, and Spinky Alston that began on Friday evenings and went on into the weekend.

One of Bearden's close friends at "306" was Norman Lewis, whom he had known since their public school days in Harlem. Bearden recalled: "Norman was a very sensitive person—he had interests of his own, very much interested in aspects of nature. He always kept big tanks of goldfish, which he kept beautifully, with plants. He'd take care of them. He had pigeons at one time, the real old fine racers, on his roof. I think this carried over when he began to paint in this kind of lyrical expressionism you might say he employed. He was very much in the school of Graves and Tobey. . . . He could be very irascible, yet his intent was always good. And he had his own way of looking at things in painting; it was very interesting. I think he's a very fine painter."[23]

To Jacob Lawrence, "306" was very much a community, "a social and artistic atmosphere. I would hear the talk about the various problems in their special fields of acting, theater, and so on. It was stimulating and very rewarding—I didn't realize *how* stimulating it was at the time, because I was too young to fully appreciate it. Romare Bearden was one of the younger people who frequented '306,' and he told of his experiences. He was an intellectually curious person in regard to his painting. He was experimental and

Opposite, above: *Mr. Blues Leaves a Calling Card.* 1980. From the *Profile/Part II: The Thirties* series. Collage on board, 8¼ x 17½". Collection Mr. and Mrs. Herbert S. Landau

Opposite, below: *110th Street.* n.d. Collage on paper, 14 x 22". The Shaw Family Collection

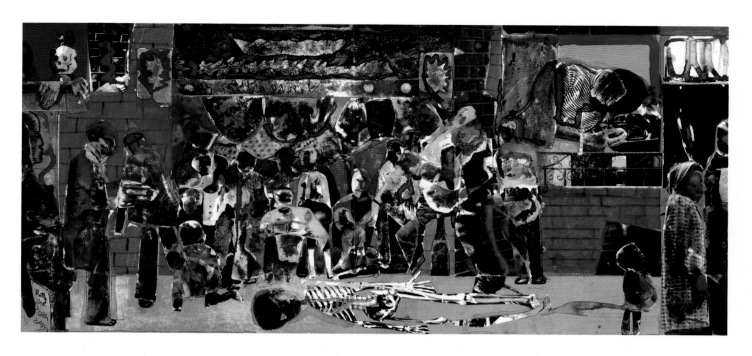

scholarly, very much involved and curious, and studied the old masters and the moderns. He attended the exhibitions outside of the Harlem community—galleries and museums. And he would come back and talk about these things, as everyone did about their own experiences."[24]

Downtowners, such as William Saroyan, William Steig, or Carl Van Vechten, would drop in at times, as would musicians and songwriters, including Andy Razaf, lyricist for songs like "Ain't Misbehavin'," and jazz musicologist John Hammond, who helped get Billie Holiday and Count Basie some of their first big bookings in New York. Classical composer Joshua Lee and songwriter Frankie Fields were regulars. As Charles Alston described it, "there was always a hot discussion going."

Bearden himself saw the milieu in relation to the artist's capacity to make his surroundings part of his own unique vision. For Bearden, Jacob Lawrence was one of several artists who had that talent:

Jake, when I first met him, was a student of Alston's, a teenager, and he was doing masks in pastel. . . . And then he began to paint on brown paper the scenes around him—the tenements, what people were doing, waiting in a hospital clinic. And I think in that period of the thirties there were three artists [who possessed the common gift] of taking a particular time and being animated by it. One was George Grosz. I think his strongest work was after World War I in Germany until the time Hitler was starting to come to power in the early thirties and he [Grosz] came over here. [Another was] Orozco, the Mexican Revolution, which he did in his drawings and his other works: Zapata Is on the March, *and that kind of thing. And the other was Lawrence, when he was a young man, of the things he saw around [him]. I think he has continued to be influenced. He is one of a very few modern artists who does what you might call a continuing narrative painting—of the migration of the Negro from the South which began in the twenties; the "Toussaint L'Ouverture" series; "John Brown" and the "Harriet Tubman" series. . . . I think that he was a natural talent—he was wonderful even when he was eighteen.[25]*

Lawrence's early interest in masks was related to a general interest in African art among young black artists in Harlem. They saw Alain Locke's extensive collection, as well as the excellent holdings of African sculpture at the 135th Street Public Library (now in the Art and Artifacts collection at the Schomburg Center for Research in Black Culture). "Professor" Wylie Seyfert, a carpenter who had informally become a teacher of the younger generation of artists, was another important figure in the community. He stressed the importance of African art and the heritage of black history in his lectures. Bearden remembered his impressive collection of books in particular. When The Museum of Modern Art installed an exhibition of "African Negro Art" in 1935, Seyfert brought Lawrence, Lewis, and Bearden to see it. Lewis asked for and received permission to copy the works on display.[26] Bearden returned to see the exhibition often, and Seyfert's suggestion that the young artists select black history as the content of their art had obvious influence on Lawrence.[27]

It was not always WPA work by day, studio work afterward. On many evenings, Bearden and his friends would meet at Joe's, about five blocks from "306" on 7th Avenue and 136th Street. Then, often three nights a week, Bearden and some of the others would go over to the Savoy Ballroom, where Charles Buchanan, the manager, let the artists in free.

The Savoy Ballroom, which occupied the second floor of a building stretching the entire block front facing Lenox Avenue from 140th to 141st streets, was one of the country's great dance palaces at a time when jazz and dance coalesced. It is a phenomenon difficult to convey to anyone who has not stood near an eighteen-piece band sounding like one man "stomping the blues," as Albert Murray put it, screaming, wailing, moaning, cat-calling, shouting and answering, while a floor filled with dancers becomes one with the band. They stomped at the Savoy every night of the week, two bands alternating on opposite sides of the dance floor. The greatest bands in the country played there, but if they couldn't make the place swing, they weren't around long. Jimmy Lunceford, Duke Ellington, Cab Calloway, Lucky Millinder, Earl Hines, Lionel Hampton, Charlie Barnet, Benny Goodman, Tommy Dorsey, Erskine Hawkins, and Fletcher Henderson all brought their bands to the Savoy throughout the 1930s.

In the early 1930s, a new kind of swing, out of Kansas City and "out of the territories," Oklahoma City and the Southwest, came into the Savoy. This was what Ralph Ellison, himself from Oklahoma and a former music student, called "stomp music." It was insistent, driving, and had a 4/4 beat—the famous Kansas City 4/4. Benny Moten's Kansas City band, which had Count Basie on second piano and which (in good part because of Basie)

had courted and imported the nucleus of Walter Page's Oklahoma City "Blue Devils"—trumpeter Oran "Hot Lips" Page, trombonist Eddie Durham, bassist Walter Page himself, tenor saxophonist Ben Webster, and Jimmy Rushing singing the blues—was among the first to play the Savoy. A few years later, Lester Young, with his porkpie hat, soloing with Count Basie's band, stole the scene with a sound like no other horn in the world, and a way of laying back just behind the beat that could rip right through you.

But the band to look out for at the Savoy was Chick Webb's. He was a short, deceptively frail-looking, partially crippled drummer whose propulsive beat could rivet an entire dance floor. In the "cutting contests" that took place not only between individual soloists but also between entire bands, Webb's tactics were shrewd. The trombonist Dicky Wells recalled that Chick would just lay in wait for the other name bands to make their appearances. His preference was for the weekends, when the Savoy dance floor was packed. The dancers would request their favorite numbers, often those that had gotten the house jumping during a slower weeknight. It was all a matter of timing. "Chick used to sit back looking out of the window while his band played early in the evening, but when the visiting band would get rough—here he would come, and that was it!"[28] It didn't matter who the visiting band was either. Chick could put away Sam Woodyard, playing with Duke Ellington, or Gene Krupa, playing with Benny Goodman. The Savoy belonged to Chick Webb, and his singer was a very young Ella Fitzgerald.

For Bearden, sitting there at the Savoy—or at the Lafayette Theatre, Small's Paradise, Barron's (Barron Wilkin's Exclusive Club), or Connie's Inn—it was all registering. He had an eye and an ear on which little was lost. Thirty years later, it would all come back in hundreds of works—collages, monoprints, murals, and mosaics—filled with his memories of a music that celebrated the affirmation of life.

Even after an evening at Joe's and the Savoy, the night was young for Romare. He, Charles Alston, and Eddie Morrow formed the nucleus of the "Dawn Patrol," which took its title from a column written for the *Amsterdam News* by Ted Yates. Together with friends like Peter Arno and the *Post* critic Archer Winston, they would hit the after-hours and then the after-after-hours spots. "The thing in Harlem in those days was that the bars closed at 3 A.M., and then everybody went to after-hours places." The first stop was usually Mom Young's on 131st Street:

For twenty-five cents, you could get a beer that she made herself in a coffee-can-size container. You'd get that, and then some food. She made a different kind of food every night, say chili gumbo. . . . This was a place where the artists came, and the show people came after the show. Nothing really began until around twelve. I remember one night that I was there and Stepin Fetchit came. After that, he wanted everybody to go to his house, and he called his piano player. And then he entertained for us—he sang and he danced at his place. And then he took everybody home; it was dawn. Seventh Avenue was a little larger then. But he was just like he was on the stage and in the movies. It was at 180th, and he

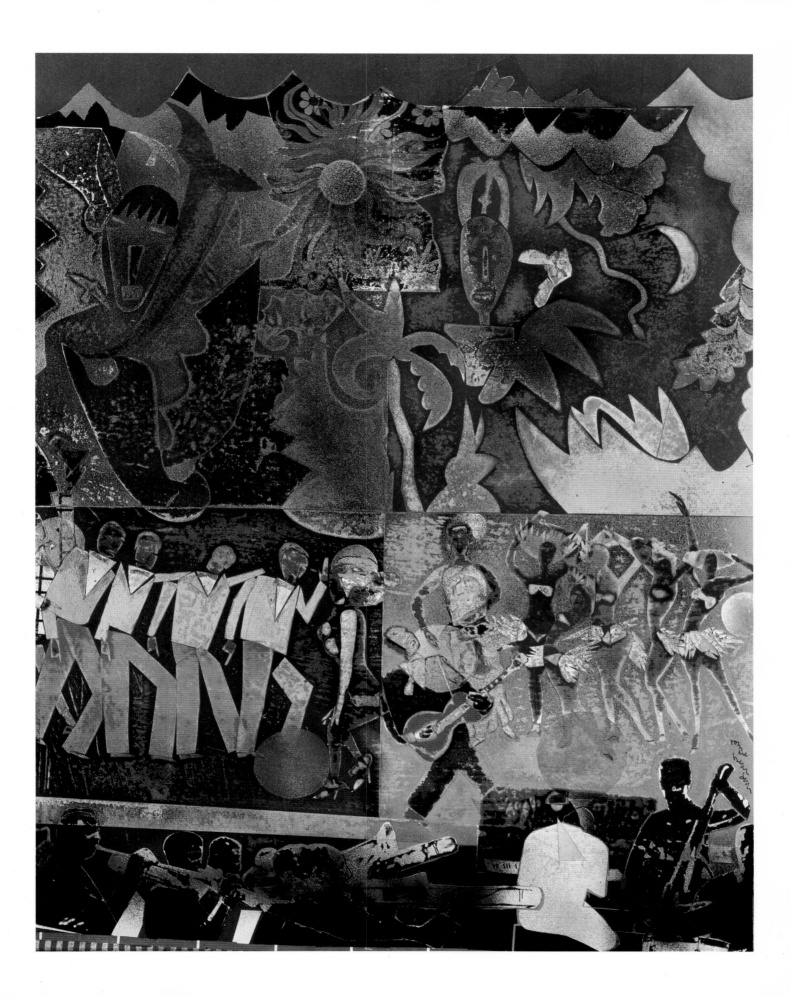

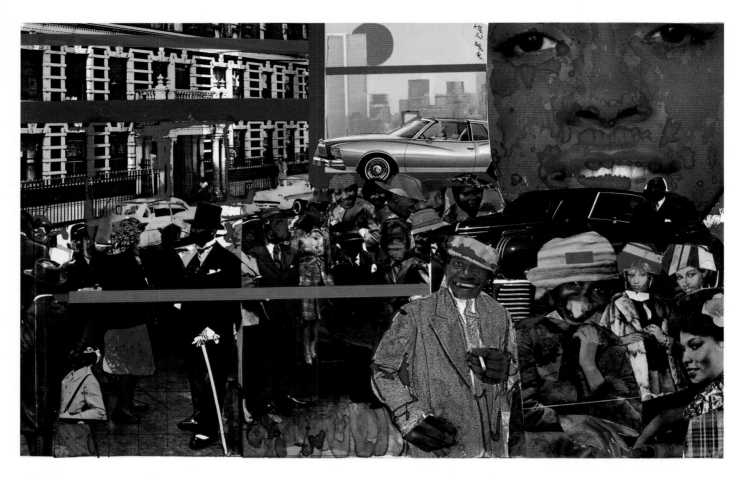

Above: *Slapping Seventh Avenue
with the Sole of My Shoe.* 1981.
From the *Profile/Part II: The
Thirties* series. Collage on
board, 14 x 22″. Private
collection

Opposite: *Black Manhattan.*
1969. Collage of paper and
synthetic polymer paint on
composition board, 22½ x 18″.
Schomburg Center for Research
in Black Culture, Art and
Artifacts Division, The New
York Public Library. Gift of Mr.
and Mrs. Theodore Kheel

was taking somebody home at 144th Street and Seventh Avenue, and he drove so fast, he just flew down, and then he went on the sidewalk—lucky it wasn't as crowded as it is now—and he said "I'm going to give you service." And he took this lady right to the stoop.

And then the chorus girls would come round Mom Young's when they finished the shows, say around two or three o'clock. And then there were the places of the ladies who had women, sometimes right next to an after-hours place. There was one lady who ran a house on 116th Street, and this was for wealthy people, and Dutch Schultz used to go there. He always had a lot of money in his pocket. He used to come up, and then close the place. He used to like to talk business with this lady and get her advice. He would get all the girls to take off their clothes, and walk around in black stockings and high-heeled shoes: they would just walk around, and he would maybe stay there two days. And everybody would be paid; he paid this woman, and then he would leave. Dutch had a huge collection of classical records. I know that he had that, because he liked Marian Anderson. He went to see her sing, but he put on dark glasses, because he didn't want to say, "Well, this is Dutch Schultz coming," and he'd sit in the balcony. And then he sent her orchids. That was back when he was never calling himself "Dutch" Schultz. And then all the gangsters—boys called the Gallo boys and others—owned many of the bars; the Cotton Club, Connie's Inn, places where Duke Ellington was playing, were in and around gangsters.[29]

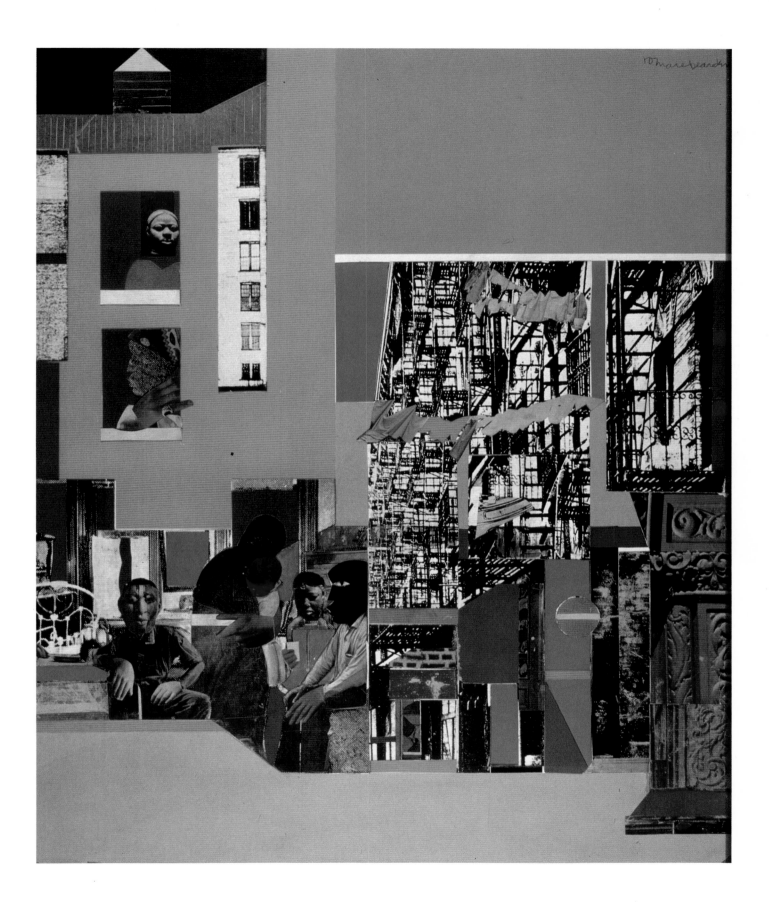

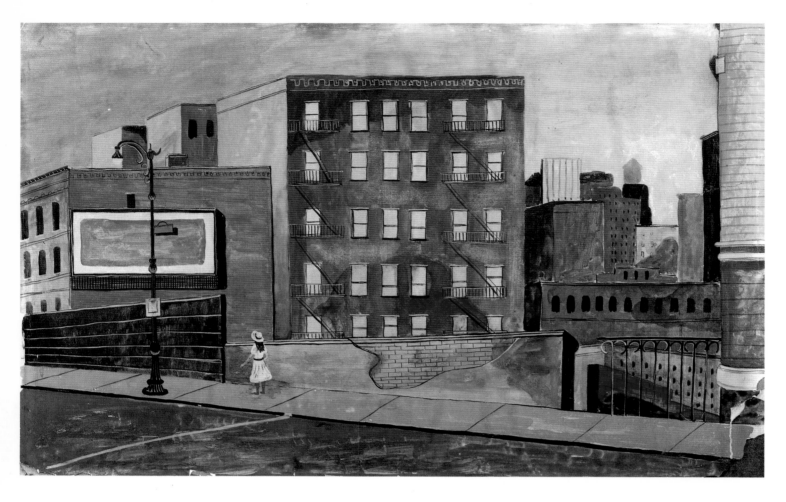

For Romare, Seventh Avenue then might have been the Champs-Elysées: "Here were we, the young artists, looking on at all of this. I'd say that we young artists had the same kind of ambiance that Toulouse-Lautrec had. It was a very interesting time. You'd want to be either in Harlem then or in Paris. These were the two places where things were happening."[30]

In 1938, Bearden became a full-time caseworker for the New York City Department of Welfare, assigned to the men's division of the Harlem office. This job, which he held for three decades, until he retired in 1967, had many consequences. It disqualified him for WPA Arts Project work; forced him to "moonlight" as a painter during the afternoons and evenings; gave him an independent income, which allowed him to have his own studio through the years; shut out the possibility of combining painting with university teaching, which many of his friends eventually came to do; and later exposed him to a special and particularly sensitive segment of the welfare population, the Gypsies of New York City, who constituted his case load for many years.

Bearden's memories of casework during the Depression are both funny and predictably grim. One incident in particular seems the epitome of Depression thinking. Bearden was called to the home of a couple who lived

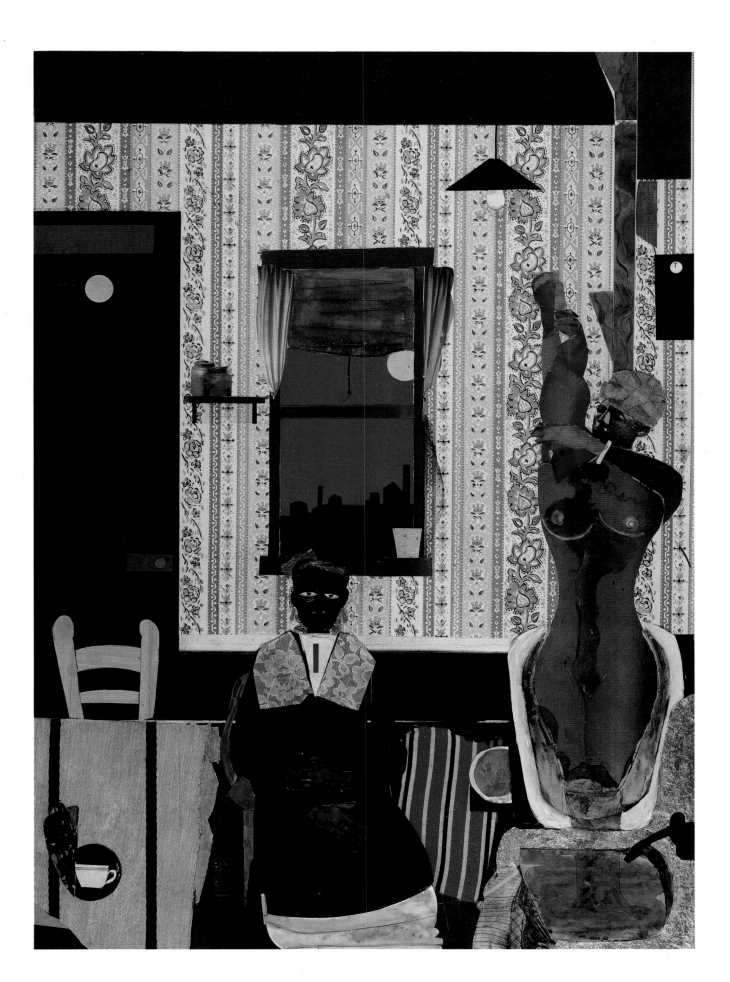

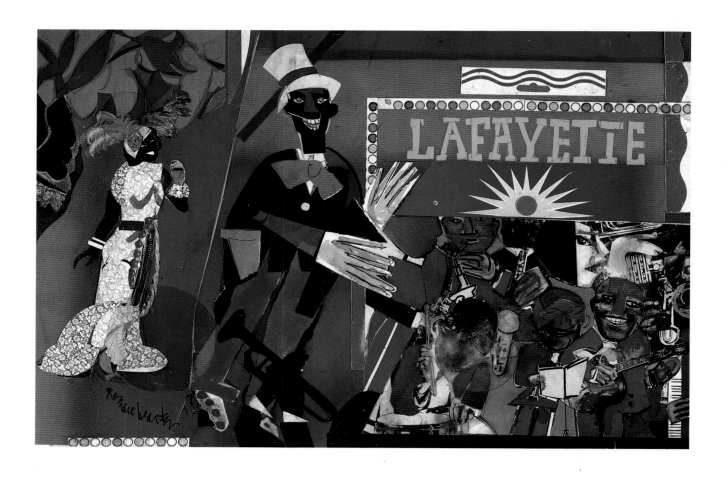

Above: *Johnny Hudgins Comes On*, 1981. From the *Profile/Part II: The Thirties* series. Collage on board, 16 x 24". Private collection

Right: *Untitled*. c. 1983. Serigraph with airbrushed border, 26½" x 37½". The Shaw Family Collection

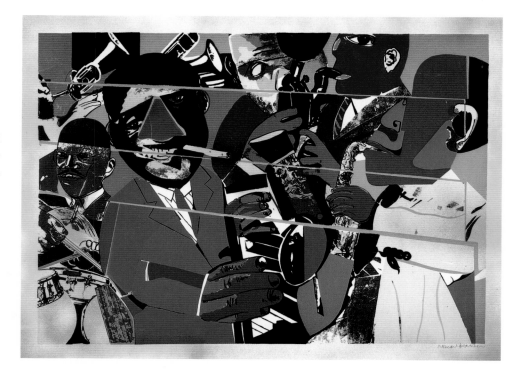

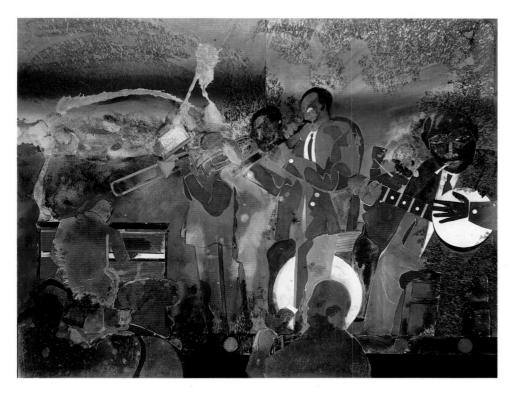

Uptown Sunday Night Session.
1981. From the *Profile/Part II:*
The Thirties series. Collage on
board, 44 x 56″. Private
collection

on Eighth Avenue around 133rd Street. The husband was sitting on his stoop when his wife came down and told him that the ceiling had fallen in. "He went upstairs and saw that it had fallen all around her but she wasn't hurt. He had a club, and he quickly hit her on the head, and made a knot! Then he went down and called the police to tell them that the ceiling had fallen and injured his wife. And so he got about a year's free rent—and some money."[31]

In the words of that quintessential blues song "Stormy Monday":

> *They call it stormy Monday,*
> *But Tuesday's just as bad*
>
> *Wednesday's worse*
> *And Thursday's also sad.*

For all, whether they were salaried under the WPA, worked for the city like Bearden and his father, or, for that matter, whether they were the first on the welfare rolls in the country's history, like Bearden's clients, the day that check came made it all feel just a little bit better:

> *Yes, the eagle flies on Friday*
> *And Saturday I go out to play*
>
> *Eagle flies on Friday*
> *Saturday I go out and play*
>
> *Go to church on Sunday*
> *Then I kneel down to pray.*[32]

STARTING OUT OF HARLEM

A MOSAIC OF TEACHERS AND FRIENDS

Bearden's close association with many New York artists during the 1930s and 1940s had an enormous impact on his art and life. He was particularly influenced by the Greenwich Village painters Walter Quirt and Stuart Davis. Quirt and Davis, themselves good friends, had planned a jazz-and-art project for the Associated American Artists Gallery that unfortunately never came to fruition. Bearden and Quirt corresponded frequently after the latter artist left New York in 1944 to take up teaching posts in Milwaukee and later in East Lansing, Michigan. Though Bearden never said this explicitly, it appears that Quirt, who had undergone Freudian analysis during the late 1930s as he moved from Social Realism to Surrealism, provided him with a paradigm of the inner turmoil he himself experienced as both an artist and a man. Quirt, isolated from the main current of the New York art scene, found he could open up to the younger artist; Bearden could be equally honest.

Stuart Davis was not only a friend to Bearden but also one of his most important teachers. Through Davis, Bearden learned how to incorporate color, interval, and rhythm in his art, infusing it with the freedom and spontaneity of the jazz Davis listened to incessantly. Jazz itself was to become one of the driving forces in Bearden's art.

Among the artists Bearden came to know as part of Samuel Kootz's gallery in the mid-1940s, the two with whom he developed close friendships were William Baziotes and Carl Holty. Bearden is revealing here how he learned from Baziotes that it was natural for an artist not to know what to paint at a certain point in his career. He is also candid about what Carl Heidendreich taught him of the importance of feeling one's way through a painting as opposed to analyzing it structurally.

Carl Holty, however, was Bearden's most important teacher when it came to the analysis of Cubist structure. Together, they set out to write *The Painter's Mind* in 1948, and spent nearly twenty years completing it.

Interestingly, these friendships and mentorships were infused with a common love of sports and, with Davis, of jazz.

MS: Coming out of Harlem in the 1930s, who were some of the artists who meant the most to you?

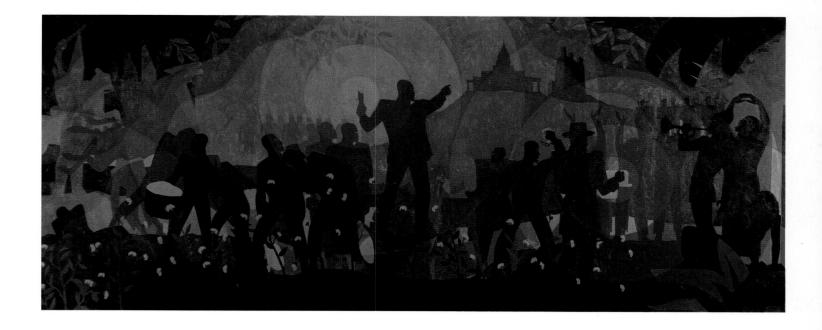

RB: One of the first artists I met, that is out of Harlem, was Walter Quirt. And I saw Walter very, very frequently. I met him through Ad Bates. In those days, say 1936, 37, 38, around in there, Ad, when he wasn't dancing, posed as a model at the Art Students League and other art schools, and he had met a number of the painters. And even the well-known painters at that time—Gropper and the rest—weren't making the kind of money that the artists make today. And so most of them supplemented their incomes with teaching. Walter Quirt had come to New York from the Midwest. At first, he did painting of a somewhat social nature. But then Walter's work became more fanciful, certainly with overtones of Surrealism. He was quite a student; he had an interest in psychoanalysis, and he often wrote (I have some of his writings) on the nature of the relation of art to the unconscious. He was very absorbed in this.

When I knew Walter first he lived with his wife, Eleanor, on Perry Street. I think he showed in several galleries here in New York at that time. He knew all the artists—like Stuart Davis; he was very fond of Stuart. Carl Holty and Quirt I don't think were too friendly. I didn't know Holty at that time, but Holty had known of Quirt from the Midwest, and I don't know whether they got along too well or not.

Then there was another artist, a sculptor really, Alonso Hauser, who was friendly with Quirt at that time and living in New York, and he later, during World War II, moved to the Midwest someplace, either Wisconsin or Minnesota, where Walter had come from and also Holty.

These artists then would usually go to the Hotel Lafayette or to Romany Marie's—that's on Sixth Avenue right around 9th Street. At that time they used to have the marble tables, and it seemed for many years that the artists used to gather there. It was inexpensive. And through Walter I began to meet Stuart, Abraham Rattner, and a number of the other artists at the time.

Aaron Douglas. *From Slavery Through Reconstruction.* 1934. From the *Aspects of Negro Life* series. Oil on canvas, 60 x 139″. Schomburg Center for Research in Black Culture, Art and Artifacts Division, The New York Public Library

Norman Lewis. *Processional.* 1965. Oil on canvas, 38¼ x 57¾". Norman Lewis Collection, courtesy Ouida B. Lewis

MS: What was Abraham Rattner like?

RB: He was tall, a very quiet and nice man. He had stayed in Paris after World War I—I think he'd been a soldier—and I believe he made a living as a lightweight boxer, he sold things on the street. . . . He had a hard time, but he remained in Paris during the twenties.

I remember he told me that he'd become a friend of Monet's grandson, and that he went to visit Monet with the grandson. And when they got there, the maid said, "Monsieur est sur le motif"—"He's on the motif"—in other words, he was out on the landscape painting. So they went out to see him, but he was so intent that they stood on a little knoll and watched him paint the scene. But it was interesting as Rattner described it, because he said that Monet had a palette, but he kept his hands going as if his right hand was a propeller. His brush would hit the paint sometimes, and that would be a dab in the canvas. So this was the way he worked—he just kept his hand going, and the colors, so he didn't get any particular detail. These things were coming into his last work. So they didn't say anything, and they watched him for several hours, until he took a rest. Rattner had many things to tell about the artists he had met at that time.

MS: Was Rattner one of the first people who told you about Paris, or France?

RB: Yes, he and his stories. I don't think Walter had been there. And then Davis, also, had been there in 1927–28, and some of his best paintings are his Paris pictures. But he didn't have much money, and he lived very penuriously, but he was able to make it; looked, saw a lot. As Davis would see things. And I believe he was changing then to his more abstract style, in Paris, because certainly some of the things he did of buildings—they've very beautiful—evocations of the Paris that he knew. I don't think he had met any well-known artists at that time in Paris—at least he didn't mention them to me, say Picasso, Braque, or some of the others. But I came later to know Davis much better, after World War II. But I met *these* fellows through Walter and through Ad Bates.

 The other artist I must mention was Ahron Ben-Schmuel. Ahron liked Michael Bannarn very much. I remember once Mike and I went out to see him in Pennsylvania. He was in Pennsylvania [c. summer 1934] and had a Guggenheim fellowship. Mike and I went out to help him; we sharpened his tools—every time he hit the granite, the tool would dull. By that time, his fellowship money had run out.

 One day, walking in the woods he noticed a little puppy sucking water up. He knew it was a wolf puppy, because a wolf sucks up the water rather than lapping as dogs do. He took the pup home and raised it. Later on, in a way, Ahron sometimes depended on his wolf for food, because it would bring back chickens, and lambs, for instance. Of course this enraged the farmers, who made constant attempts to shoot the wolf.

 Another time, Mike and I went to Ahron's studio downtown. A girl came in to inquire if she could model. He said, "Where are you from?" She said someplace in the West—I've forgotten the town.

 "You know what that means—you've got to get in bed with me." Someone, one of his students, laughed; all this was very amusing to him. But it wasn't to Ahron! He said, "Get out."

 She left in tears. Ahron came at the student with a hammer; said, "Didn't you see what I was trying to do? She didn't belong here, no way. Now *you* also get the hell out and don't you ever come back."

 Ahron was a great stone sculptor. You should do *his* life! He developed silicosis—I think he only had one lung, when I met him, or a difficulty with that lung. Then he became a painter, near the end, because he couldn't sculpt any more, because of his condition. I think he went to someplace in the Near East, and my feeling is he didn't die in this country.

 But he was a great help to Alston and to Bannarn; a lot of their carving techniques and methods. A lot of the people you see in there, who worked in very hard stone—the carving was done by Ahron, among other sculptors.

MS: You mean . . .

RB: Well, most of these American sculptors, like Hiram Fowlers and Harry Posmer—these neoclassical sculptors—were all in Italy. And since they had American dollars it was very cheap. Three or four men, artisans, did most of the pointing up and carving of the marble—not like granite, you know. And

Jacob Lawrence. *Gee's Bend.* 1947. Tempera on gesso on wood, 20 x 24". Evansville Museum of Arts and Science, Ind.

when you see these neoclassical sculptures, they're mostly done from clay models. They had methods of pointing these things up, this going into that, something like a panagraph. I haven't seen it done, but I've been reading about it. So Ahron did a lot of that stuff.

MS: He was older than the rest of the group at "306"?

RB: Yeah, he was older. [Reading] He was born in 1903, so he was older. [Shows reproductions of works.] You see, the *Torso of a Boy* that they have—that's in black granite. And *The Pugilist*—this was in black granite. *Seated Woman* was in granite. So I said, "You know, when you're working in that, you're working in the stone that the Egyptians used."

MS: And then the muralists—Siqueiros . . .

RB: Yes, those were my influences.

MS: Jake Lawrence also mentioned a man named Harry Gottlieb.

RB: Harry Gottlieb. At that time, most of the artists were on the WPA, as Jake

mentioned. And there was an organization called the Artists' Union. And this [was] mostly white, downtown, but they wanted to encourage some of the artists from Harlem to join. I think they had a fellow—Jake didn't mention this, but it comes to me—named Silas Glenn. He may have been a vice-president of the organization; I'm not sure.

MS: Stuart Davis was in that.

RB: Stuart Davis, yeah. He did a lot of covers and things. And Harry Gottlieb was important in this organization. Artists were organizing then, like labor union people. Sometimes you painted. But the revolution was around the corner; you had to be prepared! So Harry liked Jake's work, and he would come up and talk, meet with the artists.

MS: Was he himself an artist?

RB: Oh yes. I don't know what happened with him in recent years. What they call silkscreen or serigraph now was developed on the WPA, and so a lot of these artists were working in that medium. As I remember, Harry did a lot of work in serigraphy.

This was also the time that, as I told you, I met all of the German refugee artists. Ernst Toller—you know, the famous dramatist; Hans Maria Graff, the novelist; and one who had commanded one of the regiments, or more than that, Ludwig von Renn. They all came over about 1938 or 39, and they had a big house in the Bronx for a short time. And they somehow came to visit 306 West 141st Street. They were all very much taken with Jacob Law-

Stuart Davis. *House and Street.* 1931. Oil on canvas, 26 x 42¼". Collection Whitney Museum of American Art, New York

rence's work. They all thought that he had hit the essence of something common to black life in this country. Of all of them, the one I was nearest to was Ludwig von Renn.

MS: What was he like?

RB: Ludwig Renn, in World War I, was on the German general staff, and he wrote two novels that were translated into English. And he said he learned how to write because one of his duties on the general staff was to write communiques. After the war he became rather disillusioned with the whole thing and became a Marxist. I think in the thirties maybe he renounced this whole thing of German militarism, and during the Spanish war, in the mid-thirties, he went to Spain. And one of the big battles that the Loyalists won, I think he had engineered. And when it was no longer feasible—when Franco, everybody had let the Loyalists down—he came to this country and was a part of that group. I remember one time we were at "306," and Holty had told me that a German officer, one of those real Prussians, didn't like to ride in elevators, or on buses, or in public conveyances. And I remember that we walked from 141st Street to Central Park, through Central Park, to 59th Street, because he was living in a hotel there. That was a walk! And we went up, and he had a lot of German Expressionist woodcuts by Kathe Kollwitz and others that he showed me.

MS: Was Hale Woodruff a friend of the same era?

RB: I knew Hale during this period in New York. Later, when he taught at New York University, I knew him better.

MS: When did you first meet Woodruff?

RB: I met Woodruff way before I was exhibiting. . . . I'd just finished school—this was before World War II. I went back to North Carolina, and then went to Greensboro to see my aunt, and then Atlanta. This was about 1940 or 41. And then I met Woodruff for the first time down there.

MS: In Atlanta?

RB: Yeah. He was teaching down there, at Spelman College—he was the art teacher. I think it was later—maybe the early fifties, or late forties—that he was given a teaching post at New York University and came to New York City.

MS: You didn't meet Carl Holty until after the war, when you joined Kootz.

RB: I was taken into the Kootz Gallery, I think late in 1945, October. I believe the war in Europe was over, and it was coming to a close in Japan. I had just been let out of the army. Holty was in the gallery, as were Fritz Glarner, Baziotes, Motherwell, Byron Browne, Adolf Gottlieb, and myself. Later, of course, he added Hofmann, and a sculptor whose name I've forgotten now. But before opening his gallery, he had curated several shows—not in his own gallery—of vanguard painting. So he knew Davis, and Holty, and a number of other artists who were painting in the so-called modern manner.

MS: William Baziotes—could you tell me about him as an artist and as a friend? . . . You said that he gave you some ideas of feeling through painting.

RB: Well, when I first started to paint . . . I think a lot of artists are confronted with the question of "What shall I paint?" I had spoken about this with Baziotes, and he said, "Well, the same thing happened to me. I asked myself,

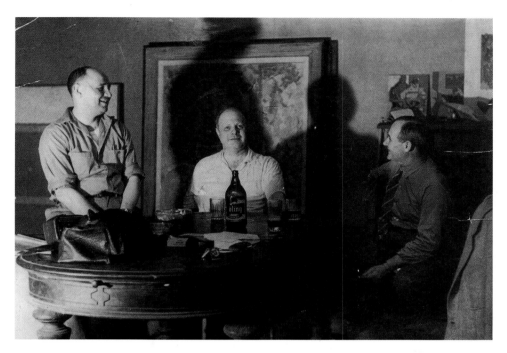

'What do I really like?' " For him it was tumblers, glass tumblers. He said he just drew these glass tumblers, and continued to draw them, you know, just one right on top of the other. His other work had this kind of a feeling, you follow? They look very abstract now, these lines coming in. You turn it upside-down. . . . So that's how he arrived at that, by just drawing these tumblers. So that was very interesting to me. Also, we were talking about Monet and Cézanne one day. Monet was coming very much into his own again, especially with the Abstract Expressionists. You know, he was kind of their man, for a while.

He said to me one evening, "You know, Monet was a great painter. But Cézanne goes down deeper in the water's start." So he knew then, even though Monet was to the forefront, that Cézanne, with his structure and his ability to take the essence of a landscape, was to Baziotes a more profound painter. He used to go—I used to go with him to places like tango palaces, and things like this that the other artists didn't go to. However, Bill did make both the artists' parties and his own special places as well—which I feel he and his Ethel, his wife, enjoyed most of all. He seemed to like going to those things. Or to jazz. He would come to my studio. He and I . . . thought alike. He liked baseball. . . . He became a friend of a boxer, named Zulueta, who was a lightweight contender. And we used to go to his bouts. I don't know what happened to him, but in the fifties he was a leading boxer. Bill liked that type of thing: boxing, baseball. Except for Holty, some of the others didn't care too much for sports. So Baziotes—in that way, he and I had a lot in common.
MS: And Holty liked baseball?
RB: Oh, he liked all the sports. I think he did—yeah, he did play football, in high school. And I think it was at a high school where Hemingway had been just before him. He said that he knew of Hemingway even as a high school

Romare Bearden, Carl Holty, and Joan Miró, 1948. Photograph by Francis Lee

athlete. And he would go to the same gymnasium, in Paris in the twenties, and play squash with Braque very frequently. Holty's father was a physician, and Holty went to medical school, at Marquette. He did three years there and left.

MS: So would you say that your very good friends were Holty and Baziotes, the two of them?

RB: Yes. Both artists.

MS: Do you think Holty was a deeply dissatisfied man?

RB: Deeply dissatisfied? Holty had so much energy and drive that I can't see him being deeply dissatisfied.

MS: Just something that came across in his letters. Maybe it was the teaching situation in Georgia.

RB: Oh, yes. At that time, there were two things. Holty had a [law]suit going on. He lost the suit, and it was a bad blow to him. When he was with Kootz, he was on a fixed salary, in return for a certain amount of work. Then when Kootz closed the gallery, he auctioned off Holty's and Byron Browne's works at one of the department stores. That hurt them, because so much work was on the market that had been sold for so little.

MS: When did all this take place, Romie?

RB: This was in the 1950s, and it went on for a while. And I think Byron Browne was devastated by it. And Holty was too. He had to teach—he had various teaching jobs, at Washington College, in St. Louis; at the University of Georgia. Then he was out on the coast, part-time in the summer. He did some lecturing, and he taught at Brooklyn College, and finally he was given tenure at Brooklyn College, where he remained until he died.

I think that Carl felt, and justly so, that he was not given all the recognition that he should have been given as a painter. I feel that in his late years he began to work in a much more lyrical way than in his earlier, so-called hard-edge or precise paintings. For a while he showed fairly regularly at the Graham Gallery, and then I think Crispo had a show following his death. In time his reputation will find the place it properly deserved.

MS: Romie, do I understand that Kootz had all his artists on commission, so that whatever you painted while you were on commission belonged to him?

RB: Well, accordingly. He worked with each artist on a different relationship. Some artists painted a lot, like Byron Browne; some artists were slower working, like Baziotes. I wasn't in that type of a deal with Kootz. I know Baziotes was, Holty, Byron Browne, perhaps Gottlieb.

MS: I was just wondering why at the auction you mentioned only Byron Browne and Holty.

RB: I don't know. I guess he saved the other work. I really can't speculate, except that maybe he was going off in another direction. You see, the whole abstract expressionist school hadn't solidified by that time—everything was still amorphous. And those words, like "abstract expression," hadn't come up yet. Maybe when Kootz reopened his place, he was moving in that direction. Hans Hofmann had come into Kootz's gallery at that time, and I think he wanted to go that way. And maybe a structuralist like Holty, and Fritz Glarner, were in another tradition. And Kootz was moving away from that.

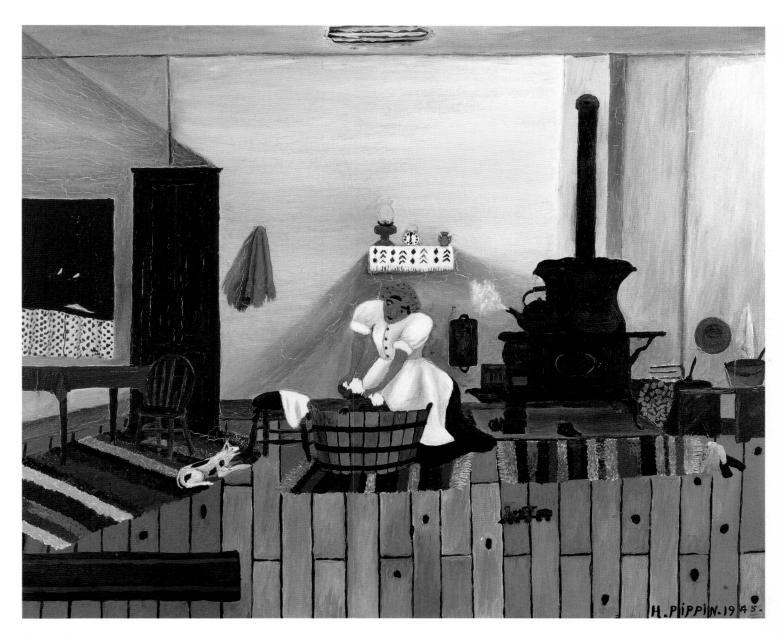

Horace Pippin. *Saturday Night
Bath.* 1945. Oil on canvas, 25½
x 30½". Collection Mr. and
Mrs. John Johnson. Courtesy of
Sid Deutsch Gallery

MS: What sorts of specific criticisms did Holty give you?

RB: He once pointed out in doing the [*Iliad*] drawings—in showing some of these to Stuart Davis—to make sure the spaces between the legs were varied, and the other parts of the drawing. Because it was done very quickly, and some I had to destroy. I tried to draw some that you saw, and it didn't seem to work well with me. You know, in stained-glass windows—the black leading around the colors. Holty didn't like that idea of just the black lines around things. He felt that if I changed some of the lines from black to, say, red and blue, the lines would then convey a color, rather than just a leading, a black line around them, as the interval between all the colors.

MS: Were you working with a brush?

RB: No, it was like a lettering pen, a speedball pen, but much larger. And Holty brought Joan Miró to see them, because he had given Miró his studio. Miró said these were the best drawings he'd seen by any artist in America.

Holty used to say, when I asked him, "Why do you like Uccello? Why do you like Giotto? Everything looks like a sack of potatoes." "Yes, but there are other things that compensate, the movement through the forms that animates it, for example." He felt that many of the American artists lacked the proper construction in their work, which is what made Picasso's and Matisse's paintings so solid. He didn't care for some of Braque's more figural works, because he thought they were too fragmented, but many of the still lifes he thought were very beautiful and in the great tradition of Chardin. He felt a student could learn most everything that he needed to know from the drawings of Rembrandt. He said, "These are the things that hold up and give unity to a work."

MS: That photo of Miró, you, and Holty.

RB: That was at Holty's studio. But Miró came to my studio. And we went around, the three of us, quite a bit, because after he'd finished working we'd take him out and show him around. We went to a football game, and then we went to a baseball game together.

MS: What was he like, Miró?

RB: He didn't speak any English. He spoke French and Spanish. And his English, when he tried, was funny—you know, "feetball." One day an avant-garde cinematographer, Franny Lee, came by Miró's studio. He asked Miró for some advice for a young painter. Holty had to translate this for me, because I hadn't been to Paris then, and hadn't studied French. The translation would be, "Work hard and say shit."

MS: Can you tell me about Stuart Davis—what he was like as a person?

RB: Stuart was another one that was very much interested in all of the arts and, like Baziotes, in baseball. Holty and I used to go with him to the Polo Grounds; mostly the Dodgers, the Giant games. . . .

MS: Did you go to the fights?

RB: Oh, he liked all that. He had gone when he was much younger to watch Jack Johnson spar, and things like this. He knew all that. He was very much that kind of a man, you know, interesting. He was interested in things American, that type of thing. And his art has that kind of a quality: the lettering, jazz.

He was quite a fine man. He had his own kind of way of looking at things. He had a hard time because all of his friends in the thirties were in the Artists' Union. And he was painting not in this kind of representational vein, or political art. So in that way, he was a maverick, and there were only a few friends of his who thought like he did.

He lived between 13th and 14th streets on Seventh Avenue. I think all that is gone now, the apartment that he had. But he had an apartment there, with a large living room, and a kitchen off of that, and in the front he had his studio. Had a record player, because he liked music, and a radio. And his wife—I liked her very much, Mrs. Davis. He would talk about so many things of interest. At that time he played a lot of Earl Hines—he loved his playing. When he lived in Newark as a young man, he would go to listen to all the old Negro piano players—around 1910, 1912, way back in those days.

I remember once, very early, I brought down some water-colors—I'd done them in ink. So he said, "Why don't you do them in water-colors, or gouache, or something that's better?" And I had done this [shows work] on these two watercolors. Whatever it was, I had the same over here, let's say a house or something, the same two things. Stuart used to say, "You've got to look at varying things. Say you have people walking—you have to consider these things as musical beats; you don't want to have just dot dot dot dot. . . . " This is one of the things he pointed out. He always had an idea, you see. . . . Most people differentiate color and form. But for Stuart, these things were one: color, form—all of them affecting each other. He would always say, "Color has a place, and it has a position." In listening to him I got a whole lot; Stuart would give good criticism of your work.

He had done small sketches, because I remember Holty and I were there [at his studio] once, and we talked about them. Once he said, "I have enough drawings for me to paint the rest of my life." He painted rather slowly. He used linseed oil and turpentine, the classic mixture of painting.

Holty told me once that he had brought Mondrian to meet Stuart, and he said that Mondrian, in talking to Stuart, said, "This country is so wonderful." Harry Holtzman had brought Mondrian to this country, I believe.

MS: Yes, after his London flat was bombed out.

RB: Mondrian said, "You know, I wish that I had been here all along. I'd have been so much further." And Stuart said, "Like hell you would!" Anyway, Stuart had a hard time. And during that period he was showing at the Downtown Gallery. I remember during the war, he hadn't had a show in a long time, and he had one there, and had some musicians come, and we went to a big dinner afterward.

MS: Can you remember the musicians who were his friends?

RB: His great friend among the musicians, one he had never met but liked more than anyone else, was Earl Hines. The one who *was* his friend, and who really adored Stuart, was the drummer George Wettling. And George, although I don't think he had art training, began to paint—these wall paintings. And they looked very much like Stuart's. I think some gallery had a show of

George's paintings. It would be interesting if they could find some now, and whatever happened to Wettling. [Davis] would frequently go to that place in the Village where Wettling would play, Eddie Condon's.

MS: And he named his son after Earl Hines?

RB: His son *is* named Earl—whether that is true or not, I don't know. It is interesting.

MS: So it was that whole group. Because George played with Eddie. . . . So they were sort of Dixielanders—Chicago style.

RB: Yes, Chicago style, Dixieland. This was in the forties. And then Louis [Armstrong], and that type. But Stuart had, God knows, hundreds of records, jazz records. Holty used to say, "Well, you know—Stuart is so American that he likes this kind of music." In some ways, Holty was more European-oriented; but Stuart wanted to be an American, and I look now at his [use of] color in things: you feel a much more American orientation. I think he is, in his best work, a Cubist, in that kind of a flat painting. But the color contrasts are very much like what you'd see on a signboard. Some of his titles—"Report from Rockport" and those kinds of things—are very American. Stuart was very witty and could write well; I have a book of some of his essays—very witty, some of his things on abstract art were very good.

At the end of his life he began to make money, he got commissions. He was a great colorist, you know. I think that he was kind of a precursor to all of the color field painting that was to come after; and the use of lettering, that a lot of the artists did afterward, I think was presaged by Stuart.

MS: Did you learn from him anything about color itself?

RB: Yes. Stuart had a marvelous analytical mind. He was able to compose out of the dynamics of color. The great colorists are the artists who have kept their works more open and less detailed. Let me explain. Take a work of Dürer, for example: it seems to be a work of marvelous drawing and composition. But it would have been possible to change the color on Dürer's *Madonna* with some little alterations. Ingres said, "Drawing is the probity of art, the truth of art." In some of Ingres's rather classical portraits, I can see something of the dynamics of Léger. But I would not say that Ingres was a great colorist, although he was a great painter. You see the difference in one of Delacroix's paintings, in his use of color as a binding force to the painting, rather than the linear quality of Ingres. I think with Matisse, and with Stuart, that color becomes that force, wedded—a dynamic which overwhelms and can completely control the painting. Color becomes form, space, direction, volume—all conceived first out of the coloration. It can't be changed.

MS: Was he sort of out of kilter with the prevailing movement from the late 1920s, until almost 1950, continuing in this way?

RB: He *was* out of kilter. Although some of the artists recognized him. I believe his father was a painter, and they knew that whole Philadelphia group, the so-called Ashcan School of painters. So it was in the teens that he would go to Newark—he was still interested in jazz way back then. He had a great friend—Glen Coleman, with his lithographs of people in the streets. A very interesting and good artist who should be more known now. He knew all these

Stained Glass Dimension. 1981.
From the *Profile/Part II: The
Thirties* series. Collage on
board, 14 × 18″. Collection
Phullis Luytens

people. But his work evolved more and more into an abstract or nonrepresentational style. His eggbeater series, and things of that nature. And many of Stuart's former associates didn't quite understand what he was doing, in that period. Even Holty, when he came back, found that there were not many people doing the kind of abstract painting or Cubism which he had been used to in Europe. America was still much into a romantic kind of realism.

Stuart, in that sense, was a groundbreaker. So he had developed a kind of good, hard protective shell around himself, and could fortify himself and take care of himself, in that way, in any confrontations with the [other] artists. His time did come, after James Johnson Sweeney became head of The Museum of Modern Art, and he had a big retrospective there. His work began to get more and more interest, and then skyrocketed.

MS: I remember in a letter either to Walter Quirt or to Carl, you mentioned that Stuart had just sold a painting on the easel for a thousand dollars, which was I guess incredible in those days. So he was by then coming into his own. But here's what I wanted to ask you: do you feel a sort of kinship with him, in this sense, that you both came out of Cubism and schooled yourselves very thoroughly? Carl certainly was a theoretician of Cubism; he knew how to analyze it very well, and articulate it. Do you feel that having schooled yourselves, you and Stuart, in this discipline, that you both made it a lifelong study, a life work?

RB: No question.

MS: And that it doesn't matter what style you go through, you remain a Cubist?

RB: Yes. I was once on a symposium or a radio panel, something like that, with Louise Nevelson. Somebody asked, "What is your style?" She said,

"Cubism." That's very interesting! But I think yes. Because I believe that color, in a certain sense, can vitiate itself by illusionism. That it should be up front. When you get into a whole lot of nuances, like you see in some of them, it doesn't have the force of color that's right up here. Like you see in a Stuart Davis—all the color up there is clear. And look at Picasso. I remember once I was visiting with Stuart (sometime around 1948–49), and there had been a show of Bonnard at The Museum of Modern Art. And I said, "Gee, I think he's a good painter, Stuart." He said, "Yes. He is deficient, however, in form." And Holty thought that too. He thought his color was very interesting, but his form wasn't very strong—it became diffuse. But he recognized that he was a very good painter. Stuart liked Léger very much, among the modern painters. Mondrian liked Léger, according to Holty. I remember I gave Stuart a book once of old mosaics from the third or fourth century—Ravenna. He liked that; he said, "The color is all right up there." I think he didn't go too much for, say, the Renaissance, or that kind of painting. Holty could, because he would see the great composition in some of them, say the early ones like Uccello, Giotto, Piero della Francesca. But when they'd get into Rubens, and the rest—Holty could understand that, because he felt that the best of the Renaissance paint-ers, at that period, the high, full Renaissance, who had to deal with perspec-tive and illusionism, the full painting of all the light and shade of the figure, had to compensate for it by making errors in the perspective and these other things. For instance, there's a famous painting of Tintoretto, the finding of the body at St. Martin's. There are tombs, or something at the side, and there are figures going across. But Holty says, "See, this goes back, and then something happens up here, so that you have an hourglass effect. Instead of going right into the depth here, he did have the knowledge to make it like this, so you don't get too much of the illusion of recession." Because both of these men felt that these deep thrusts cut holes in the canvas. They mention this all the time.

Stuart had also mentioned something about the importance of Toulouse-Lautrec: that before Lautrec, you see, you had a poster—you read it on the kiosk—you got up to it to see who was at the *Folies,* and so forth. But then *speed* dictated a lot of art—speed in the sense that you're on a train ride. And even in Toulouse-Lautrec's day, it was fifty or sixty miles an hour. So he had the figure and just—"Moulin Rouge"! But you know, you saw the dancing figure, and—"Moulin Rouge." So you see, he was leaving out things, because obviously you couldn't, flying by on a train, read the things that were before.

MS: Right.

RB: So a lot of the painting here is determined on speed. You feel a different kind of movement, in that sense, than the European Cubists.

MS: You mean, from the point of view of rhythm . . .

RB: Yeah, like a jazz rhythm. Speed and all of this. You'd feel that in Davis's paintings . . . the beginning of that type of thing, of leaving things out. Getting right to the essence of what you express in color.

MS: Did Stuart ever see that in Earl Hines?

RB: What he saw in Earl Hines was intervals.

MS: Well, that, in a way, is what you leave out. The interval is what you're

leaving out, if you look at it.

RB: Well, yes, the interval is what you're leaving out. But what you leave out, you see. . . . This is interesting, these intervals, because they reinforce the more solid forms and objects. But by doing this—it is the *spacing* of what you leave out that makes what is *in* there. Do you understand what I mean?

[A good illustration is] the Greek vase. Usually the figures are completely black. (I don't mean in the sense of that relating to black life.) You see particularly in Greek vase paintings that the spaces between these Attic figures are counted even more than the figures themselves, as the main thing. It is one of the few art forms in which not just the figures, but I want to say the design or components, seem to be torn apart. Not that they're not integrated, but there's something torn apart about them. And what holds it together is that the spacing between all the various elements seems to be more important than the figures or objects themselves. It is that which gives the figural elements measure.

MS: You've also mentioned Carl Heidendreich. Let me ask you about him.

RB: Carl Heidendreich, and Carl Holty, and Vytlacil all studied in Germany with Hans Hofmann. Heidendreich's people, although they came from working people in this town—and they had a bakery, so he worked—had some money. And I think when the Spanish war broke out, Carl went and joined the anarchists, around Barcelona. And then after the war, he got to Paris, where he met Hannah Arendt, and her husband, Heinrich Blucher, and a number of the other refugees. And he finally got to America.

And of course they had nothing, and he had hard times. He worked as a paint sprayer, and all of these things, to make a living. He taught me a great deal, and had great instincts about painting, and I thought he was one of the greatest watercolorists of all time. He showed me a lot about painting. I was with him about every week.

I think that if both Holty and Heidendreich had gone to Germany a little earlier—they were very excellent painters—I think that they would have had more recognition than they do now, because Germany wanted to honor her painters who had been neglected for political reasons during this whole fascist regime.

MS: What would he show you about painting?

RB: Well, in another kind of way than Carl [Holty]—it wasn't so much in structure, it was kind of *feeling*—he *felt* his way through a painting. You know, Delacroix said, "Feelings can work wonders." And he approached looking at a painting from an entirely different way than Holty. They were very close, good friends. But his analysis of a painting was entirely different from Carl's very structural and Mondrianesque kind of way. But Carl Heidendreich was more of a feeling, you know? He could get you moving.

MS: More like Baziotes?

RB: In a way, and then in a way no. But both of them were of the same kind of heart. So Holty, Davis, Heidendreich, in another kind of way, were all very helpful in the forties and fifties. All very helpful. You couldn't have better people.

RITES OF SPRING · THE 1940S

How I admire Baziotes his feeling for the beautiful. The nightingale of Keats flies to his shoulder. But I have to hunt this ephemeral bird in such devious ways, through the light, the dark, on plains and crags, and with every contrivance. I've never even glimpsed her as yet, only heard on occasion the melody of her song. I know I must pursue her through the dark roads of Goya, Greco, and Dante. If I find her I shall crush her to death for causing me such torment and because she has my heart.

—Romare Bearden[1]

PART I: THE EMPTY CANVAS

Ad Bates proved to be a pivotal figure in Bearden's life. Not only was he instrumental in broadening Bearden's circle of friends among Village artists, but he also gave Bearden his first solo exhibition at the "306" studios in the spring of 1940. The exhibit, which remained installed for the week of May 4–11, consisted largely of student work in oil, gouache, watercolor, and ink-on-paper that Bearden had done from 1937 to 1940. It was the first and only of her son's shows that Bessye Bearden lived to see.

In an "Artist's Statement" that Arthur Steig (brother of William Steig, the illustrator) helped him to draft for the exhibit, Bearden did not so much describe the kind of art he had done up to that point as write about what he now felt ready to do: "I believe that art is an expression of what people feel and want . . . that this fact, plus horse-sense, resolves all questions as to the place of 'propaganda,' the role of the artist in society, the subject matter of painting, the good or bad health of any particular work."[2]

In the same year, while continuing to live with his parents, Bearden took his first studio at 33 West 125th Street. "I ran into Jacob Lawrence on the street one day. He said he had a studio and there was one vacant above him. So I went and got this studio, my first studio. It was eight dollars a month including the electricity," Bearden recalled. In addition to Lawrence, Bearden's neighbors included the writers Claude McKay and Bill Attaway.

The studio was ideally located, only a block and a half away from those of Norman Lewis and Morgan and Marvin Smith. But the conditions in Bearden's studio became unbearable during the winter. "At first I had steam heat, but later the landlord sold all the radiators for scrap iron," he recalled.

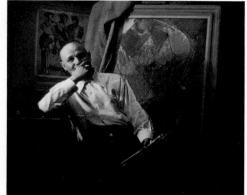

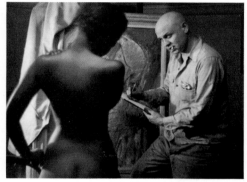

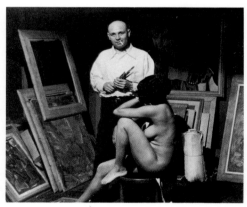

Bearden in studio with paintings
and model, c. 1948.
Photographs by Sam Shaw

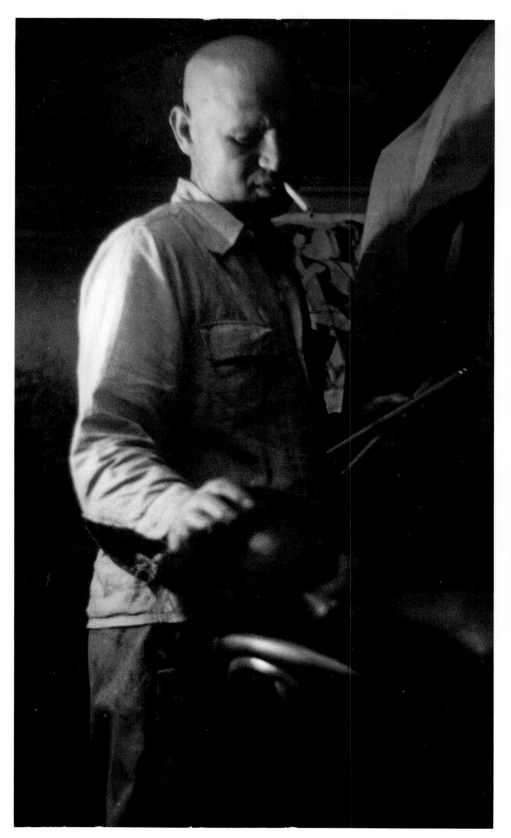

"In those days before the war Japan was buying all the metal they could get. We had to heat with kerosene stoves after that."[3] So there he was, with a stiff neck, colds hitting him in the muscles and joints, trying to paint.

His mother, concerned for his health, went to see Morgan Smith, who had moved with his brother Marvin to the Apollo building in 1940, and asked Morgan to speak to the owner's agent, "and I got a studio at about fifteen dollars a month" in 1941. Although he no longer had Jake Lawrence painting a floor away, the Apollo building at 243 West 125th Street was also a community of artists; not painters and writers, but musicians, composers, and photographers. Morgan and Marvin Smith, who specialized in portraiture and later made historically important documentary records of Harlem in both still photography and film, had a studio running the entire length of the second floor and living quarters on the third floor. Bearden's studio was at the front, looking out on 125th Street, near a music teacher's studio, rehearsal room, and the Smiths' apartments.[4] The new studio was better for his work: Romare had never been bothered by music; as a matter of fact, when he didn't have the strains of live jazz floating in the air in later years, as he did at the Apollo, he turned on an all-jazz radio station. And the new studio had heat.

Bearden remembered this flowering of his art in the early 1940s four decades afterward in a 1980 collage entitled *Artist With Painting & Model*. Beneath the collage in the catalogue, and written on its back in the form of a brief narrative, is the memory: "Every Friday Licia used to come to my studio to model for me upstairs above the Apollo Theater." In the self-portrait, Bearden stands with one arm resting on an easel which holds his 1941 gouache on brown paper, *The Visitation*. At the other side of the easel stands a model, her back to the viewer; on the floor just beneath the easel, there is a drawing, presumably of the same model. In fact, the collage is Bearden's imaginative re-creation of a photograph taken by Sam Shaw, who painted with Romare from the model each week. Bearden and Shaw used two models, one of whom would cook spaghetti for them after she posed.

Bearden's choice of *The Visitation* as the work on the easel is exactly appropriate to his memory of how he found his way when he turned to painting, for *The Visitation* is all about flowering. Before that happened, however, Bearden had no idea of what to paint.

One might entitle this anecdote "The Empty Canvas." It is a story Bearden told time and again in the 1980s.

When Bearden set up his first studio, the brown paper he set up on his easel refused to yield any images; it stared blankly back at him for weeks at a time, as empty as his imagination. One evening in 1940, coming down the stairs with his neighbor Claude McKay, Bearden heard the sound of keys jangling. It was a prostitute, as short and homely a woman as Bearden had ever seen.

She said, "Two dollars, boys." Then she said, "A dollar?" Then "Fifty cents?" Then, "A quarter?" Finally, she said, "For God's sake, just take me." She was pathetic. I told my mother about her, said she was in the wrong business, and my

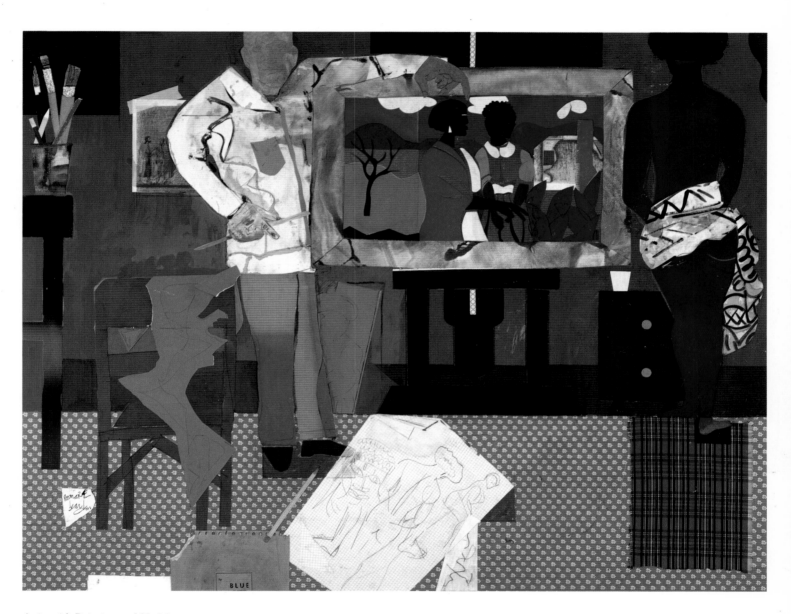

Artist with Painting and Model.
1981. From the *Profile/Part II:
The Thirties* series. Collage on
board, 44 x 56″. Private
collection

mother got a job for this woman—Ida. After that, Ida came every Saturday to clean my studio. And in the studio was my easel, with the piece of brown paper on it. When you're young, you have a lot of ideas and a lot of dreams, but you don't have the ability to realize them; I think that as you mature you don't have the same kind of ideas and dreams, because you let the work make its own fantasy. Anyway, Ida would come once a week to clean, and the brown paper was there on the easel, and one day she asked if it was the same piece of paper, and I told her that it was—that I didn't have my ideas together. She said, "Why don't you paint me?" Well, the way I must have looked at her she could see what was going through my mind. "I know what I look like," she said. "But when you look and can find what's beautiful in me, then you're going to be able to do something on that paper of yours." That always sort of stuck with me, what she said.[5]

When, in the late 1940s, Bearden set about relearning the entire tradition in painting from the Renaissance forward, he concentrated on Rembrandt's drawings. He was especially fond of a particular anecdote he had read about Rembrandt—that he would walk into the street, find the homeliest beggar dressed in rags, and invite him to his studio. "Come with me," Rembrandt would tell the beggar. "I will make you a king!" And so, in Bearden's retelling, the master did. He dressed the beggar in king's robes and created a masterpiece. But if you looked at the face carefully, you could see the lines produced by a life of suffering and hardship. Beggar and king coexisted in the same face.

The Ida story was Bearden's way of reinventing Rembrandt in 1940s' Harlem. The interiors of the little Dutch masters, Vermeer, De Hooch, Ter Borch—*Two Women in a Harlem Courtyard*; *Susannah at the Bath*—endless variations on an odyssey from his childhood in Mecklenburg County to his boyhood and youth in Pittsburgh, to his young manhood in the Harlem surrounding him. Ritual would prevail.

It was the beginning of a lifelong love affair in paint with the infinite sensuous variety of the black female form. Ida would undress, perhaps slowly, even modestly, reveal her body, and pose for him. If Bearden could capture her beauty, it would make *him* a painter-king.

And so the brown paper on Bearden's easel came to yield to Bearden's imagination. Then he began to know *how* to know what to paint.

The last element in the memory for Bearden is the advice his friend Bill Attaway gave him. "Why don't you draw—you know, just let yourself go and draw some of the things that you know about?" Bearden then began to do what he described as his "Southern themes, the people that I'd seen as a young boy when I'd sometimes visit in North Carolina where I was born. I did these on brown paper in a gouache tempera medium."[6] He completed about twenty of these paintings, including *The Visitation* and *Three Folk Musicians*.

The Visitation is a composition in earthen tones—browns, reds, and greens—depicting two black women. Their faces are massive, suggesting the Mexican muralists. The woman on the left is set against a background of bare, black trees, rock, and hills, whereas alongside the woman on

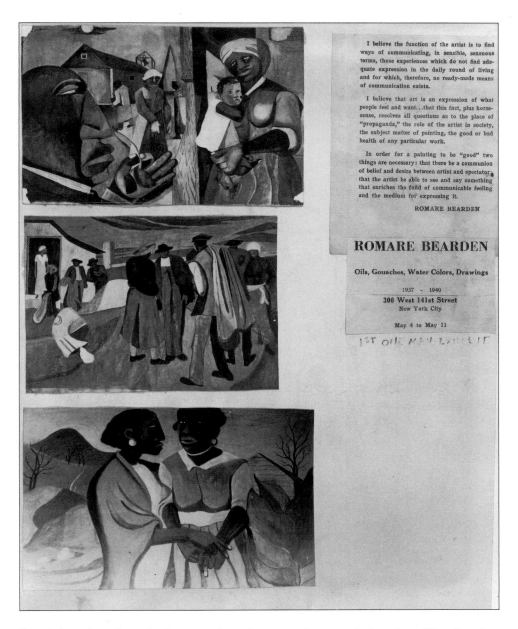

I believe the function of the artist is to find ways of communicating, in sensible, sensuous terms, those experiences which do not find adequate expression in the daily round of living and for which, therefore, no ready-made means of communication exists.

I believe that art is an expression of what people feel and want...that this fact, plus horse-sense, resolves all questions as to the place of "propaganda," the role of the artist in society, the subject matter of painting, the good or bad health of any particular work.

In order for a painting to be "good" two things are necessary: that there be a communion of belief and desire between artist and spectator, that the artist be able to see and say something that enriches the fund of communicable feeling and the medium for expressing it.

ROMARE BEARDEN

ROMARE BEARDEN

Oils, Gouaches, Water Colors, Drawings

1937 - 1940

306 West 141st Street
New York City

May 4 to May 11

1ST ONE MAN EXHIBIT

Page from Bearden's scrapbook with photographs of *Rite of Spring*, *Cotton Workers*, and *The Visitation* (all c. 1941–42). At the right, statement for first one-artist show at 306 West 141 Street, New York. Romare Bearden Papers, Archives of American Art, The Smithsonian Institution, Washington, D.C. (Roll N68–87)

the right, the gigantic leaves of a plant reach toward the sky. Clearly, the visitation suggests that she will flower.

Bearden's work of these years amounted to an agenda to which he would return over twenty years later, in relation both to subject matter and to his handling of the paper. Bearden saved black-and-white photographs of three works of the early 1940s, including *The Visitation*, and pasted them in his scrapbook alongside the announcement for his first solo show. Juxtaposed with it on the page, they are a visualization of the flowering of his art. These works vary greatly in subject and style. One, *The Rite of Spring*, possibly a gouache with ink, involves subject matter suitable for an ironic, Social Realist style. It depicts a factory with work-bell ringing in the background, while in the foreground, a black factory manager (his shirt-cuffs and

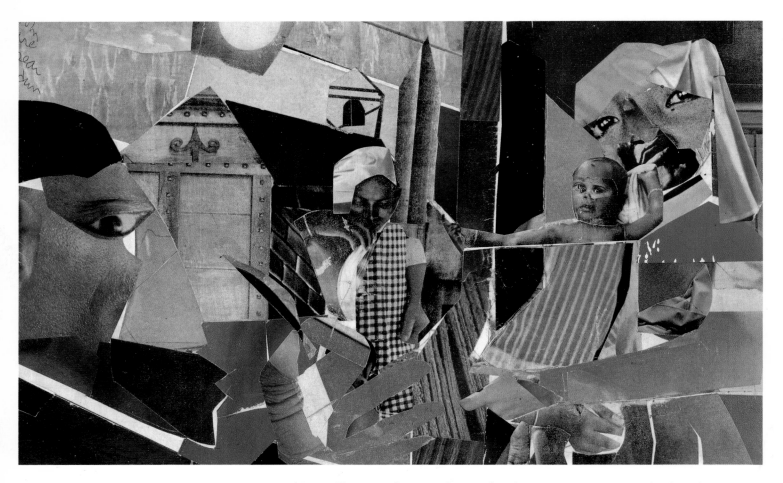

La Primavera. 1967. Collage of paper and synthetic polymer paint on composition board, 8⅜ x 13⅛″. Courtesy Sheldon Ross Gallery, Birmingham, Mich.

Opposite, above: *Three Folk Musicians*. 1967. Collage on canvas on board, 50 x 60″. Courtesy Sheldon Ross Gallery, Birmingham, Mich.

white collar are clear evidence that he is no common worker) with massive face, narrow eye-slit, and massive hand holds out a termination slip to a black mother who holds a forlorn-looking child in her arms. Their eyes tell the entire tale. (Bearden used this image again, more than twenty-five years later, in a collage entitled *La Primavera*. That work is completely different in treatment and feeling: the building is no longer necessarily a factory, the woman holding her baby suggests a madonna and child, and the face of the man is built out of parts of photographs, dislocated and rearranged to form a mask.)

The second photo is of a gouache entitled *Cotton Workers*, which Bearden may have painted as early as 1941, but which he exhibited at a one-artist show in 1944. It depicts a rural scene whose overall rhythms are strongly suggestive of the work of the Mexican muralists. Beneath these two photos is that of *The Visitation*.

Bearden's mature collage technique first allowed the ground to predominate, giving a unifying effect to the picture. As he made clear in conversation, he would begin a work by painting broad areas of color on a fine, acid-treated Arches paper which had been glued to the masonite board. Only then would he weave in in other colors. But Bearden's awareness of the importance of letting the ground play through in his painting began with his use of brown paper in 1940.

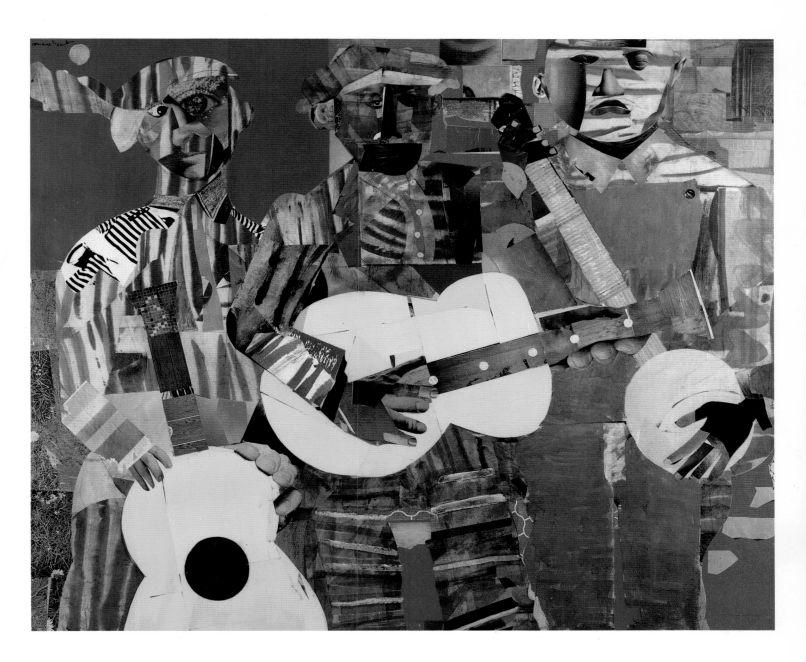

Far left: Model in front of *Folk Musicians* (1941–42), 1948. Photograph by Sam Shaw

Left: Drawing based on 1967 collage *Three Folk Musicians*. 1985. Pen on paper. Collection the author

His *Folk Musicians* of 1941–42 is in striking contrast to a 1967 collage called *Three Folk Musicians*. The more recent work has the same configuration, but illustrates dramatically how much Bearden matured in his handling of color, form, and volume. The earlier gouache is rendered realistically in subdued colors, although the hands, especially those of the guitar player, are monumentally large; the triangulated noses of the two left figures are outsize; and the interplay of caps, noses, and faces is a study in diagonal and curvilinear forces. Furthermore, although the eyes of the three men stare fixedly at the viewer, those of the figure at the right seem hooded and mysterious. In the 1967 version, pieces of photographs have been mixed with cut paper and paint to create an entirely different interplay. Like its 1941 counterpart, the figure at the right—now a banjo player whose facial contours resemble Bearden's—is made ghostly and mysterious by the pervasive grays of the torso, the streaks of blue and white through the face, and finally the eyes, which convey the unblinking stare of stone statuary. The white disk of his banjo is a ghostly echo of the red disk of the sun, and is also set off by the warm colors of the two guitars.

Bearden's work of the early 1940s was exhibited twice in 1941. At the McMillen Building, Bearden's *The Visitation* and *Woman Picking Cotton* (c. 1940–41) were included in an exhibition entitled "Contemporary Negro Art," which ran from October 16 to November 7, 1941. Then, at The Downtown Gallery, 43 East 51st Street, Bearden's *The Bridge* (gouache; 1937) and *After Church* (tempera; 1941) were shown as part of a major exhibition of American Negro Art of the nineteenth and twentieth centuries. It was an exhibition whose explicit purposes were to educate the "downtown" art audience "by demonstrating to the public the valuable contribution made by American Negro artists," and to begin a special "Negro Art Fund for the purchase of paintings, sculpture, and graphics by contemporary Negro artists, such works to be presented to museums and other public institutions."[7] It was an auspicious moment, but its timing was disastrous. The date of opening was December 9, 1941, two days after the bombing of Pearl Harbor and the day after the United States declared war on Japan. The news was not conducive to the contemplation of art.

Bearden himself felt unsettled by the critical assumptions underlying such exhibits of Negro art, and wrote his friend Walter Quirt, in a letter dated January 20, 1942, that "the criticism and comments on these last two shows indicate how necessary is a fulsome interpretation of the Negro artist's place in American cultural life." He cited a talk by Alain Locke the previous week on his new book, *The Negro in Art*, as well as comments by James Johnson Sweeney that "indicated in so many words that the Negro painter should direct his efforts largely from the standpoint of the heritage left him from his African ancestors. Naturally to try and carry on in America where African sculpture left off," Bearden wrote Quirt, "would be to start on a false basis—the gap of the years, the environment, and ideology is too great." He expressed his intent to treat these points in an article and to discuss them with Quirt beforehand. The article, "The Negro Artist's Dilemma," appeared four

years later. It stated Bearden's thesis as forthrightly as he had outlined it to Quirt but did not name either Locke or Sweeney as the standard-bearers of the ideological positions Bearden took to task.

Bearden felt even more frustrated by his struggle to express himself honestly in his art and the divergent opinions passed about it, some of which cut him to the quick. The prospect of success quite likely made Bearden as apprehensive as that of failure, for he had begun to gain insight into the merchandising of art. The balance of his letter is worth quoting at length:

I am still working quite hard on my painting and gradually I think I am arriving at some sort of personal adjustment to the things I want to say. I have tried to strengthen the pictures in a sense of a better all-over organic design and a more varied and richer use of color. I don't always express on the paper what I want, but at least I have these ideas in my mind. But I face rather a peculiar problem. I still have faith in myself and my work, and have always believed that the artist shouldn't isolate himself from the public. The press was often enthusiastic about the work—but I realize that doesn't really mean much—for I am interested in much more than having a popular success. But I have had so many divergent opinions passed about my work.

One painter wrote from the South that my stuff was forced and deliberately painted to cater to what the critics think a Negro should paint like. To many of my own people, I learn, my work was very disgusting and morbid— and portrayed a type of Negro that they were trying to get away from. One man bought a painting and brought it back in three days because his wife couldn't stand to have it in the house.

So I ask myself, is what I'm doing good or bad, are my paintings an honest and valid statement. Have you ever felt like this? Recently, I've gotten so I want to paint and then put the paintings away, except to show them to a few people. With the past two shows I've gotten some insight into what goes on behind the scenes in these art galleries. I've seen how art is only regarded as merchandise. The bad thing is that a lot of these persons who run galleries and deal in art have some taste, but will ruthlessly shun aside stuff they know is good to gain a commercial end.

I guess to be anything of a painter you need to have the hide of an elephant. There is a lot more to it than just putting the paint on canvas.[8]

Within three months of his letter to Quirt, Bearden enlisted and began service in the U.S. Army, 1st Headquarters, 15th Regiment, the (all-black) 372nd Infantry Division. The 15th Regiment, from New York City, had a proud history as a much-decorated fighting unit with the French in World War I and had been known cumulatively as the "Red Hand" Division. His entire tour of duty was spent in the United States, in a way that allowed him to be quite near his studio during his first year of service.

On February 10, 1942, two months prior to Bearden's service, the French liner *Normandie* was gutted by fire and capsized at its pier in New York harbor. Sabotage was suspected, and as a result, Bearden's regiment was reassigned from Fort Dix, New Jersey, to a headquarters in Harlem,

and, for a time, guarded the New York City subways against the possibility of acts of sabotage. So from time to time, Bearden was able to get over to the studio in 1942 and early 1943.

Bearden was stationed in Fort Dix, then Fort Breckinridge, Kentucky, then Fort Huachuca, Arizona. For a time, he was enlisted at Officers' Candidate School (OCS) at Camp Davis, North Carolina; then he was transferred to Pine Camp; Point Barrow, Alaska; and finally to Camp Edwards, Massachusetts. He was discharged shortly before the end of the war as a sergeant in a cannon company in May 1945.

In general, the segregation of the armed forces of the United States during World War II was felt much more keenly Stateside than on the fighting front. Once the enemy was engaged in battle, there was a much greater sense of democracy and mutual respect, or at the very least the commonality of mutual danger. But the experience of two comrades in uniform, one black and one white, refused service at a luncheonette somewhere outside their training camp in the South, for example, was a vicious and bitter lesson. Moreover, distorted racial attitudes prevailed even on the bases, particularly in the South, although OCS was at least in theory completely democratic.

A further irony lay in the welcoming of black artists by their peers in the downtown art scene during the war years, and certainly after the war. In 1942, Jacob Lawrence became a member of Edith Halpert's Downtown Gallery. By 1944, Bearden would show at Caresse Crosby's G Place Gallery in Washington, D.C., and by 1945, would become a member of the Samuel Kootz gallery. Norman Lewis would begin showing regularly at the Mirian Willard gallery in 1946.[9] Each of them was torn apart in his own way by his experiences during the war. (Lawrence was drafted in 1943 into the U.S. Coast Guard as a steward's mate, a common assignment for blacks in the navy, and was stationed in St. Augustine, Florida, after basic training. He serviced the dining and living quarters of the officers at the Hotel Ponce de Leon, where "the steward's mates were stuck way up in the attic."[10] Lewis, denied employment as a camouflage artist in 1941, worked as a shipfitter at Kaiser Shipyard, Vancouver, Canada, but returned to New York because of the racial discrimination he felt there.[11])

The dichotomy Bearden felt between his identity as a painter and his identity as a candidate in OCS is clear from the top of a letter he sent to Quirt during the war. The left-hand side reads, "Romare Bearden (artist)"; the right-hand side reads, "Battery 17, OCS (AA)." More and more, Bearden wrote Quirt, he felt the desire to paint. "The rest at first was good and I was making adjustments to a new life but now it's just drudgery." Moreover, he told his friend, the captain's reports had said that "my past background as an artist hardly fitted me for an officer in this field." Bearden therefore supposed that he would be back home soon. "Of course that isn't half the story, but I'll tell you my experiences when I get back."

The other half of the story was a funny and ironic commentary on conditions at Officers' Candidate School in North Carolina, a commentary no black soldier with a healthy instinct for self-preservation would have

included in mail routinely subjected to scrutiny and censorship.

Although there were three barracks at the camp, Bearden and another black candidate, Julian Pope, were housed at an all-black quartermasters' barracks several miles away. This put them temporarily in a culinary no-man's land. Until they were placed on the food roster where they slept, they couldn't eat with the quartermasters, and since they were black, they were not permitted to eat with the white officer candidates. Their first meal of the day was lunch at the PX.

Training was divided into segments of several weeks each at different sites. During the first segment, Romare and Julian attended classes from nine to five (with the usual segregated lunch break) five days a week and three hours on Saturday. It was the equivalent of a college semester of algebra, geometry, and trigonometry, which, of course, Bearden had already taken as a mathematics major at NYU. Next they were moved to a larger site some distance away. Now the tables were quite literally turned. "Pope and I had a whole barracks to ourselves and a whole table with the same amount of food as a table for sixteen." The white officer candidates would rib them about how they could possibly put all that food away.

War. c. 1948. Lithograph, 28 x 32″. Barnett-Aden Collection of African-American Art, Florida Endowment Fund for Higher Education

The anti-aircraft practice, firing at airplanes trailing parachutes or balloons, was more interesting, but there was no relief in it. Wilmington and the Carolina seacoast were nearby, but as Bearden recalled, "You didn't even bother with a pass. When you came in from all that, you were pretty tired." Besides, there was nowhere much to go and little to do for two black GIs sporting OCS patches on their uniforms in the South of that time.

In a letter to his mother written one Saturday at the end of November 1942, Romare explained the rigors of life at Camp Davis:

I believe I told you before that the 372nd was like a vacation or picnic compared to this place. Life here is honestly hard—you have to be a soldier every minute of the day. This time I will write you a little longer letter as it is Saturday and I've finished inspection, and am comparatively free until 7 o'clock Sunday.

Today we had a tough going over. We were inspected in Ranks and in the Barracks. When I say inspection, I mean they start at your shoes and end at the top of your head, looking at your pants, your coat, how your equipment is polished, see if you have a haircut, ears clean, etc. Then they see how you stand, and may ask you what they mean by discipline....

Before we had inspection in the field, our barracks were inspected. This is done every morning. Only three boys in our whole platoon passed O.K. (I was not one of them). So those boys were given the week-end off. We (those left) have to scrub floors, practise making beds, folding sheets and blankets, and polishing equipment. So you see we have little time off. I don't know when I'll get to Wilmington.[12]

The week's study had included location of aircraft by searchlight and sonar beam, electricity, motors, radios, telephone, and laying in of wire. Bearden found the work more technical than any other branch of the armed services except for certain parts of the Air Corps. After eight weeks of this (half the required course), Bearden went to see Lieutenant Colonel Barrow of the 372nd, who he knew would be sympathetic to his request not to return to Officers' Candidate School.

Romare saw his mother for the last time less than a year later when he visited her in Harlem Hospital. Her gallbladder had been operated on by Dr. Maynard, and she was in an oxygen tent. Bessye couldn't talk to her son but gave him a big "V" sign when he left. When a telephone call came for him from his Aunt Clara on September 16, 1943, Romare knew what the news would be. Bessye Bearden had died of pneumonia and other postoperative complications. She was fifty-four and had been married to Howard for thirty-three years (Romare had turned thirty-two two weeks before Bessye's death). Bearden was always reticent about discussing the impact of his mother's untimely death on him, but it was obvious that he felt it keenly. Romare was very much his mother's only child and experienced all the privileges and turmoils that accompany an extraordinary woman's dreams.

Howard Bearden took his wife's death hard. He eventually left his job with the city of New York. By mid-1945, when Bearden neared the time of his discharge from the army and his return home, his father was in

danger of a collapse serious enough to make a period of convalescence in a sanitorium seem imminent. He had always been an easygoing man, fond of music and fond of a good drink, who lived very much in the shadow of Bessye Bearden's outgoing personality and formidable achievements. After her death, he became a shadow of himself and, as Bearden remembered it, went to pieces, simply existing. Ironically, in the ensuing years father and son came to communicate with one another more fully than they had during Bessye's life. After some time, Howard's condition improved, but he was never quite the same man he had been. At show after show, Romare's friend Harry Henderson remembers Howard saying proudly, but sadly, "If Bessye could only be here to see this." He died seventeen years after his wife, in September 1960.

Bearden and Caresse Crosby, posed before *Serenade* (1941; Gouache and casein on kraft paper, 32 x 46¾"). Romare Bearden Papers, Archives of American Art, The Smithsonian Institution, Washington, D.C. (Roll N68–87)

PART 2: PRODIGAL SON

By landscape reminded once of his mother's figure
The mountain heights he remembers got bigger and bigger.
 —*W. H. Auden, "Adolescence"*

Bearden had been able to keep his studio throughout the war years; the rent was very low, and a friend kept it up for him. During a leave, in late 1943 or very early 1944, he was visited there by the painter William H. Johnson and Caresse Crosby. Caresse was the widow of Harry Crosby; together they had been copublishers of the Black Sun Press in Paris during the 1920s, and she had recently opened a gallery in Washington, D.C. She decided that she wanted to do a show of Bearden's work, and thus, from February 13 to March 3, 1944, exhibited "Ten Hierographic Paintings by Sergeant Romare Bearden"

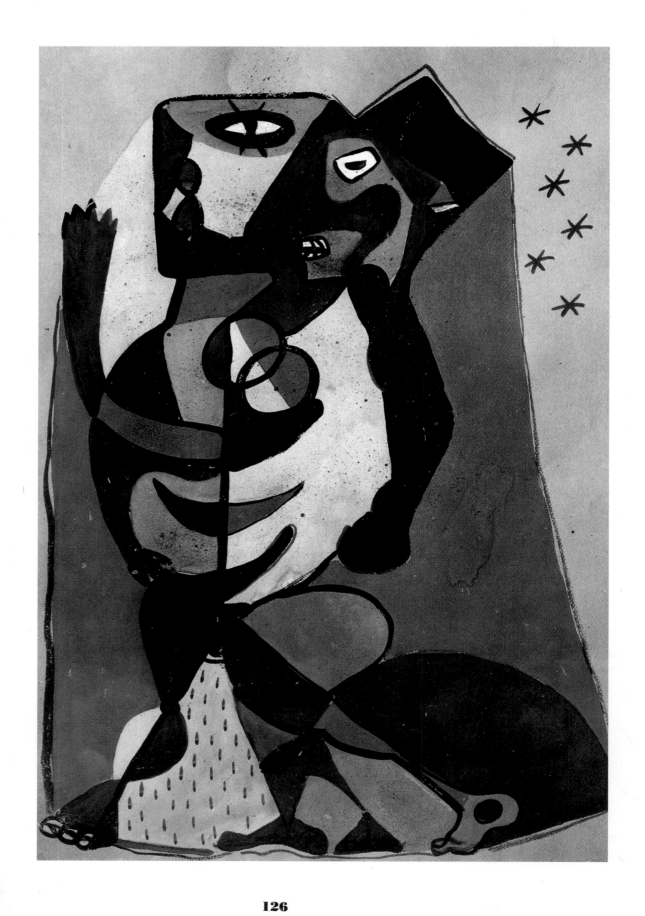

at her G Place Gallery in Washington. This was almost entirely the product of the 1940–41 tempera on brown paper period, with at least one notable exception, *Lovers*, a composition molding man and woman within a single outline with overtones of Picasso, surrounded by simple stars suggestive of Matisse.

In May 1944, Bearden's *Lovers* was included in a show entitled "New Names in American Art," organized by Caresse Crosby and David Porter. *Lovers* was singled out in a review in the *Baltimore Sun* as work "in which a singular intensity is achieved by admirable patterning and the harmony of low-ranged colors."[13] The exhibition, devoted entirely to the work of contemporary Negro artists, then moved to the G Place Gallery in June.

In January 1945, an exhibition entitled "The Negro Artist Comes of Age," representing the work of thirty-one artists, was held at the Albany Institute of History and Art in New York. One of the three Bearden works in the exhibition, *Factory Workers*, a gouache on brown paper, was typical of his best work of the early 1940s. The exhibition was a veritable "Who's Who of Afro-American Painting and Sculpture," from established painters such as Aaron Douglas, Horace Pippin, William H. Johnson, and Hale Woodruff to members of the new generation, many of whom, like Bearden, had been part of the "306" group: Charles Alston, William Artis, Henry Bannarn, Elizabeth Catlett, Ernest Crichlow, Jacob Lawrence, Norman Lewis, and Charles White. Alain Locke wrote a foreword called "Up Till Now."

The title of the Albany exhibition, "The Negro Artist Comes of Age," could, with a slight change of wording, have been as true of all American art in the pivotal postwar era from 1945 to 1951. American art was itself coming of age.

In June 1945, a month after Bearden's discharge from the army, he was given a one-artist exhibition at the G Place Gallery entitled "The Passion of Christ." The work marked the beginning of a new phase of Bearden's resolution of problems of composition, color, and theme in his art. It was also the first of four important series, all inspired by literary themes, which were to be exhibited in the midst of the downtown New York art scene in the mid- to late 1940s.

Bearden wrote Quirt excitedly to tell him that he was now out of the army, was back painting again, and had shown at the G Place Gallery that past Sunday. His father was now much better, he reported. Their mutual friend, Stuart Davis, was at a peak of success: "He just sold a new painting on the easel for $1,500 the other day." Otherwise, Bearden found the New York art world pretty much the same.

In readjusting to civilian life, Bearden found himself sticking pretty much to the studio, because, as he wrote Quirt, "I find that I've begun to alienate people, something I never did before." The reason was simple: he had no time or patience for phoniness. When he felt dishonesty around him, "I have to say so, no matter what—painting, pretty women, etc. That's why I say I'm staying close to my work."

As for his study of space in his painting, he told Quirt that he had been trying to learn the design of pictures by studying Byzantine painting

Lovers. c. 1940–43.
Dimensions and whereabouts unknown

and the Italian primitives. "I honestly believe the new stuff is better than anything before. I've studied *space* rather hard, so that the paintings are more unified now—and the fantasy is held together." Bearden's new sense of space was connected with a new sense of time in a picture. "I finally think I'm beginning to understand what makes a picture move—what *time sense* in a picture means—leading *plane by plane*—step by step in a series of counter-points—rather than a focusing to give an immediate reaction."

Bearden went on to note the improvement of his use of color. "My color is now *high* and with primaries and direct combinations of these—rather than grays and modulations—So, while the work is hard, painting has an element of fun for me now."[14] In another letter of July 1945, Bearden reiterated to Quirt his feeling that "Most all of our American boys focus their paintings in some way or the other," to give some immediate reaction, whereas he was trying to tie the elements together in a way that would lead the eye from section to section, "taking the time say as music does—a composition extended in time." To this end, he was studying Poussin, Byzantine mosaics, and other parts of the tradition in what he believed was a good sense, "not to seek surface elements but essences."[15]

It was not only from classical traditions that Bearden learned. The outbreak of war in Europe had prompted a new wave of emigrés, including, most importantly, Piet Mondrian. The Surrealists began arriving in America by 1939 with Roberto Matta, followed by Salvador Dalí, Max Ernst, Kurt Seligmann, André Masson, and Yves Tanguy, as well as the poet-theoretician of Surrealism, André Breton.

Bearden found it "interesting that a good number of those making this new experience in art were first-generation Americans or were born in Europe." He remembered it as a time of questing and searching, of a shifting from Cubism and of emphasis on a more free abstraction. "They were searching for something in the Modern tradition, but that would have something to do with their American experience." For all of these artists, it was a time of struggle, a time to come to terms with their ancestry. "Here were Motherwell, Baziotes, Rothko coming to grips with all of the elements that were later to become Abstract Expressionism. In 1946 and 1947, nothing was really formulated yet; everybody was working in a tenuous or seeking way toward their end." For Bearden, who reached a new level of maturity while exhibiting alongside many members of this group, the struggle was no less intense, although he considered himself a Cubist throughout his life. Abstract Expressionism was a direction he was largely to reject in his own painting.

Unlike the Abstract Expresionists, Bearden was to spend a great deal of time struggling to understand the structure and composition of Cézanne's work. In the end, Cézanne had as much or more influence on Bearden's handling of the picture plane than Picasso.

Bearden felt a burst of energy in all of the arts: in classical music, with the music of Charles Ives; in jazz, with the rhythmically and harmonically new music of Dizzy Gillespie, Thelonius Monk, Max Roach, and Charlie Parker; in the dance; in film. "I went one night with Carl Holty to see

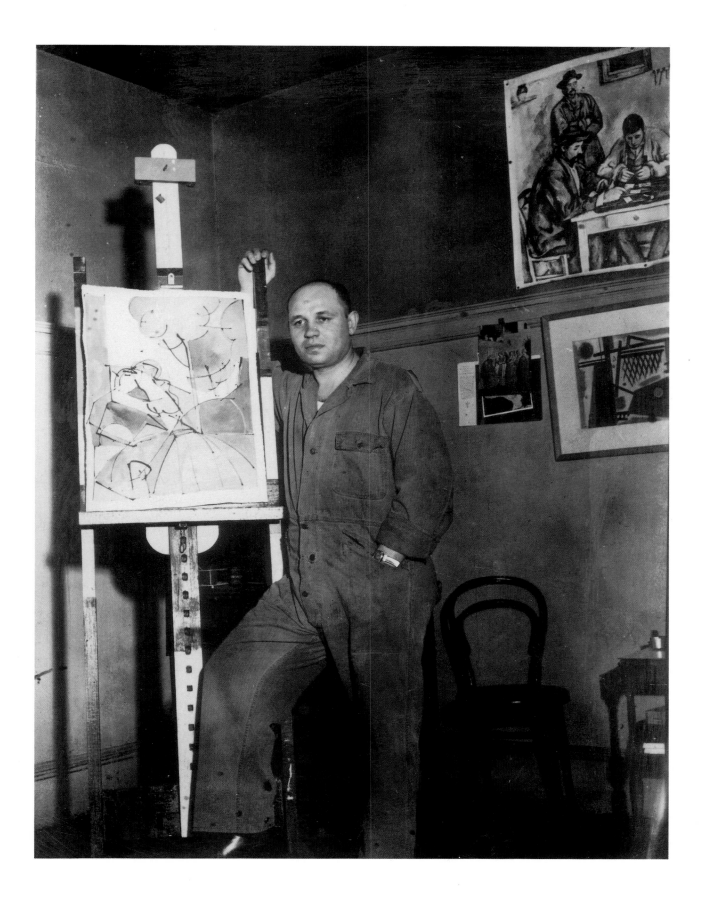

Les Enfants du Paradis. At one point an actor comes down the marble stairway of his house. Holty was impressed by the way he walked, and said he had really caught the spirit of the French nobility. It reminded him of what one critic had said of Sarah Bernhardt, that she didn't so much descend the stairs as the stairs seemed to be revolving, taking her down."

From the social and political viewpoint, the attorney Maxwell T. Cohen is as accurate a witness to Bearden's career in these years as one could wish to find. He and Bearden were friends for more than forty years. When they first met, just after World War II, Cohen's legal practice included a number of well-to-do Harlem businesses and individuals. Since he had a strong social conscience, Cohen complemented his activities as a lawyer by teaching a course entitled "Law for Your Own Use" at the George Washington Carver School in Harlem. Students in Cohen's class learned to cope with landlord and police harrassment by the exercise of their civil rights.

From Cohen's point of view, Bearden and his contemporaries "could not have been divorced or isolated from the sense of transition and political change which was taking place around them." As he recalls:

There was a renaissance taking place, possibly the result of the war, possibly the result of the assimilation process in the army, possibly because of a feeling of general restlessness, also possibly [due] to the influence of the Communist party in Harlem, which was rather salutary. . . . Romare had a remarkable intelligence. He was a very well read man, and he attended the lectures at the 92nd Street Y of the philosopher Will Herberg. Romare's interests were very diversified. He was a prolific painter, working in the afternoons, possibly moonlighting on his job with the Department of Social Services. . . . I remember the Garcia Lorca series he was working on. He had a tremendous admiration for the Garcia Lorca poetry and mystique . . .

I don't believe that he was essentially a religious person in the sense of doctrinaire, but he had a wonderful sensitivity towards biblical subjects: not the utopian concept of the fatherhood of God and the brotherhood of man. It was more of a poetic and a spiritual conception of religion and the Bible . . . So when he did the biblical scenes, it was inevitable that they would not be conventional paintings, but paintings that did convey a certain sense of peace. That's their dominant theme.[16]

The playwright Barrie Stavis, who first met Bearden at the office of Sam Shaw and writer Harry Henderson in 1945, has a different point of view altogether on the relationship between Bearden's life and art in the postwar years. Stavis had just spent a half-year in a Tuscaloosa, Alabama, hospital following service in the army, and the Bearden watercolor he saw in Henderson's office was his first exposure to visual art in quite some time.

I came into the office, and there was a watercolor there that knocked me off my feet. I said "My God, who did that?" They told me the name. It was Romare Bearden. I said, "I've never heard of this man before. How can I meet him?" Either Sam or Harry said it was simple; just return the next day at three o'clock;

Romie was coming there that afternoon. So he came; I told him how much I cared for his work. We became friends almost at once.

He invited me to his studio, and I was just overwhelmed. I knew nothing at all about the "Jesus" show in Washington; I knew nothing at all about any of his other work. But I was simply bowled over by what I saw in his studio on 125th Street.

Bearden later asked Stavis to write a catalogue note for a 1947 show of his work at the Samuel Kootz gallery. They spoke for about an hour, Stavis taking notes. "It was a piece where he was talking about the curve and the countercurve. He talked basically about Giovanni Cimabue [c. 1240–1302; the Florentine master who may have been Giotto's teacher, and who was certainly his older rival]. After he talked with me, I went to the museum and the art books, and looked at the work of Cimabue again, very carefully and with new eyes. I prepared myself for that program note, studying the whole concept of curve and countercurve, of how you use up the horizontal and longitudinal volume on a canvas."

What stunned Stavis increasingly as their friendship grew was the schism between the suffering Bearden saw around him daily in the course of his work for the New York City Welfare Department and the placid, inner vision that enabled him to capture mythic worlds on canvas. "Here was a man working for the relief agency, whose beat was Harlem—and we're dealing now with the poor in Harlem—and there was such a serenity, such a sureness on his part, and the work he was doing was so far removed from the life he was living. This dichotomy was just unbelievable. . . . When he talked with me about it thirty odd years ago . . . he talked about the endless, grinding poverty in slum areas; and here was a man who had to go into these homes, examining people for relief. And yet he did these canvases of glorious color, dealing with mythical subjects, and there seemed to be such a disassociation of one life from the other life."[17]

The synthesis by means of which Bearden had resolved this "disassociation" lay in his fundamental attitudes regarding his identity. These attitudes were formed (at the very least intellectually, even if he had not fully internalized them) by 1946, when Bearden wrote the essay he had mentioned in his letter to Quirt four years earlier. "The Negro artist must come to think of himself not primarily as a Negro artist, but as an artist," he wrote in "The Negro Artist's Dilemma." While defining himself in opposition to aesthetically limiting forms of protest art in the essay, Bearden also sounded themes which were to remain central to him in the ensuing decades. "There is only one art," Bearden asserted, "and it belongs to all mankind. . . . Examine the art forms of any culture and one becomes aware of the patterns that link it to other cultures and peoples."[18]

Bearden found the critical opinion that Negro art should be protest art severely limiting, both artistically and ethically, and therefore doubly dangerous. Of all the problems facing the Negro artist, Bearden found the "pressure to use his art as an instrument to mirror the social injustices inflicted upon his people" the most perplexing. "It is not necessary that the Negro artist

mirror the misery of his people," Bearden wrote. "The artist's greatest service consists in making his individual creations as strong as he can." Here Bearden recalled an exhibition of paintings sponsored by the NAACP before the war; the purpose of the exhibition was to show the brutality of lynching and mob violence. Bearden contrasted the sentimentality of most of these works to that of Goya, who—working with like material—"endowed the particular incidents of the French invasion that he depicted with a universal and tragic meaning, independent of race, time, or locale." In short, Bearden wrote, "A good painting has its own world. What ideas it arouses are integral and in relation to itself." Instead of confining itself to the depiction of misery and injustice in order to arouse indignation over social conditions, "Art celebrates a victory," Bearden often said later in life. It was a victory, in part, over the circumstances that give rise to it. *Therein* lay the synthesis.

PART 3: CONQUISTADOR: THE KOOTZ YEARS

In the summer of 1945, shortly after Bearden's discharge from the Army, Caresse Crosby met him in New York and took him to see Samuel Kootz. Although his ambition had always been to establish a gallery of his own, Kootz had earlier made his living, as far as Bearden knew, as an advertising copywriter for a motion-picture company. "His first idea, I think, was to have some of the leading modern American painters (such as Stuart Davis and Charles Sheeler)." But Peggy Guggenheim, in planning to close her American Place Gallery, where she had shown Robert Motherwell and William Baziotes, simultaneously created an opportunity for Kootz to form the nucleus of a stable of artists and turned his attention from the more established modernists to the younger, abstract painters who had exhibited with her.

When Caresse introduced Bearden to Kootz, "I think Sam was only committed to Carl Holty, Byron Browne, Baziotes, Motherwell." When she accompanied him to the gallery, Bearden remembered, Caresse said, "Sam, I had a show of Romare's work in my gallery in Washington. You might be interested in seeing some of his work." Kootz said, "Why not? Why don't you bring some of your things and come and see me?" Bearden brought him a portfolio of watercolors a few days afterward. Kootz liked them and showed them to Carl Holty (whom Bearden had not yet met). Holty also liked the works and suggested that Bearden be invited to participate in the gallery.

"I had done no oils and Sam asked me to do some. I did: they were pretty much in the manner of the watercolors done on gessoed masonite with black linear outlines with yellows, oranges, blues, reds, and purples predominating."

Kootz wanted Bearden to have a show immediately, and *The Passion of Christ* series was exhibited in October 1945. The exhibition, which included eleven watercolors and eleven oils, including one work on canvas, was a great success with critics and public alike. Four days after the opening, seven oils and ten watercolors had been sold. Among the purchasers were Duke Ellington, Samuel Lewisohn, Roy Neuberger, artist Yeffe Kimball, and *Art Digest* critic Ben Wolf. By December 1945, The Museum of Modern Art

He is Arisen. 1945. From *The Passion of Christ* series. Black and colored ink on paper, 26 x 19⅜″. Collection, The Museum of Modern Art, New York. Advisory Committee Fund

acquired *He Is Arisen* from the series, the first of Bearden's work to be purchased by a museum.

Writing for the *Amsterdam News* ("Romare Bearden Wins High Praise for Exhibition, 'The Passion of Christ' "), Nora Holt summarized the critical reception with a clear feeling of local pride:

Romare Bearden, young American painter, son of Howard and the late Bessye Bearden, prominent Harlem civic and social leader, opened his first New York exhibition at the Samuel Kootz Galleries, 15 East 57th Street, October 8, and has already created a spirited interest among critics and artists bordering on sensational.

The reviewers have gone overboard in their praise with such litanies as "vibrant with propulsive power" (Jewell) [New York Times] and "one of the most exciting creative artists I have viewed for a very long time" (Wolf) [Art Digest] and most of the downtown artists of creditable stature have considered it a "must" to drop in and give an appraising eye to the works of a newcomer who has aroused so much favorable comment.

. . . The deep religious note in his present paintings seems to reflect the consuming interest and ambition his late mother always had for his future.

. . . Mr. Bearden's art has developed from social interpretation of the depression days, Negro subjects, illustrations and genre painting to its present level of semi-abstractionism. He feels his series, "The Passion of Christ" presents a symbol expressing the emotional events of that cycle—tragedy, love, hatred, fear, sadism, and sacrifice—shorn of literalism as a device, but conceived and designed in his own creativeness.[19]

Christ's Entry into Jerusalem, a watercolor in the series, alludes to the narratives found in the gospels of both Matthew 21 and Mark 11

Above: *Christ's Entry into Jerusalem.* 1945. From *The Passion of Christ* series. Watercolor on paper, 17 x 23″. Schomburg Center for Research in Black Culture, Art and Artifacts Division, The New York Public Library. Gift of Mr. and Mrs. Harold Lasky

Opposite: *He Walks on the Water.* 1945. From *The Passion of Christ* series. Watercolor, 24 x 18″. The Shaw Family Collection

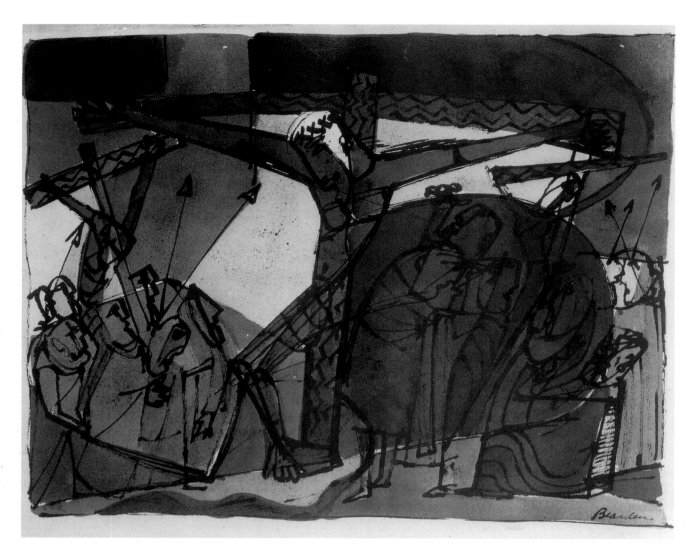

and reflects Bearden's debt to masters whose work he had studied. Because of
Bearden's particular interest in the Sienese painter Duccio, as well as the
Florentine Giotto, their two versions of *Christ Entering Jerusalem* are echoed
in Bearden's. Of the two renderings, Bearden's watercolor is closer to the
Giotto in tonality, its radical simplification of detail, and the flatness of the
picture plane than to the Duccio, which has more brilliance than the Giotto
watercolor on plaster, largely because it is executed in a different medium, egg
tempera on gold ground.

In Bearden's rendering, the composition is tight, yet he
manages at the same time to convey a sense of openness and placidity through
the curvilinear rhythms and the soft, delicate combination of light olive, soft
blues, soft reds, and browns. *Golgotha*, another watercolor in the series, con-
veys a radically different feeling. The figure of Jesus dominates the composi-
tion, his arms forming a diamond shape against the horizontal of the cross, his
legs bent sharply at the knees. The entire composition is flat; Bearden draws
both of Christ's nostrils against the profile of his face in Cubist fashion. A

single exaggeratedly long spike, easily the length of Christ's face, is set diagonally against his splayed right hand. These compositional elements notwithstanding, the emotion conveyed is unmistakably one of raw suffering.

At the Whitney Museum of American Art's Annual Exhibition of Contemporary American Painting held from November 27, 1945, to January 10, 1946, Bearden was represented for the first time with *Madonna and Child*. This oil painting is strongly characteristic of the effect of stained glass and prismatic color Bearden achieved in many works of this period. It was described by a writer for *Newsweek* as "part-Picasso, part thirteenth-century-French-Gothic-stained-glass-window" in its effect. The work is a study in ovals held by the rectangle: the madonna's head echoes the circle of her arm around the child. Her face is a flat mask split diagonally into contrasting areas of color in the manner of the African masks which so influenced Picasso when he saw them at the Musée du Trocadero. Just as importantly, it reflects the Florentine tradition, perhaps Cimabue's *Madonna Enthroned* (c. 1280–90; Uffizi Gallery, Florence) especially.

The Whitney's selection for its 1945 Annual was the barometer of the new, postwar spirit. *Newsweek* quoted Hermon More, curator and selector of the exhibit, to the effect that the principle of selection had remained constant: "We just follow the artists wherever they lead." At the same time, the article noted that the 165 paintings, 50 of them by artists represented at the Whitney for the first time, "sparkled with a new kind of American painting. . . . Taking many forms, dictated by the individuality of the artist, it is developing out of all of the main streams of twentieth-century art."[20]

Even as *Madonna and Child* remained on exhibit during the final days of the first part of the Whitney Annual (the second part, devoted to sculpture, watercolors, and drawings, included another Bearden), his painting *The Annunciation* (1946) was part of a show of the work of twenty-four artists at the Durand-Ruel Galleries in New York. Although the Durand-Ruel exhibition, "Modern Religious Paintings," was more or less unified in its subject matter, its scope was international and the manner of treatment was often that of masters who had long since developed unique styles. Max Beckmann's *Descent from the Cross*, for example, was shown alongside Georges Rouault's *Christ in Profile*, Salvadore Dalí's *Nativity*, Marc Chagall's *Obsessions*, Max Weber's *Talmudists*, and two paintings entitled *Crucifixion*, one by Milton Avery, the other by Pablo Picasso.

One has only to compare Bearden's earlier *The Visitation* (c. 1940–41), essentially a realistic treatment of the same theme, with his later *Annunciation* to gauge the movement toward abstraction in his mid-1940s art. In *The Annunciation*, the angel is winged, Mary is kneeling, both faces are masks, and the striated column of an archway set diagonally at the upper right "sets" the overall composition. Bearden's handling of the formality of the picture plane in the 1946 work is a clear nod in the direction of the Cubists. His admiration of Matisse is evident in the linear rhythms that create a unified ornament of the entire composition, moving from the robes of the angel and Mary to the column.

Duccio. *Christ Entering Jerusalem*. c. 1308–11. Panel from back of the Maesta Altar, 40⅛ x 21⅛". Museo dell' Opera del Duomo, Siena

The subject matter once more demonstrates Bearden's careful study of the tradition. His *Annunciation* echoes rather strongly Duccio's *Annunciation of the Death of the Virgin* (back of the Maesta Altar). Bearden, it seems, compressed the space between the two figures, altering the positions of kneeling and sitting in Duccio's angel and virgin but maintaining the gestures of their arms and hands. Finally, he seems to have tipped the Duccio portal diagonally and frontally in order to eliminate the illusion of spatial depth enclosing the figures, as defined by the architecture.

"I think, and others have suggested," Bearden said, "that some of my paintings of the time suggested the approach of the Futurists. I recall a work, *Christ Driving the Money Changers from the Temple*, in which the line enveloping the painting suggests the movement of Christ's arm through consecutive spaces."

While enjoying the acclaim accorded his *Passion of Christ* series, Bearden began work on a new series inspired by the poetry of Garcia Lorca. His striking watercolor *The Bull Bellowed Like Two Centuries* was selected for the Whitney's Annual Exhibition of American Sculpture, Watercolors and Drawings in late winter of 1946 (February 5–March 13). Dominating three-quarters of the pictorial space, the bull, rearing up on its hind legs, its tail curving in the air, is titanic; the arc of its horns is emblematic of the tension Bearden creates by infusing the machinery of death with an abstract, almost geometric precision.

The Bull Bellowed Like Two Centuries was literally an *hors d'oeuvre* to the series of twenty-one works composed of nine watercolors and

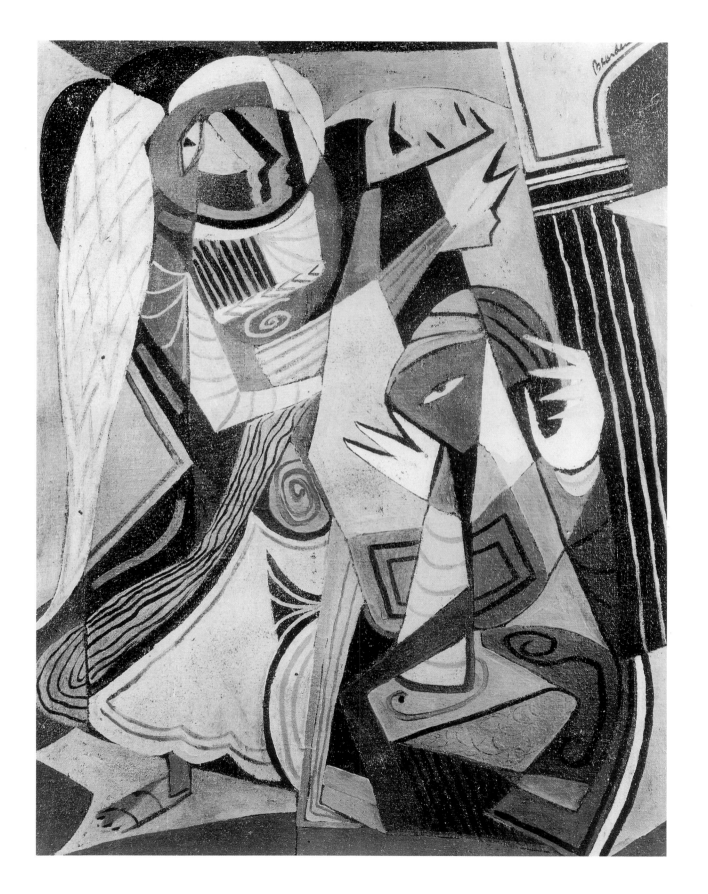

twelve oil paintings inspired by Lorca's "Lament for a Bullfighter: Ignacio Sanchez Mejias." A one-artist show of the series ran from March 25 to April 13, 1946, at the Samuel Kootz Gallery.

Bearden had been introduced to Lorca by Langston Hughes, who spoke Spanish fluently, in the 1930s; Hughes translated the conversation for his young friend. At the time, Bearden said, he was too young to have any interest in Lorca, and his work was not generally available in translation. But a decade later, in the wake of the Spanish Civil War—the prelude, in miniature, of World War II—and Lorca's New York City poems (especially his "Lament") Bearden created perhaps the most conspicuously "literary" of his four series from the 1945–48 period. The works themselves are not in any way illustrative of the poem's text; Bearden's lamentation scenes evoke the incantatory spirit of Lorca's lament, however, and all his titles are drawn from Lorca's dirgelike repetition of such lines as "At five in the afternoon" and "I will not see it . . . Do not ask me to see it." But the heroism of the bullfight, the aesthetic of the ritual played out in the ring, is inspired by another piece of literature: Ernest Hemingway's *Death in the Afternoon*, which, it is worth noting, contains a short description of the bullfighter Ignacio Sanchez Mejias.

The series is composed of scenes in the bullring and lamentation scenes in both oils and watercolors. The oils are more highly stylized and abstract in their composition than the watercolors. *Formed of Tears* appears to abstract the contours of the bull—horn, tail, ears, and body—within a large rectangular motif whose upper edges are rounded and whose lower line is scrolled and curved. The composition is made to focus on two large eyes, evoking lamentation, at the upper center.

Ben Wolf, reviewing the exhibit in *Art Digest*, singled out another oil, *Banderillas of Darkness*. Here a highly stylized horse, facing away from the viewer at the right, and the bull, charging toward the viewer at the lower center, surround two immense banderillas just placed by the matador, who dances Chagall-like in the air between the bull's horns. Wolf called it "an ambitious work that exhibits a comprehension of form that has little fear of large areas—a fortunate ability that should recommend him as a muralist."[21] Twenty years later, his prediction proved quite accurate.

In the watercolors, Bearden's handling of space is as sure as, if not surer than, that of his *Passion of Christ* series. One of the bull-ring scenes again uses the large triangular motif Bearden had employed so effectively in *The Bull Bellowed Like Two Centuries*. In this work, the triangle frames an upended horse, its foreleg splayed out grotesquely, its head reminiscent of the horses in Picasso's *Bullfight* (1934) or *Guernica* (1937). Beneath the horse, at the bottom center of the composition, the matador lies with his high-stockinged legs as grotesquely splayed as the horse's, his outstretched sword useless in his right hand. At the upper left of the composition, the bull, as if standing on its hind legs, is drawing away. The colors move from a slate-gray with a tinge of blue surrounding the matador, to salmon-red and the white of the paper surrounding the horse, to slate-browns in lightening planes moving to the brown of the bull.

The Bull Bellowed Like Two Centuries. 1946. Watercolor on paper, 24 x 20½″. Whereabouts unknown

Overleaf, above left: *You Are Dead Forever.* 1945–46. Watercolor, 19¼ x 26¼″. From the series inspired by Lorca's *Lament for a Bullfighter.* Private collection

Overleaf, below left: *Bull with Bullfighter.* 1945–46. Watercolor, 19¼ x 26¼″. From the series inspired by Lorca's *Lament for a Bullfighter.* Private collection

Overleaf, right: *The Shepherdess.* 1946. Pencil, watercolor, and ink on paper, 24 x 17½″. Collection Judith H. Schwartzman, New York

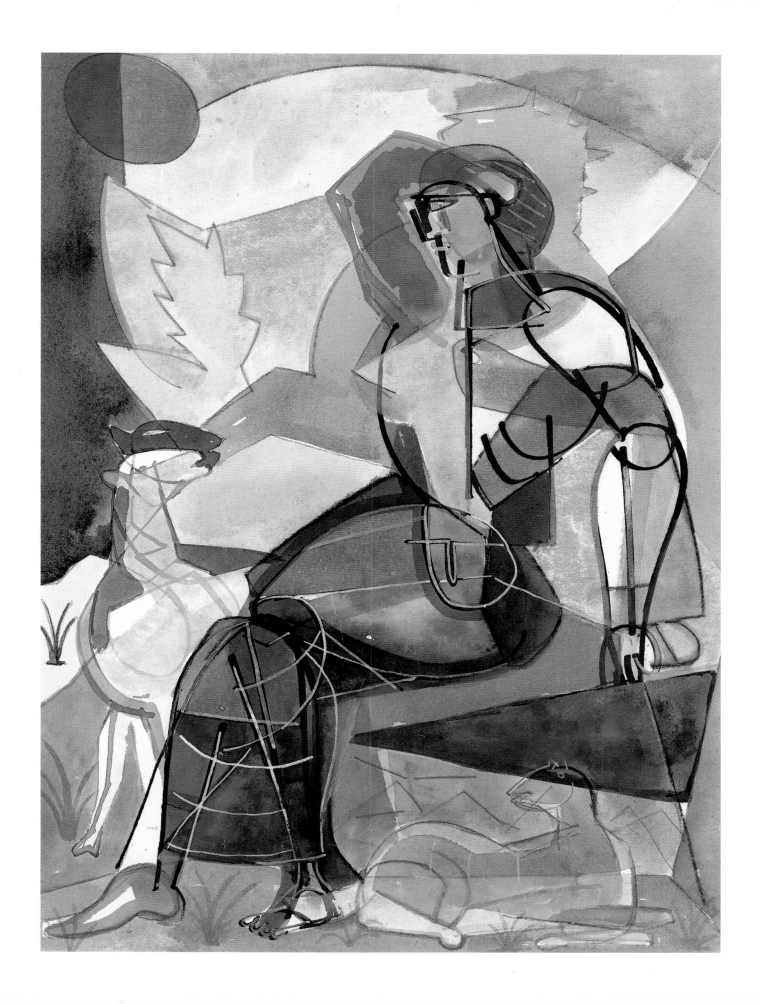

In another watercolor, this time a lamentation scene, three women mourn at a sepulchre. Their faces are masks of lamentation. The faces of the women to the right and left are cleft vertically into areas of color juxtaposed with the white of the paper, a delicate light olive in the bowed head of one woman and a light slate-gray in the face of another. The downcast head of the woman at the center is the sheer white of the paper, the face featureless. The mourners' hands extend towards the sepulchre, showing a diagonally cut stonework that Bearden would use again and again in the *Iliad* series a year and a half later. It is a sensitive, carefully composed work.

A review in *Art News* praised the watercolors as "fully developed": "Planes of color penetrate each other, in no way subdued from their former radiance, but with a more mature and subtler relationship. Surfaces are enlivened with a splatter-technique and lines are loose and free. They have caught the curious almost palpable tension of the bull-ring and the precise, unequivocal movements of its protagonists. In the scenes of lament, color is used for its lyric powers, bright but with the special pure, deep quality of Gothic stained glass."[22]

But apart from *Banderillas of Darkness* and perhaps one or two other oils, the review contended, "Bearden seems still to be searching." In retrospect, Bearden agreed that at the time he had not yet achieved the control of his oils that he was seeking, particularly with regard to scale. If he chose to make a preliminary sketch for an oil, for instance, he was unable to re-create the effect he wanted on the larger scale of the painting. His friend Holty therefore advised him, in the case of the oils, to photostat the sketches up to the size he wanted. It was a temporary solution to the problem of control that he had obviously handled with success in *Banderillas of Darkness* as well as other oils of *The Passion of Christ* series earlier.

By 1946, Samuel Kootz's "stable" of artists was in place. It included Bearden, Browne, Baziotes, Motherwell, Gottlieb, and Holty. With the exception of Bearden, who had resumed his duties as a case worker for the New York City Department of Social Services in 1946 and therefore had a full-time job, Kootz's artists were in his employ. "Except for myself," Bearden said, "Kootz had an arrangement with them whereby he paid them a certain yearly salary, on a sliding scale upward, and disbursed on a monthly basis, for a certain individually agreed-upon amount of work—whether paintings, watercolors, or drawings—by each artist." According to April Paul's study of Byron Browne, individual artists had differing contractual periods; Browne, for instance, and probably Holty had three-year contracts, while Motherwell's was for five years. The terms of Browne's contract were such that he was obligated to turn over some three hundred works over a three-year period. In return, he received an annual salary of $3,000. Sometimes, Bearden recalled, this financial arrangement led to complications. "I remember once Baziotes won a prize, and there was the issue of whether that belonged to him entirely, or did some percentage belong to Kootz."

For the artists in the group with whom Bearden was closest—Baziotes and Holty—this was an uncomfortable arrangement. Baziotes,

for instance, worked slowly and meticulously, by contrast with, say, Byron Browne, who worked easily and rapidly, and whose work was arguably the most popular of the artists in the Kootz group in those years. Holty, as his letters demonstrate, sometimes struggled through arid periods and was later to characterize his arrangement with Kootz as "the awful agony of push production." Once, Bearden remembered Browne's turning in some overage in drawings; Adolph Gottlieb asked him why he had given Kootz more than he had to. "Oh, I just do them; I just do them fast, there's nothing to it," Browne replied.

Kootz had meetings with the group almost every month. Often, especially in 1946, they discussed possible themes around which group shows could be organized. In fact, 1946 could be characterized as the year of the group show for Kootz. Just before Bearden's Bullfight series was exhibited, for instance, Kootz gave a group show entitled "The Big Top" (March 4–23), which included work by Bearden. In June, a Kootz group show called "Modern Paintings for a Country Estate" included Bearden's *Madonna and Child with King*, as well as work by Alexander Calder (who showed with Kootz briefly around this time) and the "regulars." Robert M. Coates, writing in *The New Yorker* (June 23, 1946), praised both Bearden and Browne as "men who have made unusual progress in the past year or so." Reviews of the group shows also made clear how wide (and interchangeable) an umbrella the particular theme could be. The *New York Times* (June 9, 1946), for instance, commented that "Modern Paintings for a Country Estate" certainly "does not preclude the suitability of the work in other surroundings. Bearden's *Madonna and Child with King* would translate beautifully into stained glass."

Kootz gave an exhibition called "In the Sun" to open the fall season (September 4–29), including work by all the regulars, as well as Léger's *Four Acrobats* and a work by Picasso. For this show, Bearden contributed what the *Herald Tribune* reviewer (September 8, 1946) called a "bright, rhythmical and well organized *This Year's Grain*."

The most significant of these shows for Bearden, in that it was prophetic of the substance and spirit of much that was to come later, took place at the end of the year (December 1–21). It was entitled "Homage to Jazz," and included an important oil of Bearden's, *A Blue Note*. Ben Wolf reviewed the show for *Art Digest*:

Homage to Jazz *provides the theme for an exhibition now current at the Kootz gallery. Of particular interest in this novel showing is the fact that the abstract and comparatively objective entries are equally successful in translating this form of music to canvas.*

Two watercolors and oils by Romare Bearden are present. The last mentioned, A Blue Note, *incorporates handsome combinations of blues and greys and is of particular interest compositionally, with its creation of a circular movement within a rectangle. Carl Holty scores with two vigorous examples titled* Drum Riff *and* Solo Flight. Jazz Trio, *by Byron Browne, involves black on black successfully.*

Opposing rhythms keynote Black and Tan Fantasy *[after the*

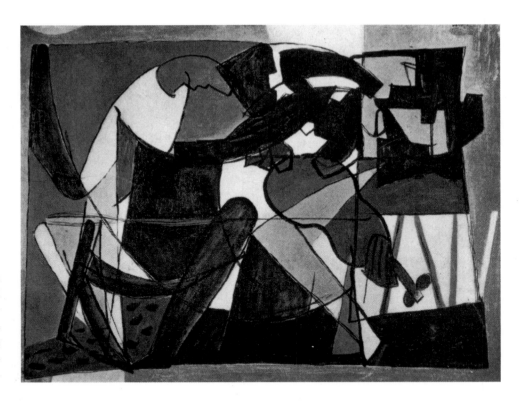

Duke Ellington composition], by Adolph Gottlieb, whose recent canvasses show greater interest in color than has heretofore been apparent. Textural interest makes Robert Motherwell's Homage to John Cage *one of the painter's most successful collages to date.*[23]

A Blue Note is interesting compositionally also in the way Bearden fills his canvas with his musician, holding a violin the size of a viola, caught just as his right hand is about to bow the note which gives the composition its title. Above the violin, an abstract design echoes perfectly the contours of an upright ragtime piano at the top right corner of the painting. Filled with energy, *A Blue Note* is an early instance of Bearden's enduring commitment to jazz, its musicians, and the process of improvisation in his art.

PART 4: UPTOWN LOOKING DOWNTOWN

"I had two worlds," Bearden said of the late 1940s, "two different polarities. The blues up here; the downtown scene there at Kootz." Apart from Holty, who had a studio in East Harlem, Bearden was the only one going uptown to Harlem proper. "At some point, this had to coalesce." It had come together momentarily in the "Homage to Jazz," but, as far as Bearden was concerned, it would take another fifteen years for him to understand what both worlds meant.

Sometimes, albeit exceptionally, a great European modernist would bypass the downtown art scene to work in Harlem. In the summer of 1947, the painter Joan Miró stood before a gigantic canvas in Holty's studio, stripped to the waist, a towel around his neck. He had come to New York specifically to paint a mural commissioned by the Gourmet Restaurant of the

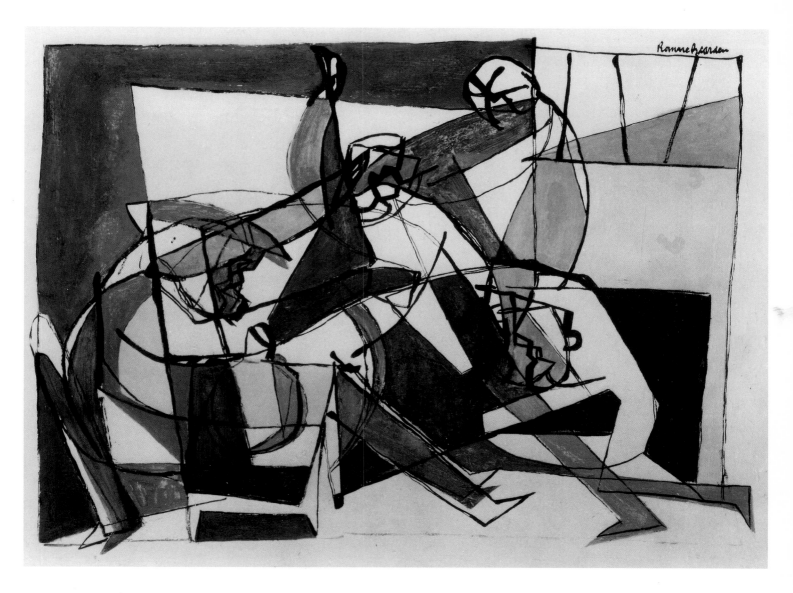

new Terrace-Hilton hotel in Cincinnati, Ohio. Bearden remembered how the huge mural (oil on canvas, roughly 7 x 32') began with a small sketch about three by five inches. First Miró mixed an ultramarine blue and a cobalt blue in coffee cans, then he laid in the entire blue ground with stenciling brushes about three inches in diameter. This was arduous work, which Miró did without assistants. "He wore out about four or five stencil brushes. It wasn't a matter of just covering the canvas like a house painter with the cobalt-ultramarine mixture, because the streakiness, or the fact that it was uneven in some places, with various movements to it—all that gave him compositional ideas. It was his genius that he was able to seize upon it: that was the 'accident.' "

　　　　After the blue ground was laid in, Miró very carefully outlined the biomorphic forms with charcoal, and only then painted the black. "When I asked him (through Holty, whose French was fluent) why he put the charcoal on so carefully, he said it was a more dry method that gave the black

Some Drink! Some Drink! 1946. Oil on canvas, 25 x 32″. From the series inspired by Rabelais's *Gargantua and Pantagruel.* Whereabouts unknown

147

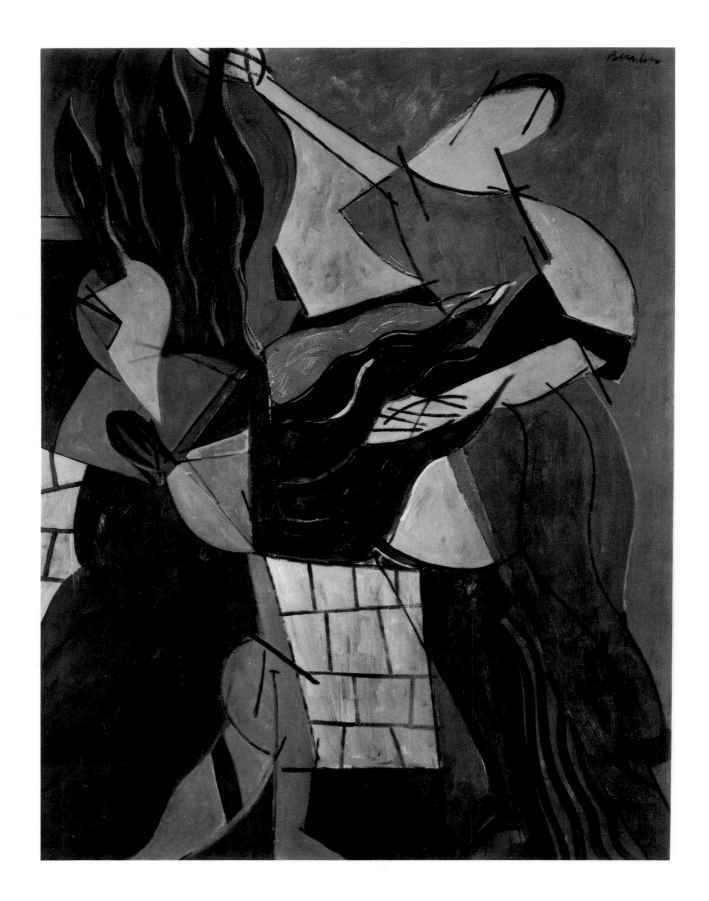

oils a mattelike or gouache-like quality that he liked; it didn't have the normal glistening of oil paint. Here he was fixing two compositional positions across the canvas from each other, around which, like a jazz musician, he began to swing his rhythms and improvisations. So what he was coming up with had little to do with the original small sketch, just as the improvising jazz musician's 'continuing thesis' has little to do with the original melody. This is not a method for everyone, and I certainly did not feel capable of doing what Miró did at the time—because it calls for sureness, a confident feeling that everything is going to turn out all right, and a way in which a kind of playfulness is kept moving throughout the composition. When I say 'playfulness,' I mean it in the sense of the 'divine play' Schiller and other nineteenth-century aestheticians delineated as one of the real and true purposes of art."

While the "Homage to Jazz" show was still on at Kootz, the Whitney's Annual Exhibition of Contemporary American Painting (December 10, 1946–January 16, 1947) had selected Bearden's *Some Drink! Some Drink!* As had been the case early in 1946 with *The Bull Bellowed Like Two Centuries*, this painting constituted a kind of "opening chorus" for Bearden's solo show of paintings inspired by Rabelais's *Gargantua and Pantagruel*, which was to open at Kootz late in February 1947.

Some Drink! Some Drink! is distinguished compositionally by a forceful diagonal thrust moving across the heads of three of the four figures in the painting. Although the composition is structurally tight, infused with the tension created by the diagonal thrust held within the rectangle, it shows a new sense of freedom of line, especially by contrast with the oils of the Bullfight series. There is also a great deal of wit and playfulness in Bearden's figures, somehow reminiscent of the scenes of ribaldry one finds in Hals and Breughel. This allusion to the Dutch, like the subject and theme of *A Blue Note*, foreshadowed much that was to come in Bearden's work a generation later.

A watercolor in the series, *The Fox Hunt*, was included in Kootz's final group show of 1946. In its review (December 29, 1946), the *New York Times* wrote, "Bearden rather leads the group with such examples as the 'Fox Hunt,' the new work being less in the stained-glass decorative manner than earlier paintings."

Bearden's "Rabelais" show ran from February 24 to March 15, 1947. Like the Bullfight series, the Rabelais series was composed of two kinds of scenes—this time drinking, carousing, and dancing on the one hand; hunting on the other. The titles, drawn from Rabelais, suggested the sense of *joie de vivre* found in the eighteen works: *The Soul Never Dwells in a Dry Place*; *Lash Them Soundly*; *Not Mad, But Nobly Wild*; *We Poor Innocents Drink*; *Our Fathers Drank*; and *This Bowl*.

On March 28, 1947, at Galerie Maeght, Paris, the Kootz group was given an exhibition, "Introduction à la Peinture Moderne Americaine," under the sponsorship of the United States Information Service. Each of the artists exhibited five works. Bearden was represented by *Around Around, Interior, A Blue Note, The Drinkers*, and *The Fox Hunt*, the products of his December 1946 group show and his "Rabelais" show. The French press

Opposite: *The Walls of Ilium.* 1947. Oil on canvas, 31 x 40″. Whereabouts unknown

Overleaf, left: *The Parting Cup.* c. 1948. Watercolor and ink on paper, 24 x 18″. Collection Judith H. Schwartzman, New York

Overleaf, right: *Untitled.* 1948. From the series inspired by Homer's *Iliad.* Watercolor on paper, 24½ x 18¼″. Schomburg Center for Research in Black Culture, Art and Artifacts Division, The New York Public Library. Gift of Mr. and Mrs. Irving Sherman

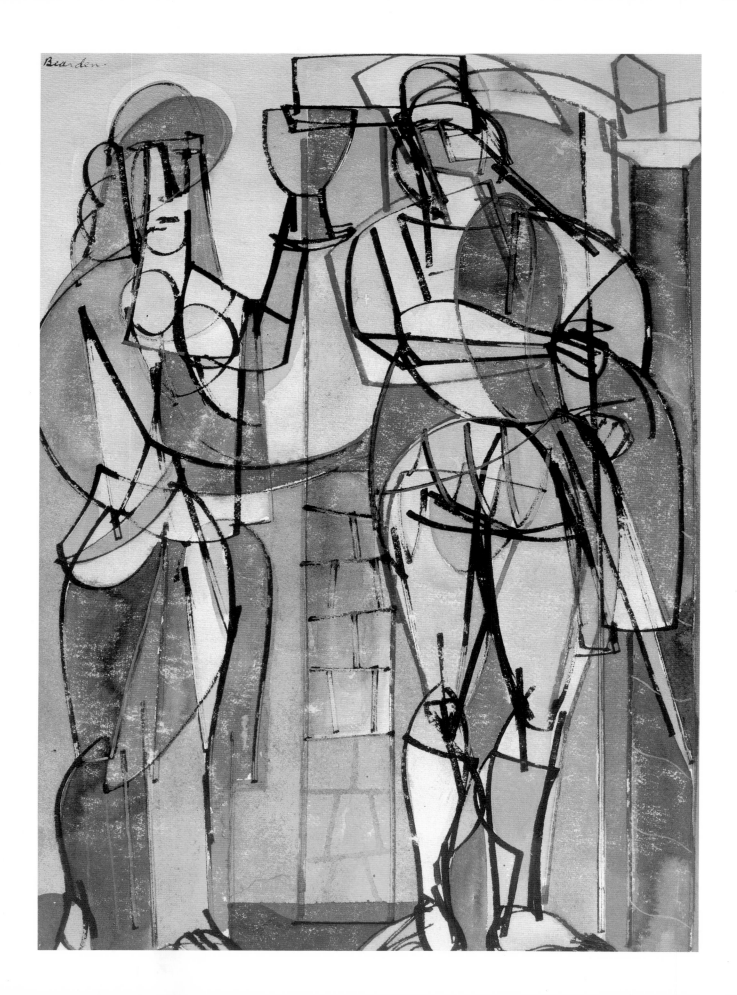

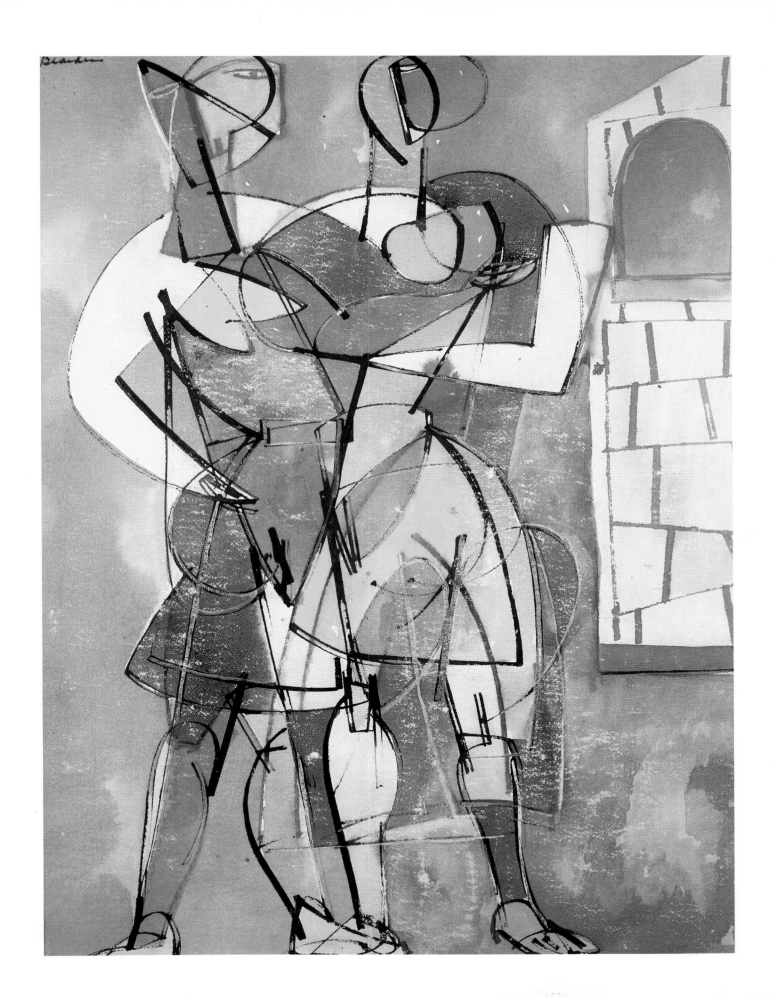

was not kind. In a word, it lambasted all the artists except Motherwell as imitators—and poor imitators at that—of the modernist school long since established in France by Picasso, Braque, *et al.*

By July 1948, Kootz had closed his gallery. It reopened in September 1949 without Bearden, Browne, and Holty. Kootz kept Motherwell, Baziotes, Gottlieb, and Hans Hofmann, who had joined the gallery in 1947. His first show at the new gallery featured the work of the regulars who remained, as well as work by De Kooning, Pollock, and Rothko.

Bearden's last important involvement with the "old" Kootz group was in a group show resulting in a book, *Women: A Collaboration of Artists and Writers* (New York: Samuel M. Kootz Editions, 1948). Bearden's 1947 *Women with an Oracle* was accompanied by William Carlos Williams's text.

Bearden's best work in watercolor was done in 1948, including such splendors as the much-reproduced *Woman Seated on Rock* (27 x 20″) and the series of sixteen variations on *The Iliad* that showed in a solo exhibition at the Niveau Gallery in November of that year. The *Iliad* variations brought Bearden's work of these years to its culmination. Structurally, they were far tighter than the works of the earlier series, and were often confined to two figures—on horseback, as in *The Walls of Troy*, or juxtaposed, as in *The Parting Cup*. They were in no way tied to specific scenes or episodes in the Homeric epic, but were truly Bearden's "variations" on them; the musical overtone of the word is probably intentional. Again the colors were prismatic, enclosed by the architectonics of the lines separating them. Bearden likened the intervals between colors to the lead in the stained glass of Chartres cathedral. The lead holds the colors together, both literally and figuratively. "If you forgot everything else and just traced the black lines of the lead, that would be interesting too."

In fact, Bearden did just this in a series of fifteen to twenty line drawings of this year, on the same theme as the *Iliad* variations, but with a greater emphasis on scenes of armed struggle; his draftsmanship in a number of these drawings was quite strong. The drawings are in no way preliminary sketches for the watercolors; if anything, they are studies *after* the watercolors.

Bearden was doing something new at this point with the lines between colors, not only in the *Iliad* variations, but in most other watercolors of this year. *The Parting Cup* shows a characteristic pattern of Bearden's creative growth; each time he reaches a synthesis, he begins to break it down from within in an effort to find a new form. In *The Parting Cup*, which focuses on the goblet held out by a woman to her departing warrior, a vertical red line descends from the center of the goblet and becomes the outline of a brick wall at the lower center. The interweaving of black and red architectonics was the beginning of Bearden's effort to establish intervals between colors by using color as form.

Although the reviews of the *Iliad* works were generally very good, Bearden was dissatisfied with them, with his art, with the departure of his good friend Holty for a teaching post in Athens, Georgia, and with the New York art scene in general. In more than one sense, Bearden had reached an

impasse. He had no permanent affiliation with a gallery, and he had no definite notion of the direction in which to take his painting. His solution lay, in good part, in what amounted to a master-class correspondence course.

The aesthetic hammered out in the Bearden-Holty correspondence of late 1948–early 1949 was, in one sense, a dialogue between a teacher and the most brilliant student he could wish for. Holty, who felt isolated in Georgia, and who was dissatisfied with his students there, filled his letters with an intellectual ferment that was intensified by what he perceived as the cultural desert surrounding him. Bearden could adopt the role of student with ease; after all, Holty by his own characterization was a painter "about to enter my fiftieth year," while Bearden was in his mid-thirties. Moreover, Holty's grounding in art history was formidable, and if he was often long-winded, he was always articulate and occasionally inspired. In effect, after George Grosz, from whom Bearden learned the rigorous discipline of his draftsmanship, Holty was Bearden's second great analytical teacher. From Holty, Bearden learned how to articulate his analysis of the Cubists, Matisse, and Mondrian in relation to structure and space.

Their correspondence shows how precisely Bearden was identifying problems whose solution would eventually trigger his artistic growth. Bearden's companion in those years was a young fashion model and art student named Jean. Holty knew Jean, and had sketched her. It is probable that she also modeled for Bearden.

In his first letter to Holty [c. September 1948], Bearden described his reaction to a short film he had seen the day before in which Henri Matisse did a portrait of a young boy:

The painting was shown as it changed over a period of 4 or 5 months. In the end he arrived at such a simple statement; because at first the subject was in a ¾ view on a couch with an elaborate wallpaper and ended with nothing in the background, with a frontal view of the subject, minus couch, chairs. "Then Matisse said, he just finally relinquishes a painting—maybe never finishes one."

You know Carl, that whole experience gave me courage, because I get discouraged taking so long to finish my own work. Also, it was good to see the mistakes that even a master like Matisse had to paint out before he finally passed third base.[24]

In his reply of October 2, 1948, Holty was reassuring. "Don't worry about your painting Romie. You're doing fine. Only remember what I said about color and remember that *all* your forms and figures must spell out *one* form—the subdivisions of which must never destroy or reduce."[25]

"I wish you were here to talk about painting," Bearden wrote Holty following the opening of the *Iliad* watercolor exhibition the next month. "You may recall that you advised me in a portrait that I had done, to get a black shape through the middle around which the rest of the painting could pivot. I did this, and the painting came to life. Later, I noticed in many successful paintings, that there is always some kind of 'leading motif,' or 'unifying track,' that holds the other elements together."[26]

Holty replied on December 22, 1948:

Now, I'd like to answer your questions relating to a "containing form" or shape. I don't have to tell you how soon and how often this admirable device was used but the ornamental cubists, Picasso, Braque and Gris, were the most recent masters to use it, and I do remember that I told you to use it on those portrait figures you were working on when I left New York, but I meant it only as a step for you in the assembling of forms—not as a final method by any means. I doubt very much whether the emphasis of such a form every really did set *a picture, otherwise a host of abstract cubist painters would have been great. When it does seem to* set *the work, I think it is because the method went with the space and image intention of the artist.*[27]

Bearden wrote again shortly after Christmas 1948 to thank Holty for his analysis. "For the past week I have been doing some drawings again to try and clarify a few things. Now I notice that the present drawings are rather different from the Greek ones. In what ways I can't say with certainty as yet, but I do notice a certain color approach (seemingly less colors) and a general emptying out of the surface. . . . Isn't it strange in this painting business that you work harder and harder to put less and less on the picture plane."

Bearden went on to wonder what "actual philosophy" would justify what he and Holty were each attempting in their art. "To know," he wrote, "would certainly clarify the problems—even those of structure." By "the justification of philosophy," Bearden said, he meant the extent to which Rembrandt was influenced by Spinoza's humanism, "either directly or by osmosis," or, say, the Cubists by Mondrian. "Most all of [Mondrian's] followers miss the true touchstone of Mondrian's genius," Bearden wrote. "[He] offered a 'point of view' more than a plastic method."

Earlier in the letter Bearden had set forth his estimate of his artistic identity in relation to the Cubist legacy. The philosophy justifying their work, Bearden made clear, must emerge from a careful study and resynthesis of the tradition: "The cubists have left us with a synthesis of reality—and their work is based on the real. We contemplate the picture on their terms—plastic ones. Mondrian was the logician of the movement (more mystic in the true sense of mysticism than one would imagine) and Mondrian's [philosophy] dealt in ratiocinative terms with the actual—or real." Bearden felt that his and Holty's work represented a reaction to some aspects of Cubism, "although we accept the space attributes."

Jean was mailing their belated Christmas present, Bearden wrote, a book of Delacroix's drawings, and Baudelaire's essay on him. "Baudelaire says, 'In our relations, respect on my part and forebearance on his did not prevent mutual confidence and familiarity.' Imagine a critic of today feeling like that even about God."[28]

Holty wrote back on January 29, 1949, thanking Bearden for the book. "To open it was like—if you will, uncorking a bottle of real champagne, and the analogy becomes better when continued—and one compares the bubbling forth of the brilliance and esprit (you can't translate it) of

Diagram of mosaic in letter from
Bearden to Carl Holty, Feb.
1949

a mosaic ((by now, I suppose you're ready to send me to that hell where your Georgia students are going, for constantly harping on the mosaics — but my grandpa used to say "beware of the man who knows one book well. Of course, he was referring to the Bible)) and I see where the artists used the vertical-horizontal directions in much the same idea as I think you mean. This is a rough diagram of the picture — with the horizontal directions in red, and verticals in blue.

I have probably stressed the verticals and horizontals more than the big in and out movement, but you see what I mean by the pattern of these forces — which surprisingly enough as I look

have a sort of musical beat and it actually serve as intervals.

Yes I also see why this discovery of yours can be important, I think of several reasons.

① The intervals can be the sustaining beat of the picture rhythm we have so often spoken of.

② The movement in and out can act as the thrust diagonally that establishes the volume, instead of tilting the center plane as the cubists did.

③ The horizontals and vertical can indicate the plane, that is help bring the moving rhythms back to the flat.

I'd really appreciate knowing if the foregoing

both artist and writer. This then is the real—the corporeal. It saved my day and possibly my year, so thanks again for the sentiments of Delacroix, Baudelaire and—Bearden.

"You know that I am teaching a class this quarter and I put in three whole afternoon hours a day at it, and it is a success because I am teaching *me*," Holty continued.

The stupidity of the students (almost without exception) forces me to reiterate and prove again and again a point that is very important and which up until now I must say was what I feel my weakness and now I know that I have solved it once and for all. What I am talking about is the distance in depth (though made with two dimensional means) of the longest movement back (i.e. up) and the counter-movement forward (i.e. down). I am certain now that there must be a point of entry into the plane and following that a return down and out.

All other movements in placement relate to these—loosely and in a grand manner or tightly knit, if one has a particular relationship to define. The vertical and horizontal divisions of the surface then serve as intervals and as constant reminders that all this activity *is taking place on a* flat *surface. . . .*

I draw (in pencil) a dozen likeness portraits a day that are as good or better than the one I made of Jean, and I frequently do them with twenty lines. They are not at all exact but very real.

Holty went on to agree with Bearden's insight into Mondrian: "You are quite right when you say that Mondrian presented a point of view rather than a method of work and/or God forbid a world of all-embracing content. I think that both he and his followers made the great mistake in trying to make the artist who is part scientist into the complete scientist."[29] To Holty's mind, as he made clear elsewhere, Mondrian's method of work was a trap: "namely, to destroy the memory of the world seen and sensed."[30]

It was this world, experienced first through his own sensations, but more importantly as a world seen and painted by his predecessors and contemporaries, against which the individual artist must assert his identity, Holty wrote, "and he is faced with the greatest task of all, the recapture of his vision not completely free but sufficiently so that he can express himself clearly and with a minimum of reference to his teachers. Again, he must do this—not to be or appear original but to be clear and shining."[31]

In Bearden's reply to Holty's letter in early February, very soon after he received it, he addressed the aesthetic issues Holty had raised:

I was glad to read your thoughts about the latest paintings you're working on, and the grasp of the new ideas. . . . The idea of using the horizontals and vertical directions as intervals is really a peach of a one, because in that way you can conceive of these directions as a design pattern relating to, yet homogeneous from the centrifugal movements in and out of the painting. At this very moment, I look at a mosaic . . . and I see where the artists used the vertical-horizontal directions in much the same idea as I think you mean. This is a rough diagram

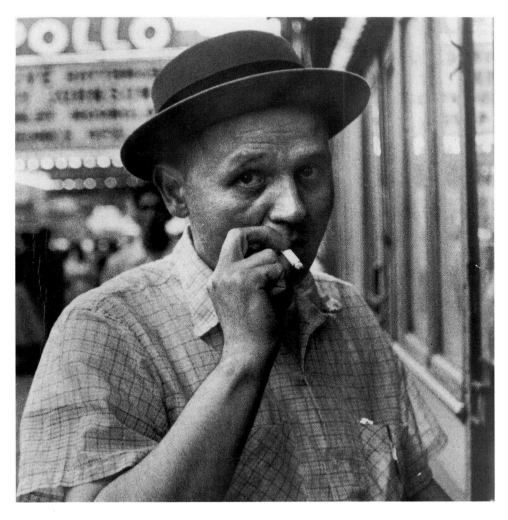

Bearden in front of the Apollo
Theater, New York, 1952.
Photograph by Sam Shaw

of the picture—with the horizontal directions in red, and verticals in blue.

I have probably stressed the verticals and horizontals more than the big in and out movement, but you can see what I mean by the pattern of these forces—which, surprisingly enough, as I look have a sort of musical beat and do actually serve as intervals.

Yes, I also see why this discovery of yours can be important, I think of several reasons.

(1) The intervals can be the sustaining beat of the picture rhythm we have so often spoken of.

(2) The movement in and out can act as the thrust diagonally that establishes the volume, instead of tilting the center plane as the cubists did.

(3) The horizontals and verticals can indicate the plane— that is, help bring the moving rhythms back to the flat.[32]

Bearden's reply to Holty's letter is an excellent illustration of the way in which he was attempting to integrate an analytic breakthrough into his own art by synthesizing Holty's insights in order to arrive at a new way of seeing. How polite Bearden was as he related the importance of the discov-

ery—which he credited to Holty—to the handling of intervals in relation to rhythm; the movement in and out as the diagonal thrust; and the horizontals and verticals as the forces holding the frontal plane. In essence, he had just hammered out the spatial aesthetic which would sustain him through twenty-five years' work in collage.

When he wrote to Holty again [c. end February 1949], Bearden described his struggle with problems of conception and structure:

I find that I'm beginning to understand the plane much better—which I think you'll see in my latest things. What concerns me is when I move about the entire surface adjusting the planes, and trying to get certain shifts going across each other, I run into choppiness (like Gris). I believe I have a tendency to overwork. The picture comes like a great puzzle that I hate to leave. So now, I can only do one watercolor a day. I make a lot of little pencil sketches while (and before) I work, but when I get going I constantly see new chances—but the work gets overloaded. Often, when I do the whole thing over, using what I think are the best directions, the whole picture looks good—but this is such a tedious procedure. Actually, I'm pretty exhausted when I finish an evening's work.

Maybe at some time or other you might have experienced the same thing—and what did you do about it?

Actually, I see whole new vistas opening up. For instance, the other night Jean and I looked at a Brouwer reproduction, and she did a little thumb-nail line analysis of it. Then I began to see things—look at the wedge-like plane that makes the man sit. Look at the curving rhythms around the man's body—into the guitar and down in the jug on the floor. . . . How do you get all these things so that it looks (as Sam [Kootz] used to say) "like it was blown on." And sailors refer to the sea as that "ole devil sea."[33]

When he wrote to Bearden on May 14, 1949, Holty referred to Kootz, who he felt had used him badly, and Bearden's allusion to the "blown on" look, with great irony. Holty realized, as perhaps Bearden did not, that Kootz had done them both a great favor when he let them go. Moreover, he understood that Bearden was talking about the need for freedom in his reference to the sea: "That freshness, that 'breathed on' appearance is the result of freeing 'something' and the breath that breathes is a sort of last gasp." He also realized that his friend and protégé was at an impasse:

My insistence on your going away does not imply any dissatisfaction with your work. I think it is very good and I know it will be grand one day. It was O.K. for Kant never to move more than 20 mi. from the place of his birth but he wasn't a painter. What you need now is banquet after banquet for your eyes. You are what you are but one has to be more than oneself. I wish I had been more willing to entertain other worlds when I was young. That was my fault and that's why I have to wait as long to grow full.[34]

The other world to which Bearden would travel, it turned out, was across "that ole devil sea"; the breath of freedom was a *brise marine*; and the banquet that would feast his eyes was being held in Paris.

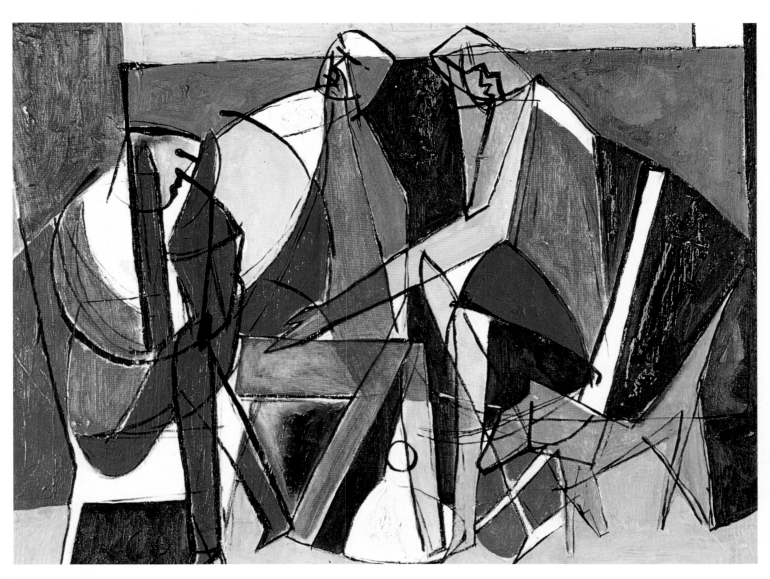

Poor Thirsty Souls. 1946. Oil on masonite, 26¾ x 30¼″. Private collection

SEA BREEZE: · THE 1950s

PART 1: PARIS

The flesh is sad, alas! And I've read all the books.
Flee! far away to flee! I sense that somewhere birds are drunk
Suspended between unknown foam and skies!
Nothing, not the old gardens reflected in eyes
Will restrain this sea-drenched heart
Oh nights! nor the lonely light of my lamp
On the paper void that whiteness protects
Nor still the young wife nursing her child.
I shall go! Steamer with your swaying masts,
Weigh anchor for exotic wilds!

—*Stéphane Mallarmé[1]*

Opposite, above: Bearden and Friends. USS *America* crossing, 1950. Bearden, wearing hat, center; the poet Myron O'Higgens at right. Photograph by Morgan and Marvin Smith

Opposite, below: Americans in Paris, 1950. Marvin Smith, center; Bearden (wearing hat) next to him. Photograph by Morgan and Marvin Smith

As late as 1950, the center of modernism seemed to Bearden to be Paris. The giants of the revolution in art were still working and even teaching there. Good friends like Carl Holty and Stuart Davis had told him a great deal about their sojourns in Europe during the 1920s, so life abroad, he felt, would not be completely unfamiliar to him. Moreover, American artists, black and white, had proven that Paris was a city in which one could feel welcome (Richard Wright had been invited to live there by the French government), practice one's art while living reasonably well, and grow artistically. No longer the postwar Paris of Hemingway and Fitzgerald, it was now the Paris of such painters as Robert Rauschenberg, Herbert Gentry, and Robert Breer; musicians like Sidney Bechet, Kenny Clarke, and Don Byas; and writers like Richard Wright and James Baldwin. This post–World War II Paris beckoned.

The artists who came to live and study in Paris in these years were often veterans in their mid- to late twenties or early thirties. Their experience of the Great Depression and the war gave their generation a special character. They were as different from their predecessors, the post–World War I generation, as they were from their successors, the "beats" of the mid-1950s and the "flower children" who joined at the barricades in May 1968.

If they were eligible for benefits under the GI Bill of Rights, they could receive $75 monthly (the equivalent of about twice a French worker's monthly wage at the time) for tuition, supplies, and room and board, provided they studied at a school approved by the United States government.

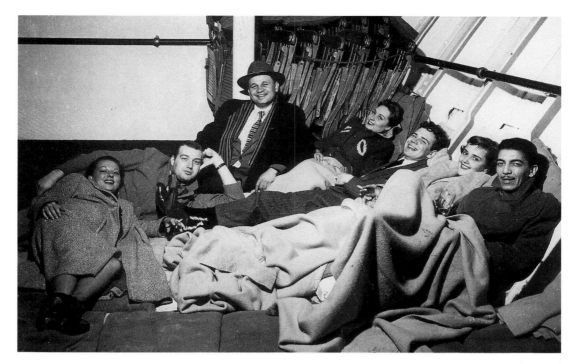

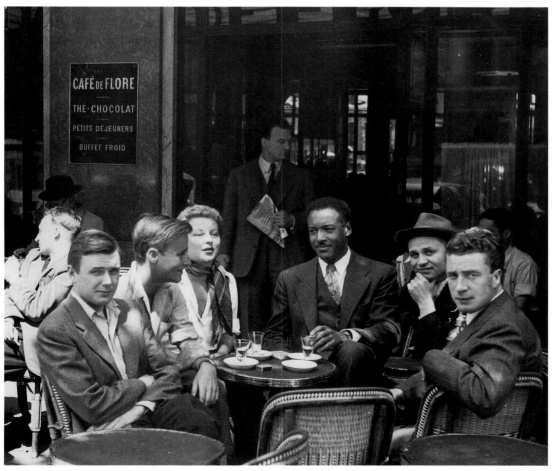

Among art schools in Paris approved under the GI Bill were the École des Beaux-Arts and the Académie Julien, historically the principal alternative to the Beaux-Arts, still conservative in its teaching but without the rigid entrance requirement that all students be proficient in French. Robert Rauschenberg studied at the Académie Julien in 1948, as did the American sculptor and painter Robert Breer (at least nominally). In fact, Breer, according to a recent account, "arrived in Paris in 1949, dropped by the academy once a month to fulfill the attendance requirement and pick up his check, while actually studying with the sculptor Ossip Zadkine at the Académie Colorossi." Several doors down from the Colorossi was the Académie de la Grande-Chaumière, a gathering place for many American artists from the 1920s, when Betty Parsons and Alexander Calder were students there, to the late 1940s, when Herbert Gentry both studied and taught there. By 1949, more than two hundred Americans were studying art in Paris under the GI Bill.

The climate of Paris in the years immediately preceding Bearden's arrival in 1950 is described by his friend Gentry as a very special ambiance combining school, camaraderie, painting, and jazz. Like Bearden, Gentry lived and painted in 1930s Harlem, where he began his studies under the WPA Federal Artists program. He too served in the U.S. Army from 1942 to 1945, but unlike Bearden, who had never seen Europe before arriving there in 1950, Gentry had served in North Africa and Europe and first arrived in Paris as part of the army of liberation. "Everybody was singing and dancing, happy, kissing one another, kissing the soldiers. I'll never forget the perfume. That's the thing in Paris I'll never forget: that aroma."

Two years later, back in the United States, Gentry decided against returning to NYU and opted for Paris. "I went to Beaux Arts, just for a short period, because I didn't like it; it was very stiff. Then I went to L'Académie de la Grande-Chaumière, where I eventually taught painting and sculpture while I was still a student. We all went there; we were very free. . . . We had a wonderful time. We were just going out and looking at the city. It was too much for us to be able to have time to put it down. So we were constantly visiting people, looking at, meeting the girls, and just exploring everything.

"We went to the Louvre, we went to the Musée Moderne, we went to every museum in Paris. I knew those museums in and out. The French opened up, I mean they really opened up to us. You know, it wasn't easy to go to Europe right after World War II because everything was rationed in most of the European countries, especially in France. . . . But it didn't matter to us, because we were young, the city was exciting, that city was so beautiful. The odor, I can smell it now."

Along Boulevard Montparnasse, within three blocks of one another, were the cafes—La Closerie des Lilas, Le Sélect, La Coupole, La Rotonde, Le Dôme—where three decades earlier another generation of *émigrés* had held court: Apollinaire, Picasso, Vlaminck, Max Jacob, Tzara, Hemingway, and Fitzgerald.

"We would sit at the Dôme," Gentry recalls. "It was not only our cafe, it was our office. Wine was very cheap, but still we considered it

expensive so we brought our own wine and we'd stay there and the waiters wouldn't bother us, so we would just hang out. It was the Americans who really made Montparnasse at that period because when we arrived it was very difficult for us to exhibit in Paris, but we gave the spirit to Montparnasse."

In the late 1940s, Gentry opened Honey's Club, or the Club Galérie, in Montparnasse with his first wife, Honey Johnson, an American painter and singer with Rex Stuart's band. Club Galérie was a salon by day and a jazz club in the evenings. In addition to attracting well-known American jazz musicians, the club drew an international clientele of artists and intellectuals: Larry Rivers (who arrived in 1950), Richard Wright, Jean-Paul Sartre, Simone de Beauvoir, Eartha Kitt, Orson Welles, Jean-Louis Barrault, and Marcel Marceau.

"It was a special club: the idea of the club was that a lot of artists were invited there to express themselves and to meet other artists, mostly Americans, but also Danes, French, Swedes, who would come there to discuss art and music, and to exchange ideas. In that place you couldn't say anything against anyone, race, color, creed; you had to be really a special person to go into the place. You had to be hip and sensitive."[2]

This was very much the Paris Bearden found early in 1950. Since he was still eligible for benefits under the GI Bill, Bearden had arranged from New York to study philosophy at the Sorbonne under Gaston Bachelard and Étienne Soriau. The response to his letter of inquiry was affirmative, but the Sorbonne official who replied expressed surprise that Bearden had written in English rather than French, reinforcing Bearden's awareness that whatever else he studied at the Sorbonne, he would have to master the language as quickly as possible. Bearden sailed to France aboard the USS *America* with Marvin Smith and the poet Myron O'Higgens. He arrived in Paris with letters of introduction from Samuel Kootz to Picasso, Braque, Brancusi, Matisse, and Mary Myerson, who ran the Cinémateque Français. Carl Holty gave him letters to the painters Jean Hélion and Hans Reichel.

For Bearden, Paris was a "thing of dreams." One March evening, he went to dinner with the poets Samuel Allen (whom he had known during his army days) and Joseph Menasch. When they finished eating, Menasch suggested that they walk down by the Seine, right beside the river, not on the quai above. It was a hazy, moonlit night following the rain. The floodlit facade of Notre-Dame looked endlessly high to Bearden and his friends from where they stood on the riverbank. The main tower, a symbol of the finger of God pointing to the heavens, was awesome to behold. Bearden knew that Manhattan's skyscrapers would dwarf Notre-Dame, but realized that Paris was a city built on a sufficiently human scale to allow Notre-Dame its majesty. "The cathedral," he told Holty, "is built in such accord with the human measure that it seemed the most immense structure on earth."

At the same time, the change from 125th Street, where he felt he had lived in comparative isolation with his "*chat*," was a great shock to Bearden. In a letter to Carl Holty dated March 9, 1950, he describes his first reactions to Paris and his lodgings in a *pension*, where for forty dollars a month,

he had a skylit studio room, heat, laundry, and three plentiful meals a day, enabling him to eschew the cheap but institutional fare of the student restaurants. His letter goes on to describe his feelings of isolation as an American, analyzing the "not outwardly hostile but standoffish" attitudes of the French as a reaction to the behavior of American GIs during the war. He was keenly aware of the inadequacy of his French: "Then there is the language barrier—so many Americans here refuse to learn the language—so that intimate conversation is only possible with those Frenchmen who speak English. I have been so busy getting settled at school and in a hotel that I haven't visited the Louvre, Cluny, or St. Chapelle as yet. However, I believe that some of my classes will be in the Louvre—so I'll be killing 2 birds with one stone."

Bearden also found the rhythms of Parisian life radically different from those of New York:

Another surprise I had was thinking of Paris as such a gay city, and finding everything closed at midnight. While not completely naïve—we Americans feel that women will be breaking into doors—mad artists' balls take place all the time, etc. However, few Americans are intimate with the average French girl—they go out with other Americans or girls from the Scandanavian countries.

Of course, along Pigalle and the Champs Elysées there are the whores on every corner, but most Americans don't go for that sort of thing. Even they are off the streets by 12.

Bearden concluded his letter:

Then I just can't get my thoughts together yet. I recall that I used to be a painter back in the States, but I'll have to think about what I painted like.

It's a little difficult to get going here, because I'm unused to the complete freedom—where nobody gives a damn what you do.[3]

Bearden arranged to study French at the Institut Britannique, since courses in French language were not offered at the Sorbonne. He first registered for a course in French civilization that was popular among American students, but was told to change his curriculum to courses offered by the Department of Philosophy leading toward the Ph.D. Gaston Bachelard, Bearden's professor of philosophy, was by 1950 an *éminence grise* among academicians at the Sorbonne. Bachelard was an iconoclast who had grown up in the provinces and who had not entered academic life until mid-career. He had established his reputation in the philosophy of science before turning to aesthetics, and was to write at least two seminal works, *The Philosophy of Space* and *The Psychoanalysis of Fire,* before his death in 1962. The material was intrinsically difficult to master: listening to Bachelard lecture in French, Bearden felt himself at a considerable disadvantage.

Bearden wrote to Charles Alston on March 23, 1950, in a much more confident voice. He now felt sure enough of his impressions to describe student life in Paris in a way that he hoped would dispel some of Alston's preconceptions and outlined the French system of medical training for Alston's wife, Myra, a physician. By this time, he had begun to discover

some of the advantages of Paris: cheap art supplies, half-price student fares at the opera and the movies, inexpensive travel, and the custom of the *garçons de café* to compute each person's check separately, making it unnecessary to pick up the tab for women. He cooked on a little alcohol stove in his *pension* room, and had even grown accustomed to French cigarettes. He had also started to acquaint himself with the museums and galleries.

I've seen a great number of shows—and of course the big museums. The quality of painting among the younger men here is not too promising and I think the Americans are doing better on the whole....

I was overwhelmed by the sculpture in the Louvre—What would you think of Assyrian bas-reliefs, and figures 30 to 40 feet high. Sculpture from old civilizations in the Mesopotamian Valley that I'd never heard of. Magnificent tombs from Phoenicia—Greek vases and sculpture by the thousands. I walked all day, not pausing to look very long at anything in particular, and didn't cover the whole building. Then, there is the Oriental Museum, with sculptures from Java—China, etc. The Museum of Man, with wonderful African sculpture. The Cluny, with the old tapestries, and so on.

The art galleries for the current shows are not set up so formally in Paris. On this side of the river, they're mostly located around the Academy Beaux Arts, and the butcher shop, or book store, is right next door. The shows are advertised in all the cafes, and wherever bills [and] signs can be posted.

Bearden continued to be frustrated by his lack of command of French, and he lamented the affectations of some of his compatriots:

One bad feature about Paris is the great number of American students here now. They've affected all the mannerisms of Bohemian life as they've read of it in Henry Miller. If you think some of the characters you saw in the village were something—you ought to see these boys—with ear rings—long beards—looking like actors in a road company of La Bohème. But it's amusing, because they're rebelling against the restraints and negative aspects of America; unfortunately so much of their energies go in the rebellion that they're unable or incapable of acting positively towards those things that Paris does offer.

I know you hear, or have thought yourself, "When I get to Paris I'm going to be among Frenchmen." This is not easy, for the French are rather reserved by nature and do not as a rule like Americans. However, the boys of color are much better received.

Implicit too in Bearden's letter is the danger he felt in the absence of a more positive, creative tension necessary to his art.

Paris is a wonderful place for a person who has some direction, and is not impelled to loaf in relation to the great freedom. By that, I don't mean the lack of racial feelings, but something that is almost intangible until you experience it yourself. You can sit down at a cafe, no one bothers you, it's hard to find a waiter even to pay your bill—no one would say "You lazy bastard why don't you paint

a picture, or write a poem"—if you were there 6 months. In America, as you know there is the constant justification of yourself being an artist in the first place—and there's none of that sort of tension here.[4]

By the time Bearden wrote to Carl Holty again in early April, he was considerably more comfortable in Paris. In the monthlong interval since his last letter, as his correspondence with Alston makes clear, he had gotten to the Louvre and to the galleries where the younger artists were showing. In this letter to Holty, Bearden describes a "crit" given by Fernand Léger. He was unimpressed by the great French painter's teaching and suggested to Holty that he return to Paris to set up his own *atelier*, perhaps to teach American GIs with the sanction of the French government. In one section of his letter, written on April 3, Bearden writes of his visit with Hans Reichel, a friend of Holty's and a close friend of Paul Klee's. Reichel's small watercolors had been shown in America at the Willard gallery, and were, in Bearden's description, "sensitive and good—if Klee-like." Reichel had a small apartment with a small studio downstairs. He showed Bearden a suitcase and told him, "If I went to Shanghai tomorrow, I could take my studio with me." In the top of the suitcase were small sheets of watercolor paper. The case could serve as the makeshift easel of a makeshift studio.

The suitcase was emblematic of Reichel's style of living at the time, for when Bearden first met him, Reichel was a heavy alcoholic. One night, Bearden remembered, Reichel came to see him at rue des Feuillantines in order to talk to him about Klee. He told Bearden that an artist like Klee could never be completely understood unless one knew the man himself completely; even then, Reichel maintained, one's perception would be incomplete, for Klee's message was elusive and transcendent. To underscore his point, Reichel poured large tumblers of eau de vie for himself and Bearden. The eau de vie, 100 proof, knocked Bearden out completely; when he awoke the next morning, Reichel was still there talking. He had gone through the eau de vie and about four bottles of wine. Eventually, Reichel stopped drinking. "His kidneys," Bearden said, "made a gentleman out of him."[5]

In another letter to Holty, this one from about April 1, 1950, Bearden writes of his newfound affinity for Paris:

Now at last I'm beginning to understand some of those things you used to talk about—and try indirectly to make me understand of life here in Paris. I've begun to love it here—the strangeness is wearing off & I'm getting used to the tempo. In fact, I'm actually so used to my surroundings, that I'm repelled when I have to walk on a boulevard, or into those places frequented by the American bourgeoisie. . . .

But I really began to enjoy Paris one day last week when I went to an exhibition of medieval Jugoslav frescos. It was an amazing job of presentation. . . . I came out of the museum perspiring and shaking and had to take two cognacs in an effort to collect myself. Then I was saved by the breathtaking Champs de Mars—and a good walk along the Seine. . . .

So the other night I came home late and drew with charcoal,

Letter from Bearden to the author with sketches of Hélion's studio and a sketch after Léger, 1986

something I've never heretofore been able to do—and I drew very well, with rich tones and nice passages felt all over the paper. I'll be able to work in Paris from now on.[6]

Despite his purchase of an easel and his feeling that now he could work in gouache, the activity Bearden was least ready for in Paris was painting. Instead of forcing himself to paint in a milieu that was bombarding him daily with new impressions, Bearden opened himself to the intellectual and artistic life of the city. He enjoyed the camaraderie of a number of American writers, painters, and intellectuals, among them the poets Myron O'Higgens and Samuel Allen; the novelist/critics James Baldwin and Albert Murray; the painters Paul Keene, William Rivers, and Herbert Gentry; the engineer Jim Moseley; and the photographer Marvin Smith.

Bearden also became friendly with the sculptor Constantin Brancusi, whose beautifully appointed studio he described to Avis Berman. In the interview he recounted his adventures shopping with Brancusi, who infuriated shopkeepers by appearing ten minutes prior to the noon-hour closing time of the markets, when prices would come down, to squeeze the produce. Bearden remembers a splendid roast, cooked on the forge at a temperature of "about 3,000 degrees" by Brancusi, who at the time proclaimed himself "one of the world's second or third greatest cooks." Bearden also told Berman of a nearly lethal punch, consisting of dried apricots soaked in cognac, white wine, and a liquor, which Brancusi concocted for a garden party.[7]

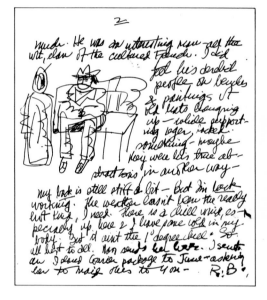

Jean Hélion, who was then married to Peggy Guggenheim's daughter Pegeen, invited Bearden to his *atelier* on rue de l'Observatoire, and was impressed with the work Bearden brought to show him. Hélion had been one of the leading nonrepresentational painters of the 1930s. Then he was in the French army, was captured, and made a rather daring escape, which brought him celebrity outside artistic circles. Bearden had first met him in New York after the war, when Hélion, a close friend of Holty's, came to an opening at Kootz. Hélion's studio had belonged to one of the academic painters of the late nineteenth century and was "like a skating rink," with a balcony encircling it halfway around. In Bearden's description, "it was a studio of studios."[8]

During one of his visits Bearden listened as the wife of László Moholy-Nagy, who had known Hélion for a long while, remarked with surprise that Hélion had changed his style of painting since the war. It had moved toward a figurative, factual medium somewhat reminiscent of Léger, with whom he was very close. Moreover, Hélion was now painting in this style despite the current vogue for nonfigurative work. Mrs. Moholy-Nagy asked Hélion why the change. Hélion replied: "If I have a watch, I'm interested in knowing the time, and not in opening the watch to see the entire mechanism." Hélion's experiences during the war, it was clear to Bearden, had altered his sensibilities as a painter.

Bearden and Hélion grew close, and in an attempt to help him further his career in Paris, Hélion gave Bearden three letters of introduc-

tion to dealers in the city. Bearden never pursued the opportunity, however.

At the cafes along Boulevard Montparnasse, Bearden would see artists like Alberto Giacometti and Henri Matisse. Giacometti and his brother Diego were accustomed to eating at the Sélect every night. Once Bearden was sitting at the Dôme when Matisse passed by, supported by a young man, and a young woman, perhaps a model, on either side. "A waiter hollered something like, 'He is passing by,' " Bearden remembered in interviews. "All the waiters ran to the front of the cafe and started clapping. He [Matisse] was oblivious to what was happening until the young man said, 'That applause is for you.' Matisse was delighted and started to smile. He walked over to the waiters and shook hands with them. Then all the people were reaching over to shake hands with him. I thought, 'Isn't this wonderful. They're not applauding a movie star, but a man who changed the way we saw life because he was a great painter.' After being in the States, Paris was a miracle because things like that could happen."[9]

Albert Murray remembers first seeing Bearden at La Coupole: "Romie was with Myron O'Higgens, the poet. I couldn't tell if he was a Russian or what. But then he put his head back and laughed, and I thought, 'Nobody but a Negro man is going to laugh like that.' Romie already knew everybody, it seemed. He was going to all the galleries, looking in all the shops, being part of Paris."[10]

Bearden came over to Herbert Gentry's Club Galérie also, mostly during the day, and he and Gentry became close friends early during Bearden's stay. "I would take walks with Romare, in Montparnasse, in the *quartier Latin*, and I was amazed that Romie knew so much about the history of France. In later years, I lived in Europe, and when Romare came to Paris, we would meet and take long walks in the Jardin du Luxembourg. Do you remember all those busts in the Jardin du Luxembourg of the great, people like Voltaire? Well, Romare knew exactly every name; no one knows that! And so we used to kid him. So Romie said that when he was in Paris that's what he did: he didn't paint in Paris; he just went around and investigated everything."[11]

Still, during his nine-month stay in Paris, Bearden was constantly thinking about his art. As another mid-spring letter to Holty shows, he was particularly concerned about the possibilities of color in relation to form and to the flat surface, for which he had always had a predilection.

I've been twice already to see an exhibition here of German primitives. Wonderful painters—and the paintings are as fresh as if they had been done yesterday. . . .

It was good to see some men who could paint with force, and yet build their mansions on form and technique. The Frenchmen are packing L'Orangerie to see the show, and I laugh to myself, saying, "Look you grey-bellied bastards, who drove out every real colorist that France ever had, at artists who aren't afraid to use a real green and red without first dipping the painting in a gray rinse. . . ."

I'm well into finishing both chapters of the book [The Painter's Mind] *and I've had time to read and think a bit. More and more I'm certain*

that (our idea?) of the surface is correct. It'll be grand when I can get the colors to walk about the picture like free men and not isolated in certain areas like people with smallpox. But to find those controls whereby the colors can act like free men and not exist in a state of anarchy.

To find the answers to problems like this is all that really interests me. On 125th St. I used to wonder if such an endeavor was worthwhile, but now I know that it is one of the few important things in life. . . .

But the idea is, that art is done in relation to a need, a place, and a circumstance. And it appears that America doesn't want the real artist— after all what country has so many foundations and scholarships to help the artist. I'm beginning to see what you used to mean, and how you shocked people, art isn't a palliative for maladjusted morons, nor an escape, nor does the real artist want a yearly handout and a pat on the back. This is a proud career. And while these Europeans aren't going to break their backs helping you, and have but little more interest in art than the American, somewhere there's the feeling that painting a good picture is as important as pulling an abscessed tooth. Two of the things that are most difficult to take out of France are money and paintings, so they take this art business rather seriously. And if one could get enough money to pay the rent, I do believe they'd leave you alone.

Then too, [it] is necessary to be here awhile if you're interested in art, because most of it was done here.[12]

Since 1950 was a "holy year," railway fares to Italy were cut in half to encourage pilgrimages, allowing Bearden to take an extensive tour. During the summer, Bearden journeyed through much of Italy and saw a great deal that reinforced his feeling about art in its proper setting. Traveling by night in order to avoid hotel costs, Bearden was able to stop off at Saint-Tropez, where Nellie Barnes, whom he knew from New York, offered him the hospitality of one of her two homes. From there he traveled to Juan-les-Pins to see Picasso. People stopped by all day to see the master. "It was like going to see the Eiffel Tower"—a colossal tourist attraction.

"Art goes where energy is," Bearden wrote ten years later in a letter to Holty, "and Paris seems a tired place." The painter Larry Rivers, who was a veteran of twenty-four or twenty-five when he reached Paris that summer of 1950, agrees. As he said recently: "Paris in 1950 was still an 'up' atmosphere. There was enthusiasm for the whole scene, but after that I think it shifted to New York in a funny way—because of the painting. Nothing was happening there, and more was happening in New York; there was more money and more interest. . . . The center changed; it was going the other way."[13]

Bearden himself came to the feeling that the focus of creative energy was changing, and made plans to leave for New York at the end of the summer. He would return to Paris once more for three or four months the following year, and not thereafter until the early 1960s with his wife, Nanette. On that trip, he wrote Holty:

This doesn't seem to be the same place in many ways that I left 10 years ago.

Empress of the Blues. 1974.
From the *Of the Blues* series.
Collage with acrylic and lacquer
on board, 44 × 50″. Collection
Mr. and Mrs. George Wein

Now Paris is a very prosperous city. . . . Nothing is cheap anymore. In going around to the art galleries, I was appalled. Really bad stuff. Of course you can expect the landscapes of Normandy, and the palette knife views of the Seine—but even that work which attempts more is quite bad.

Do I sound disillusioned with the city—Well not altogether. But I feel that something has got to start shaking here.

Sometimes the past—the lovely old apts and houses, etc, and the spirit of those places can sit too heavily on one. Houses alone can kill you. Here are places built to listen to Mozart, and delicate chamber music. And now, when there is this great affection over here for jazz (and I speak not just of the music, but the jazz spirit) you feel an anachronism, whereby something must change.

In other words, there ain't nobody trying anything new. . . .
I don't know, now, if I would want to live in Paris; New York, at this time in history, is far more alive.[14]

The day before Bearden left Paris to sail back to the United States as he had come, tourist class, he dashed around Paris in a last-minute search for art supplies. He was not to make use of these supplies, or of the theories of color about which he had written Holty, for years. But when he finally did, it represented a renewal of his creative energies, first by way of a decisive return to his own painting in the mid-1950s, and later by way of a decisive transition toward collage in the early 1960s.

But on that last day in late summer 1950, before Bearden was to set sail, Albert Murray remembers: "His eyes got more and more moist the later it got. 'This goddam Paris,' he kept saying."[15]

Soul Three. 1968. Collage.
44 x 55½″. Private collection

Tedium, ravaged by cruel hopes,
Still believes in the handkerchiefs' supreme farewell!
And the masts, perhaps, inviting storms,
Are of the kind that wind inclines to shipwrecks
Lost, without masts, without masts, or fertile isles . . .
But hear, oh my heart, the sailors song![16]

PART 2: NEW YORK

(Sensuous Beguine):

In dreams I see you plainly—
Awake there is the pain,
I find only your mem'ry—
To guide my blind ecstasy.

Adoring—unending—
I'll keep on searching for you.
For are you real or a dream
That won't come true—"Who Can Say?"[17]

170

SONGWRITER

In Paris, a neighbor of Bearden's at 5 rue des Feuillantines was a cartoonist who sold his work to European magazines and traveled widely. It seemed to Bearden that every time he looked around, the fellow was off to some new destination. "This is marvelous!" Bearden thought to himself. "He could go to Shanghai, all over, and do what he's doing." Before leaving for Paris, Bearden had applied for a Fulbright grant. It represented a dream of life abroad with a bit more ease than the monthly GI Bill stipend would allow. In Paris, he had been assured that he was a strong contender for the next round of grants, but he was told that he must first return to New York. He would then travel to Paris in September with the entire group of Fulbright scholars, and would be obliged to matriculate at an *école des arts decoratifs* to study vitraux—ancient stained-glass windows. Bearden said, "Fine!" and returned to New York.

At the Fulbright office back in New York, the story was different. By reason of his age, Bearden had been listed as an alternate in the event one of the grant recipients pulled out. This was more of a letdown than Bearden realized at the moment.

Samuel Kootz had closed his gallery two years earlier, in June 1948, reopening it in September 1949 with "Intrasubjectives," an exhibition (in which Kootz collaborated with Harold Rosenberg) that in effect announced the membership list of the avant garde. Baziotes, De Kooning, Gorky, Gottlieb, Graves, Hofmann, Motherwell, Pollock, Reinhardt, Rothko, Tobey, and Tomlin were each represented by a single canvas. The catalogue introduction set the agenda for Abstract Expressionism, a movement whose name was yet to be coined: "The intrasubjective artist invents from personal experience, creates from an internal world rather than an external one. He makes no attempt to chronicle the American scene, exploit momentary political struggles, or stimulate nostalgia through familiar objects. He deals, instead, with inward emotions and experiences."[18]

The rejection of work too closely aligned with the School of Paris in favor of the nascent "New York School" established its own tyranny of taste. As one critic put it, in reopening without Bearden, Browne, and Holty, "artists who found it difficult or impossible or were unwilling to omit from their work humanistic (therefore recognizable) aspects," Kootz had made a judgment. "Kootz felt these artists' lingering dependency upon Cubist structure incompatible with what he (and Rosenberg) saw emerging (and desired to promulgate) in American art, a tendency away from nature as source and one turning inward instead."[19]

Because he had gone to Paris, and because, unlike Browne and Holty, he owned his unsold work, Bearden averted the possibility of seeing the prices commanded by his art, even such as they were in 1949, lowered as the capricious winds of taste began to shift. Back in New York, Bearden must have twinged inwardly when Kootz unceremoniously disposed of hundreds of works by Browne and Holty (322 in all) at a "50 percent off the Dealer's List Price Sale" through Gimbel's department store in November

Gospel Song. 1969. Collage, mixed mediums on board, 40 x 30″. Memorial Art Gallery of the University of Rochester, Marion Stratton Gould Fund

1951. As one critic commented, "Collectors who saw these artists disgraced hastened to sell off their works to other galleries."[20] Holty himself was extremely upset by the Gimbel's sale, Bearden recalled. "He certainly felt that it had hurt him sales-wise and in the art world's price structure. Carl had to take teaching assignments and lecture tours in order to support his family." These posts took Holty from Georgia to Washington University in Saint Louis; to Florida; then to Berkeley, California; and finally to Brooklyn College, where he was granted academic tenure and taught until his death in 1973.

Holty, the German intellectual, had H. L. Mencken's rousing but virulent contempt for the "booboisie." Nor did Holty have much more hope for the minds of his students. "After all, I am more or less at or on the assembly line of that factory (the American College) that trains children to remain children forever."[21] Still, the teaching and lecturing allowed Holty to go on painting, and his output was vigorous. Possibly because he was so far removed from the New York art scene through the early 1950s, Holty was able to continue growing as an artist.

The humiliation was felt more keenly by Byron Browne, whose prolificity during his years with Kootz further lowered the Gimbel's "bargain basement" prices of his work. Browne suffered a severe heart attack on February 19, 1952, one from which he never fully recovered.

Browne could have been speaking not only for himself, but for Holty, Bearden, and Stuart Davis as well when he differentiated his lifelong predisposition for Cubist structure from the prevailing trend in American art: "I like that art best which shows the consideration of planes and the integration of planes, the movement of planes and the integration of planes. That, for me, is true painting. I do not care for the overemphasis on texture through dribbling, smudging, etc. which constitutes so much of the half-realized type of picture that so many artists do today."[22]

Bearden's reaction, in retrospect, especially regarding his and Holty's place in the shifting artistic currents of the 1950s, was made explicit in an interview:

In my opinion, possibly in an effort to free himself from what he considered the restraints of completely non-representational style (such as Mondrian's), Carl's work became a bit too subjective. I believe he would have found more insight if he had remained in France. His small watercolors, some of which I have, were little masterpieces. [In Europe], he would have attained the stature of some of the great twentieth-century painters, because his orientation in everything was more international, rather than, for instance, [that of] Stuart Davis, who abstracted the American landscape, its color, its tempo, and its rhythms.

Where previously there had been only a few galleries showing postwar American paintings, certainly by the mid-1950s there were a number. And most of the painters were involved in the movement that had by now become Abstract Expressionism. For me, the trouble is the word "abstract." Except for a few masters of the genre—De Kooning and Rothko, for instance—I find there is a billowing in many canvases painted in that manner. For instance, if the top is

blue, and the bottom orange, the painter might not represent any familiar subject, but has surely created the effect of sunlight. So there is this "atmosphere" that you see in the use of receding and advancing colors that are not properly oriented, making for deep vistas.

Rothko was different—he and Barnett Newman restricted the coloration into great chords of color without great variations of color value. De Kooning seemed to be an authentic Expressionist. In this period he painted with great gusto and vision.

When I was in Paris, the work of Sam Francis and others was for some reason called "Ecole de Pacifique." In America this was Abstract Expressionism. But this was an indigenous American way of seeing. What comes to mind is color dissonance: throwing, say, violet against orange—the concept of improvisation—letting oneself go—acting on the canvas itself—in a word, jazz. A lot of these painters painted with jazz sounds filling their studios. They didn't need a cattle ranch or an oil rig—most of them were émigrés like De Kooning, or first generation Americans. Rothko was certainly not painting like Chagall. They had come to terms through one of the most positive elements in American culture—its music.

Now I was lost in this. I felt it was not the way that I would want to go about painting. Nor do I feel that one should put up a predetermined set of rules about what to do or not do in painting. At my studio at the Apollo, I found the music more interesting, and although I couldn't see any painterly equivalent at that time, I did see it as a source of great strength and value that was there. Nor, in all truth, did I see all that I now see in it at the time. I did try some experiments with Holty in the use of color—that it sometimes broke open the picture for me—that it seemed to run away and not stay on the canvas. So I just began to work in bigger chords of color that turned out to look like an oriental carpet of some kind.

Then just as color was getting away from me, so did painting as a whole. My aim was to go back to Paris, but like the surveyor (K) in Kafka's Castle, it always seemed to elude me.[23]

In the midst of all this, Bearden went along seemingly unscathed. For the moment, he was out of the fray, for he was not painting with his whole being. Bearden's trouble resulted from his having allowed himself to drift away from his art. Back in his studio at the Apollo Guild, an upright piano was all that remained of a former rehearsal hall. Bearden first approached old friends like Dave Ellis, a composer and arranger; Joshua Lee, a classical composer; the composer Frank Fields; and Fred Norman, a composer and arranger, requesting one favor; "Teach me how to write a song here; I've heard of Irving Berlin and these people who made a lot of money on one hit song." His idea, of course, was to return to Paris, riding the wave of one or two hits. It was a vision worthy of Don Quixote himself.

Together, Ellis and Bearden founded and registered the Bluebird Music Company. Romare also teamed up with Bob Rosenwald, grandson of Julius Rosenwald, the tycoon who had founded Sears Roebuck &

Co. Bob and Romare had been friends in Paris. Both Bob, a sculptor, and his wife, Ruth, were very much interested in songwriting, so Ellis and Bearden would go up to the Rosenwalds' apartment near Columbia University. They shared many good times, but nothing much came of it by way of publication.

In fact, Bearden made no real headway in the songwriting field until he met Laerteas "Larry" Douglas, a newspaper columnist and publicist. Romare was at the Hotel Theresa bar, talking with a Cotton Club chorus girl he knew, when Larry struck up a conversation with her. After the girl left, Bearden and Douglas got to talking. Douglas mentioned that he was a songwriter; he had a company called Laerteas Publishing. Bearden told him that he was trying to do the same thing, but without any success. Before they parted, Bearden gave him his studio address, and Douglas told him that he would come by sometime: perhaps they could collaborate.

Four months later, there was a knock on Bearden's door. There was Larry Douglas telling Bearden to open up the window and listen to the song blaring across 125th Street from the outdoor speaker of a record shop. "That's my song they're playing!" he told Romare. "Now let's see what you've got here." Douglas, who made demonstration records to play for various companies, once showed Bearden how they would sell an MGM executive a song they had written together. "He began to talk to the easel. He said, 'Mr. Murphy, I've listened to you very intently. Now I want you to hear what I've got to say.' It was like a totem to him: there he was, having a serious half-hour conversation with the easel!"

Ultimately, Bearden did publish a number of songs with Larry Douglas and Fred Norman. About twenty of them were recorded, and he became a member of ASCAP in 1954. One song, a beguine called "Seabreeze" (which Seagram's used to promote a gin and tonic of the same name) became a hit in the mid-1950s. It was recorded by Billy Eckstine, the great jazz cellist Oscar Pettiford, and later by Tito Puente, among others:

> SEABREEZE—blowing to the shore,
> Cool—like the perfumed kiss of a starlight
> night; Awakening love that burns so bright.
> SEABREEZE—while I close my eyes,
> Come—touch and caress me then go steal away,
> While my dear one waits near some silv'ry bay.
>
> It seems only yesterday, in that cafe, a tropic
> isle,—Those golden drinks—Icy foamed like
> the ocean spray hear it say,
>
> SEABREEZE—way out in the blue,
> Go—where a thousand stars drop to kiss the sea.
> How bright is the night—where my love waits for
> me. SEABREEZE—SEABREEZE—SEABREEZE.[26]

Bearden, Douglas, and Norman also collaborated on two songs for Billie Holiday, one entitled "A New Tomorrow," but she became ill

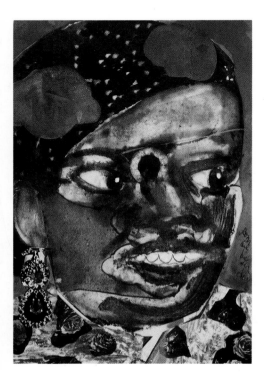

Blues Queen. 1979. From the *Jazz* series. Collage on board, 6 x 9″. Private collection, Southfield, Mich.

and was unable to record it. They also wrote "Mrs. Santa Claus" and "My Candy Apple" for Leslie Uggams, who was then nine or ten years old and had to stand on a box to reach the microphone.

Despite the relative success he achieved, Bearden felt a deep malaise. He knew deep down that he was not cut out to be a songwriter— "I don't think I ever could have been, no matter how much I studied"—and that his was a temperament suited to one dedication alone—painting. Moreover, he realized, "the public knows, or can sense, what is real for them, and the fellow who can speak their language."

European intellectuals of his acquaintance, particularly Hannah Arendt and her husband, the philosopher Heinrich Blucher, whom he had met through Carl Holty, could not have agreed more. Blucher and Arendt had an apartment near the Bearden family apartment at 114th Street and Morningside Drive. One Monday evening late in March 1952, Bearden stopped by to see him. Blucher explained that when he had been a student in Berlin in the 1920s, he had supplemented his income by working for a filmmaking house. He had a friend who had written a song, "Two Hearts in Three-Quarter Time," and who gave him work in the musicals for which he wrote songs. However, Blucher explained to Bearden, he had never really been *involved* in the musicals or the fast life of the entertainers. It had simply been a sinecure to help him get through school. "What you're doing is something else altogether, because you're not painting. If you keep on, you're going to ruin yourself as a painter, because you're just not attuned to this."

Bearden described the evening in much more general terms in a letter to Holty of April 1, 1952:

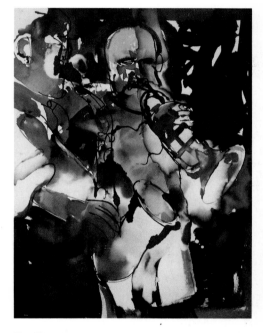

Two Jazz Musicians. c. 1981. Watercolor, 30 x 22". Courtesy Sheldon Ross Gallery, Birmingham, Mich.

Last Monday, I went over to see Blucher, and spent all the evening with him. His wife is in Europe and presently he is all by himself. We had a most interesting evening—and he gave me some good advice about my song writing attempts, which he thought was not too good a thing to do. He said he had a lot of experience along the same lines in Europe and knew [from] his own experiences this was bad for the artist.

So it seems Carl, most of the things the artist can do to make a little money are all bad for him. C'est la vie!

I have been doing a lot of drawings from the model and for the first time I've attempted a large oil on canvas directly from the model. I see why you told me now to try this. I've got lots of ideas—and I want to also work up some large gouaches on brown paper as exercises. Then maybe I can move from the atmospheric, in a succession of attempts, to a stronger statement. Because I find with me, a good deal of the "particular" creeps in to the initial work.[25]

Bearden's 1952 letters to Holty are crucial to dispelling the generally accepted notion that he had stopped painting entirely on his return from Paris, and was devoting himself wholly to songwriting from 1951 to 1954. Bearden himself is largely responsible for perpetuating the myth; one interviewer after another has faithfully paraphrased it and reproduced it in print.

The facts are complex, and indicate great ambivalence on

Bearden's part. In a letter to Holty written the day after the 1952 presidential election, Bearden again described his progress in art: "I have been doing a few drawings and I'd like to complete some more during the next month. I had been trying to work them out as you did, but they don't come out so clean looking for me. I believe I have been trying to make them too large. I noticed that yours are usually not more than twice as large as this paper." The same letter ends with a reference to the elusive dream of returning to France with Holty: "Do you ever think we can get that little studio in Southern France?—'cause the chill winds are blowing now. . . ."[26]

A return to the Continent had become an *idée fixe* for Bearden. As time passed, France became more idealized, a couple of hit songs more gigantic an obstacle, and painting was caught in a kind of no-man's land. Like Blucher, Hannah Arendt warned Bearden that he would wreck himself if he did not devote himself wholly to painting. Bearden must have considered the advice, but he was swayed by the strength of the *idée fixe* he carried about like a lance into an increasingly unreal terrain of battle.

One night after dinner, Bearden developed so acute a stomachache that he called his father and told him he thought he was dying. Similar episodes reoccurred, until he went to see Dr. Aubré Maynard, now head of surgery at Harlem Hospital, and told him that he had stomach cancer. The examination revealed nothing. Bearden returned a short time later, sure that he was having a heart attack, and was prescribed a tranquilizer to calm him.

Soon afterward, Bearden collapsed on the street and woke up in the psychiatric ward at Bellevue Hospital. When he asked what had happened to him, a doctor explained, "You blew a fuse." As Bearden saw it, "What Arendt and Blucher had said was going to happen to me had happened." He described the entire episode briefly in a letter to Carl Holty:

I got ill recently, and of all things a nervous condition. I began to get gas on the stomach, and I thought Lionel Hampton was playing the xylo's on my heart. I was sure I had some kind of coronary failure. But Aubrey gave me a check, and found I had a nervous condition, overwork, vitamin deficiency, lack of rest, etc. Well we all get the jitters in time. But nerve medicine is a new thing for me. Now I'm going to do nothing but paint—no more wildcat schemes to get rich quick with a hit song, etc. Creative work never leaves you with the kind of tension I had built up. So, I hope to be healthier, even if Paris is a little further off.[27]

Around this time, Bearden met Nanette Rohan at a benefit to aid the victims of a hurricane in the West Indies. Although she herself had grown up in Staten Island, her parents were from French St. Martin. Romare and Nanette were married on September 4, 1954, several months after they met, and two days after his birthday. They lived for about a year and a half with Romare's father in the apartment on Morningside Drive. Then, in 1956, with the help of Merton Simpson, a friend who dealt in African art, Nanette encouraged a significant double move: the consolidation of studio and apartment to a fifth-floor walk-up loft at 357 Canal Street on the corner of Wooster Street.

The move downtown was salutary for Romare; he was more

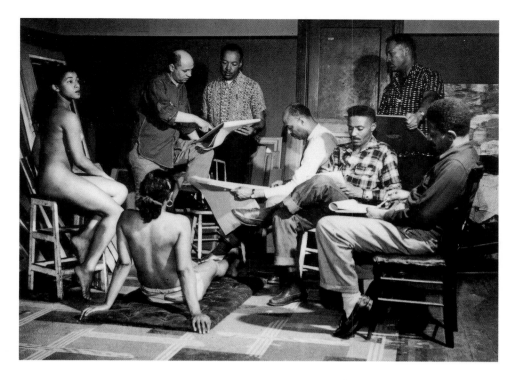

than ready for it. It took him away from the Apollo studio, which had gotten so interwoven with songwriting that uninterrupted painting was all but impossible. Romare kept his old friendships, but he could now paint without a constant stream of musical associates dropping by the studio. He was one of the first artists to move to the Canal Street area. It was a quiet neighborhood

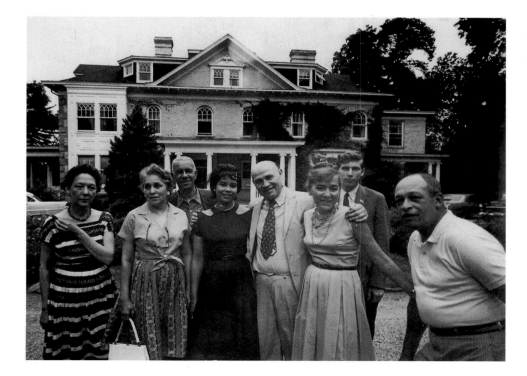

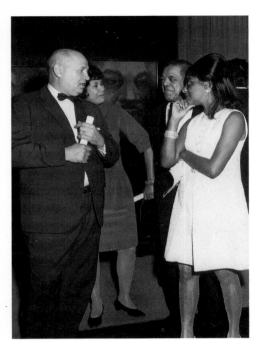

Romare and Nanette Bearden
with Ad Bates, c. 1968

bordering on Chinatown and Little Italy, without the blaring traffic, Soho chic, and glitzy shops and galleries found there today. The streets rolled up at 10:00 P.M. His fieldwork for the Welfare Department left plenty of time for painting and socializing. He and Nanette saw Carl Heidendreich, Arendt and Blucher, and later on Carl Holty, who came back to live and teach in New York.

While they were still living on Morningside Drive, Romare and Nanette became acquainted with Laura Barone, who had been a famous model and, as Nanette put it, "had married into money." Her husband backed a gallery that Barone opened at 202 East 51st Street with a one-artist show of Bearden's work in November 1955. With that exhibition, Nanette recalled, Romare "started back painting" in earnest. The show was reviewed favorably in both the *New York Times* and the *Herald Tribune*.

Nanette's influence on Romare's life was profound. The first years of their marriage not only marked his full return to painting, they also resulted in other healthy changes in his life. Nanette got him to stop taking tranquilizers and to stop smoking cigarettes. Most important, she was a stabilizing presence in his life. It was no easy task for Romare to devote his concentration to painting once more, but as Nanette remarked, he was now again "at one with himself."[28]

CASEWORK AMONG THE GYPSIES

In 1952, when Bearden returned to work for the Department of Social Services, he was assigned New York City's Gypsy population. It was delicate work that demanded understanding, tough-minded compassion, and the ability to avoid being conned.

Bearden teamed with three different partners, Loften Mitchell, a playwright; Frederick Romano, a lawyer; and Leonard Lutzker. At first, each went out alone to work with various families, but so litigious were some of the Gypsies that it soon became necessary to have a partner to serve as a witness. Once, a lawyer for one of his clients claimed that Bearden had extorted a bribe. The woman, a Gypsy who lived in the Bronx, had brought suit against a taxicab driver. Bearden had to bring the department's documentation on the woman before the trial judge, and to do that, Bearden had to charge a fee of $10, which was reimbursed to the city. When his client's case was dismissed, Bearden remembered, her lawyer wrote to his supervisor claiming that the $10 had been a bribe, and that he had called the woman into the office to take money from her. In answering the charge contained in the letter, of course, Bearden was cleared of the accusation: he had records and receipts for all his fees as well as their reasons. After the incident, though, the department determined that it was safest for two people to make the visits together.

Sometimes Bearden and his coworkers would have to go outside New York City in order to render assistance. A Gypsy couple had raised the familiar traffic-accident scam to the level of high art—or craft. On major highways outside the city, the couple would select a likely truck, pull up in front of it, and stop suddenly. The truck would more often than not hit their car in the rear, and the wife would fall out as if she were hurt. After a rapid

exchange of information with the truck driver, the Gypsy would race off to a hospital with the supposedly injured woman. Shortly afterward, an insurance inspector would come and offer a settlement. This went on for a year, until an insurance clearinghouse noticed the pattern. The Gypsy was to go to jail, and although it was outside his jurisdiction, Bearden was called to help.

Other disputes were settled within the Gypsy community, which Bearden came to know as an authentic culture within a culture. "The Gypsies came from India," Bearden told an interviewer in 1968. He had worked with the Gypsies for fourteen years. "From their language they've been traced almost to the exact place in the Himalayas where they came from. . . . They've maintained their own particular culture down through the years. They had their own so-called kings, chiefs, [judges] of their own. In the present day they conduct trials that ordinarily would go to a court—such as divorce. This the Gypsies handle among themselves. Marriage ceremonies, matters leading to monetary disputes between two people are handled in a Gypsy court."[31]

No matter how bizarre, poignant, or conniving the way of life Bearden found among the Gypsies, he saw their unique culture threatened on every side by the encroachment of modern technology and the resultant homogenization of life. Gypsy fortune-tellers had thrived on generations of immigrants who put stock in their prophecies, but first-generation Americans did not share their parents' beliefs. Gypsies had followed the carnival seasons, wintering in New York, but the carnivals themselves disappeared. They were coppersmiths until copper utensils were replaced by stainless steel. As their means of livelihood disintegrated, the Gypsies themselves began to marry outside of their culture. Bearden found it ultimately saddening to see the fabric of Gypsy life steadily eroding during the years he worked among them.

There is a distinct parallel between Bearden's feeling for the eradication of the Gypsies' unique identity and his feeling about the South in which he spent his earliest years. As his work in collage was to show, that South—with its cotton fields, its omnipresent railroad trains, and its universal rituals of work and play—had embedded itself indelibly in his memory. In his account of why by the 1960s he came to focus on subject matter directed to his early experiences, Bearden spoke of "arriving at the space"—the overall design of the canvas. "A lot of the life that I knew in certain rural Negro surroundings is passing, and I set down some of my impressions of that life. It's in a certain sense historical, and has certain [classical] affinities."[30]

ACT OF REDISCOVERY

The early 1950s had taught Bearden a valuable lesson: he could not be at peace with himself unless he lived to paint. He was not sure if he could make a living as a painter, but his work for the Department of Social Services continued to bring in a steady income, and the hours left him ample time for his art. The years from 1955 to 1961 represent a renewal of Bearden's creative life as an artist, and the bridge, by way of experimentation with increasingly nonrepresentational work in oil, to collage.

Overleaf, left: *Blue Lady*. 1955. Oil on canvas, 40 x 31¼". Private collection

Overleaf, right: *A Walk in Paradise Gardens*. 1955. Oil on masonite, 33½ x 29¼". Barnett-Aden Collection of African-American Art, Florida Endowment for Higher Education

Years earlier in Paris, Bearden had reread Delacroix's *Journal* and was strongly affected by its description of constant visits to the Louvre to copy the old masters. "Here, I thought, is a great painter learning something from a method now frowned upon because some of our educators felt—and still feel—there is a genius lurking inside us [that] only needs to be conjured out—but I decided to try that old method."[31] Bearden had copied works for several years, starting with early Renaissance painters like Giotto and Duccio and proceeding to such later painters as Veronese and Vermeer, and finally to Matisse and Cézanne, giving up his own work almost entirely.

With his complete return to his own painting, Bearden found that he had definite new ideas about color. Now, in the mid-1950s, he began to expand his canvases dramatically, painting in an increasingly non-representational manner, and allowing color to give itself free rein. "I began to put color down in big marks," Bearden said in an interview, "and I found that using the color in this mosaic-like way destroyed the form, opened up the form. And I felt that by using these tracks of color up and down and across the canvas I learned a great deal more about the color's action." The colors could now "walk like free men" because Bearden had found a way of using his friend Stuart Davis's advice: "that in a painting color has a position and a place, and it makes space."[34] Bearden now studied Cézanne's late work, learning how the master worked up, down, and across the canvas, never losing the tension that held the elements together as if a wire had been stretched taut from end to end.

A Walk in Paradise Gardens (1955) shows how successfully Bearden had come to handle color and announces techniques he would exploit in his later work in collage. In this Cubist figure composition, the components of each figure—each leg, each arm, each face, each body—are broken up into several different color planes.

Structurally, the tracks of color encompassing the several figures are held by an oval arc passing through the lower half of the canvas and suggesting a complete oval in the arms and heads of the two central figures. This was a technique Bearden had used repeatedly in the late 1940s, particularly in the Bullfight and the Rabelais series. But there was now a significant difference; where in the 1940s Bearden had relied on ink lines to make the geometry of the canvas explicit, he now used pure color.

A Walk in Paradise Gardens has a collage-like impact. The planes of color that describe the figures are generally executed in the flattest and most saturated of the primary colors; the figures themselves are thrown into prominence against areas of more subtle, layered color. Bearden used the same technique of combining flat areas with more painterly areas in his later collage work, especially from 1966 to 1969, when he began to get away from photomontage and started doing flat-planed surfaces.

Bearden's 1942 gouache *Factory Workers*, a social realist work that had been used as the frontispiece for a *Fortune* magazine article entitled "The Negro's War" (June 1942), was included in "World at Work: 1930–1955," an exhibition of paintings and drawings commissioned by *Fortune* during its first twenty-five years. The exhibition, sponsored by the Ameri-

can Federation of Arts, opened May 12, 1955, at the Arts Club of Chicago and circulated for a full year. In a sense, it marked the art world's "rediscovery" of Bearden. This was followed in November by Bearden's solo show of oils and watercolors at the Barone Gallery. It was his first since 1949.

The Barone Gallery exhibition was a *succes d'estime*. An unsigned review in two separate editions of the *New York Times* characterized his work as having undergone "a sea-change in manner," stressing the "heavily charged" color and rich surface effects of his oils. Bearden "has become primarily a colorist," whose work now shows "less dependence on linear elements" and "a new freedom in his space-filling figure paintings. Sketchiness and linear organization have given way to a looser, more all-over color statement and at the same time his thematic material has been expanded." Three oils were singled out: *Mountains of the Moon* "recalls something of Patinir in its dreamy quality." (Like *A Walk in Paradise Gardens*, *Mountains of the Moon* is a Cubist composition primarily exploiting rich chords of blue in broad planes of color, but unlike the former work it is nonfigurative.) The surface of the painting's lower left corner is built up considerably, layer upon layer, in fractured planes of color pulling the viewer's eye toward it. *River Merchant's Wife* was also noted for the figure's "persuasively oriental swirl in the richly broken color." To the reviewer, the figure "seems to have stepped from the pages of an old Chinese legend."[35] Indeed, she probably had: Ezra Pound's widely anthologized translation of "The River-Merchant's Wife: A Letter" by Rihaku (Li T'ai Po) was likely the inspiration for Bearden's work. Both the *Times* and the *New York Herald Tribune* singled out *The Oracle*, which, for the *Tribune* critic, transcended Bearden's other oils. In *The Oracle*, the reviewer wrote, "form rises above the washes of color to retain its solidity." As for Bearden's bright watercolors, the *Times* found them "quite abstract in their fluent interpenetrating washes," yet suggestive of "remoteness in space and seasonal moods. Mountain contours and loneliness are implicit in these statements, which are intrinsically and appealingly decorative." If in his oils Bearden had achieved a breakthrough, his watercolors had not lost their impact. Bearden was back.

After the move to the Canal Street loft, Bearden met Mr. Wu, a bookseller who had a shop on Bayard Street. Although Mr. Wu was not an artist, Bearden regarded him as a master teacher of Chinese art, a great aesthetician. Bearden began to study with him informally, and through Mr. Wu, learned some of the principles of Chinese calligraphy—"The emphasis on calligraphy as an abstract art is valued in China even more than paintings themselves," Bearden said—and painting.

I began to work with him on the spirit of Chinese painting, the perspective. The great landscapes usually use three perspectives: the lower part is as if you were looking down upon it; the middle part, with the philosopher looking at a brook, or something like that, is usually [conceived] as if you were looking at it straight on from the front; the mountains that come at the top are done as if you were looking upward at them. The Chinese concept of the world getting larger as it

Overleaf, left: *Old Poem*. 1960. Oil on canvas, 32 x 25". Private collection

Overleaf, right: *Mountains of the Moon*. 1956. Oil on canvas, 40½ x 31¾". Private collection

recedes from us: from the secure situation of the philosopher or poet, you see the world then is becoming larger. This is in absolute contrast to the Western concept of diminishing perspective. This made for a flatter space, and is more in keeping with my way of thinking of painting . . . because it did away with illusionary space. . . . I began to use some of these concepts in my work at the time. There had been a long hiatus of painting for me, and this allowed me to free myself, to incorporate the color ideas I had in some kind of form.[34]

From Mr. Wu, Bearden also learned about the "open corner" of Chinese landscape painting, usually the right-hand corner, that acts as an entranceway for the viewer, who becomes part of the painting by imaginatively completing areas the artist has deliberately left unfinished. Under Mr. Wu's guidance, Bearden's work in oil took on an exquisite thinness and luminescence. He was now able to achieve within the medium those effects that had eluded him a decade earlier. Bearden's oils of the late 1950s have a kind of translucence reminiscent of his most delicate watercolors. "I would paint, and then take turpentine and wash it out, so a few stains would remain; then I'd paint again—maybe do that two or three times, and gradually build up these faint things." From the late 1940s, when he began to have a feeling for space in his oils, to the late 1950s, when he was able to create space with color, Bearden became more and more interested in "flat space, flatness, the space and the volumes arrived at through something going over something else."

Adapting an ancient Chinese method he had discussed with Mr. Wu, Bearden began to make a transition toward collage by experimenting in a purely formal way with some of the primary techniques of the medium: *déchirage*, or tearing away; *collage*, the cutting and pasting down of *papier collé*; and application of broad areas of color. Bearden brushed broad areas of color on various thicknesses of rice paper of the kind he had searched for so frantically on that last day in Paris. He glued these to the canvas in as many as nine layers. Then he tore sections of the paper away, always tearing upward and across the picture plane. When he found a pattern or motif he liked, he added more paper and painted additional colored areas to complete the work.

During this period, Bearden also experimented with a microscope outfitted with a polarizing element. Certain compounds like sodium chloride or potassium chloride polarized quite well, he found. The polarization continually changed the color with each new lens setting, creating a world "of pure fantasy, of pure feeling, of the unconscious."

In a 1952 letter to Holty, Bearden had articulated a vision of color and light whose shape in his own painting he could discern only vaguely as yet:

I rather envision large planes of light that spell out the form; with the philosophic intent that in a world of darkness we could hardly conceive of form except in a tactile sense. And in a sense, the artist with his colors lights his world. . . .

Possibly the cubists conceived their paintings in the belief that form was integral within the picture frame and needed only development. While I think of some light source that moves across the canvas, pausing to become

yellow, blue, pink, or what have you during its passage; and always yellow, blue or pink according to the painter's desire, so that the effect would have nothing to do with illumination or atmospheric effects.[35]

The emphasis was clearly upon *feeling*. Now, after study with Mr. Wu, Bearden was ready to risk integrating all he had learned by adopting a more spontaneous, more improvisatory approach to the canvas. While his work prior to the late 1950s had been based on a kind of Cubism, Bearden now placed himself spiritually and philosophically in a position of readiness: readiness to take a chance, to be surprised, to play.

No longer painting from a subject in nature such as a tree, Bearden described his attitude in the late 1950s as a way of "coming out from within the tree with your feeling. It was work that could be done by a blind man if he really felt it." "The Chinese felt that color was deceptive," Bearden said recently, "that you could read color better in black-and-white." Eschewing color, Bearden sought what he described as not so much a "true" but an "essential" harmony in which everything in nature is a part. "You want just the two or three right relationships that will *hold* the painting." It was a crucial step toward collage, and presaged the attitude that informs his later work.

If you work in an art, it wants to help you, but you must follow where it leads. Cézanne still needed the information of nature. But like the Chinese artist, he needed the quietude which in any great composition emerges from some other place. The attitude of the great Chinese landscape painters was one of saying to the tree: "I deny you the leaf, but I will not deny you your essence, your harmony with all of nature. So now you are more than yourself.

I now don't "do" a collage in the sense of rational, predetermined composition. I just invite some of the people I knew to come into the room and give it an ambiance. The ambiance [I give the room] must be telling and focused, such as the rectangle of a window or the circle of the sun's disk. This is what holds the work, because it gives it the focused projection.[36]

The attitude Bearden found in the great Chinese landscape painters recalls Holty's heartfelt advice in telling Bearden to go abroad: he must become more than himself. Bearden had followed the advice and gone to Paris; ironically, only a decade later was he in a position to become more than he had been as an artist. It had required a great emptying out for Bearden to finally relinquish the notion that a "*brise marine*" was the answer. His recognition came with the insight that he could accomplish all that he hoped to right on Canal Street, whether by looking through a microscope at a lyrically polarized world of color; by looking back out at the streets, more surreal in themselves than any Surrealist's imagination; or by opening up his memory to the familiar presences of his youngest childhood.

Painting had been the act of recovery, discovery, and rediscovery. Painting in collage, the medium he would transform into a unique series of statements simultaneously personal and universal, Bearden would celebrate the victory.

IN THE BEAR/DEN

• THE MATERIALS OF ARTISTIC CREATION

Over a fifty-year span, Bearden has produced an *oeuvre* that suggests a vision at once highly inventive and rigorously disciplined. Like other creators who have attained mastery over their materials by virtue of a lifetime of self-training, Bearden combines two seemingly contradictory images of man as artist: *homo faber* and *homo ludens*—man the artificer juxtaposed with man at play. How else explain the phenomenon of a worker who arrives at his studio precisely at 10:30 A.M. daily to play with glue, scissors, and paste, inks and oils, spinning out image after image of people he knew sixty or seventy years earlier, people who knock on the door of his imagination and who, invited in, know exactly where to arrange themselves on the surface of his canvases?

Over the years, Bearden worked surprising combinations in a range of mediums: line drawings in pencil and inks; watercolors and temperas; oils on canvas and on paper; screen prints and lithographs; collage in many variations; murals; and mosaics. He limited this range with the exactitude of a playful but rigorous mathematician. In preliminary invention of the controlling rhythms in a large work depicting Duke Ellington, Bessie Smith, and Louis Armstrong, for example, Bearden brought to the studio large graphs of the curves generated by various mathematical functions. He by no means *replicated* these in the work; they simply stimulated his imagination, and perhaps suggested some logical possibilities in a work of a large scale. The credo of Bearden's artistic life is expressed in the value placed on discernment and choice. This is evident in his choice of mediums and in his ceaseless experimentation with the materials of a given medium.

In this interview, conducted early in 1986, Bearden "talked shop" about the various mediums in which he has worked and about the materials and processes generic to them. Almost always, he raised issues that went far beyond the merely technical to a level of discourse that seems to me universal. It is a three-way interview conducted with Gwendolyn Wells, who is herself a painter.

GW: Early in your work, you were using those black lines, like leading—the whole stained-glass idea—and then Carl Holty talked to you about using colored lines instead of those black lines. By doing those lines in color, what difference did that make in terms of composition and the energy of the piece?
RB: For one thing, I didn't stay with that too long. But when I did [do that], I found that I couldn't work in the figural things as I did before, because the

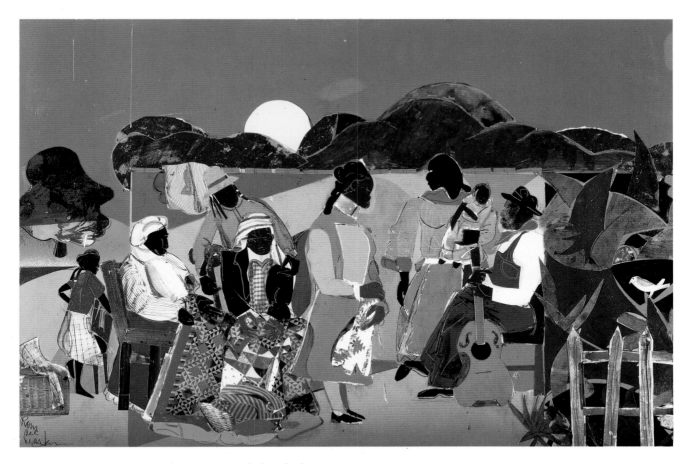

color kept pushing things apart, and this led to a more nonrepresentational work, in that period of time.

GW: But in terms of the line, the function of the line.

RB: That's what I'm saying. That changed, since you use that word, the *process* of doing this totally, because the lines then took on the quality of *forces*, not as what the stained-glass makers used to hold the various colors together. So if, at that time, I had thought of the black line as just intervals, or voids, and designed out of that, instead of all the color and the figures I was doing around it. But I didn't know that at that time; I didn't have experience enough to try that.

GW: It seems in a way analogous to the difference between a drawing, where the line is *it*, and painting. Sometimes when painters use that black line, especially when it's very graphic, chicken-scratch stuff, I think it's kind of a cop-out; that the artist is not really working with . . .

RB: . . . color.

GW: Yes. What they are meant to be working with in painting. So it actually seems logical that that would have been a direction that you would take.

RB: Yes. You know, you just begin to pick things apart, and so it led me to another way.

MS: That had originally been the problem with the oils, back then, right?

RB: The problem with the oils . . . I had never, at that time, worked in oils

Quilting Time. 1985. Maquette for a mosaic glass mural installed in the permanent collection of the Detroit Institute of Arts. Paper collage on board, 19⅜ x 28½". © The Detroit Institute of Arts, Founders Society. Purchase with funds from the Detroit Edison Company

before. And so when I first had to do them, I almost painted the oils like watercolors—thinned down, on a very bright, white gesso surface to give it that same kind of sparkle that the white paper [gives]. But it takes a little time, you know, to get used to painting in oil.

GW: What made you feel that you *needed*, or wanted, to use oil paint?

RB: Well, you could do larger things on canvas, although people have done it on paper. But you would have to paste them on something, and then paste the papers around, say, four sheets of paper to get what you wanted. When I was painting on canvas, I could do something larger.

MS: When you did the double series *Of the Blues*, in the mid-seventies, one was all collage, and the other was all monoprints?

RB: I had one show there where I did the monoprint, but then put collage elements right on top of it. Ekstrom had a show of that. The Smithsonian made a poster of one of them like that, the man playing an instrument. That was a monoprint, but I cut out a collage.

GW: It struck me—when you make a print, you have to deal with the reversing of the image, and so forth. And in a sense, also, when you press down on the paper, there is something slightly out of your control that's going to happen to that image. It's a slightly less direct way of working than putting paint down.

RB: Well, you throw those away!

GW: But a print seems somehow more akin to collage, as opposed to just directly painting on paper. The monoprint and the collage seem closer together in their indirectness.

RB: Well, I didn't do them all like that. I cut out pieces of paper, sometimes, and put them on the paper itself at first, so that when I painted around it, and it went through the press, it had that open space, or edge.

GW: In your work now, when you choose to work in one medium or the other, are there any special reasons that determine your choice?

RB: No. When an artist decides on a *space*, when you get that—we all get a certain kind of space. When I say space, I'm not talking about, let's say, distance; I'm talking about relationships, that you do automatically. When you get that, it doesn't matter what you're working in. It's whatever is convenient to you. For instance, Monet painted the facade of a cathedral, and haystacks, waterlilies—not a whole lot of people would do it. But the main thing was that it meant something to *him*. Do you follow? He applied his idea of relationships to these things. The subjects, or what he took, meant something to him. When you paint, you take something else, because that would mean something to you. A portrait, or something nonrepresentational. Whatever.

MS: So you don't use a medium because of the subject matter. What you are saying is what you said a long time ago: that once you've got the space, the rest flows from it.

RB: For instance, when I'm in the islands—if anything, I would do a small collage, or a watercolor, because the space I had to work in there, until I get the studio finished, would not be conducive to working in oils—on my wife's tile floor!

GW: Myron and I looked at reproductions of your Obeah series, and slides of

the new watercolors you did down in St. Martin. And it seemed to me, in looking at those, that there was a different emotional quality in your use of color in these, particularly with the Obeah watercolors.

RB: Well, you are influenced by where you are. There is a French painter who painted the fog, the harbor scenes: Marquet—he was a friend of Matisse, a great French painter. He became known for his harbor scenes, but if you transported him to Tahiti, or someplace, where he didn't have that, he would paint differently, since he painted from nature, water and things.

GW: I guess what I was sensing was that tropical atmosphere, but also, in the Obeah series, the color, beyond being an obvious indication of the fact that you were in the Caribbean, conveys a real emotional, or almost spiritual power.

RB: That's right.

GW: How would you compare working with watercolor and gouache, in terms of what the paint does? Or don't you now work in gouache?

RB: Yes, I've done some things. Sometimes I combine both. If you want to be a little bit more precise, then you would use the gouache, because it doesn't have the luminosity of watercolor, where you can see the paper through.

GW: Also, the colors mix like oils.

RB: Yes. If I wanted to do something very precise—if I wanted to copy that little collage over there—I'd probably do it in gouache; trace it and do it in gouache.

GW: I see that you're now working on masonite; you have also worked on canvas. Is it just a question of size?

RB: It's a question of *collage*. A gentleman called me from Bard College, and said that he wanted to do some collages on canvas. I told him it wasn't such a good idea. Because when I first tried it, I had to go to a doctor! There was nothing wrong with me; there was something wrong with the canvas: bubbles, and things, on the back. Because you can't press hard enough. You would have to take a canvas off of the easel and put it down. But you must remember that canvas breathes, and that contraction would do something after a while with the work. So that the people who do it—when I first started this, I went to see the backs of some Old Masters paintings that they had at the Metropolitan. And they had staves in the back, to take care of the wood warping when it was pressed against things. When I started doing this, after awhile I would put something on the back, to make a counterpull. And if I was doing anything large, when I would leave, I would put bricks—you see those paving bricks over there?—because wetness is what makes things come up. Rather than canvas, I would now use fabric, because it's more like the canvas, and put it on with an acrylic medium, so it would fuse with the canvas.

GW: Then again, if you wanted to make a gigantic collage, the masonite would be extremely heavy.

RB: It would be too heavy. When you get larger than this size, it would pull off the wall. You would have to do it in another way; instead of doing a collage, paint in oils if you want to get that big.

GW: I'm curious. You said that when you were having these troubles with the canvases, that you went to see a doctor...

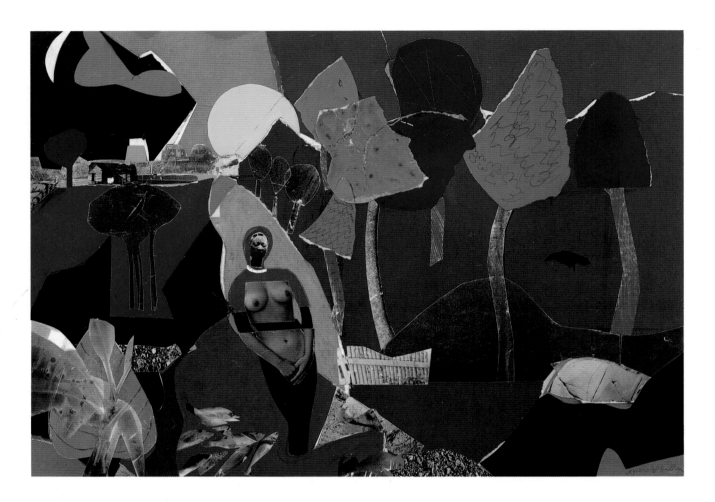

Memories. 1970. Collage on board, 14 x 19¾". Collection Sheldon and Phyllis Ross, Birmingham, Mich.

RB: I went to see a doctor and got a prescription for a hypodermic needle. You had to have a prescription—if you were not a diabetic, you had no business with a hypodermic needle! Because in the back of the canvases, these little bubbles would form, and I could put the glue in the hypodermic needle, and get it into the pocket.

GW: That was a good idea—a bit of ingenuity.

RB: Yes. Well, I knew a fellow who was a conservator at the Museum of Modern Art—I think he is now chief conservator at the Hirschhorn. Since he knew all these things, he told me. I must say that it was not an idea that came to my mind.

MS: When you stopped trying to work with canvas in collage, when you were breaking the stretchers, did you move right to masonite?

RB: I just stopped doing this for a while. And then I tried masonite. When I was working with Jack Schlindler over there, they did things like this, and I could see how they backed it. They showed me how to do a lot of things, because they were displaying, and doing things of this nature. I learned a lot.

MS: What about the glue, Romie?

RB: I use a glue called Glue-Fast; it was developed during World War II by the navy, and it is for paper. The other glues that people use, Elmer's, and so

on, are glues for wood and will burn paper after a while.

MS: Were you using that glue as far back as the early sixties?

RB: Not the early sixties, no. But Jack and the rest used this when they had to mount photographs. That's one of the things that I was mentioning, that I learned.

MS: Did you always lacquer, right from the beginning?

RB: Yes. But I lacquered over at Jack's; when he would do it, they could do it a little better, because he'd put it under a hundred pounds of pressure, and put the lacquer in a place where you could use a spray-gun.

GW: So you had a perfectly uniform surface that way, which unified all the pieces you had put down.

RB: *Exactement!*

MS: You were saying last week that once the lacquer is put on, it heightens the color?

RB: Well, it protects your work.

MS: But does it have any action on the color?

RB: No, if you get the right thing. It just remains there, and protects the color from certain light.

GW: In a sense, though—for instance, if you put a glass over a picture, it somehow equalizes the surface and enables you to look at it, like looking at a glossy postcard. The lacquer seems very valuable, in that it gives the colors equal luminosity.

RB: I think that if I painted in oil or watercolor I wouldn't put anything on it. I think that is one of the things that has kept back our realization of Rembrandt as a colorist, because they put so much varnish on his paintings that it changed him into another kind of painter, which he wasn't at all. So I would leave it. I do this just to protect it—it's very light.

MS: Let me go back to asking you about the forties, and scale—just questions about scale. When we began talking about the watercolors and the oils, in those early series, you did tell me that Holty suggested to you that since you were having trouble with scale in the oils, that you do a sketch and stat it up, and then work with the oil.

RB: I know what you mean now, but when you said "scale" there, that was a different question. I had trouble—I still do—if I do a work and then have to copy it, everything starts getting wrong. So he suggested that from a sketch that I made, I have it blown up, so that it would be scaled up higher. But I think scale is something else again.

MS: Now, when you did the Projections, starting from those original, small collages eight by ten inches or so, and then statted them way up, and then after that, in the late sixties, when you began to work on the Projections, on a scale of three by four feet, did you have any similar problem with scale?

RB: No, because I wouldn't go by a sketch. My trouble was if I made that sketch, and wanted to copy it—some people have a good eye; I don't. It would turn into something else.

GW: I don't know if that's always a problem of just copying or size; sometimes when you do something at first, it's great, because it has all this energy. And

then if you try to go back and do it again, or rework it, it loses that.

RB: Yes, well I have to trace it, you see.

MS: One question Gwen brought up that was interesting to me was the idea of the process of going from a maquette to a mosaic, as will happen with *Quilting Time*. Do you see that as in any way similar to the Projections—small original collages statted up?

RB: Yes, that would be the same.

MS: And does that affect the way you render the mosaic? Let's say comparing the mosaic that you did for *Quilting Time* with the collage.

RB: Well, it would affect things. . . . Sometimes if it gets too large, or something: you would see that what might be acceptable in a smaller work, enlarged you might find a big empty space. It hasn't been a problem so far. Then you would have to do something about it.

GW: How do you visualize those huge pieces? You have to have a kind of a microscopic vision, have the imagination of what that image is going to do when it's enlarged.

RB: If you work in voids, you can avoid that problem. That is, like the Greek vases. While the figures come out, the most important thing is the background. They designed that, you see, and that projects these black or red figures. If you've got that right, you can just blow it up. It's when you are getting into a lot of details, or something, that you find when it's blown up, you have to do something about reworking it.

MS: Way back, had you intended at some point to work at that large a scale? Back in the forties, had you ever thought about it?

RB: It was not something that came into my mind, in the forties.

MS: I mean, friends of yours were working on these huge murals. Stuart . . .

RB: Yes, but I wasn't thinking, myself, of that. I was just trying how to paint a bit, in the forties!

GW: When these mosaics go up, will you be there to oversee what's happening?

RB: Yes. The first part is getting all the colors—they do it in Italy—and bring it over here. And then I'll go up for the final putting it all together.

GW: So you do still have a lot of control; you're there, adjusting the color.

RB: Yes. And then you make a color board.

MS: Romie, this is just a very open-ended question. When you wrote that essay with Al [Murray], for *Leonardo*, "Structure in My Montage Paintings," it was very articulate and very clear about your evolution in collage from about 1963 to 1968. If you were to write a similar essay today, 1986, and describe what had happened between then and now, in collage—as far as your intentions are concerned, the materials you've used, the scale on which you work— what would you say?

RB: Somehow, you ask a good question, but to answer it really well for you, maybe I'll put that on hold, and look at some of the things that I did then and look at some of what I've done now, and see some of the changes, or not, that I might have made. I think, right off, that I still try to hold to the rectangle, which I mentioned in the essay. I still try to do that.

MS: As far as that is concerned: that was a structural consideration that seemed to me to have changed a little bit, maybe, when we got to talking about jazz, and the void, and rhythms. Have you become more concerned with the rhythm of a picture, and the freedom of it?

RB: You see when I used the rectangle to try to structure those terms, it gives a kind of a classical format, or classical set-up. But it restricts a great deal of the movement, that you would find in, say, some of the Venetian painters, or Rubens, or the hunting scenes of the Baroque painters—the spiraling movement of Tiepolo—for something more stable. Not that they weren't great painters, but the rectangle gives you more of a silence. But you can't do that so much in jazz!

GW: It seems like a contradiction.

RB: You've got to tack on track of something else. Because that's another kind of movement. But I did a little bit of it with the portrait of Max Roach—these horizontal lines of varying colors. But I feel you have to do something like that to get something of that jazz feeling.

MS: Do you begin a collage now as you began it then, by putting down rectangles, or do you begin in another way?

RB: All of the ones that I did here, I didn't begin that way. After a while, you should have something in your hand! You don't need to do certain things, after a while. Like the one that you said you liked that was nearly finished—I just started putting something down to see what would happen. Jazz is improvisation, and you've got to get some feeling of that.

It seems to me, when I hear French jazz musicians play, that I can kind of *tell*. The music that they play circles back onto itself, where jazz music, if it's going to go over here, it may take a little digression, but it's always straight, it's linear. It doesn't curve like that. I don't mean to say that Berlioz and Couperin and the rest weren't great composers, but in jazz, it's an American kind of way, and the French jazz musicians would have to come over here and play with a group to get that feeling, that you can't go back, you've got to move on.

GW: It's like learning a language—a musical language, or a color language that you're using.

RB: That's right. I think you put it well.

MS: I can't account for it, but somehow the Japanese hooked onto jazz much more easily than the French. The French have been at it for a long time now, and maybe it's the influence of so much classical music that they tried to hook their jazz into, whereas the Japanese are learning another language.

RB: There is a certain precision in the French—Descartes and the rest, even Seurat. Not like Van Gogh, who let himself go. A French musician doesn't want any surprises, like the ones you have to deal with in jazz. That's not putting that down; they have their own great music. But in jazz—you hit it very well: you've got to learn that language.

MS: Romie, when people look at your collages, one of the comments I hear most often is, "That's really surprising, what he did right there. That piece of color: that was unexpected." How do you keep the element of surprise going?

RB: Well, those are the unanswered questions. I don't know. There are certain things you're better off not knowing!

GW: The mystery . . .

RB: Yes. You'd better stick with that, if that's the case! Until you told me, I never knew that people said that.

MS: People say that over and over. The other question I wanted to ask you had to do with the idea of working in so many different mediums between 1968 and now: working in monoprints and oils on paper; working in watercolor so much, and being down in the Caribbean. Do you think that has influenced the way you approach collage?

RB: Yes, all of those things. Because we are the sum of our experiences. But as I said before, once you get the space, the relationships, the medium doesn't matter so much. Some people don't like the smell of oil, for instance, and work in something else. It's just a personal thing.

GW: So when you put down a certain color, do you choose it visually? Is it based on an emotional reaction? I'm thinking specifically of the things you did down in St. Martin, where the color is so emotionally loaded.

RB: Well, you put down one, and it calls for an answer. You have to look at it like a melody.

GW: Counterpoint or chord . . .

RB: Yes. But I've seen—in a bookstore, or somewhere—a book on color, with the little squares of this or that. And it didn't seem to me to be color at all. It was like big charts. In Paris I had some Russian friends whom I would visit, and they would invariably put velvet in their apartments. They would have green, or tan, reds. And it would be very oppressive to me. And then you would see a French apartment, with the oyster white, the gold, and the blue. It was much more airy. So it was just two peoples. The French probably wouldn't like to live in a Russian apartment—it would feel too closed in, and they're very happy. So each of us has our own way of looking at color, or feeling about it.

MS: I do remember that in that essay, "Structure in My Montage Painting," you spent a lot of time talking about the use of gray as a way of heightening everything else.

RB: Yes. When you run into trouble it neutralizes things.

MS: Do you still feel that way?

RB: Even with the brightest of colors you use in these things, the ensemble should all add up to a certain kind of gray: light gray or dark gray, or whatever.

GW: So you didn't mean literally using gray; you meant the visual addition that gives you a light or dark gray.

RB: Instead of the leading we were talking about before, you use a gray to move from one thing to another, to hold the bright colors in a certain balance. Rather than putting the black line in like before.

GW: Also, you can think of what happens to colors on a gray day. If you have that kind of pearl-gray light, everything is very bright to you when you're outside, especially the greens and yellows are very enhanced by that light.

RB: Absolutely. But I also mean it as an interval, like playing a note, a gray note.

MS: Of the mosaics you've done—there must be about seven or eight, or more of them, by now . . .

RB: That's a whole different ball game when you get into those little spots of color. I have looked at some reproductions of mosaics, old ones, and some of the pieces have fallen away. And underneath you can see the drawing, which is always very simple. It is the movement of the individual pieces, going this way, and turning around on their sides, that gives it that plastic shimmer. So it's good, when you do a mosaic, to try to keep your design rather simple, and let the play of the mosaic . . .

GW: You mean the actual lines of the pieces, say in the curve of a sleeve?

RB: Yes, turning this way and the other. When you're working out the mosaic that happens. I think that's one of the things, when you look at Seurat's paintings of beaches and things—that he takes the most simple elements—a post, a ship—and there isn't too much in it, except for in his big major pieces. But the rest of it he keeps very simple. Those little dots of color—your eye would be jumping all over. That was one of the things I was trying to write about in this essay that I have to write. Sometimes you go to a wedding, or New Year's Eve, or Carnival, and people throw confetti. And it's all of varying colors, and it dazzles the eye. But out of those same spots of color, Seurat organized something.

The thing is that the artist confronts chaos. The whole thing of art is, how do you organize chaos? So when I first started showing work, these nonrepresentational things, or even before, I was very fortunate. I always found someone who would help me. Like Davis, Holty . . . and these lyrical works that I did with Mr. Wu. Because probably, if you take it symbolically, there is no greater chaos than in inferno, down in hell. Dante, in his *Inferno*, meets Virgil after a while. He's lost and confused there, and Virgil says, "I'll guide you, or take you through here." And so I think he is—to me, he is like the artist. This is the help that he needs in understanding what is going on, what he is going through. It's still organized in a way that is different from the other world, because you're going through the various tortures, or whatever. But it's still some kind of organization that he finds. And he's talking about sin, and the rest of these things. But he needs that guide.

So I think it's the same thing with the artist. Chinese painting, when I first met Mr. Wu, didn't have much meaning for me. Then, as I began to look at it, underneath the seeming simplicity was a great, long tradition, and a very complex one, in which so much had been taken away to find the essence of the landscape, which is what they usually painted. Mr. Wu would always humanize everything when I talked to him. He would never say, "You have this, and you need something over here." He would say, "This over here *looks* at that over there." It was always some kind of human thing when I talked with him. So it was not like going to school, or anything, but it showed me certain things that I had never seen, because it was so different a way of looking at life.

GW: It's very big, what you're saying: that it's the artist's mission to make sense of the chaos in the universe.

RB: Isn't it? That's what I think!

MS: Between the time that you studied with Bachelard and the time that you met Mr. Wu, you went through a bad period. I was just wondering—it may be a way-out notion—but do you think, looking back on it, that you had to get to a point of impasse before you would be ready to learn from a man like Mr. Wu, to take what he had to offer?

RB: I think so, because it was not just painting. It would be too long to go into here, but he gave me something once, the Buddhist story of the archer, whose greatness is learned from a master who uses an imaginary bow. The story had many ramifications; we have to go through many things like that, other than painting, so that when I was nuts, or something like that, all these things helped me to understand chaos, and how to give it some order back.

MS: It just seems that at various points, the people who were teachers to you appear. And then there would be maybe an exchange of letters, or the story you just mentioned, or something that happened to you, that would kind of empty you out and ready you for a new experience. For example, I remember an exchange of letters with Carl Holty—he was in Georgia, and you were in New York, and you were telling him about what you were doing. And he said, "I want you to go to Paris. You have to have a new experience. It's not anything negative that I'm saying about your painting; your painting is wonderful, but you need something new."

RB: It was just one of those things. Like Baziotes told me, one time, "There is always something for you. There is always something that will come and happen." It's true for all artists. Picasso looked at African sculpture. This was a kind of guide—not necessarily a person—that he found. You find what you need at a particular time. Or, if you're a jazz musician, and you say, "I'm going to play with Duke." You're good, and when you leave, you're kind of a superstar. There's something to guide you, that the artist must have, because then he understands how to make the order that he needs.

GW: It's knowing how to make sense of the clues along the way, or the people who are there.

RB: They're there for all of us, you see. As Sherlock Holmes said, "I've eliminated everything that's impossible; what's left must be the truth." They're there, but you must take advantage of it. They're there for all of us.

One of the difficulties that we in America have, from the teaching of John Dewey: we feel, and everyone has told us, that it's all in us, and it just has to be released out. Which is the worst possible thing you could tell an artist.

GW: That presents all sorts of ego problems. You have to be receptive . . .

RB: . . . to so much. They've wrecked hundreds of kids in schools. What you're now taught, because of that, is success. In art schools—when they come out, they can do an Abstract Expressionist painting, or a color field painting, and then the galleries are not showing that anymore, and they're stuck. With Matisse or Picasso, they could have done *anything*, if they wanted to.

MS: During the late fifties, when you were working in oil, and had met Mr. Wu, and were studying calligraphy and Chinese landscape painting—you really showed only once, at the Barone gallery, and then it wasn't until Michel Warren that you showed again. What gave you the strength to go on?

RB: I didn't have too much strength!

MS: There was no material success of the kind you enjoyed in the late forties. You were painting, but . . .

RB: I wasn't even painting so much. I was trying to be a songwriter.

MS: But then when you went back to painting.

RB: Going back to painting is very hard. It was *hard* to get started. Because once you stop, it's very hard, just to do the things with the brush that you take for granted now; you don't do it in a long time, you get rusty. And that fast ball that you used to hit is going by you! Yes, it's very hard, to get up off. You shouldn't quit.

GW: So how *did* you get started again; was it Mr. Wu who made you do it?

RB: Yes, that was a great help. And I've always been very lucky; I had Holty, Carl Heidendreich. . . .

MS: What made you attempt to get that lightness in your oils—when you went back to working in oil, you were building up the layers, so that the figures almost came out of the painting: the mid-fifties ones, like *A Walk in Paradise Gardens*. Then they became very, very light, almost with a translucency to them.

RB: You didn't need much. You should read Delacroix, because he wrote down some of his concerns, a lot of them not necessarily about painting: "I have to do the king; he has to be highest, above everybody else." All of the things these people had to pick up. We don't *need* a lot of the things; we use maybe three elements, but they've got to be right. When you see a Matisse, or something, you feel the rightness of that.

MS: You were working with thick tracks of colors, down and across. Then it got thinned out. I guess you've been looking at those more often recently, because they'll be on exhibit, than in quite a while.

RB: Yes, very thin paintings.

MS: As you look back on them now, how do you feel toward that period?

RB: I feel, looking back on them, that if these had been shown then, and I could have carried on and not lost my head, that it would have been one of the big paintings in that style. That when these come out, the people who are knowledgeable will see they're as good as De Kooning's, all of them. I don't mean to boast, I'm just saying this is my objective feeling of looking at them.

GW: You feel they still hold up, that they were successful.

RB: Yes, and that people who have some feeling for that style still will see it.

MS: Do you think that you were experimenting, and going through as many different changes, in that period as earlier and as later?

RB: Yes. Well, as they went on, they became less and less on the canvas. Which is another simplicity that is very, very difficult to achieve, because of the reasons that we mentioned before. They've just got to be exactly right.

POSTSCRIPT

Bearden turned out to be not far off the mark in his estimate of the critical reception for these large fifties abstractions. The works were shown in New York, at the Bronx Museum of the Arts late that year, following the exhibition at the Detroit Institute of Arts.

Michael Brenson's article "A Collagist's Mosaic of God, Literature and His People" (*New York Times*, Jan. 11, 1987) commented on the pieces to which Bearden was alluding:

In the abstractions of the 1950's, Bearden found a new freedom and experimented with a larger scale. If previous works in the show suggest Picasso, Matisse and the School of Paris, the abstractions belong to a decade marked by Abstract Expressionism and Chinese painting, which Bearden studied . . .

The movement in the abstract paintings can be slow, as in "Leafless Garden," where the paint seems to ooze across the canvas like a mudslide. Or it can be fast, as in "The Heart of Autumn," where everything seems to be sucked into or shot out of a vortex. There are intimations of landscape everywhere. "River mist" seems like a collage of natural forces. The blue expands like the sky and crashes like a waterfall. In these works Bearden plays with cut-out shapes, which in his hands seem like pieces of a primal jig-saw puzzle. On an art-historical level, the abstractions are among the richest works Bearden has done.

IN THE BEAR/DEN, PART 2

This interview with André Thibault/Teabo, Bearden's assistant, was conducted on April 16, 1988, in Thibault's studio in New Jersey, about a month after Bearden's death.

MS: You are one of the only people—maybe the only person—who has watched Romie actually *work* a collage through from start to finish, because as we've been saying, he didn't let people watch him work, except when he drew. Could you talk about how he proceeded in working a collage, from step one?
AT: Oftentimes he would sift through books, and they would range from Japanese print art to Persian art, even to photographic essays of the old South, and ideas I guess would start coming into his mind as to what he wanted to do. If [he] were to do a scene that dealt with a lot of landscape, he would get that idea from landscape art. Then he would start with a background color.
MS: Let's back up a couple of steps. Did you see him make a sketch before he ever started?
AT: Rarely. Rarely. He did make sketches at times, but I guess once he had the idea in his mind, the process for him was to get it down on the board—and what I mean by that is not so much in sketch form, but more in color. Romare made a statement to me one time. I was working in a lot of grays, a lot of tonal colors, and he sort of looked directly at me as if to shake me by the shoulders and said, "Don't be afraid of colors. Use colors." And this is what he did when he would start some of these works: pick up a vibrant color. If it was a land-

scape scene, he would pick up a green that at the time I felt was quite shocking; or pick up a blue, a very jazzed-up blue for sky or even water background. But it always seemed to work in the end. That's how he would start most of the time. And then the process became almost mathematical. He would pick areas of the board and start putting in shapes.

MS: Before that, would he lay in a ground? That is, would he use the wood of the board or the masonite as the ground itself?

AT: No. When I talked about the initial color that he would lay down, let me explain that: Let's say you had a board that was twenty by twenty inches, that entire twenty by twenty square would be covered with either a mix of colors or one color, depending on what kind of paper it was. [The color] would already be on the sheet of paper, either a full-size piece of color-aid, or a watercolor. But it was rainbowed—I mean, the shifts of colors were very subtle, almost like a rainbow. When you look from the greens to the yellows to the blue, there's that subtlety there. That's what he liked to work with. If you look at some of the pieces like *The Piano Lesson* (1983), you'll notice that in the background there is that paper being used. Well, that sheet of paper was the first piece he lay down: glued down [on glue] right onto the board. Even though on the finished piece you don't see that much of it, that is the first sheet.

MS: And then?

AT: He would take this sheet—now this is how he did it in the past—and he would soak that sheet of paper [in water] and put it onto the board, back it with glue, and then put it on the board directly, and then he would use a small printer's ink roller, and roll that onto the board. Later on we started using an entirely different technique of applying the paper [using] a little blue scraper. What surprised me about Romare's technique was that he did work on a ground, and the ground was a sheet of color or colors. Then he would start from there. It's almost that he needed that. It would be like priming his canvas, but then if he were to paint on it, what color would he want in the background to peer through now and then? That's how he worked—almost in an oil painting sense.

MS: But in collage.

AT: But in collage. And that's what surprised me. Because my idea of collage had always been that you started with a small image, and then you cut and worked your way around there. What that did for him was give greater room for flexibility. You weren't committed to certain spots, certain areas. You could move through the board, and just go wherever you wanted, and add to the colors. Romare also had a flexibility with the dyes where it was almost like I'd want to say, "My God, you're not gonna do that! You're spilling! . . . Look at all the water on this!" But the end result of the drying process was that, yes, it did belong there. It did create that striking imagery in contrast with the colors that were already down on the paper itself as to the pigment that he added from the dyes on the surface.

MS: Would he pour the dye from the bottle directly?

AT: Oftentimes yes. A lot of times they would sort of spill out. I mean, there was no controlled amount, as if he were to say, "I'm going to use seven or eight

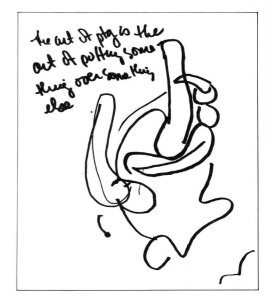

Drawing made for André Thibault/Teabo. 1983. Marker on paper

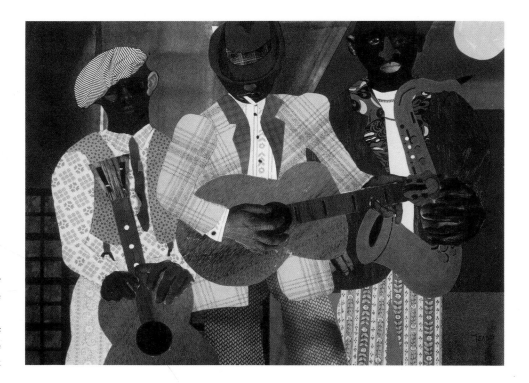

André Thibault/Teabo. *Three Jazz Musicians*. 1988. Collage on masonite, 11⅝ x 15⅝". Based on Bearden's *Three Folk Musicians* (1967). Collection the artist

drops." It was more a matter of whatever struck his fancy at that moment. But what I noticed from that was that it was very controlled for him. He probably could not have answered if someone were to ask him, "Well, how much of the dyes do you use?" He might try and give you an answer, but it's more just something that happened. You know, oftentimes I thought it was a mistake, but it wasn't; it was exactly what he wanted. He knew how to do it, and what the end result would be. That came from years of doing that, and I'm sure also from years of doing pieces that were probably scraped off and thrown away.

MS: Would he pour a dye, and then a second dye on top of that?

AT: Yes.

MS: They would mix and form a pool on top of the cut and pasted paper?

AT: Well, not so much a pool. If you pour liquid over a piece of paper you will get moisture there, but most of the time the paper quickly absorbed it. If you look at the collages, you will see that what that technique did for Romare was give him freedom. It was a quick means of expression, producing a nearly spontaneous result. What always struck me about Romare's collages was that representation of almost total flexibility, total freedom in putting it down—and I don't mean the dyes, or any other single technique in particular—I saw just how strongly he knew how to use color. He had total freedom in the use of color, unlike any other artist.

MS: Did he gravitate toward any color in particular, say blue?

AT: Well, his coveralls were blue, so he must have had an affinity for it. But to answer you honestly, I'd say whatever was at hand. There were days we were picking through garbage cans in the studio to find certain pieces of colored paper that we needed. It was whatever was in the paper rack: if we had ten

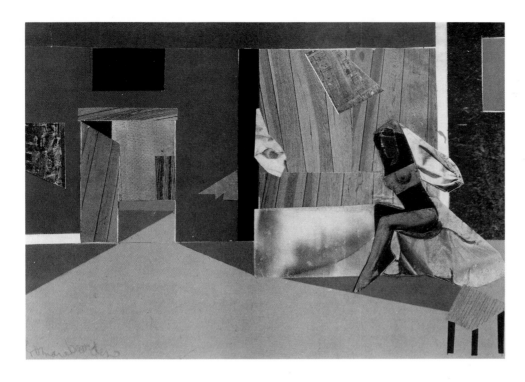

Blue Monday. 1969. Collage of paper and synthetic polymer paint on composition board, 9 x 12″. Private collection

colors to begin with, and we did four pieces, and then there were only two colors remaining to work with, he would make it work. Say we were left with just a blue and a green. Now combining those two pieces of paper, blue and green, and the dyes, we could make just about anything we wanted out of it. So Romare was never thrown off creatively by the lack of a part. If we didn't have it at hand, he would make another part. And that's again the process of improvisation. He used to say to me, "Don't let that piece beat you; let's beat it." He said that to me on many occasions. As we were going along, and a piece was giving us a lot of problems, he'd say, "It's not going to beat us; we're going to beat it and pound it. Let's pound this thing!" Well, as time went along, sure enough, we pounded quite a bit of imagery on that board. To me that was a very important lesson from him. He said to me also that a great artist does not make mistakes: he just works them out. We were never really limited with anything. It was just improvisation, going with it, and making something happen.

It's the equivalent of a musician who has finally mastered his instrument and no longer feels the need for rules, he's paid his dues. "Now let's create our own rules." This is how I felt he was working. As he went along, he was writing his own rules for his own situations, and really letting his years of experience and knowledge move him. Romare's experience and ability were so great that he no longer needed to confine himself to his own past rules. From that point on I think he threw away the rule book and just went ahead with what he knew and what his gut reaction told him to do. . . .

The process may be magical and mystical to everyone but the artist himself. With Romare, it was having the freedom, the confidence, and the know-how to go ahead and create. There are no blueprints!

REINVENTING COLLAGE:
1960–1976

Such devices . . . as distortion of scale and proportion, and abstract coloration, are the very means through which I try to achieve a more personal expression. . . . It is not my aim to paint about the Negro in America in terms of propaganda. It is precisely my awareness of the distortions required of the polemicist that has caused me to paint the life of my people as I know it—as passionately and dispassionately as Breughel painted the life of the Flemish people of his day.

—*Romare Bearden*[1]

Circus (Circus: The Artist Center Ring). 1961. Cut and pasted paper, 26 x 20″. Bearden's first signed collage. ACA Galleries, New York

One bitterly cold November evening in 1959, Arne Ekstrom (the guiding force behind and, before long, the owner of the gallery that would become virtually synonymous with Bearden's art for nearly three decades) and Michel Warren, a twenty-nine-year-old Parisian on the verge of opening his own New York gallery, knocked on the door of the five-story building at 357 Canal Street to keep their appointment with Romare Bearden. He had been recommended to them as a likely artist to be given a show at the new gallery. Brushing the sleet from their overcoats, they began the long, slow climb to the fifth floor.

"The stairs rose to the sky," Mr. Ekstrom recalled nearly thirty years later, "the worst stairs and the worst climb. We were met by Nanette, a young black girl who was slender and pretty; Romare, who was so fair-skinned he could easily be mistaken for white; and Gyppo, their cat. This cat *flung* itself from one painting to another, not tearing the canvas, but gripping the top."[2] The loft was not wide but very long, with a small kitchen at one end and a studio at the other; living space with shelves of books from floor to ceiling along one wall separated the two ends.

The loft was dimly lit, so Romare and Nanette trained spotlights on the canvases. Bearden's oil paintings, large, luminous, almost incandescent abstractions, struck both men. For Arne Ekstrom, this was to be the first of many visits to Bearden's studio.

The Michel Warren Gallery opened in the Rhinelander building, 867 Madison Avenue, with a group show. After this, in January 1960, Bearden was given an exhibition of his large abstractions of the late 1950s, his first one-artist show in five years. The works, at least fifteen, had been given such lyrical titles as *Remembering Golden Bells, The Silent Valley of Sunrise,* and *Wings of the Dragonfly* by Romare and Nanette.

The critics received Bearden's return to the New York art scene warmly. Carlyle Burrows wrote in the *Herald Tribune* that it was good to see an artist "once as well regarded as Romare Bearden exhibiting again." His abstractions seemed "remote and poetic. . . . Forms and colors seem filtered into the canvases gaining remarkable hues and textures as though they were strained through a sieve. Grays and quiet brick-reds are used, with the luminosity of the color of an insect's wing, or the flaring form of a mysterious lovely flower."[3] The *New York Times*, in a brief notice, characterized Bearden as "a virtuoso of texture and of sumptuous and subtle color if ever there was one."[4]

One of Bearden's oils, *The Silent Valley of Sunrise*, made an interesting voyage. It was first donated to The Museum of Modern Art, New York, by what had now become the Cordier-Warren Gallery, and was shown in the MoMA exhibition "Recent Acquisitions" (December 19, 1960–February 12, 1961). A year and one-half later, it turned up on on the office wall of Dean Rusk, John F. Kennedy's secretary of state, the sole visual riveting-point apart from photographs of the president and the Cabinet members. Another Bearden work, *Golden Dawn*, had been hung in Kennedy's pre-Inaugural suite at the Carlyle Hotel (opposite the Cordier-Warren Gallery) alongside works by Degas, Pissarro, Murillo, Gilbert Stuart, and Mary Cassatt.[5]

Cordier & Ekstrom, Bearden's gallery from its inception in the early 1960s to his death in 1988, had its roots in the Parisian art world. Arne and Parmenia Ekstrom had met Michel Warren when he came to a party at their Paris home given for a young painter who had just opened an exhibition in the gallery of which Parmenia was director. Multitalented, full of panache, a painter, draftsman, designer, and expert chef, the twenty-one-year-old Warren charmed the Ekstroms. A few years after their return to New York in 1955 following a ten-year sojourn in Europe, the Ekstroms were glad to help Michel Warren acquire a New York gallery.

Daniel Cordier had been a hero of the French Resistance, serving as secretary to the legendary Jean Moulin. Under constant threat of betrayal and death, Cordier barely survived the Nazi occupation. After the war, and a brief attempt at painting, he opened a gallery with the work of his friends Jean Dubuffet, Michaux, and Matta.

Daniel Cordier came into the picture when Michel Warren traveled to Paris and convinced him, the owner of an important gallery there, to form a business association with Arne Ekstrom and himself. For Cordier, a New York connection seemed a good venture. He welcomed the opportunity to exhibit his artists' work in New York. Moreover, neither Warren nor Cordier had a financial investment in the gallery lease itself.

For about two years, the Cordier/Ekstrom/Warren partnership flourished. Early in their association, Ekstrom and Warren had invited the representational artist Richard Lindner to join the gallery (a risk in the prevailing climate of abstraction), and Ekstrom had also extended an invitation to the sculptor Isamu Noguchi. With these artists—Dubuffet, Matta, Michaux, Duchamp, Lindner, Bearden, and Noguchi—the new Cordier-Warren gallery opened in a colossal (and expensive) space at 978 Madison Avenue.

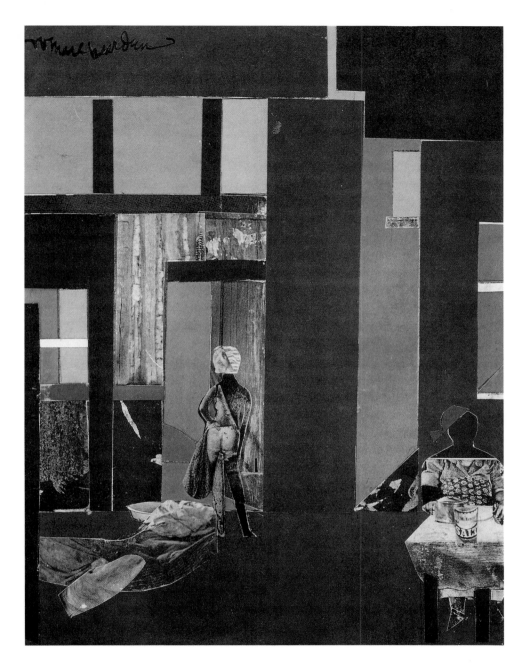

Susannah. 1969. Collage of
paper and synthetic polymer
paint on composition board,
9 × 12″. Private collection

When Bearden was given a solo show there in April 1961,
the works were again nonrepresentational, and this time untitled. He pushed
the technique of thinning out the canvas that he began in the late 1950s to its
limit, producing several extraordinary works. The reviews were good. Brien
O'Doherty, writing in the *New York Times*, saw Bearden, like Empedocles,
dividing nature into its primal elements including "(in one warm painting full
of glowing embers) fire. For they are full of suggestions of stratified earth,
subaqueous suspensions and clear auroras of atmosphere." Bearden's style
was deemed "most inventive and fully controlled," capable of wide ranges of
expression and mood.[6]

On the issue of Bearden's deliberate, almost diaphanous thinness of texture, the reviewers divided. A critic in *Arts Magazine* found them "so dry in texture as to cause the tongue to cleave to the roof of the mouth . . . but they had something, just as cool jazz has something, in a cerebral way."[7] The *Times* review praised the same effects: "He paints thinly, so thinly that at times the substance of the paint seems to have evaporated," making each canvas "a complex of highly evocative suggestions."[8]

From an art-historical point of view, it is important to note that Bearden was creating representational work in collage as early as 1961, even as he pushed his abstractions in oil to their limits. In all probability, the first collage Bearden signed was entitled *Circus*, also known as *Circus: The Artist Center Ring*. Bearden worked in the classic collage tradition: literally *papier collé*, cut and pasted colored paper on a simple white backing. He had taken the modernist subject matter of Picasso, Braque, and Seurat—the circus and its acrobats—cut his figures partly in the style of Matisse, partly with a suggestion of Miró, and set them on tenement roofs. Bearden's *Circus* is delightfully simple and naive. He signed it "1961" at the lower left on top of the name "Bearden." Here he was at fifty, showing diaphanous abstractions in oil, but at the same time a child of Picasso and Braque, playing with scissors, color-aid paper, and glue.

In May 1961, Romare took Nanette to Europe, touring Paris, Florence, Venice, Genoa, and Geneva. He wrote Ekstrom (whom he respectfully and affectionately called "Mr. E.") in June to report that a poster he had created some months back for a show there had been "blown up huge all over the city" and moreover, that fifty lithographs on very fine paper had been done of it. "These will sell for fifty dollars each. Needless to say we do not participate in the proceeds." Bearden supposed wryly that it was a contribution toward the expenses of the show. In Paris, he and Nanette had made the round of galleries. They found the city seemed to be sleeping artistically. It wasn't the Paris Bearden remembered, and he was anxious to get back home and to work. "Paris doesn't have the old enchantment for me. I suppose I need another kind of reality."[9]

Meanwhile, lured by the romance of a return to Paris, Michel Warren had left New York, neglecting to inform his partners that he would probably not come back. Cordier promptly traveled to New York to assure Ekstrom, understandably apprehensive at the prospect of a ten-year lease on the gallery solely in his name, of his continued affiliation. He told Ekstrom that on his return to Paris, he would liquidate his arrangement with Warren and become Ekstrom's partner. Ekstrom went to Europe and met with Lindner and Noguchi, who told him that they were in fact delighted with the new arrangement. Feeling buoyed in spirit, Ekstrom returned to New York to open the newly named Cordier & Ekstrom gallery with a major Dubuffet exhibition.

In 1964, Cordier closed his gallery in Paris with a much-discussed public letter in which, Ekstrom recalls, "he decided to tell the world his thoughts about galleries, the world of art, in fact the very status of painting and sculpture." The New York gallery name remained Cordier & Ekstrom.

"My warm relationship with Daniel Cordier has continued," Ekstrom says, although the financial relationship ended in 1964. Among his other activities, Cordier turned to the writing of a multivolume biography of Jean Moulin.

Michel Warren's life ended tragically some years later, when he was found dead on a Paris street near his home. "There was an abuse of pills and alcohol," Ekstrom says. "No one knows to this day exactly how he died, whether by a fall, or by his having been attacked."[10]

A mathematics major during his undergraduate years and a voracious reader of history, literature, and philosophy, Bearden had a proclivity for logical juxtaposition and a taste for aphorism. When he was asked if, as a man and artist, he had any desire to escape from reality or tensions, he replied: "I think the way to escape from reality is to get to the heart of it; confronting it, moving to the core is the only way."[11] He went on to liken this to flight into the eye of a hurricane, where calm is surrounded by destructive force.

Bearden's Projections of the early 1960s were not only the result of his decisive turn from abstraction to representational work in collage by 1963–64 but also the articulation of his attitudes as an artist toward political and social upheaval. The Spiral Group, concerned with the position of the black artist in relation to the civil rights movement, met initially at Bearden's Canal Street studio. With Bearden's longstanding friend Norman Lewis as its first chairman, and with Bearden as its secretary, Spiral included Hale Woodruff, Charles Alston, James Yeargans, Emma Amos, Calvin Douglass, Perry Ferguson, Reginald Gammon, Alvin Holingsworth, Felrath Hines, William Majors, Richard Mayhew, Earl Miller, and Merton Simpson.

As the foreword to Spiral's 1965 show made clear, "During the summer of 1963, at a time of crucial metamorphosis just before the now historic march on Washington, a group of Negro artists met to discuss their position in American society and to explore other common problems. One of those present, the distinguished painter Hale Woodruff, asked the question 'Why are we here?' He suggested, in answering his own question, that we, as Negroes, could not fail to be touched by the outrage of segregation, or fail to relate to the self-reliance, hope, and courage of those persons who were marching in the interest of man's dignity. . . . If possible, in these times, we hoped with our art to justify life."[12] Some of the group's earliest discussions focused on such practical matters as hiring a bus and joining the demonstration.

The group's name represented the mathematical symbol of its aesthetic and human philosophy. The Archimedian spiral was chosen "because, from a starting point, it moves outward embracing all directions, yet constantly upward." (The group's logo displayed a spiral that looked roughly like a figure "6" moving from a starry center; lines emanating from the center intersect the "6" at fifteen numbered points, presumably symbolizing Spiral's fifteen members.)

Bearden's work with photomontage emerged almost improvisationally from the idea of a collaborative collage by the Spiral group.

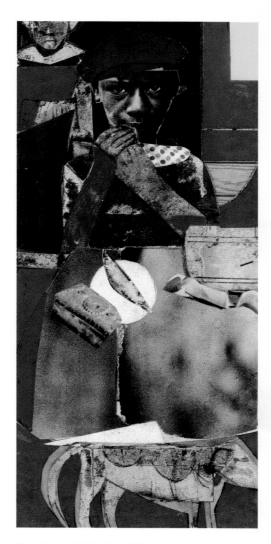

Untitled. c. 1965–70. Collage on board, 9 x 4". The Shaw Family Collection

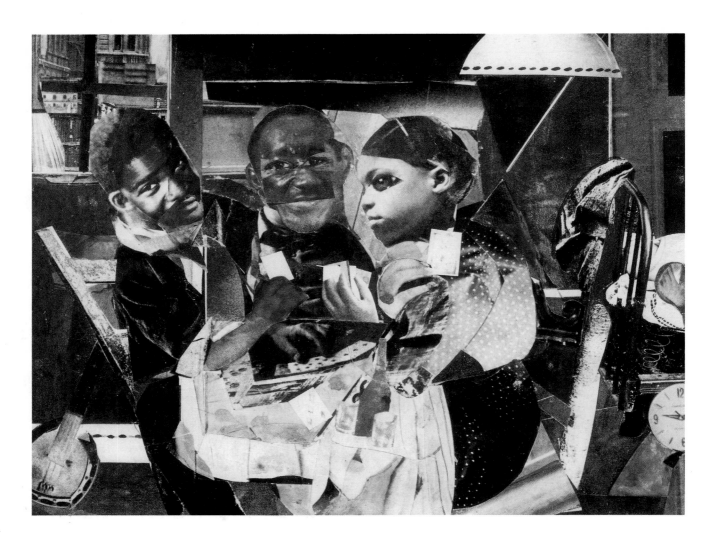

Evening, 9:10, 461 Lenox Avenue. 1964. Collage of photochemical reproduction, synthetic polymer, and pencil on paperboard, 8½ x 11½". Davidson College Art Gallery, Davidson, N.C.

Emma Amos, one of the younger members of the group, remembers Bearden having collected "an enormous picture file, all cut out in shapes and stuffed in a bag. He brought it to the Spiral meeting space on Christopher Street and spread it all out on the floor, suggesting we make a collaborative piece."[13] Interest was difficult to maintain after Bearden's presentation, so he went ahead on his own. At his friend Reginald Gammon's suggestion, Bearden enlarged five or six of his small photomontages photostatically from their original dimensions, about the size of a piece of typewriting paper, to three by four feet, or six by eight feet.

When Arne Ekstrom came to Bearden's Canal Street studio in late spring 1964 to discuss a show for the fall season, he asked about the enlargements, which were standing wrapped up on a side of the studio. Bearden dismissed them, saying that they probably wouldn't be of interest. He felt that their content was probably too strong. But when he described his experiment and displayed the enlargements, Ekstrom was fascinated. He suggested that they would make a good show, and asked Bearden to create another twenty over the summer. They might be exhibited with the title "Projections," which

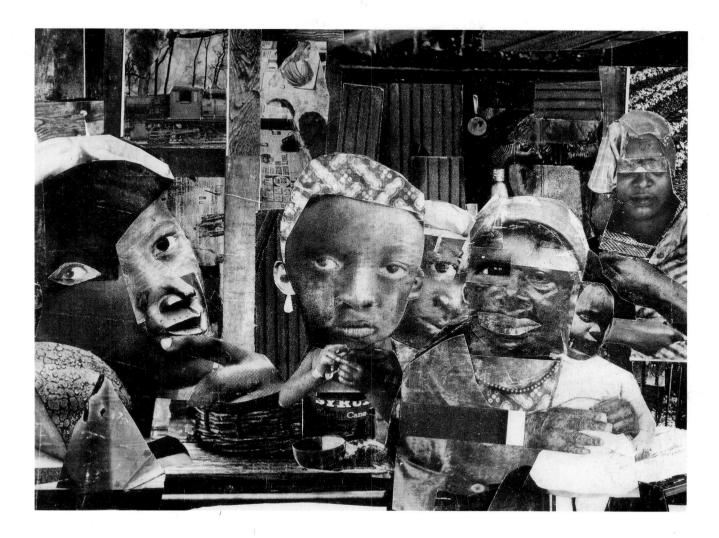

seemed apt not only because it delineated the physical process of enlargement, but also because it suggested the strong photographic and documentary quality of Bearden's "montage paintings." In this way, Bearden's turn toward collage, the primary medium in which he worked until the end of his life, began as what Albert Murray characterized as "a teaching device," Bearden's solution to the problem of creating a composite collage with the members of Spiral.[14] And in fact, as Bearden made clear in conversation, he signed one of his earliest collages "Spiral Group."

The Projections were first shown at Cordier & Ekstrom, New York, in October 1964, with their source collages, and then at the Corcoran Gallery in Washington, D.C., in October 1965. A September 1964 letter from Ekstrom describes both the provenance of the Projections and their ambiance: "Romare Bearden has done a series of twenty-one collages which have been photographed in quite large format, some 2 x 3′ and some larger. I am showing these as an edition of six, each signed and numbered, mounted on board and put on strainers and framed by Kulicke Frames in narrow silver frames. They are really extraordinary and constitute a sort of re-living and re-telling of his

memories as a Negro. The subjects range from burials and cotton fields to jam sessions, Harlem streets, Conjur women, etc. In these days of civil rights strife they are, on the sociological side, a unique statement of pride in tradition, dramatic in many instances but never a form of protest or agitation. Artistically they are most remarkable. . . . The Corcoran Gallery in Washington will exhibit a whole series . . . and I think that the exhibition, which opens on October 6, will receive a lot of attention."[15]

Ekstrom was right. Because of their photographic and documentary quality, the Projections seemed a radical departure from Bearden's abstract paintings of the late 1950s and early 1960s. While they spanned the entire range of his memories of the South, Pittsburgh, and Harlem, a number of them represented urban street scenes filled with faces set against brick walls, stairways, lampposts, tenement windows, latticed fire escapes, and bridges. *The Street* and *The Dove*, both 1964, show Bearden striving for maximum multiplicity in his use of space. The faces and bodies are built up from portions of photographs taken out of their original spatial configurations, and are quite different in scale from one another.

Charles Childs, writing in *Art News* (October 1964) described one of the most striking collages in relation to the received idea of Bearden: "In Romare Bearden's *The Street*," he wrote, "a forehead, an eye, and a dark man's cheek lie suspended in front of a figure in a lace dress, her hand up flat: on a stoop four men sit, one smoking, another dolefully musing at the presence of somebody's cat: substances, shadows and subjects of a half-forgotten Negro world . . . will surprise many who thought they knew Bearden from his abstractions."[16] Childs was also insightful in noting that Bearden's *Women in a Harlem Courtyard* referred directly to Pieter de Hooch's *The Spinner and the Housemaid.* Juxtaposed reproductions made the point explicit. Dore Ashton, in an article for *Quadrum* (Brussels) in 1965, saw the collages as "a piercing, activist bill of particulars of intolerable facts," and related their arrival to the activist photomontages of World War I.[17] Other quite favorable reviews appeared in *Time, Newsweek,* the *Herald Tribune,* and the *New York Times,* which called the Projections "knockout work of its kind, propagandist in the best sense."

It is important to realize that the Projections did not constitute the kind of series Bearden was later to create in his jazz, Mecklenburg, Pittsburgh, or Harlem collages. Rather, they were defined by the medium and the documentary quality of the photographic enlargement. Nevertheless, as the list of collages in Bearden's hand demonstrates, he had *grouped* them in a way that was quickly apparent to Ekstrom.[18] In so arranging them, Bearden set himself an agenda for the following decades. For a "jazz" group, for instance, Bearden bracketed two: *(N.Y.) Savoy—1930s; (Chicago) Grand Terrace—1930s.* By the mid 1970s, Bearden would do two entire series of jazz collages. The same was true for each group in the "Projections" show.

In 1975, in a rare letter to a critic (the review, in the *International Herald Tribune,* had stated, "His collages are peopled by black faces cut out of magazines"), Bearden took pains to explain how he used a variety of

The Prevalence of Ritual: Conjur Woman (1964). Collage of paper and synthetic polymer paint on composition board, 9¼ x 7¼". Collection Sheldon and Phyllis Ross, Birmingham, Mich.

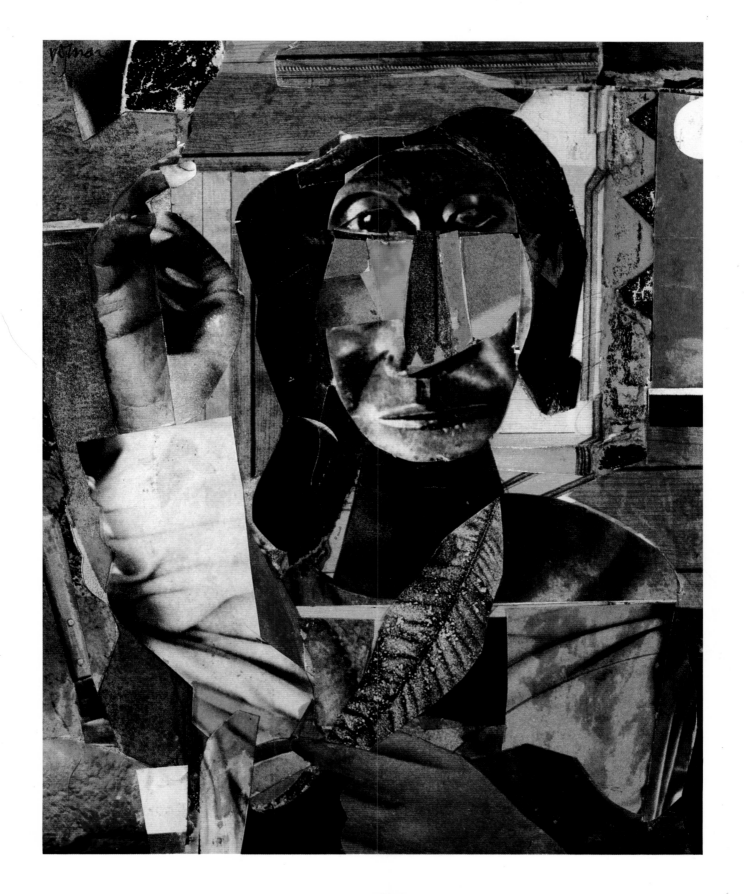

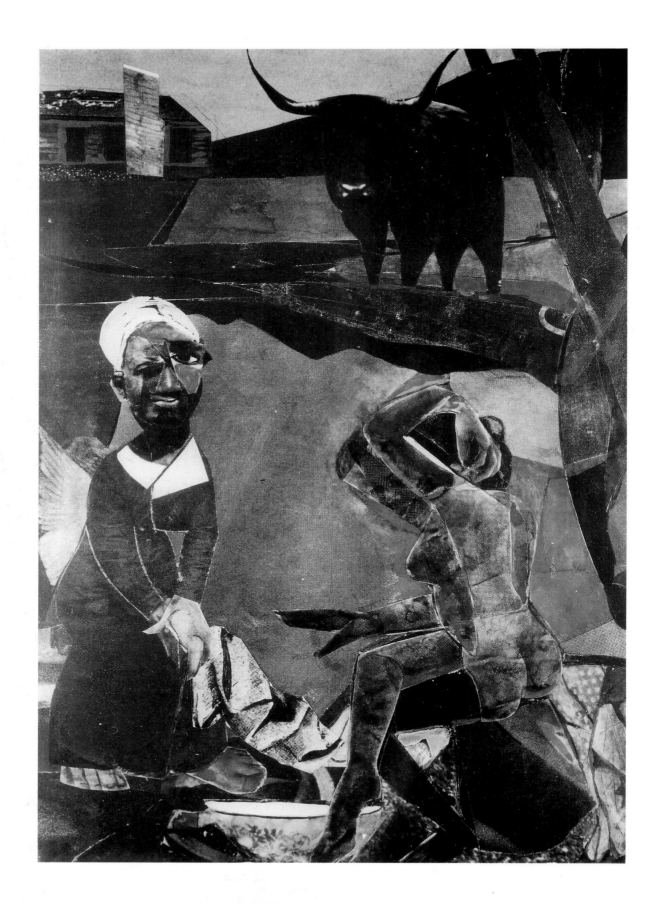

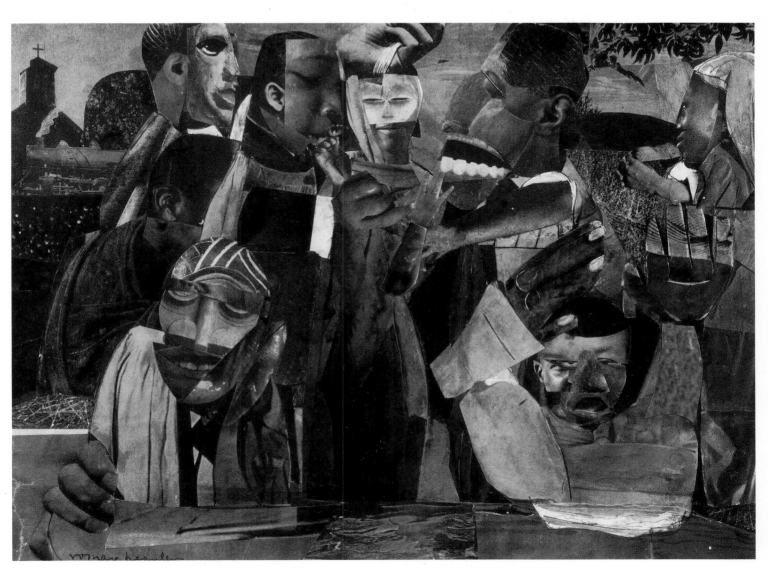

Opposite: *The Prevalence of Ritual: Conjur Woman as an Angel.* 1964. Collage of photochemical reproduction, synthetic polymer paint on composition board, 9½ x 6½″. Private collection

Above: *The Prevalence of Ritual: Baptism.* 1964. Collage of photochemical reproduction, synthetic polymer, and pencil on paperboard, 9⅛ x 12″. Hirshhorn Museum and Sculpture Garden, Smithsonian Institution. Gift of Joseph H. Hirshhorn, 1966

Melon Eater. 1966. Collage, 12 x 3½″. Private collection

found objects to create relationships that did not exist prior to the collage: "In most instances in creating a picture, I use many disparate elements to form either a figure, or part of a background. I build my faces, for example, from parts of African masks, animal eyes, marbles, mossy vegetation [and corn]... I then have my small original works enlarged so the mosaiclike joinings will not be so apparent, after which I finish the larger painting. I have found when some detail, such as a hand or eye, is taken out of its original context and is fractured and integrated into a different space and form configuration it acquires a plastic quality it did not have in the photograph."[19]

In the photomontages, distortions of scale and fracturings often extend the larger rhythms of Bearden's picture, but are always subordinated to the total structure. This structure is set, as it had been in the late 1940s, by the rectangle, although its mathematical precision is obscured by the jarring immediacy of the photographic images. As Bearden told an interviewer in 1968, "I first put down several rectangles of color, some of which, as in a Rembrandt drawing, are of the same ratio as the canvas."[20] "Slanting directions I regard as tilted rectangles," Bearden wrote in *Leonardo* in 1969, "and I try to find some compensating balance for these relative to the horizontal and vertical axes of the canvas."[21]

Of the early Projections, the group specifically titled "*The Prevalence of Ritual*," including *Baptism*, the *Conjur Women, Conjur Woman as an Angel*, and *Tidings* illustrates the perspective shared by Bearden and his friend Albert Murray. The two men began collaborating on the collage titles as early as this, and Murray's phrase "The Prevalence of Ritual" was an apt literary means of making the universal dimension of Bearden's work explicit from the outset. It became the general title for the major retrospective at The Museum of Modern Art in 1971. In titling an urban street scene *The Dove*, Murray employed a traditional literary device, choosing a single specific image as a metaphor. The title made it difficult but not impossible to interpret the fractured and displaced photographic image in relation to the sociological images which had their own kind of prevalence in the mid-1960s: "accusing eyes," "anguished faces," "tale of horror."

One test of the lasting validity of the *Projections* is that more than two decades later, when many of the fashionable political and sociological styles of the 1960s now seem curios of a bygone era, images such as *Spring Way* remain immediate and eloquent. (Spring Way, of course, is the name of the street in Lawrenceville near Romare's grandmother's boarding house.) Detached now from the rhetoric and emotion of the mid-1960s, which inevitably lent their reception an ambiance of political and social protest, the Projections seem more eloquent, the statement of a sensibility that was not caught up in the hurricane, but instead had found its eye.

Bearden contributed the projection entitled *Conjur Woman* to the Spiral Gallery's group show, "Works in Black and White," which was installed from May 15 to June 5, 1965. Considering the black-and-white format the group set for each member's contribution, a Bearden projection lent itself by definition. Strong work was also present in Hale Woodruff's *Africa*

and the Bull and two complementary (though markedly different) oils on canvas by Charles Alston and Norman Lewis depicting processions. Alston's *Walking* is a representational work in which a group of people, led by a black woman with her head held high, walk across the picture from left to right. The abstracted figures in Lewis's *Processional* are seen as if held within the flood of light from a spot, or perhaps a motion picture projector, against a stark black background. (Bearden thought this was the outstanding resolution of the artistic problem set by the exhibition's format.)

Collage is almost by definition an improvisational medium, in that it allows the artist to combine found objects from the everyday world—pieces of wood, fragments of photographs from old catalogues, fabrics—and literally "play with" them until they form a coherent composition. Bearden had known long before he made his first collage that painting was play: not child's play, he observed in a 1947 journal entry, "but a kind of divine play." Bearden was able to synthesize the classical temper of his art—his liking for the interiors of the little Dutch masters, the precision of Mondrian, and the frontality of African sculpture—with the improvisational nature of collage. His ability to do so illustrates his double identity: as a modernist but also as the most idiosyncratic of painters. On the one hand, he absorbed the legacy of the Cubists, Matisse, and Mondrian by the time he established his reputation as a semiabstract painter in the late 1940s. On the other, he transformed the legacy into a uniquely personal statement—sometimes idiomatically Southern, sometimes 1920s steel-mill Northern, sometimes quintessentially Harlem—by stressing in the human drama the ceremonial dimension that gives it universality. The stylistic possibilities he opened up by means of this synthesis were increasingly rich and surprising.

By the late 1960s, Bearden synthesized the texture and color and the small original collages from which the Projections had been made with the monumental scale of the Projections themselves. By 1967, he had moved to larger canvases, often four by five feet, was working in color and handling the paper differently. Instead of using prepared colored paper, Bearden now painted the paper himself before pasting it down on hard masonite board (he had been stretching his canvases so tight that the backing would snap). His friend John "Jack" Schindler was instrumental in showing Bearden how to define his technique of backing the canvas, and ultimately suggested that he use masonite rather than canvas. Schindler also gave Bearden space to work in Long Island City, creating the rhythm—living on Canal Street, working in his Long Island City studio—that Bearden would follow for the rest of his life, except when he was working in St. Martin.

The 1967 show at Cordier & Ekstrom sold out. (New York Senator Jacob Javits bought the last collage for his wife, Marion, who very much wanted it.) With this success, Bearden's life underwent another fundamental change. Despite his official retirement in 1966 from the Department of Social Services, he had continued to do some work there into 1967; now he was able to retire fully and to devote his life wholly to art.

Bearden's activity during the mid-1960s was intense. In

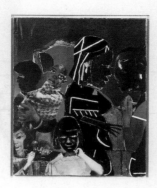

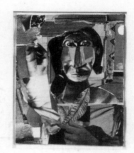

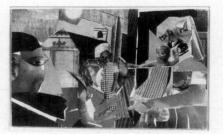

March 1966, four collages entitled *Panel on Southern Theme* were included in
an exhibition at The National Institute of Arts and Letters, the Academy Art
Galley in New York City. Two months later, on May 25, Bearden received a
Grant-in-Art from the National Institute and, in recognition of the achieve-
ment, exhibited ten collages (again inset in panels) at the institute's gallery, in
an "Exhibition of Work by Newly Elected Members and Recipients of Honors
and Awards," from May 25 to June 26, 1966.

 The idea of installing the relatively small collages grouped
two or sometimes three to a panel had been Ekstrom's. It gave Bearden a

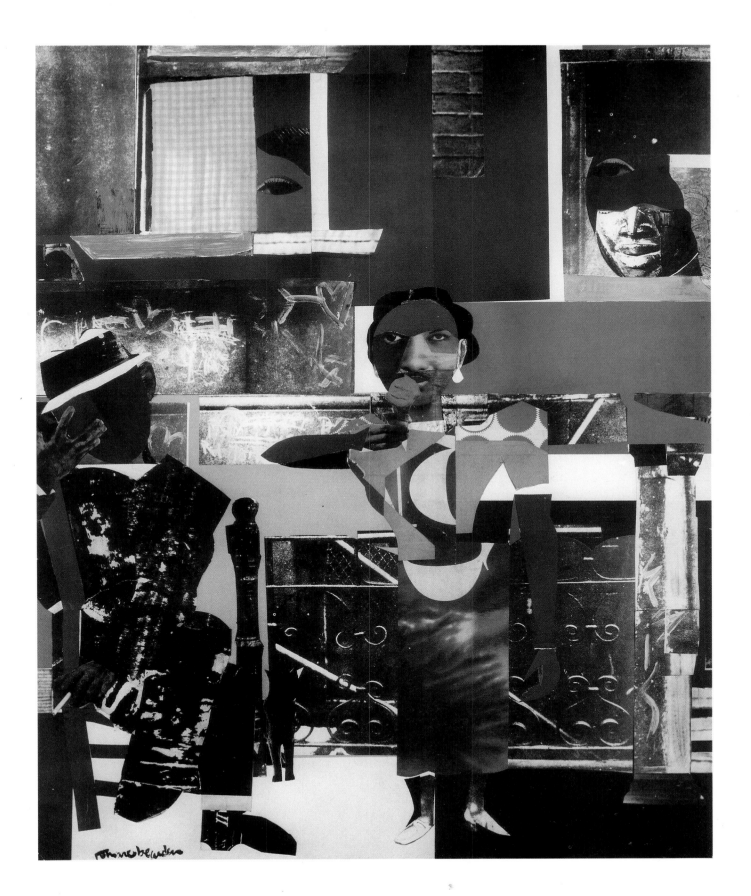

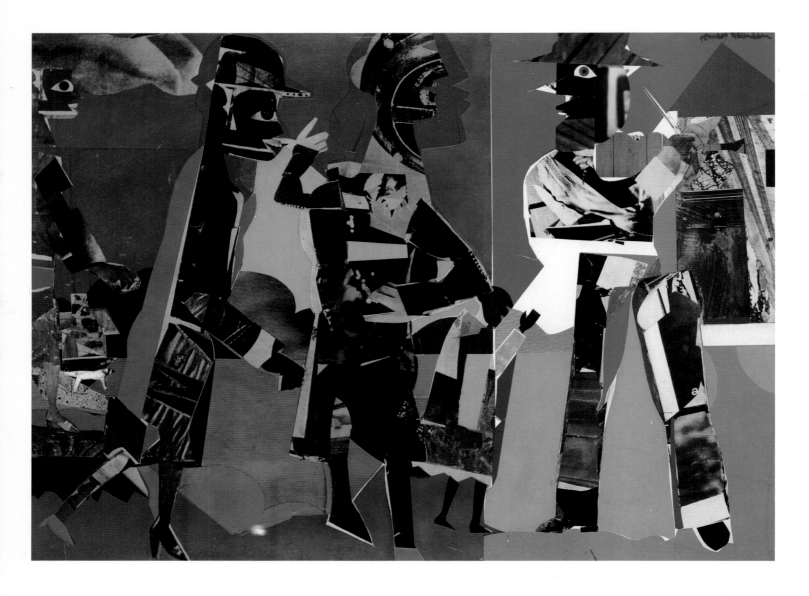

The Fiddler. c. 1965. Collage, 30 x 40″. Collection Sheldon and Phyllis Ross, Birmingham, Mich.

format not only for exhibitions at the Academy, but for a continuing installation he called "Six Panels on a Southern Theme" for "The Negro in American Art" (the Dickinson Art Gallery, UCLA, September 1966) and for a solo exhibition at the Bundy Art Gallery, Waitsfield, Vermont (April–May 1967).

Following the 1967 success at Cordier & Ekstrom by one week, the landmark exhibition "The Evolution of Afro-American Artists: 1800–1950," codirected by Bearden and Carroll Greene, Jr., opened at the Great Hall of City College of The City University of New York. In November, a Bearden exhibition was given at the J. L. Hudson Gallery, Detroit.

Fortune magazine ran a Bearden cityscape on the cover of its January 1968 "Special Issue on Business and the Urban Crisis."[22] From an art-historical perspective, Bearden's subject matter was of a piece with such urban street scenes of the Projections period as *The Street* and *The Dove*. But the manner in which he used fewer, more disparate human subjects and simul-

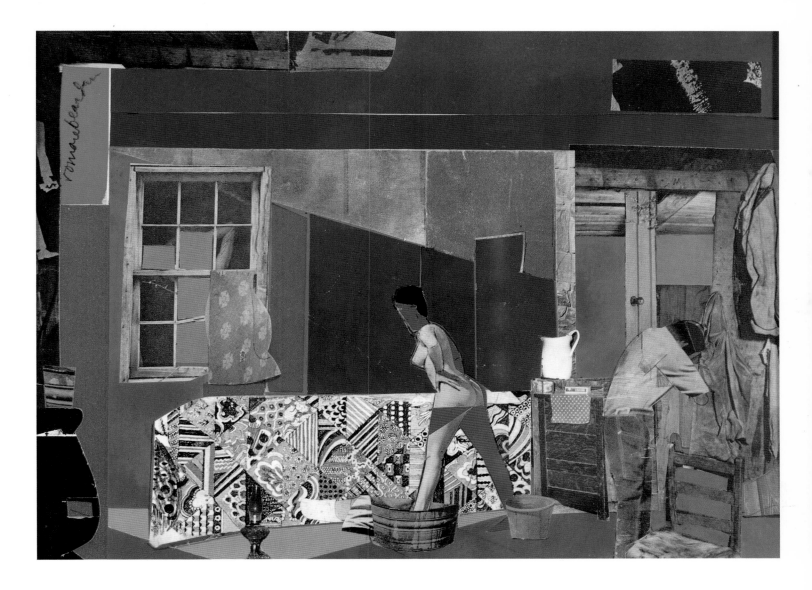

taneously compressed the visual impact was new. Bearden accomplished this by juxtaposing the stained-glass windows of a church with a set of stairs leading up to a tenement, each of whose windows seemed "torn away" to reveal a separate interior.

 In November 1968, "Romare Bearden: Paintings and Projections," was mounted at the Art Gallery, State University of New York at Albany. To twenty-one of the 1964 black-and-white Projections, almost all of which had been part of the original Cordier & Ekstrom exhibition, Bearden added seven collages created between 1965 and 1968, executed on the same scale. The smallest was *The Fiddler* (1965), 30¾ x 24″; the largest was *Circe Preparing a Banquet for Ulysses* (1968), 44 x 56″. The show was marked by Ralph Ellison's catalogue introduction, much reprinted, which remains among the most eloquent pieces of writing on Bearden's art. In the same month, a Bearden maquette was used as the basis for the cover of *Time* maga-

Patchwork Quilt. 1969. Collage of paper and synthetic polymer paint on composition board, 9 x 11⅞″. Collection Sheldon and Phyllis Ross, Birmingham, Mich.

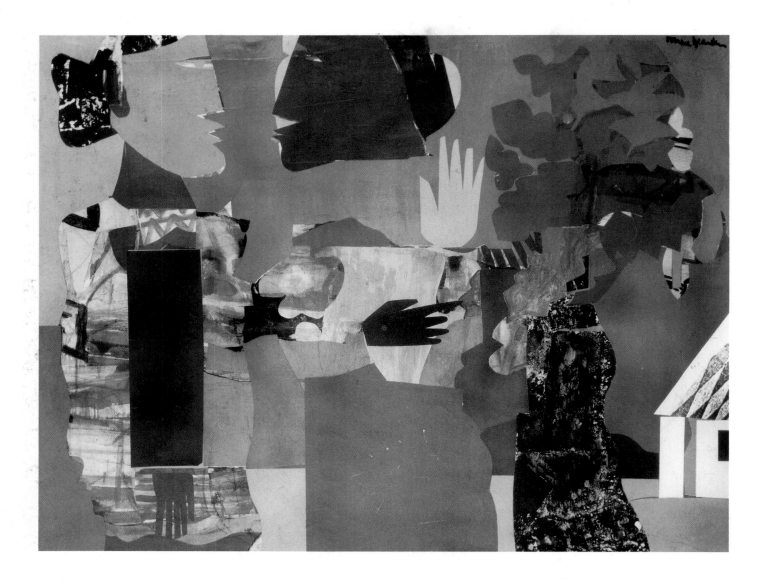

Two Women. 1967. Collage, 44 x 56″. Private collection

zine's November 1 issue, "New York: The Breakdown of a City." Mayor John Lindsay, hands outstretched, is framed by the fragmented faces of impoverished children and the toppling skyscrapers of the city.

The following June, *The Painter's Mind*, which Bearden had been working on for twenty years with Carl Holty, was published by Crown. It was a succinct restatement not only of all that Bearden had learned from Holty over the years, but of the aesthetic of form and space that had emerged from it in Bearden's art. Hale Woodruff, in a congratulatory letter to Bearden, told him that he would pore over it as a piece of required reading.

The Cinque Gallery, founded by Bearden, Norman Lewis, and Ernest Crichlow, was an important project of this period. "There were a number of young minority artists out of the whole 'uplift' thrust of the Johnson years who were on scholarships to various colleges, art schools. Many of these young people had graduated with academic degrees; others had come out of art school and felt that they were ready to paint, and we found there was very little

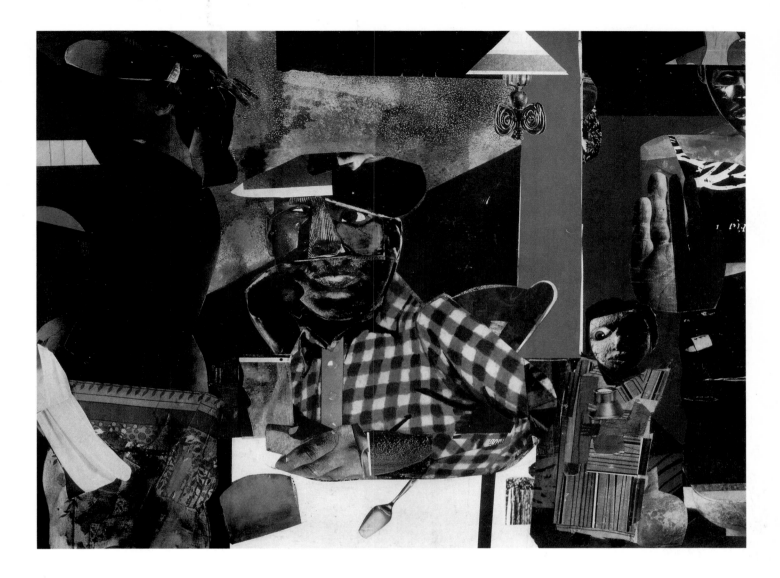

outlet for their work. . . . The other problem was that there were a number of people (especially women), who had majored in Art History, and were anxious to work in the field of art, but who had no experience. So this was the problem we had to face in order to make some disposition toward helping these young people." The idea of a nonprofit gallery to give aspiring young artists a showcase and young academics a chance to become curators and gallery directors took shape at the home of Dr. Arthur Logan in 1967. "The Ford Foundation had given a million dollars for the improvement of black businesses in Harlem," Bearden recalled; the Cinque Gallery was proposed to the Foundation under the aegis of the grant, and Bearden, Lewis, and Crichlow then spent several months looking for a suitable location. They approached Joseph Papp, whose New York Public Theater space at 425 Lafayette Street seemed ideal. Papp was in agreement, "so they built a place for us outside his offices, and this was our first studio. Norman wanted the place to be very well kept, so it would have all the appearances of a professional gallery you might find on 57th

Sunrise. 1967. Collage, 30 x 40″. Private collection

223

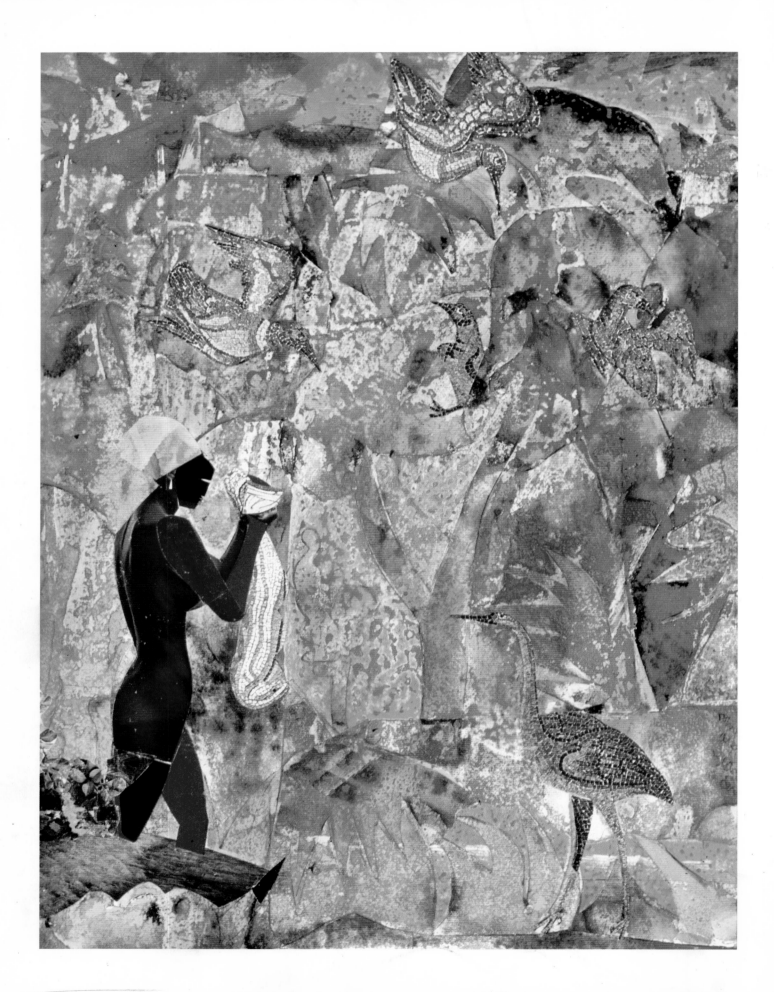

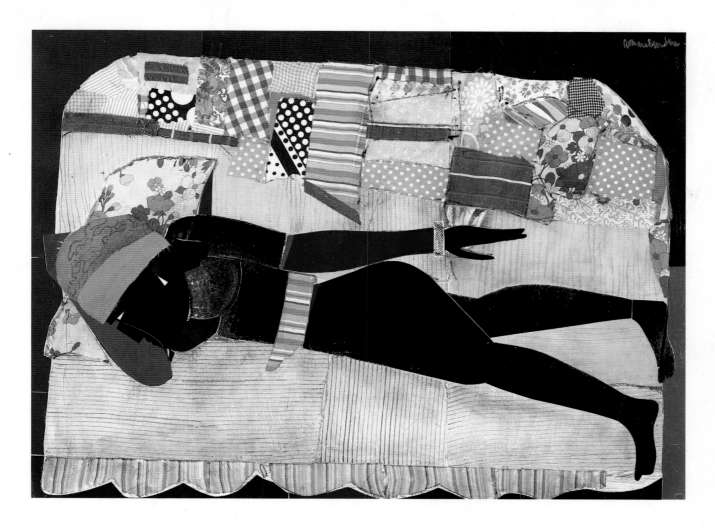

Above: *Patchwork Quilt*. 1970.
Collage of cloth, paper, and
synthetic polymer paint on
composition board, 35¾ x
47⅞". Collection, The Museum
of Modern Art, New York.
Blanchette Rockefeller Fund

Opposite: *Byzantine Dimension*.
1971. Collage, 24 x 18". Private
collection

Street." The Ford Foundation seeded Cinque with some $30,000 over a one- or two-year period, and all was in readiness. Malcolm Bailey was the first artist to be shown at the new space in December 1969 (various works representing "The Middle Passage" of slaves from Africa were installed, augmented by some of Papp's *mise-en-scènes*—chains, pieces of wood which, Bearden remembered, "gave it a kind of ambiance"). Next, a show was given to Louise Parks, who had been working on her masters degree at Hunter College. "She did paintings with some kind of a dye process on large sheets of plastic, and we had to find some way of backlighting these, so you could see it with a kind of tapestry effect."[23] Bearden later spoke to an administrator at The Metropolitan Museum of Art on her behalf, which resulted in Parks becoming the first black member of the curatorial staff there. Cinque was a quintessential demonstration of Bearden's lifelong commitment to helping younger artists—in the public schools, as undergraduates at such colleges as Williams and Bard, as college teachers, by letter, and in his own studio.

By the early 1970s, Bearden had become a presence in the New York, and increasingly the national, art scene. His February 1970 exhibition at Cordier & Ekstrom, "Montage Paintings," received an important

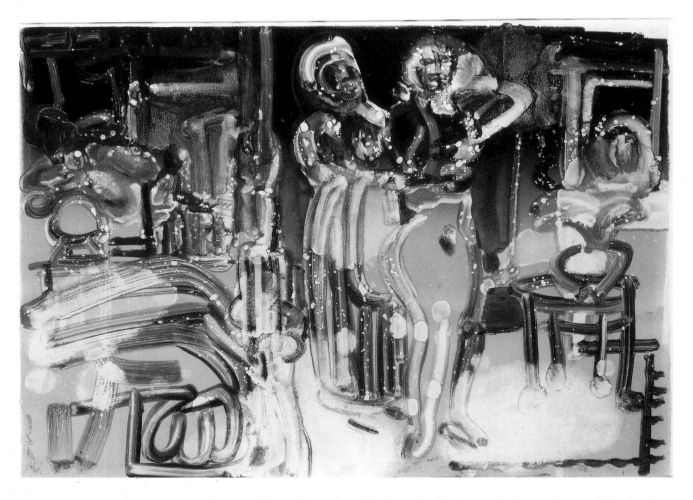

Preceding pages, left: *Delilah.*
1973. From *The Prevalence of
Ritual* series. Collage and
acrylic on board, 56 x 46″.
Collection Jane and Raphael
Bernstein, Ridgewood, N.J.

Preceding pages, right:
Prologue to Troy #1. 1972.
From *The Prevalence of Ritual*
series. Collage and acrylic on
board, 55½ x 45½″. Exxon
Collection

review by Grace Glueck under the title "A Breughel from Harlem" in the *New
York Times*. "Full of sophisticated serendipities—a Harlem face made from an
African mask, a shirt cut out of a dish towel, shifts in scale that make hands
bigger than heads—they give elegant credence to Bearden's claim that his aim
is not to make Negro propaganda."[24] Even the *Times* had come around in its
estimate of Bearden's art in relation to the turbulent racial strife of the sixties.

In June 1970, Bearden received a Guggenheim Foundation
grant to write a book on the history of Afro-American art. He cowrote *Six Black
Masters of American Art* with Harry Henderson, published in 1972; Henderson
is himself completing the enormous tome on which he and Bearden collaborat-
ed on the history of Afro-American art. In December, Bearden's 1970 collage
Patchwork Quilt was shown at Cordier & Ekstrom, and subsequently acquired
by The Museum of Modern Art. It is arguably one of his greatest masterpieces
in collage.

The six panels constituting *The Block* were a highlight of
Bearden's work that year. Accompanied by a tape recording of street sounds
and church music, it was one of fifty-six works included in The Museum of
Modern Art's retrospective "Romare Bearden: 1940–1970: The Prevalence of
Ritual," (March 23–June 9, 1971), an admirable summing up of Bearden's

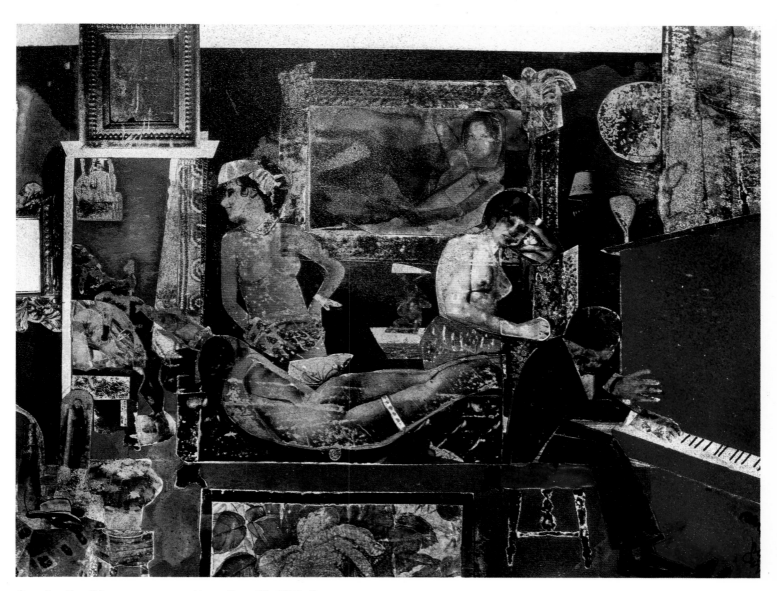

Opposite: *New Orleans:
Storyville/Ragtime Preparations.*
1975. From the *Of the Blues:
Second Chorus* series. Oil on
paper, 29½ x 41″. The
Metropolitan Museum of Art,
George A. Hearn Fund, 1976

Above: *Storyville.* 1974. From
the *Of the Blues* series. Collage
with acrylic and lacquer on
board, 15¼ x 20″. Collection
C. T. Ives

oeuvre to that point in his career. After MoMA, the retrospective traveled to Washington, D.C.; Berkeley and Pasadena, California; Atlanta; Raleigh, North Carolina; and to the Studio Museum in Harlem.

The highlight of 1972 was his election to the National Institute of Arts and Letters in recognition of his many achievements. Bearden had most assuredly rearrived.

Bearden's work since 1971 moved away from inclusion of photographic materials. There is much less fracturing of parts of the body, particularly the face, and less distortion for effect. The collages of the 1960s, frequently filled with figures, gave way to compositions often focused on one or two people. They rely on pure color because, as Bearden commented, "It gives the work more sonority, more amplitude."

After shows at Cordier & Ekstrom in both February and April 1973, Bearden opened a new dimension in his life by building a house and studio in French St. Martin, in the Caribbean. As if to underscore the effect of the Caribbean on his work, Bearden created twenty collages in 1973, almost all of which captured the vibrant color and light of the islands. Together with four 1972 collages, these works were installed in a one-artist exhibition at Cordier & Ekstrom, "Romare Bearden: Prevalence of Ritual, Martinique and Rain Forest," from March 28 through April 28, 1974. The titles themselves, often in both English and French, emphasized Bearden's immersion in the blue-green waters of the Caribbean in relation to time of day: *Morning, Pale Green, And at Noon, The Blue Pool (L'Etang Bleu), The Lady with Blue Face (La Dame au Visage Bleu)*.

In summer 1973, Bearden wrote Ekstrom to say that he, Nanette, and the cat were still staying at a hotel on the Dutch side, although "the house is finished and looks quite handsome—and the view Mr. E. across the open sea with the plunging breakers is worth our selection of the site, alone." He also mentioned that he had been thinking about the work he had begun on jazz themes, and he concluded his letter by describing some Dutch girls who, swimming in front of the hotel, seemed to Romare "some of the biggest young women I've ever seen." He drew a little sketch to show Ekstrom what he meant.[25]

Of the Blues (1975), a series of nineteen collages, and *Of the Blues: Second Chorus* (1976), a kindred series of monoprints, are particularly rich and celebratory. Bearden was coming to exploit the improvisational possibilities of collage and other mediums in a manner that allowed him to unite a freer, more open approach to his art with his subject matter, blues improvisation. He began to brush benzine directly onto a plastic plate to "pick out" the color, which was then allowed to splatter and disperse on the paper. The more volatile the mixture of benzine, the more quickly the plate dried. Both series traced jazz from its folk sources, sacred and secular, to the cities in which its major styles evolved (New Orleans, New York, Chicago, Kansas City), then to its performers, and finally to its abstract sounds.

New Orleans: Storyville / Ragtime Preparations (1975), an oil on paper from *Of the Blues: Second Chorus*, is set in a bordello district so

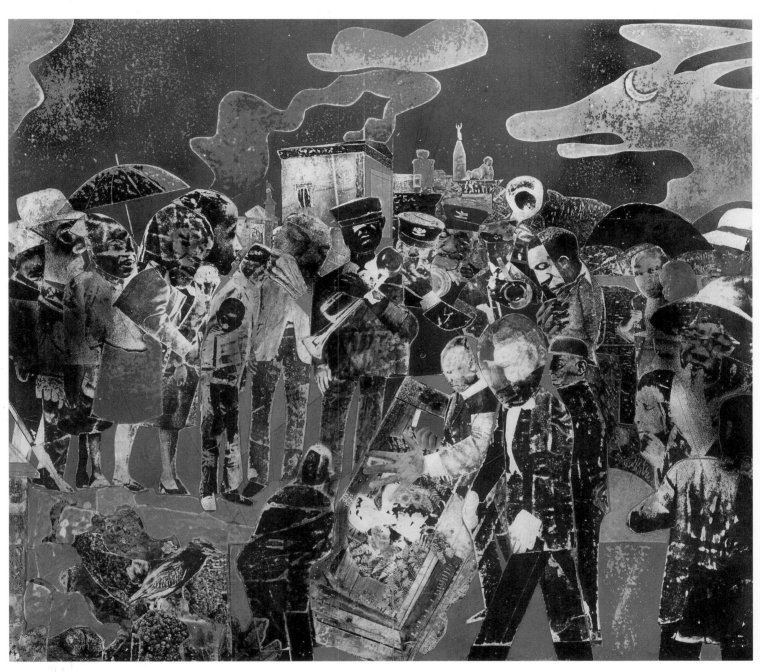

New Orleans Farewell. 1974.
From the *Of the Blues* series.
Collage with acrylic and lacquer
on board, 44 x 50″. Collection
Mr. and Mrs. George Wein

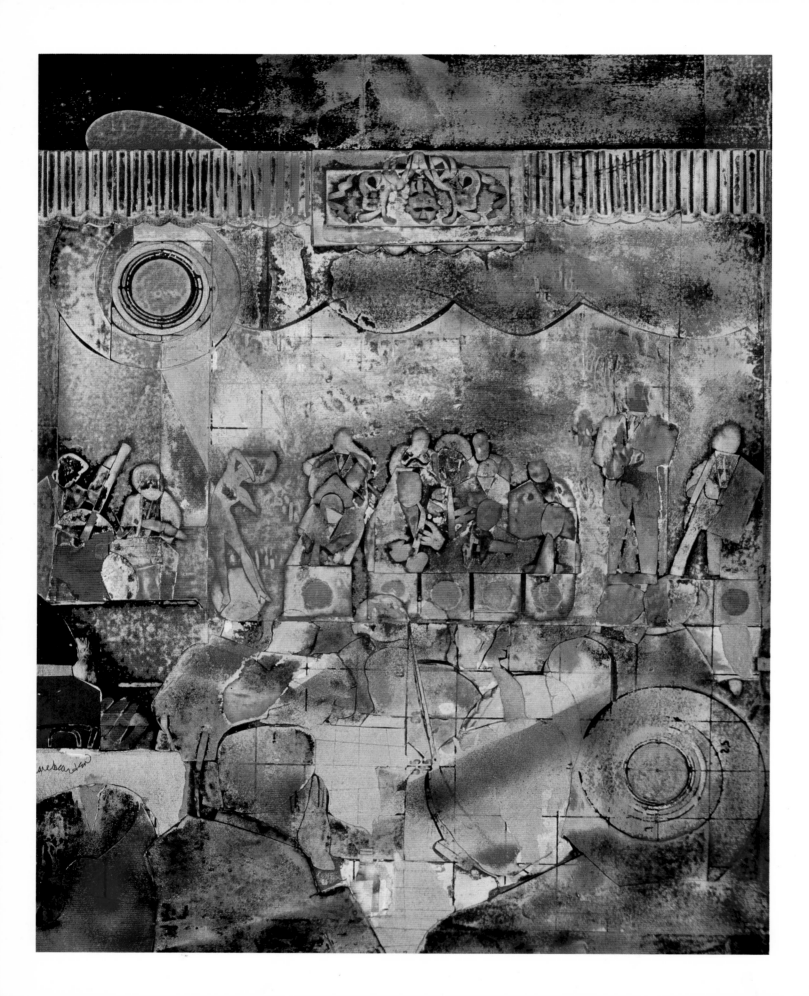

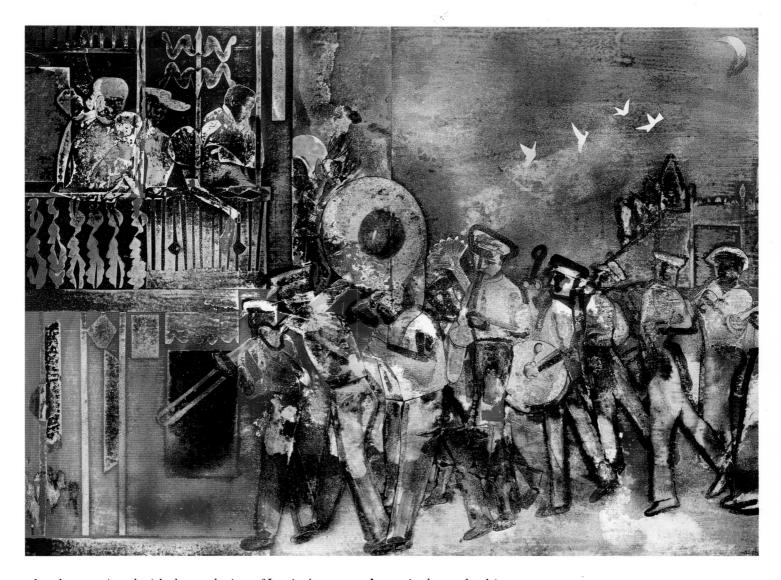

closely associated with the evolution of Louis Armstrong's music that today his statue stands near the site. In the bordello, a latter-day odalisque stands in the foreground with her servant primping her. In the background, seen through a doorway, a piano player is absorbed in a ragtime composition. In the view of Lowery Sims, associate curator of The Metropolitan Museum of Art's twentieth-century collection, of which the piece is a part, "There is a much freer kind of drawing here which I think at the time was shocking to people, because Romie had done collages for so long that they forgot how well he could draw."[26] Critics reviewing the *Second Chorus* monoprints found the synthesis of earlier Bearden styles appealing. "The works are representations done not as collages but in the signature style Bearden developed as an abstract painter," noted *Art News*. "Painterly mist now represents the smoke in the room where the jazzmen play."[27]

The road had been a long one, and Bearden was now poised for the last great period of his career, the late 1970s and early 1980s.

Above: *New Orleans Ragging Home*. 1974. From the *Of the Blues* series. Collage with acrylic and lacquer on board, 36⅛ x 48". Private collection

Opposite: *At Connie's Inn*. 1974. From the *Of the Blues* series. Collage with acrylic and lacquer on board, 49⅞ x 39¹⁵⁄₁₆". The Brooklyn Museum. John B. Woodward Memorial Fund

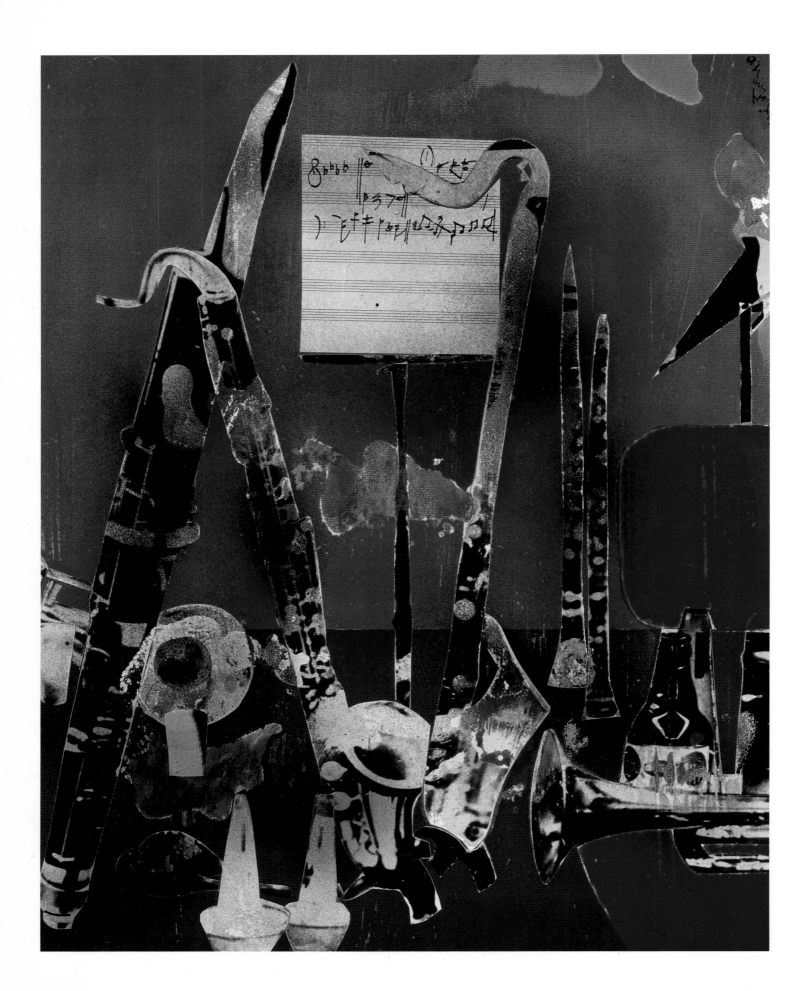

Opposite: *Intermission Still Life.*
1974. From the *Of the Blues*
series. Collage with acrylic and
lacquer on board, 28½ x 22″.
Private collection

Above: *Alto Composite.* 1974.
From the *Of the Blues* series.
Collage with acrylic and lacquer
on board, 50 x 44″. Collection
Barbara B. Millhouse

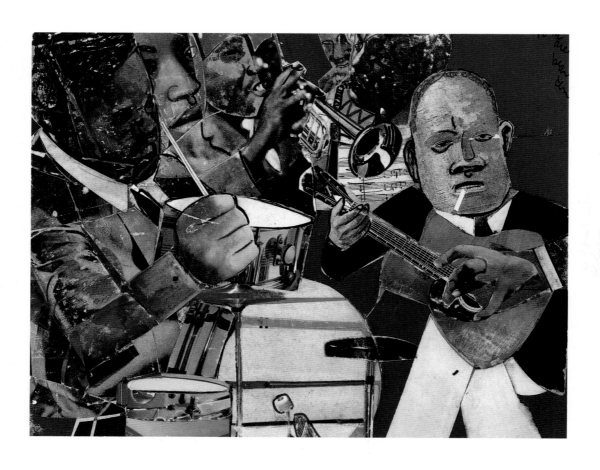

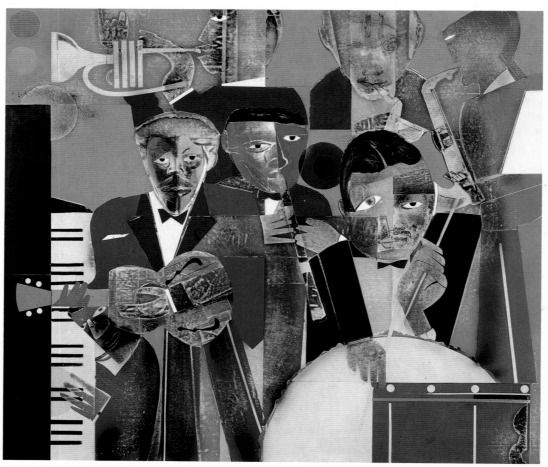

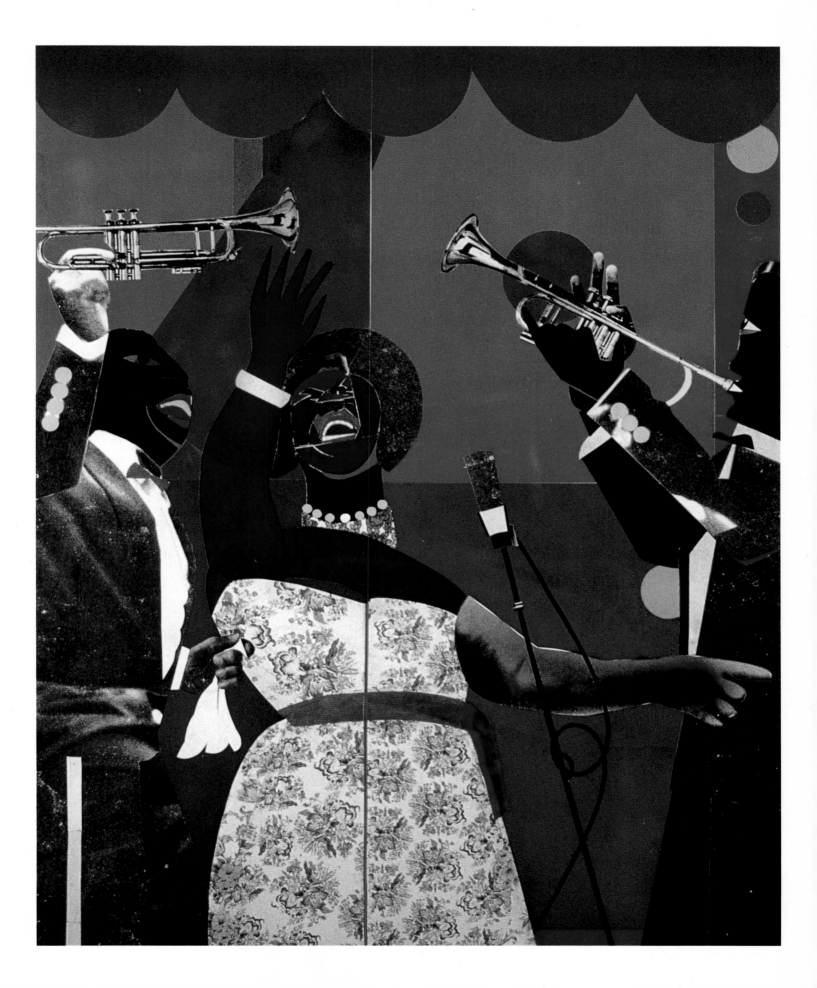

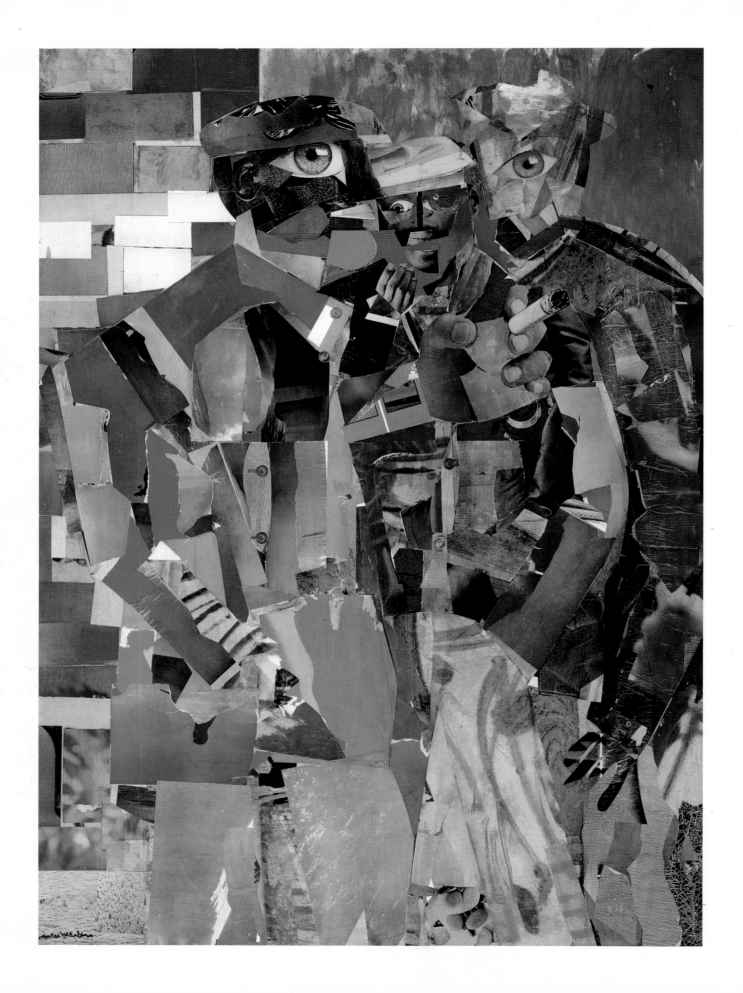

Preceding pages, above left: *Improvisations.* 1968–69. Collage, 10¼ × 13″. Private collection

Preceding pages, below left: *One Night Stand.* 1974. From the *Of the Blues* series. Collage with acrylic and lacquer on board, 44 x 50″. Private collection

Preceding pages, right: *Show Time.* 1974. From the *Of the Blues* series. Collage with acrylic and lacquer on board, 50 x 40″. Collection Dolores and Stanley Feldman, Lynchburg, Va.

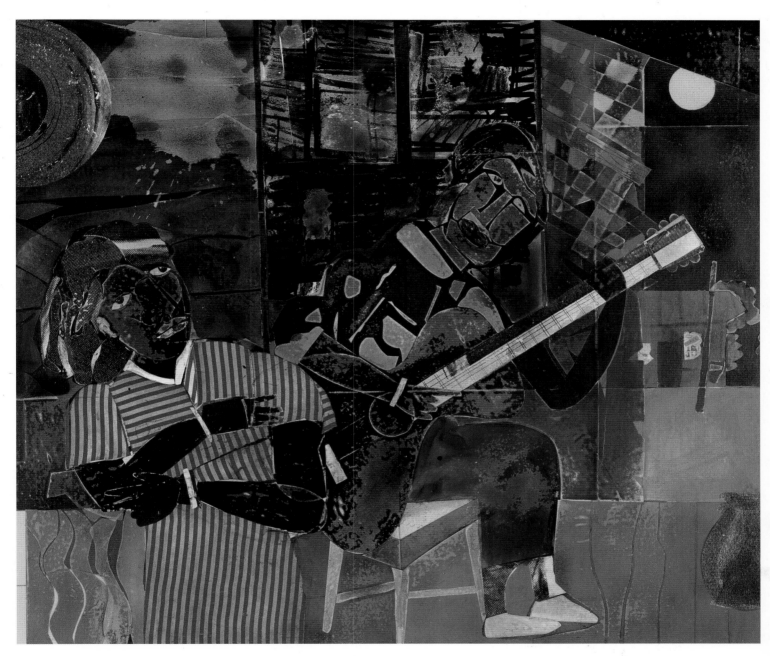

Opposite: *Three Men.* c. 1966–67 (Bearden's written dating). Collage on board, 58 x 42″. Private collection

Above: *Blues From The Old Country.* 1974. From the *Of the Blues* series. Collage with acrylic and lacquer on board, 44 x 50″. Private collection

The obvious is only the semblance," Heinrich Zimmer wrote in *The King and the Corpse*; "beneath lies something hidden, the real." Bearden had studied Zimmer's existential analysis of comparative mythology carefully. In 1984, in the Caribbean, Bearden had indeed penetrated the semblance of things to capture the Obeah and their rituals in art. Although in conversation, Bearden maintained that Obeah is not a religion, but rather sorcery, the Cordier & Ekstrom exhibition catalogue for "Rituals of the Obeah" included this definition, quoted from Webster's New International Dictionary, Second Edition: "*Obeah*: A religion, probably of Ashanti origin, practiced esp. formerly among the blacks, chiefly of the British West Indies, the Guianas, and the Southeastern U.S., characterized by the use of sorcery and magic ritual."

Bearden showed me these Obeah watercolors in his studio before they were framed and exhibited. He was understandably excited about his new work and was filled with energy as we talked about it. A segment of the interview took place two years later, in 1986, and has been incorporated. We began by discussing the whole issue of suggestion, superstition, and the unknown.

MS: Are there any numbers you're leery of? The number thirteen? Would you ever avoid having thirteen canvases in an exhibition?

RB: I think I would. I think I would. I don't usually think about it, but now that you mention that, I think that has happened a couple of times: "This exhibition is thirteen—we've got to put one more in!" And down in Charlotte, I think it was thirteen, we had fourteen now, or added two more.

MS: What about weather? Is there any kind of weather that seems ominous to you?

RB: No. I very much liked, in the islands, to see those raging storms. I guess it's the kind of Turner or romantic in me—with the lightning, and all like that. It's not frightening to me. The cats running under . . . Nanette doesn't like it, but I don't mind.

MS: Any kind of animal that you would feel is ominous?

RB: Well, I didn't care for snakes. And I told you about the Obeah woman, how she changed the relation to snakes, or did I?

MS: Tell me that again.

RB: Well, she had this big anaconda in a basket. I didn't know it—I was talking to her, and the basket opened, and here came this big snake, crawling

across her! So, you know, I was startled. She said, "What are you afraid of?" in French. I said, "The viper!" She said, "You know what fear is?" I said, "Yes, it's that goddamn snake!" And she said, "No, fear is that which is not there." And then she hit me—pow!—someplace like this [in the chest]. When I got back, there were two boys who had a snake, and I'd let the snake crawl all over me. But I said, "You know, if I brought it home, that'd be the end of the marriage!" Nanette would have left.

MS: And the Obeah—that includes all of the people, the priests and priestesses . . . ?

RB: No, there are just a few Obeah, and one high priest. [Bearden shows watercolors of the Obeah, which he titled in English, French, and Creole.] This I've changed since you saw it, because this was at dawn, when the Obeah left, and I had it white up here, and it wasn't clear. Now I think the idea that it's dawn and they're leaving is more clear.

MS: Yeah. And you have the cock there in the foreground . . . always for the dawn. Let me just read the title: *Loa Leaves with the First Cock*. This one is *Marriage of the Viper*; this was the anaconda wrapped around her neck.

RB: Right.

MS: This one is *Green Man*. He could be anywhere; he could be in New Orleans, or in the South. . . .

RB: Sure. He could. Harry Henderson was by and he liked this, but he had a criticism: he thought that the face was too compassionate; that it should have been more fierce.

MS: Now this one is the *High Priestess*—did she have those horns as part of her headdress?

RB: Yes. She had lived in Nigeria for seven years, and so she had brought back some of the things that the high priestesses there had given her.

MS: Some of them are very light and airy, they feel . . . Because of the white. These others are very dense, and rich.

RB: These are two in a trance. . . .

MS: *Two Obeahs in a Trance*. Was this a complete trance?

RB: Yeah.

MS: And this one?

RB: They're in a trance, but the other one is gone, out of this world.
This one is *The Obeah's Choice*. She has chosen this girl, but she's holding this part of her. And this girl can't go away, do you understand?

MS: I think so. And when she holds a person . . .

RB: She's taking some part of her; if she wants to change, go into a man, or somebody else, she's got her. And that was the way I symbolized it. This is a great myth, and it shows the arrogance of these people. You didn't see this one before, did you? *The Obeah's Dawn*.

MS: Is that the rooster coming out of her head and producing the day? When you say "arrogance," what do you mean?

RB: Well, you know, that you would feel that you make the *sun* come up?

MS: You ended an article you wrote for the *New York Times* with this description of the myth: "An Obeah woman once told me she took in the moon before

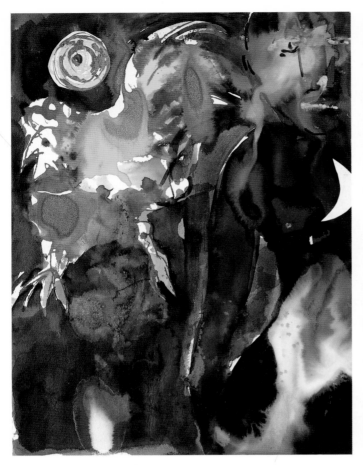
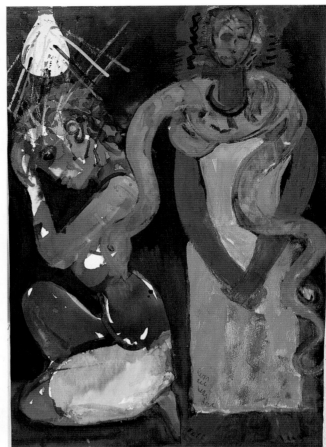
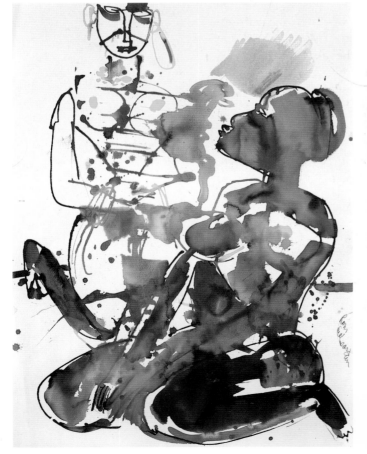

dawn and held it as a locket on her breast and then threw a rooster out in the sky who spun himself in the rising sun." Your concluding line was, "That is energy." So there seems to be an attraction in this myth for you: a dimension that goes beyond skepticism and that connects the energy latent in the myth with the energy that produces art.

RB: Yes. That's a good description.

MS: Well, if that's true, please talk about it.

RB: Well, let us, if you will, go back—you might be interested in reading it—to Whistler's "Ten o'Clock Lecture"—that's as far from the Obeah. . . . He talks about energy here, in this lecture. And he said, "Art is something that cannot be commanded; no emperor, no king can command it. And at a certain time when the energy level is low, it will go someplace else." And he mentions Japan—Hiroshige and Hokusai, these men were the ones who picked up on this ephemeral bird, which just flies away. My point is that art, as he says, will go where energy is. I find a great deal of energy in the Caribbean. I found, when I was last in Paris and walking down the rue de Seine, in the places and the galleries there, little energy—maybe competence in painting. I had a card, today, in color, from a show of four French artists who were Impressionists. They were continuing in what they thought was the tradition of Impressionism. But you felt that the energy that it took to produce that—I read of Pissarro, and these other men, who were up at dawn. They went to various places in France, Venice, some of the others, to find a kind of motif that they felt best exemplified what they wanted to paint. And others were coming. They were attacked, and then they had to build up more energy. They were all together. Renoir—no matter what they say, I think he was a good painter—Degas, they were all together. They had all this thing going. And then at a certain time, other things happened and that energy began to dissipate, that initial thing that drove them. But in the Caribbean, it's like a volcano there; there's something underneath that still smolders. People still *believe*. When you stop believing in the gods, they pack their bags and go someplace else! They say, "You don't believe in me; you don't want me; it's time to check out!" So Zeus, and Poseidon, and all the rest of them take off. And so it is with these people. But with them, however, you enter into something else. Freud and Jung and these men who tried to probe the unconscious stirrings that go on in all of us. . . . I think these people, and what they believe in, are down deep into our consciousness in that way. Sometimes to consider it all, if you are from a rational perspective, can be rather frightening. My wife Nanette won't go near them! She has her antecedents on the island, and people joke. Like we say here, "The bogeyman will get you." So they say, "What, are you going to Obeah woman, to get some kind of tricks to hurt me?" It is still there. And they live in their own particular society, their own beliefs, their own initiations, which I don't know at all. But I did try—in some of these places, I did see them go into trance. Like this one . . .

MS: That's *Obeah in a Trance*.

RB: Yes, and how to depict this. She seemed to be just not right. And it was moving in from this into some other person or some other force that was taking

Opposite, clockwise from above left: *The Obeah's Dawn (L'Aube de la Sorcière; Douvan Jou Manmbo-A)*. 1984. From the *Rituals of the Obeah* series. Watercolor on paper, 29⅞ x 22⅜". Private collection
Marriage of the Viper (Le Mariage de la Vipère; Mariaj Vipè-A). 1984. From the *Rituals of the Obeah* series. Watercolor on paper, 30½ x 20½". Schweber Collection, Kings Point, N.Y.
The Obeah's Choice (Le Choix de la Sorcière; Choua Manmbo-A). 1984. From the *Rituals of the Obeah* series. Watercolor on paper, 30⅛ x 22⅜". Courtesy of Maya Angelou
Two Obeahs in a Trance (Possession de deux Sorcières; Deu Manmbos Procédé). 1984. From the *Rituals of the Obeah* series. Watercolor on paper, 29¼ x 20". Collection of The Newark Museum. Purchase 1985 Helen and Carl Egner Memorial Endowment Fund

possession of her. And this was the best way that I felt that I could try to portray that.

MS: As well as you can remember back, to enter into the spirit of that trance, did you try to change your state of mind, try to enter into it yourself?

RB: No, because I didn't have that kind of belief or ability. I could only enter it artistically, I guess, but not with the full spirit of an Obeah. There was something in me that was there—I guess in all of us—but it's still untouched; it's still wild.

MS: Have you yourself ever been in a trance?

RB: No I haven't, not that I recall.

MS: Do you think that it would be possible for you?

RB: I imagine a hypnotist, or something like that, might be able to put one into me. But not a trance in this sense, where you're shaking and all. I've *seen*, as a little boy going to Baptist church, people be possessed, or what they call "gettin' holy." But I never have . . . just gone outside of myself. But these people are also not afraid of these things. That would be rather fearful to me, to lose myself. Because you wonder if you'll get back. But obviously they do, and they're not worried whether they do or not!

MS: Right.

RB: This is something entirely out of our rational experience. Maybe way back in our unconscious that we've inherited, as Jung says, there are things that are there. Maybe things we're afraid of! But there it is. . . .

MS: What's the relationship between the mask, the "extra rational" or unconscious power, and terror?

RB: Say an African puts on a mask of a tiger, or something like that. He assumes that power. And by assuming that power (and by becoming as fierce as the lion or tiger), he then is protected from the terrors of the universe, for with that extra power, he can overcome his adversaries.

MS: What attracted you to these particular rituals?

RB: Well, that's the thing that I've been interested in—a handshake, the rituals by which people live, baptisms. . . .

MS: Because they cross cultures, and establish patterns between peoples in all times—the universals?

RB: Yes, that's part of it.

MS: You say, "That's part of it." I guess you mean it's more complex than my "family of man" idea. Are there important differences between the Mecklenburg rituals and the rituals of the Obeah?

RB: Mecklenberg, and these new Obeah watercolors that you are looking at, are different but interrelated in that both deal with myth and ritual. The lady, Mrs. Sleet, that I have used frequently in my work, would be appalled at the Obeah people: they don't go to church, and have all this mysticism. The way I have represented her is not "photographic," but she is a fixture of my imagination. I've represented her surrounded by flowers, in something like the way the Greeks put a goddess in such a setting: Flora, I imagine they would call her. And so are *all* the people from Mecklenburg. I did something [in 1960] called *Remembering Golden Bells* [and a collage called *School Bell Time* in 1978]

because when I was in school in Charlotte, the teachers would ring the big bell and it was kind of brass, and looked golden. To me it was a golden bell. And in the background I had the school, with a bell on top of it. I saw a photograph [of the Myers Street School in old Charlotte] that, while I wasn't thinking of it, was very much like the collage I had done. It looked like I had had an actual photograph to go by, which I didn't. It just happened to come out that way. The other objects and people don't have the same verisimilitude, I'm sure. But the people, and the symbolism that runs through it—the train, the nude woman, the mask—all these are elements in Mecklenburg that are as mystical as Faulkner's Yoknapatawpha County: these elements bear another reality. It is up to the artist to make it *real*: more real than the reality of things. You try to do it with art.

I don't put masks on the Obeah, it's not necessary, because each of their faces *is* a mask. We all are dual personalities. I don't want to get into psychoanalysis, because I don't know anything about it; I'm just going from my imagination. I think that Oscar Wilde said something to the effect that the life many of us have to live is not really our life. And so the Obeah has transformed herself into this masklike figure to be commanding—you see, to have power which they believe over the occult; the ability to turn back certain forces of nature, to stop illnesses, or if you're cut, to stop the bleeding. They believe that. They have power over events amounting, they feel, to a godlike control. So they have transformed themselves into a way of life which they feel gives them this extra power, you see, the mask. They become different persons, [a transformation] that starts early in their lives, by initiations; dealing with ancient powers; living elementally, with nature.

MS: Is it what you would call the dark part of nature?

RB: Only in that we think so. I think that in Conrad's *Heart of Darkness*, that is what he sees: these forces around him, these dark irrational forces, to the Western mind. But to the witch doctor, he is just going about his normal way. He doesn't see that in the same way that Kurtz would see it. You know, this is the way he and the people before him have lived. The only way that Kurtz could deal with that—as is happening in Africa now—would be to *transform* the natural or irrational into the mechanical and industrial: steamboats that go down the river, roads on which automobiles run, high buildings like those they have in South Africa. Therefore, they would put the people in another context, taking them out of what had been the natural into another completely different context. On the other hand [with these transformations] you would no longer have the kind of face, or the kind of sculpture that would make *Jefferson Cooley* anymore. That's gone—gone out of Africa. You can't do that unless you have certain beliefs and live in a certain kind of way. And so there is writing coming out of Africa now, but not much graphic art. Most of it is Expressionistic, German Expressionism or that type of thing; and the other is copies of the old things to sell to tourists.

It is very easy to "civilize" people we assumed to be "primitive." People learn the *mechanism* of things right away. You can bring people from the Stone Age, as they are doing in New Guinea now, right into the

Above left: *Obeah High Priestess (Sorcière Haute Prêtresse; Lougarou-Gro Manmbo).* 1984. From the *Rituals of the Obeah* series. Watercolor on paper, 29⅞ x 21¼″. Private collection

Above right: *Three Obeahs (Trois Sorcières; Trois Manmbos).* 1984. From the *Rituals of the Obeah* series. 30½ x 22⅜″. Collection Mr. and Mrs. Walter Christmas

Opposite: *Green Man (Homme Vert; Misié Vet La).* 1984. From the *Rituals of the Obeah* series. Watercolor on paper, 30½ x 21⅝″. Schweber Collection, Kings Point, N.Y.

twentieth century in a very short time. You could take a child and put him in Oxford right away, show him how to use a washing machine, how to pull the trigger of a gun to kill people instead of using bows and arrows or spears. There are those who are resistant to the encroachment of civilization, but not the young. The gods and goddesses of Olympus had to pack their bags and leave before the encroachments of the Judeo-Christian civilization, in the face of a loss of belief in Zeus, Poseidon, and the other gods and goddesses. With the Obeah, you had people who were holding on to an irrational set of values that Freud and others feel is still present in man. If it weren't, we would no longer have the killing machines, the machines of war. As someone said, "Man is still an ape with a velvet glove."

There is this thing that is still present within us, this element that we haven't eradicated yet—the irrational. A fellow told me that his mother went to see an Obeah man; I think it had to do with his father: a dispute between the mother and father over a girlfriend of the father. And the Obeah said, "Yes, this man wants to kill you," to the mother, "because he has fallen in love with another woman." She said, "What can I do?" And he enumerated certain herbs which the mother knew how to get in the mountains. Then it would be put in his tea, and in his bath. The Obeah said this would give her control over the situation. She asked, "Would you go home with me, to see what you could do?" And he said, "No, because he knows that I am here, and

he wants to kill me." So she said, "No, that's impossible, because I never told him, and he has no way of knowing that you are here." They started walking down the road, and about halfway, the Obeah man wasn't there any more. They couldn't figure out how he had disappeared. But when they got home, his father was sitting on the steps with a machete to kill the Obeah. So this is what I mean about the Obeah. They live in terms of people who would believe in them. In the face of Western skepticism, their power is lessened. And that's why I say that now they live very much to themselves, because obviously they believe in themselves.

In painting the Obeah I expressed my own feelings, not creating a "documentary" or in any sense a photographic reproduction. I do *have* a [videotaped] documentary interview with an Obeah. In the sense I am describing to you I am inventing, but it has to do with Obeah life. They are living in a now that is a "not-now" because their antecedents may have been witch doctors—all of these rituals that point to other forces, or ways of looking at the world that we have now for the most part rejected. But they are forces that are still in a certain sense inchoate within us. As in the film *Orphée Noir*, the face of an Obeah may belong to a great-great-grandfather. We may call this an archetype, but this is for him a *real* life!

Mecklenburg has nothing to do with magic, or enchantment, in the sense that these people use it. The Obeah is part of magic, while Mecklenburg is a recall of things that were most often pleasant to me. They both deal with myth and ritual which, however different in their particulars, are universal to human experience.

MS: You once said, "Well, these *sorcières* are like a cross between a Conjur Woman and our witches, and we burned all our witches, like they killed all the buffalo, destroyed all our good natural resources." So here's what I wanted to ask you: You're making an interesting but strange analogy between the buffalo, witches, and conjur women. In what way do you see witches, conjur women, and *sorcières* on a par with the buffalo, which to begin with is essentially a harmless animal, with no knowledge of good and evil?

RB: Yes, but he was a food supply; he was that which clothed you. When he was killed by the Indians they revered him; they saw the buffalo as a spiritual force, like the maize or corn which also fed him. And the other thing: I meant it in that way. That while it was what the Indian read into the buffalo, not how we see the buffalo itself. And what we read into the Obeah, who are acting *naturally,* as far as they're concerned. They're living in the world of magic, but it is natural to them. A lady sent me something about an Obeah in the jungles of Guiana. He went healing; he had a certain way of talking in an ancient African language. . . . All these had obviously been handed down, because these were people who had escaped into the jungle in the 1600s; for two or three hundred years they've been living in the back country. So they were long since torn from their own geography. But they could take anything—a stick—and say that it is something holy. This is what they are ascribing to it. Naturally, we see the buffalo: he just wants to eat, he's not bothering anybody. But to [the Indians], he was their food. And revered in that sense. They gave thanks to him for sustaining them.

MS: What happens to society when it loses touch with that, or when it eradicates it?

RB: Well, when they begin to eradicate that, we begin to lose touch with nature. I think modern man has in many ways completely protected himself from nature: air conditioning, refrigeration, type of housing, pesticides, all of these things that protect us from what we feel takes us down, which is nature. But it is something that keeps asserting itself. If something would happen here, an atomic bomb, for instance, we might be gone, but some kind of weeds or something would start sprouting up, and nature would continue. Because nature doesn't give a damn about us—about man, or a tree, or the ocean. While we're doing these things that are taking us further from nature, we're divorcing ourselves from something that is part of us.

MS: Romie, do you think that if the divorce were complete, society would lose its art?

RB: I don't necessarily think so. For instance, Mondrian, in his later work, becomes completely against nature as a force that may pull people downward. And you could see this exemplified in the severity of his art; in its complete nonrepresentational quality. It's a surrender to a certain mathematics. So it would just be something else. But, for instance, we conquer one thing, and then we have AIDS. We conquer one thing, and we have something else. Other things keep coming back.

MS: In your journal, when you're talking about Mondrian to Carl Holty, one of the things that you thought was that he established a sort of moral polarity, that was artificial, between good and evil. And that these extremes were somehow forcing the matter. I'm just thinking back now, to when I was asking you about the buffalo—maybe witches, conjur women, and *sorcières* can't be thought about in terms that simple, of good and evil. In other words, the *sorcières* of the Obeah, whom you think of as witches, but that doesn't necessarily mean that they conceive of themselves that way.

RB: Exactly. Nor does nature! We feel a storm, or lightning is bad, but it's not so in nature. When some tension builds and it has to be relieved, and we have a storm or lightning, it is just nature reinforcing itself. It might hit us, or burn a building, but nature's not concerned with that.

MS: So what when you saw those ceremonies, there was something deep you felt in them, something filled with energy, but nothing particularly evil or good. You didn't see them in those terms.

RB: Beyond that.

MS: That's the way Nietzsche put it, "beyond good and evil."

RB: That's right. To me, they were beyond that. It's just in another realm, that goes way back. As rationality takes over, or what we call that, obviously they will be gone. But these are the people who are one with this still.

MS: As far as you know, were you the first artist they allowed to watch a ceremony, or in any way participate?

RB: I can't say for sure, but I don't know many people who have painted the Obeah.

MS: Then, the year after you did those, when in the course of doing a number of watercolors over the next summer, you came to want to do another Obeah. I

Overleaf, left: *Conjur Woman.* 1975. Collage on board, 46 x 36″. Private collection, Southfield, Mich.

Overleaf, right: *Conjur Woman.* 1971. Collage on board, 22¾ x 16⅜″. Private collection

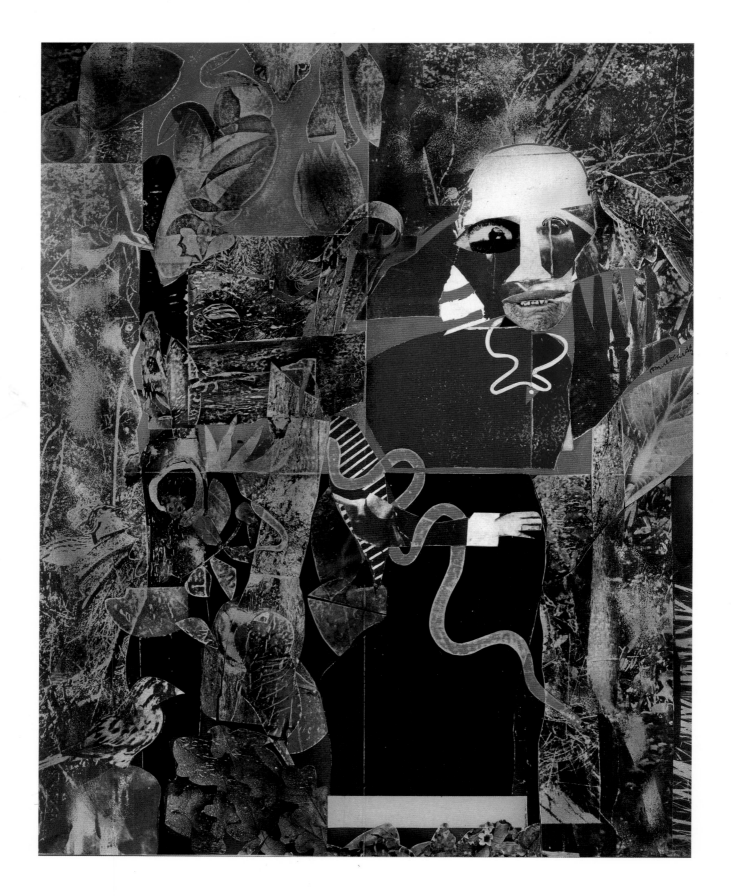

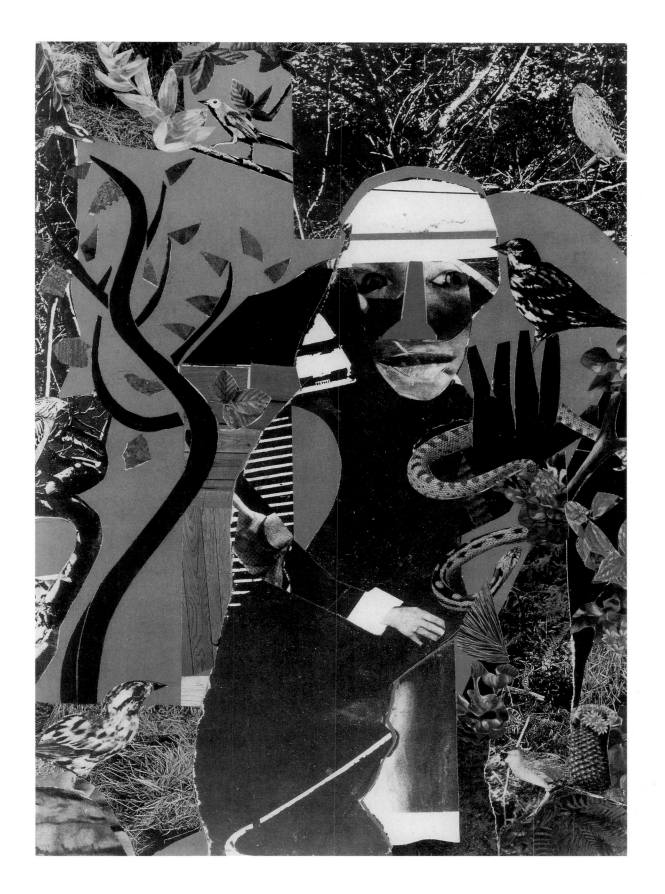

remember your doing one or two, that next summer. In what state of mind would you have to put yourself in order to paint that subject matter?

RB: Well, I didn't do it so successfully after that, because . . . I remember reading an interview with Picasso—he'd been to see a garden, with lilacs, or something. So he said, "I had the color purple—it had come out of the garden—but I had to get it out of my system!" And I believe if you're around this, you have to get it out, and that's it! To be able to go on and do more, you'd have to associate yourself more with that. But I don't want to get to that attitude that you find so much with Americans, and other people now: people getting grants to come down and study the Obeah. "I'm going to be there and I'm going to make friends with them. I'm going to be really nice and show them I don't intrude on what they're doing." All the right things that they would say, that are wrong. Do you follow? It's best that I did this, when I went and talked with the woman. It's best not to intrude anymore, and let their ground be sacred to them. But I will say this: that we all cast a shadow, and sometimes we look backward. And I think that this was like the Obeah—they are part of our shadow. That part of me is gone, or killed. That me is over. I think we have a lot of I's, or me's—we look backward sometimes and find these things that are not in the light of reason.

MS: It's extraordinary to find artists, in whatever art, who remain in touch with that. I read an article in the *New York Times*, an interview with Amos Tutuola, the Nigerian who wrote *The Palm Wine Drinkard*. And he would have that—that's part of him. He writes out of that spirit.

RB: That's exactly right. He doesn't have to go looking; it's all in him. Ghosts are as real to him as people. Some of the African sculpture is done for when ancestors are going to visit. They've been dead a couple of hundred years, but it's waiting for them when they decide to come back. They [the sculptures] are vessels which they can fill. But our rationality tells us they can't come back.

MS: This is interesting. At one and the same time you're able to, with the skeptical part of your mind, see the arrogance of putting the moon in a locket, throwing it out, and it's a sun. In another way you're able to suspend disbelief. To go back to your encounter with the Obeah woman and the snake, and animals in general . . .

RB: She said there's evil in snakes. But otherwise . . . I think everybody would be very fearful—I think this is in everybody's genes—of something like a Tyrannosaurus Rex coming at me, or . . . the crocodiles, at one time, sixteen and twenty feet long, would pass. One of those things grabbing you. Or those things that fly. I used to be very frightened that way. I was playing, as a little boy, in the yard in Charlotte, with some little chicks. And a mother hen flew over—I guess she thought that I was harming them. And I had this kind of fear of chickens, you know. In those days in Pittsburgh, they used to buy the chickens live and then wring their necks. They had barrels, out in front of everybody's house, so that in their last convulsions, they wouldn't just roll all over the ground. So the head, and everything like this, just didn't please me. Even as a grownup, it would be impossible for me to wring any chicken's neck, like they did. It curls around like this, you know.

MS: When you were young, can you remember being scared of darkness, at all?

RB: No, because my mother would tell me, when they'd go out—they didn't have babysitters in those days—and she'd say, "You know the angels are here. They're all around, you needn't be afraid." So I never had a fear of that.

MS: To come back to the Obeah woman. Do you have any fear of the unseen?

RB: Like of ghosts, or something like that?

MS: Ancestors . . .

RB: It would be interesting for me to see one. You know, they don't seem to hurt you.

MS: My friend Arnie Lawrence was telling me about the night Clifford Brown was killed in a car crash. Max Roach told Arnie—Max was far from the accident, in a hotel room in Chicago, I think—that Clifford came to say goodbye.

RB: Well, I've had one experience something like that. Nanette had a very close friend, who was once one of Alvin Ailey's lead dancers. And after she stopped dancing, she taught at City College. She was a very influential woman in the dance world, knew everybody—her name was Thelma Hill. And at about 2:00 or 2:30 in the morning, my phone rang. So I answered the phone, and it was a woman named Joan Sandler, who works at The Metropolitan Museum. She was crying, and she said, "Thelma is dead. But don't tell Nanette." Because they were very close. So I asked what had happened. She had been to Philadelphia to see people—she got home very tired, and she was cooking a turkey, and fell asleep. And something, with the oven and all that, had caught fire, and she suffocated. So I asked when this had happened. She said it was around 10:00, that she was dead. So I was up at that time, and I went into the kitchen. And I had a clock, and the clock had stopped at 10:15. So I fixed the clock—it was now going on 3:00.

There was a little hiatus, because her parents were dead, and they took a little while to find the second cousins, to identify the body, and so forth. So the funeral was maybe ten or twelve days following her death. And I was supposed to go up to the grave site and say something. And I went back home. The clock had stopped again, at 10:15.

MS: Romare, when you were growing up, or at any point, did you ever have occasion to find a dead body, or see a dead body?

RB: Oh yes, several times. I remember as a little boy on 140th Street, looking out the window. As a man was crossing the street a car hit him—he rolled over, he came down; he was dead. This man, or boy, was a little drunk. He was a big, husky fellow. He beat his head against the curb a couple of times, and then he sat there sobbing and crying.

Then in Pittsburgh, there was this lady, the Ice Cream Lady; and her daughter, going with this man. She shot him; I heard the pistol shot, so we ran out there.

MS: She shot him?

RB: Yeah. She killed him—the daughter.

MS: And after the death of a person close to you, did you ever sort of *see* the person, in a dream, or hear the person's voice? Your mother . . .

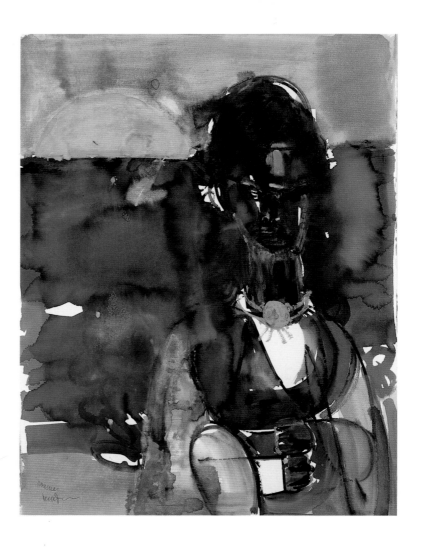

Obeah in a Trance II (Possession de la Sorcière II; Manmbo-A Procédé II). 1984. From the *Rituals of the Obeah* series. Watercolor on paper, 30¼ x 22⅜″. Private collection

RB: Yeah, or something like that. And it would be strange, you know, like it was in the past. Something else was happening, you know, that had nothing to do with the dying. I mean, it [the dream] would go on into something else. I don't know all the meanings of them, but I forget. I had a little book, and I said, "Whatever I dream, if I can remember it, I think I'll draw it."

One of the things I drew was a policeman. When I was a little boy in the twenties, some of them had these leather leggings, that came up to here. And there were a number of them, standing in water, up to here, like the ocean, maybe. And they were all standing up at attention. And the captain, or lieutenant was in front. That was all that I remembered, from that dream, and I did a drawing of it—a little sketch. It's so wild, what you dream about. But you dream something, and then you forget it, when you get up, as the day goes on.

MS: Yeah. You forget it immediately. Any fear of death, as such?

RB: Yeah [chuckles]. I mean, I'm going to try to be here as long as I can! That's the *real* unknown!

We're not raised in a culture like, say, Japanese soldiers, who get in the army and they give his funeral for him, you know? It's a different

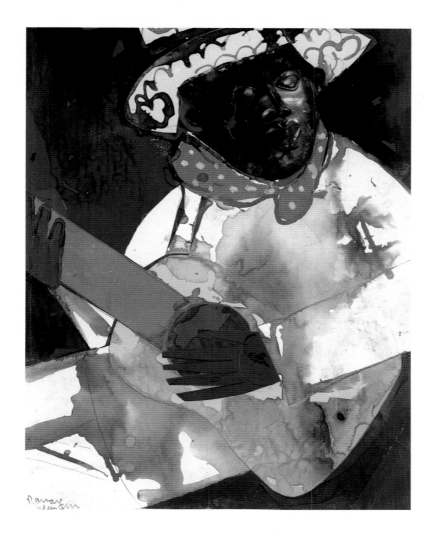

Jefferson Cooley's Evening Guitar. 1986. From the *Mecklenburg: Morning and Evening* series. Collage with watercolor and ink, 14 x 11″. Private collection

thing. And as an artist, one of the things that you have is a reverence for life.

MS: Yeah. In the midst of everything else.

RB: Yeah. I was in Spain, and there was a military funeral, and I stopped to look. And there was a group of soldiers—I guess it was a big funeral, for one of Franco's generals, I don't know. And they were playing—you know how they walk [hums dirge]—and then they went around the corner, the whole thing. And then these men with trumpets began to play a flamenco! Those long army trumpets, you know, not something like Louis played that you hold with one hand. And it was like Hannibal: these people crossing the Alps with trumpets. There was an English gentleman behind me, and he said, "Now, life is typical!" And I had to say, "I think you're right!" I think that: there's always life, in the presence of death, because we begin to die as soon as we're born. But there is a continuum.

MS: Same thing in the New Orleans scenes that you've done, like those Storyville Ragging Home scenes. I guess it's the same kind of thing.

RB: You're gone, let's have a ball!

MS: Yeah. Or an Irish wake!

THE VOYAGER RETURNS: 1976–1988

Most artists take some place, and like a flower, they sink roots, looking for universal implications, like James Joyce did in Dublin and the photographer Mathew Brady did for the Civil War. My roots are in North Carolina. I paint what people did when I was a little boy, like the way they got up in the morning. But I would like it to have more."

—Romare Bearden[1]

By 1976, with two highly successful *Of the Blues* exhibitions in two years fresh in memory, and at the height of his creative energies, Bearden began the long voyage of return to ancestral lands (African-American, Cherokee Indian, Southern, Afro-Mediterranean, and Afro-Caribbean) in both his life and art. A year after the Mint Museum in Charlotte, North Carolina, purchased *Carolina Shout*, perhaps the outstanding work of the 1975 *Of the Blues* collages, Bearden was invited home in May to give a talk in conjunction with the installation of his collage in the Mint's permanent collection.

Set *Carolina Shout* beside Bearden's 1964 Projection *The Prevalence of Ritual: The Baptism*, and it is immediately clear that Bearden had done a masterful variant on the theme. Although the subject remains a baptism, the artist's handling of color and form in the new work gave it additional resonance. As Albert Murray comments: "The figures suggest an ecstatic high point in a downhome church service. At the same time, however, the title, made famous by a Harlem stride-piano composition [by James P. Johnson], implies that the movements and gestures are not unrelated to the dance hall, the juke joint, the honky tonk, and the barrel house. So even as the figures evoke the Sunday Morning Service, there are overtones of the . . . Saturday Night Function."[2]

In Dore Ashton's view, *Carolina Shout*, like other collages in *Of the Blues*, draws liberally on jazz-inflected idioms: "The scene is essentially flat, a series of images and movements against a hot red ground. The heads are masks, and masks always permit expressions that are not usual: hidden but felt. The hands perform a balletic ritual. As one's eye traverses the surface of this painting and adjusts to its re-phrased spaces and scale, foreground and background merge and separate constantly."[3]

Despite the celebratory nature of the occasion, the return to Charlotte overwhelmed Bearden with a bewildering sense of displacement. Too much had happened to the early-twentieth-century Charlotte he played in

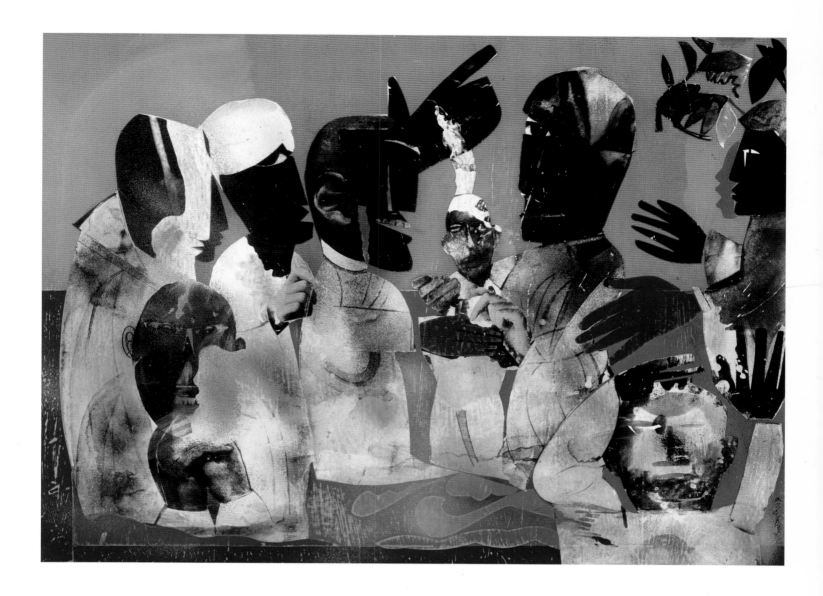

as a young boy. The entire landscape he had locked into memory—his great-grandparents' wood-frame house near the Graham Street railroad trestle, the Magnolia Mill, the church in which he had been baptized, the Myers Street School—was gone. Accompanied by reporters from the *Charlotte Observer*, Bearden searched in vain for familiar landmarks as the car drove slowly down Graham Street. He saw only empty lots and billboards. When he passed two old frame houses, Bearden commented, "This was the type of house. They're all gone. Everything's been torn down."[4]

Even the old United States Mint on West Trade Street had been razed during the Depression to make way for an expansion of the post office. Its brick and stone had been purchased for $950; federal public works crews had reassembled them on three donated acres of flood plain in what was to become one of the wealthiest sections of Charlotte by the time of Bearden's visit.[5] Its relocation, restoration, and conversion to an art museum had been

Carolina Shout. 1974. From the *Of the Blues* series. Collage with acrylic and lacquer on board, 37½ x 51″. Mint Museum, Charlotte, N.C. Museum purchase: National Endowment for the Arts Matching Fund and the Charlotte Debutante Club Fund

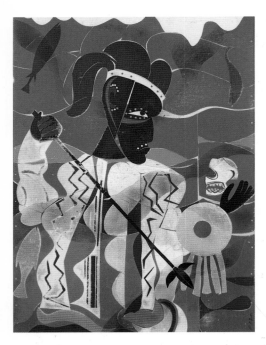

The Sea God. 1977. From the
Odysseus Collages. Collage on
board, 44 x 32″. Collection Mr.
and Mrs. Ellis D. Schwartz,
New York

executed so tastefully that the building itself maintained its original look, although a 1967 addition had doubled the exhibition space. But for Bearden, the very authenticity of the restoration must have intensified the feeling of surreality: it was the old building in the wrong place. The boy who had played on those steps with his cousin Spinky Alston was now nearly fifty years older, a nationally acclaimed artist. But if the experience was bewildering, if the feeling was surreal, Bearden appeared to take it in stride.

The return had been a rite of passage. Bearden often spoke about painting as a kind of Odyssean voyage of rediscovery: "If you're any kind of artist you make a miraculous journey and you come back and make some statements in shapes and colors of where you were."[6] As for the Charlotte that existed no more, he had not needed to go back, Bearden would say a few years later, because he'd never left, "except physically."[7] Then Bearden characteristically synthesized the whole experience visually: "You know," he said in conversation, "I was thinking about those stereoscopes recently—those wooden holders we used to have in my childhood. You put two identical pictures into it and look through the lenses and your two eyes turn the pictures into one three-dimensional picture. I see that left picture as my childhood and that right picture as how I see it now as a grown-up. I use a fairly modest technique in trying to focus both images into one."[8] Bearden's "fairly modest" technique was painting in collage, which he defined as the art of "putting something over something else."

Like many other passages in Bearden's life, the return to Charlotte had been important in that he managed to assimilate it creatively, making it work for him to trigger a renewal. He would go on creating and re-creating a Mecklenburg that in some ways had never existed at all, a world of ceremony and ritual common to all cultures, notwithstanding the idiomatic particularity of its Southernness and the prevalence of its black subjects.

"Between us and ourselves there's a door that's weighty," Bearden said. He used Vincent van Gogh, whose life and work had always moved him, to illustrate the point: "If I look at a book of Van Gogh's pictures, first I see *The Potato Eaters.* Then I see that he came to Paris and met Seurat. After that he became the Van Gogh that we know. In other words, he had passed through something, and this gave him the impetus to be himself."[9] Romare Bearden, great-grandson of H. B. and Rosa Kennedy, still remembered as a little boy by two or three prominent members of Charlotte's black community, had become the Bearden the art world had long respected. He now established himself as a national presence for a new generation of Charlotte's gentry, and they celebrated him as a prodigal native son returned.

Back in New York, a Bearden line-drawing of an urban street scene, reminiscent of such 1964 Projections as *The Street* and *The Dove* was commissioned by the *New York Times* Op-Ed page to accompany an excerpt from Richard Wright's posthumous *American Hunger* in April 1977. The Wright excerpt was an extension of *Black Boy,* the autobiography published in 1945. Bearden's drawing was obliquely appropriate to Wright's angry message ("Sharing the culture that condemns him, and seeing that a lust for trash is

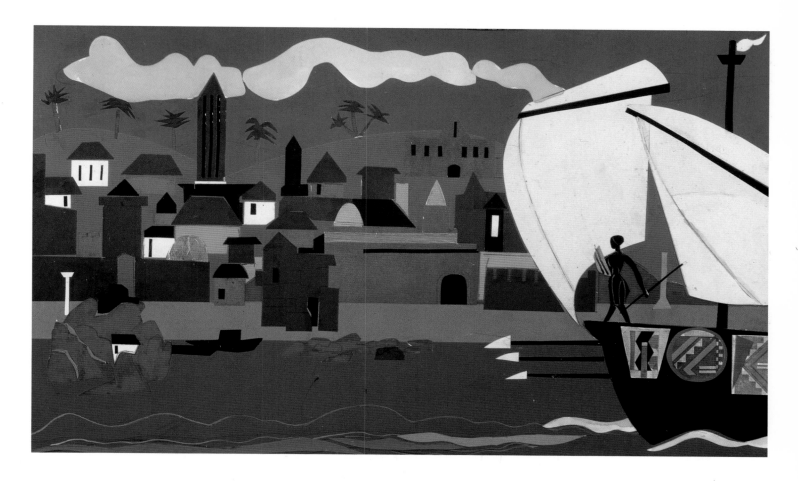

what blinds the nation to his claims, is what sets storms to rolling in his soul").[10] But Bearden's figures, unlike Wright's thunderous persona, do not confront the viewer: instead, they all focus on a cat sitting on the pavement in the left foreground of the picture.

The *Odysseus Collages*, exhibited at Cordier & Ekstrom in May 1977, marked Bearden's return to the Homeric material of his 1949 watercolor *Iliad Variations*, but with enormous differences in treatment. The *Iliad* watercolors had the prismatic quality of stained glass, the handling was Cubist-inspired, and the subjects were rendered almost geometrically. If Bearden's twenty *Odysseus Collages* were linked more closely to the narrative line of Homer's *Odyssey* than the 1949 watercolors had been to *The Iliad*, he playfully set forth *this* epic as if Homer had been a Mediterranean-African bard. In his treatment, Bearden bowed precariously close to the late Matisse of *Jazz* and the undersea cutouts. In a sense, Bearden might have done better had he followed Matisse's literary example more closely, for in his illustrations of James Joyce's *Ulysses* for the Limited Editions Club in the mid-1930s, Matisse gave no indication whatsoever of having read Joyce's work.

In reviewing the *Odysseus Collages* quite favorably in the *New York Times*, John Russell acknowledged the "rash nature" of an artist who would undertake the double danger of invoking *The Odyssey* by way of Matisse.

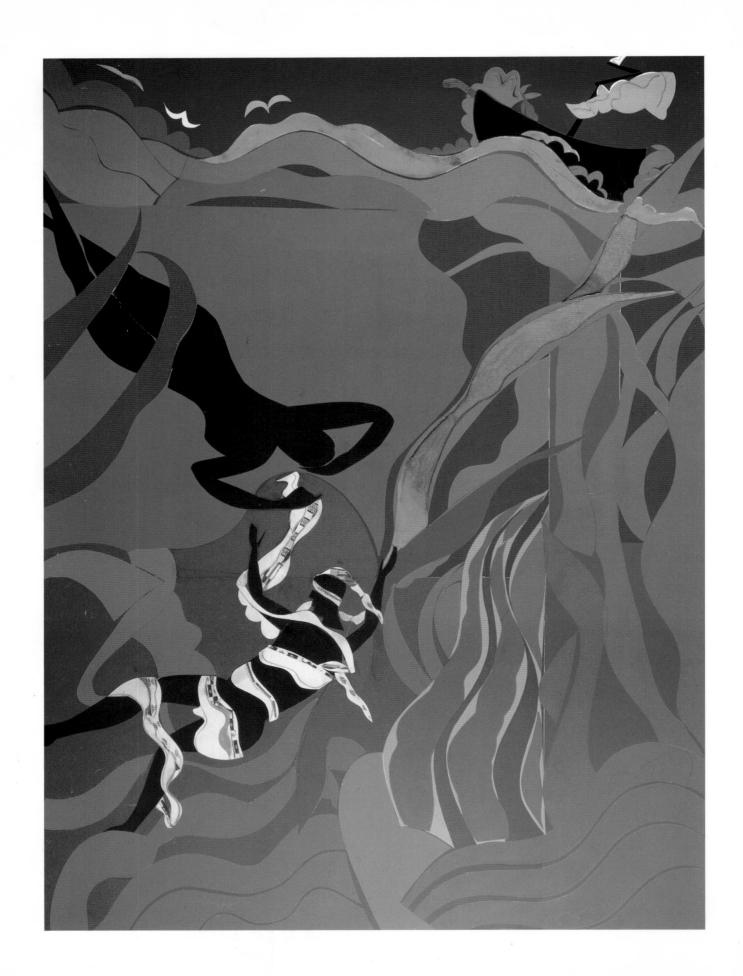

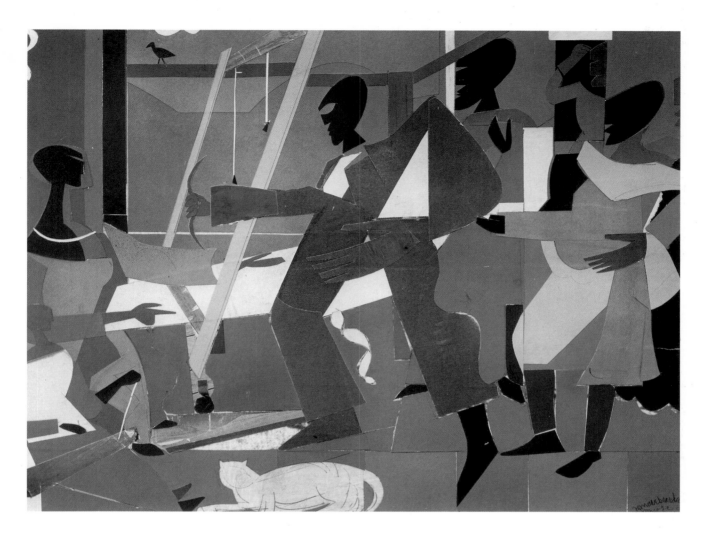

Instead of being effaced by the stature of his precursors, Russell wrote, Bearden, by the sheer quality of his artistic imagination, had managed to make us see his giant progenitors as friendly allies. "His high-breasted Nausikaa, for instance. We do not feel at all disoriented when she turns out to be as black as she is comely (which is saying a great deal, by the way). Nor does it perturb us that Mr. Bearden shows Odysseus taking leave of her outside a city that is of Moroccan or Tunisian derivation. Imagination is all, in such cases, and Mr. Bearden carries us with him."[11]

Bearden had divided the scale of the *Odysseus Collages* roughly in two. Thirteen of the twenty are rendered in what was, for him, a very large scale, 32 x 44" or 36 x 48". The remaining seven are about 12 x 15".

The series is uneven. Two of the small collages, *Home to Ithaca* and *The Bow of Odysseus*, are undoubtedly successful. The first is a landscape representing Odysseus's ship coming into harbor, the second a landscape of suitors about to be slain. Of the large collages, *The Return of Odysseus* (homage to Pintorrichio and Benin), Bearden's reworking of his smaller 1969 collage *Hommage à Pintorrichio*, is of unquestionable excel-

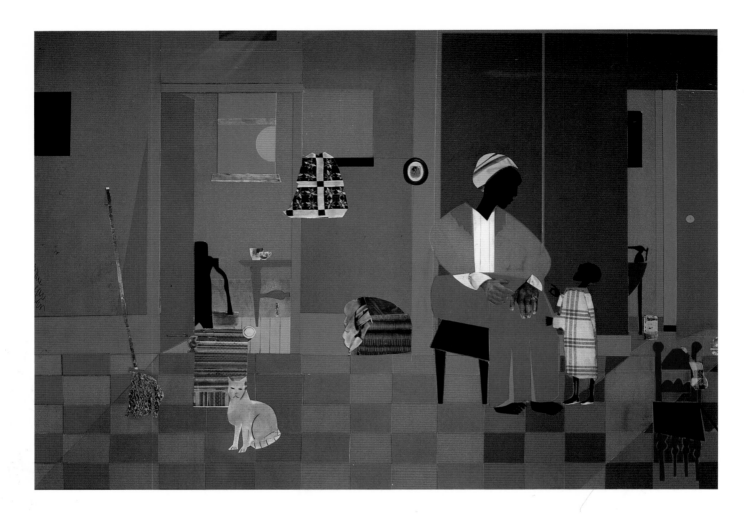

lence. The same is true of *The Sea Nymph* and *Odysseus Leaves Nausikaa*. But the collages dealing with Odysseus's other adventures—with the Cyclops, for instance; with Circe, the witch who turns his companions into swine; the trip to the realm of the shades; the passages between Scylla and Charybdis; or the Cattle of the Sun—while forceful in their cobalt-blue or red-hot chromatics, are not so well conceived or resolved. Bearden's work suffers when his human figures seem lost in the lush foliage of a landscape (though he may be quite faithful to his theme), as occurs in *The Land of the Lotus Eaters*. Elsewhere, Bearden's sensibility seems tied to the story line of Homer's epic, just as Odysseus is tied (literally, in Bearden's rendering) to the ship's mast in *The Sirens' Song*. The collages depicting metamorphoses (*Circe Turns a Companion of Odysseus into a Swine*, for instance) come perilously close to illustrating the literary.

On the whole, Bearden is at his most eloquent when his subject matter is most human. And one or two of these pieces, set on African shores and shot through with the light of the Caribbean, will stand among Bearden's best work of the decade. In a letter of praise, Bearden's cousin Edward Morrow summed up Bearden's progress from *Iliad* to *Odyssey* suc-

cinctly. Bearden had signed on thirty-odd years earlier, Morrow wrote, attempting to "launch his art upon a cruise with Odysseus." He'd "made the roster, but not the crew," and had gotten lost at sea. "Now he has made the shore, charted the voyage, illuminated the log, and lives to pull the bow."[12]

For the premiere of choreographer Dianne McIntyre's "Ancestral Voices," performed by the Alvin Ailey American Dance Theatre at New York's City Center in early May 1977, Bearden had designed a memorable front curtain. "Ancestral Voices," Anna Kisselgoff commented in a *New York Times* review, "is an abstraction of an African ritual, and the abstract note is obvious from the start in Romare Bearden's beautiful front curtain of foliage and African forms. The theme of the 'ritual' onstage is the world's four elements—earth, water, air and fire."[13]

The November 29, 1977, issue of *The New Yorker* published a significant profile of Bearden by Calvin Tomkins entitled "Putting Something Over Something Else." The title was apt, since it was not only Bearden's definition of painting, but also alluded to an agenda of concerns throughout

Spring Fever. 1978. From the *Profile/Part I: The Twenties* series (Mecklenburg County). Collage on board, 7 x 9⅝". Private collection

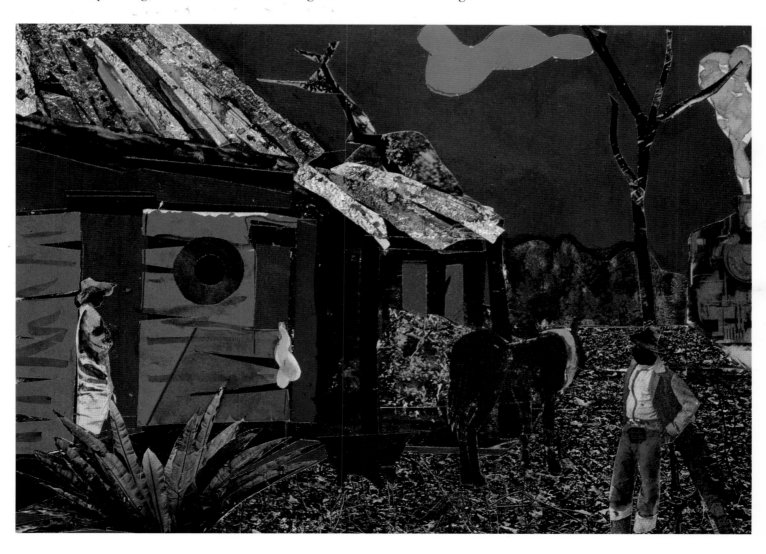

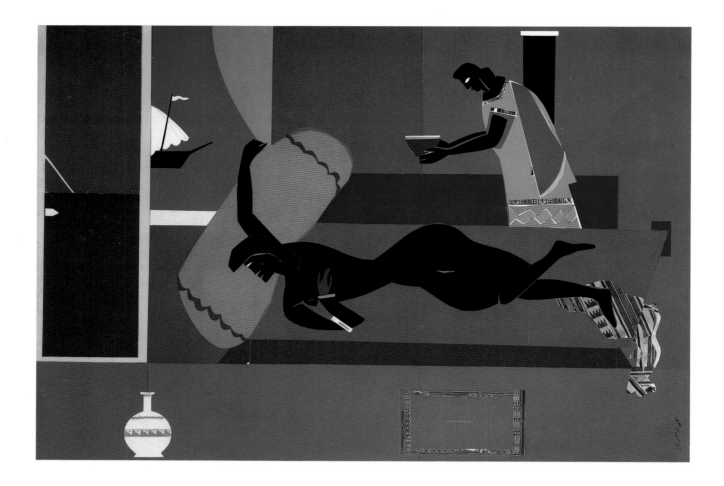

Bearden's life and art. The profile began with a description of the opening of
the 1975 *Of the Blues* exhibition at Cordier & Ekstrom, complete with a jazz
quintet and singer. Tomkins went on to lay out the geography of Bearden's
odyssey by way of the cities and neighborhoods that had been his ports-of-call:
Charlotte, Pittsburgh, Harlem, Paris, and Canal Street. It was an excellent
piece and gave Bearden an idea; he could go on to create a new set of collages
which would be the visual equivalent of a profile.

Throughout spring and early fall 1978, he created a series of
twenty-eight extraordinary collages, each of which was unique, but which,
taken together, coalesced in Bearden's anecdotal memories of his childhood in
Mecklenburg County and his youth in Pittsburgh. As was his habit, Arne
Ekstrom visited Bearden's studio on Bearden's return from St. Martin in early
fall. Like the Projections fourteen years earlier, the unifying theme came from
Ekstrom, who suggested that some of the memories contained in the *New
Yorker* article could give the exhibit its format. Bearden and Albert Murray
then collaborated on a series of short narratives, one for each collage, which
Bearden would write on the walls of the large Cordier & Ekstrom gallery.
Murray asked Bearden for his recollections of specific people and scenes,
found a narrative style for them, and orchestrated them to form a series.

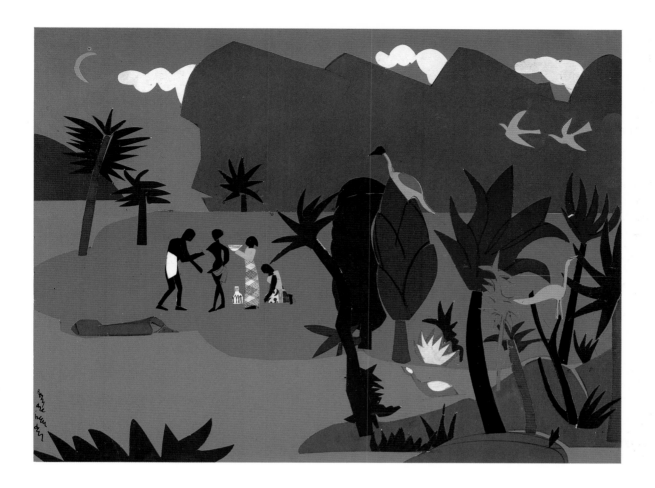

The exhibition's title, "Profile / Part I: The Twenties" implied of course that there would be a sequel. That exhibit, "Profile / Part II: The Thirties," took place nearly three years later, in May 1981, when the gallery had relocated to 417 East 75th Street. The new two-story space was easily as large as the Madison Avenue gallery space, but its brick walls did not physically lend themselves to the handwritten narratives, which accompanied the collages only in the catalogue.

Taken together, the two series spin out the tale of an odyssey from Mecklenburg to Pittsburgh to Harlem. In a sense, however, their real subject is time: "In the *Four Quartets* T. S. Eliot talks about time," Bearden said, "about how you have to go back where you started to gain insights. Things that aren't essential have been stripped away and the meaning of other things has become clear. . . . My great-grandfather's garden, the lady who sold pepper jelly from her basket, and Liza, the little girl I played with, all left a great impression on me."[14]

"Part I: The Twenties," for instance, included two collages devoted to a woman named Maudell Sleet. "Al Murray would ask me what she did, and I would tell him about her: that she had a green thumb, that she kept a small farm going by herself after her husband died. When I passed as a boy,

Overleaf, left: *Miss Bertha and Mr. Seth*. 1978. From the *Profile/Part I: The Twenties* series (Mecklenburg County). Collage on board, 25½ x 18½". Private collection, New Jersey

Overleaf, above right: *Round About Sunset*. 1978. From the *Profile/Part I: The Twenties* series (Mecklenburg County). Collage on board, 6¾ x 13⅝". Collection Jane and Raphael Bernstein, Ridgewood, N.J.

Overleaf, below right: *Liza in High Cotton*. 1978. From the *Profile/Part I: The Twenties* series (Mecklenburg County). Collage on board, 17½ x 32¾". Private collection

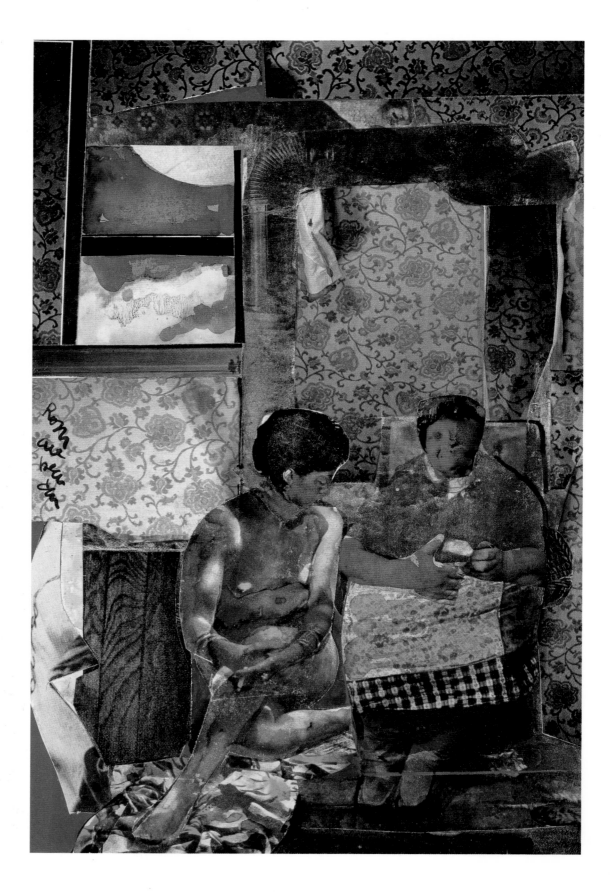

phy: the nude at the bath with a grandmother figure in attendance, the lamp, the potbellied stove, and the train—framed by a window—steaming across the fields beneath a hot sun. Beneath it is the memory: "She came to the depot in her best dress to see me off. As the train began to move she ran alongside blowing kisses."[16]

The Harlem collages—particularly *Susannah in Harlem* (40 x 30″) with the *same* iconography as *Prelude to Farewell* transposed North, and *Uptown Manhattan Skyline: Storm Approaching* (40 x 30″), with the motif of a grandmother figure holding an umbrella over a young girl on a Harlem rooftop, the sky ablaze with the light and darkness of the approaching rain-cloud—are very often excellent. Only in three or four (*Jackie at Bedtime, Helen*, and *Manhattan*, suggesting the downtown skyline with a dreamy, watercolor effect; or *Rehearsal Hall*, which seems linear, jagged, and hasty, almost sketchlike) is there a falling away. Juxtaposed with excellence, however, *any* falling away is all the more apparent.

The most autobiographical of the Harlem collages, *Artist with Painting and Model* (44 x 56″) is a unique Bearden statement about the first flowering of his art in his studio above the Apollo Theater, where he and Sam Shaw painted from the model weekly (the canvas was no longer empty). It is also one of only five instances of Bearden's having perhaps placed his own

Miss Mamie Singleton's Quilt. 1978. From the *Profile/Part I: The Twenties* series (Mecklenburg County). Collage on board, 29 x 41″. Courtesy of Addie J. Guttag

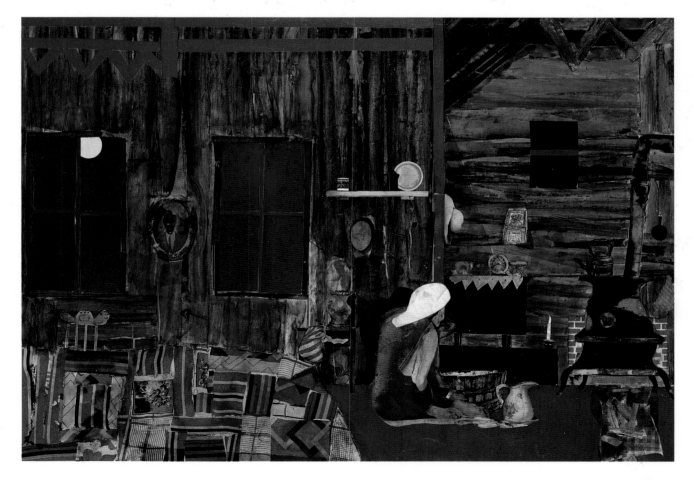

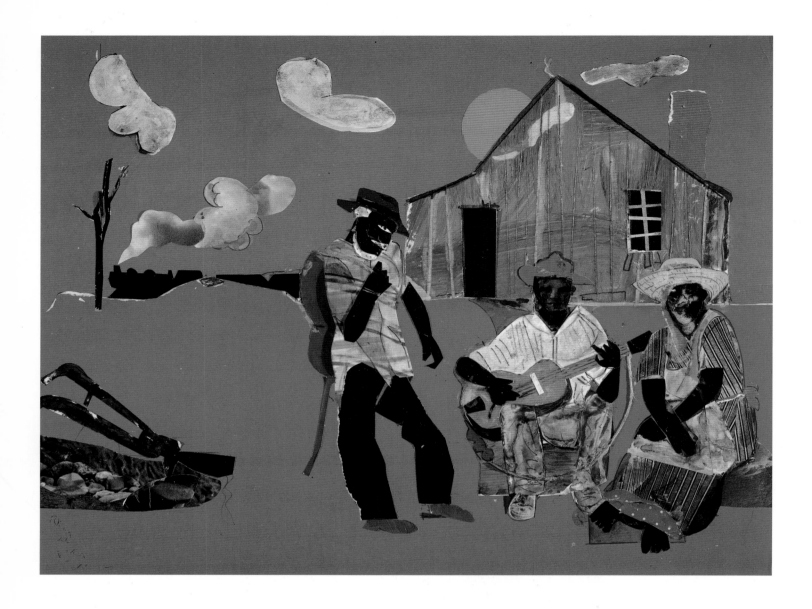

image in a collage. Here, he has confined himself to suggesting the artist's facial features; otherwise the face is simply brown, the fingers holding the brush are green with paint. That splash of color echoes the green of the work on the easel, *The Visitation*. Artist and model stand on either side of the painting, the artist facing the viewer, the model facing away. Bearden's statement might have been: "Keep your eye on the painting; the energy went there."

The other four "self-portraits" in collage are equally oblique. *Pittsburgh Memory* (1964), a photomontage of two teenagers' heads against an industrial backdrop (an ironwork bridge, a boxcar, a furnace smokestack, and a gridwork of lines suggesting a pathway), could be construed as Bearden and a chum in East Liberty. Bearden's is the face on the left, with large, rounded head, a large ear, and large nose. The eyes and mouth are at odds with one another, in Bearden's signature style of the Projections years.

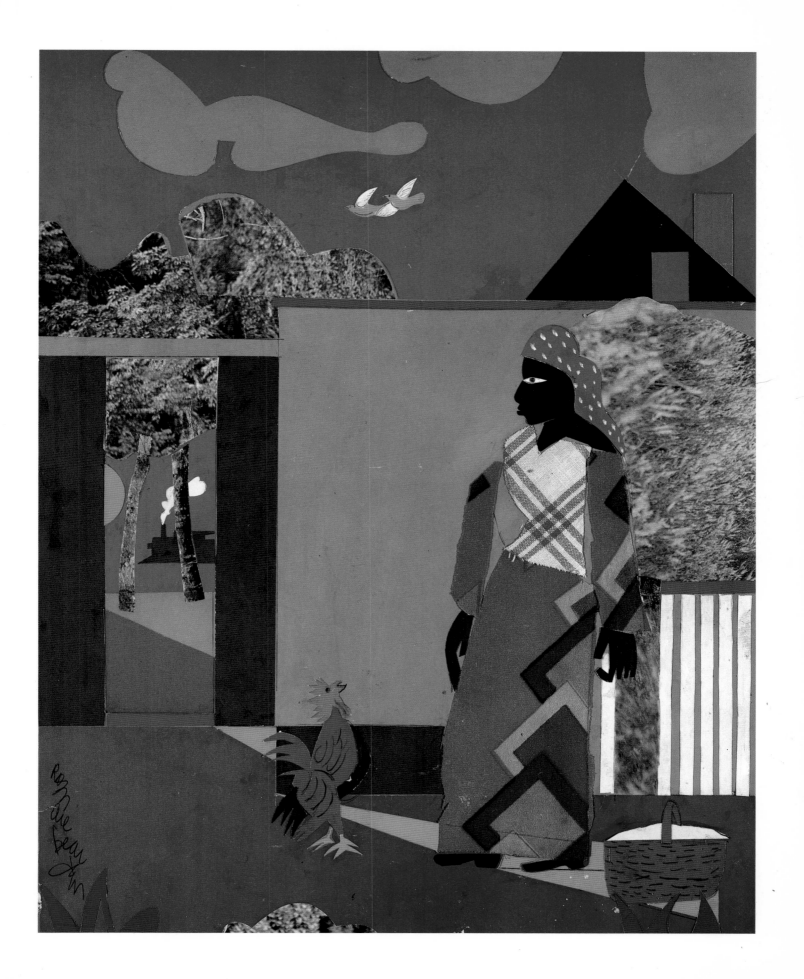

One eye is rounded, with what is perhaps the penetrating gaze of his great-grandfather; the other eye, cut from a different photograph, is more introspective. His mouth is cut into a smile. Next to him is the head of his pal, Bill Kennevan, capped, with an elongated face and his hand up to his chin. *Childhood Memories* (c. 1966), with its blind guitar player led by a little boy holding a rose, is the visual distillation of everything Bearden remembered—and told me at length—about Lutherville, watermelon cakes, and Mrs. Johnson's husband, E. C. *Three Folk Musicians* (1967) includes a banjo player at the right whose rounded facial features echo Bearden's. Finally, the 1978 *Conjur Wom-*

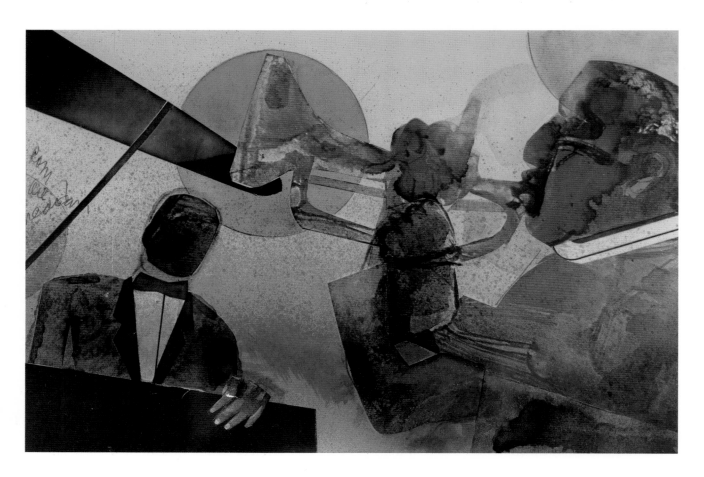

Solo. 1979. From the *Jazz* series. Collage on board, 6 x 9″. Courtesy Sheldon Ross Gallery, Birmingham, Mich.

an & the Virgin, which depicts an initiation ritual in a wooded Southern setting cut by a stream (the stream of blood; the stream of water), includes the figure of a boy watching from the stream's other bank. The boy is Romare; he had said so to others, and he had seen such a ritual.

Such detective work transcends biographical interest where it illuminates Bearden's art. If it is accurate that he placed his image in these five collages (and there is little question about all but one), then several conclusions may be drawn. Bearden placed his image in his work to register the effect of mysteries upon him: watching the mystery of a conjur woman deflowering a virgin; hearing the mystery of a music created by a blind soothsayer

whose fingers strayed over the strings as if moved by the wind; unraveling the mystery of what to place on the empty canvas. He kept his image in his work to bear witness to the means of coming to grips with these mysteries: in art, on canvas, putting something over something else. It did what Bearden often said art should do—celebrate the victory.

In December 1979 through mid-January 1980, an exhibition of Bearden watercolors and collages was held at the Sheldon Ross Gallery, Birmingham, Michigan. The watercolors, often with collage elements, had been done in St. Martin the previous summer. The collages, some as small as

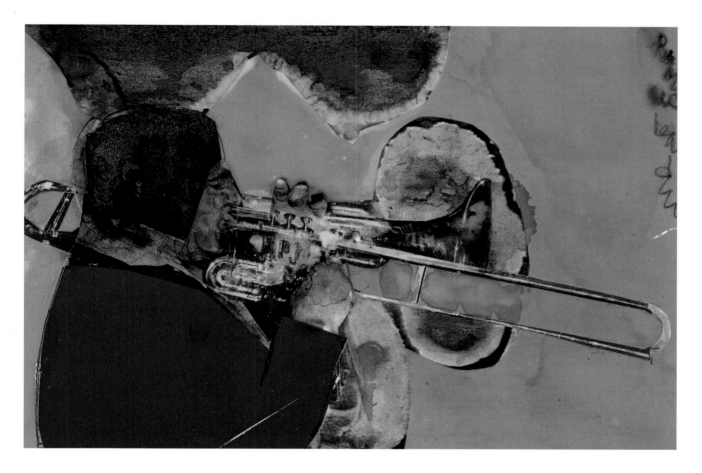

5 x 9″, were on Southern themes. Three months later, from March 29 through April 19, 1980, the Ross Gallery held an exhibition of twenty collages entitled "Romare Bearden: Jazz." Eighteen of the twenty were executed on a small scale, either 6 x 9″ or 9 x 6″, like the wonderful *Solo Flight*, a valve trombonist in profile; or *Storyville*, depicting a piano player with a cigarette dangling from his mouth, his hands on the keys, his back to two odalisques. *Guitar Executive* is another small gem with the clarity and precision of the 1975 *Of The Blues* collages. The two larger pieces, *Tenor Spot* and *Encore* (both 18 x 14″), have the same precision. In many other pieces here, Bearden strove to achieve the freer, improvisational effect produced by the oil-on-paper technique he had

Solo Flight. 1979. From the *Jazz* series. Collage on board, 6 x 9″. Private collection, Southfield, Mich.

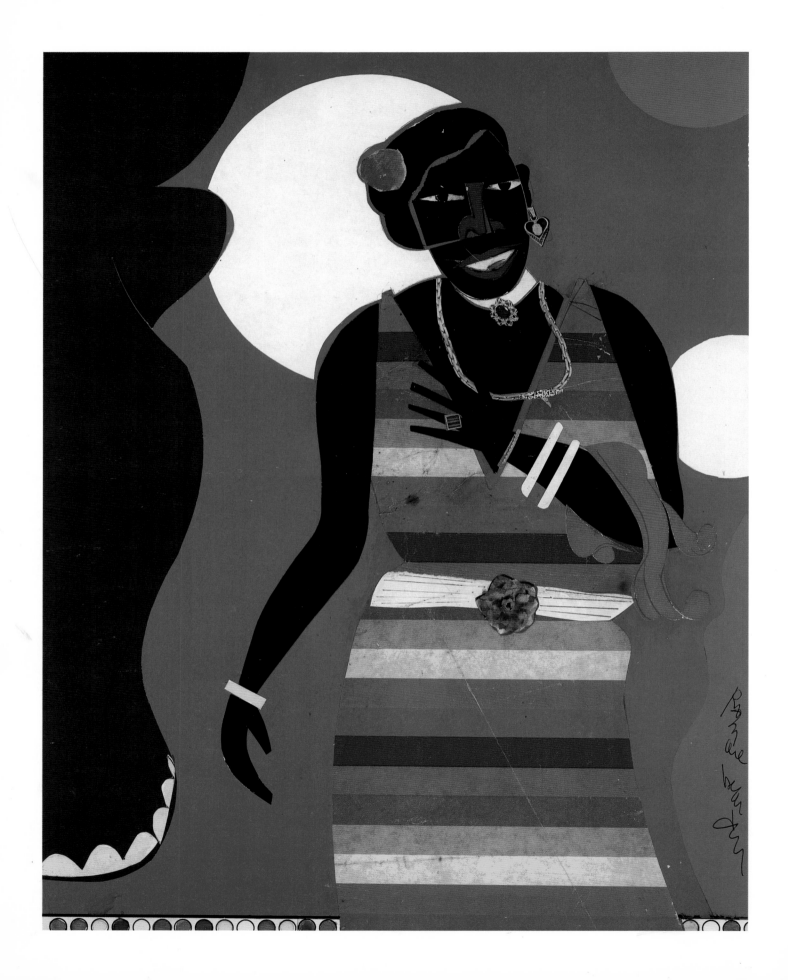

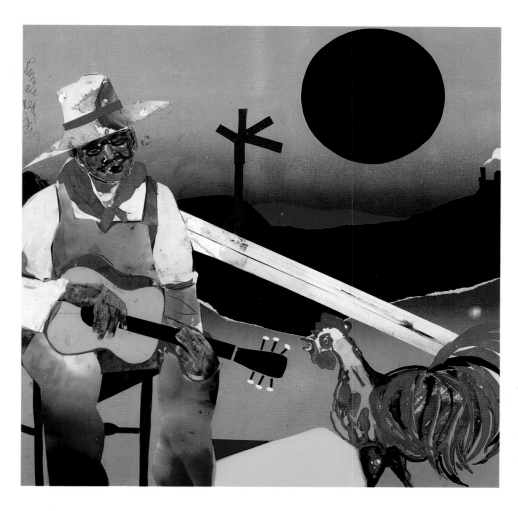

Left: *Blues At the Crossroads*. 1985. Collage on board, 25 x 25". Private collection

Opposite: *Encore*. 1980. From the *Jazz* series. Collage on board, 18 x 14". Private collection, Southfield, Mich.

employed in the *Of the Blues: Second Chorus* series.

Ross's association with Bearden began in the early 1970s, when Sam Shore, who had purchased *The Block* and later donated it to The Metropolitan Museum of Art, introduced them.[17] Ross had purchased and shown Bearden's work in March 1972 at his first milieu, the Middle Earth gallery in Detroit. He gave Bearden solo exhibitions at his new gallery in Birmingham, a suburb of Detroit, in 1976, 1979–80, and throughout the 1980s until December 1987, shortly before Bearden's death. The watercolor shows were almost always Caribbean in theme; the collages were on themes either of Mecklenburg or jazz.

For this reason, when selections were made for the landmark "Romare Bearden: 1970–1980" retrospective at the Mint Museum, Charlotte, the vast majority of the fifty-six works displayed came from collectors who had purchased from Cordier & Ekstrom, but a good number also came from collectors in Michigan who had purchased them from the Ross gallery.[18]

The Mint's Bearden retrospective, more than two years in the planning, nearly opened without Bearden. This was because he had been embarrassed in print. In what may have been an unprecedented move for a

Opening of the "Romare Bearden: 1970–1980" retrospective at the Mint Museum, Charlotte, N.C., October 12, 1980. All photographs *Charlotte Observer*

newspaper of its size, the *Charlotte Observer* assigned a team of reporters to the Mint/Bearden story over a period of several weeks. The paper would devote its entire Entertainment section to a twelve-page "Special Report on Artist Romare Bearden" on Sunday, October 5, a week before the opening.

The men and women writing these stories may have been on the cultural side of the desk, but they were also general-assignment reporters well versed in their profession who "tried to get behind the scenes . . . including the backroom haggling."[19] Richard Maschal, who later became art and architecture critic for the paper, traveled to New York to visit Bearden at Canal Street and his studio in Long Island City. Having done his research diligently, Maschal located the site of Bearden's great-grandfather's house on South Graham Street, which Bearden and *Observer* reporters had been unable to find four years earlier. It was now a parking lot. He also accompanied Bearden to Pinewood cemetery, where his great-grandparents, grandparents, and cousins were buried.[20] Lou Powell, a feature reporter, was assigned the Mint Museum angle, for this show was to put the Mint on the national map.[21] Another reporter, Miriam Apperson, was assigned the corporate sponsorship angle, writing of how Jerald L. Melberg, who had been brought in as curator of exhibitions at the Mint in 1977, opened a letter one day in October 1978 to find a check for $24,000 from Phillip Morris, Inc. Apperson's story devoted several paragraphs to an investigation of the image-enhancing motives of an industry with such close economic ties to the state.[22]

It was Lou Powell's profile of the Mint's Jerald Melberg that was the source of Bearden's embarrassment. Melberg, then thirty-two, had worked for two years on the show. Perhaps flush with excitement in the weeks immediately prior to it, he did not demur when a reporter came to his office to interview him, and then *stayed*—for many hours—while he conducted last-minute arrangements. The lead paragraphs of the profile ("Mint Museum Put Up a Fight for Doing Show Its Own Way") set the scene: Melberg on the telephone with June Kelly, Bearden's manager, on the other end in New York. The issue was the size of the type on the Mint's poster design, which, the article said, Phillip Morris, Inc., and Kelly had altered, making "Phillip Morris" dominate "Mint Museum." Melberg's end of the conversation is quoted in detail. Then the paragraph: "Ms. Kelly puts Melberg on hold. He looks up and grins. 'How'm I doin'?' he asks."

Melberg had been doing well. His only mistake was to have allowed a reporter to sit there getting it all for the record. The story went on to quote correspondence from collectors who could not lend their Beardens for personal reasons, and Melberg's comments on Albert Murray's catalogue essay, which he felt tended "to amble and ramble." It also made clear that in assembling the show, Melberg, "thinking his gallery sales had been handled exclusively by Cordier & Ekstrom," had eventually "learned by chance that Bearden has used secondary galleries in Detroit, Cambridge and Toronto." And it preceded *that* information with the line "He visited Bearden, who sells many pieces directly from his studio."[23]

That did it. In high dudgeon, Bearden let it be known that he

would not attend the opening. His attorney, Morris Cohen, demanded retractions from the newspaper, and threatened a libel suit. The *Charlotte Observer* stood by its reporters and their stories, refusing to retract a word. In fact, the accuracy of the information published was never in dispute; it was its publication that rankled. By week's end, Milton Bloch, director of the Mint, was relieved to hear that Bearden had bought himself a Brooks Brothers suit and would indeed attend.[24] So, of course, was Melberg, whose feelings upon reading the article and hearing of Bearden's reaction can only be imagined. (In time, all was forgiven. Melberg subsequently left the Mint to open the Jerald Melberg Gallery in Charlotte, and Bearden returned there in May 1985 for the opening of his solo show combined with a benefit for the nearby Afro-American Cultural Center.)

That brief "Carolina Shout" over (its reverberations never extended much beyond Charlotte), the opening festivities began on October 12 and the days following with talks by Bearden and Albert Murray; the screening of a documentary film, *Bearden Plays Bearden* (which had been undertaken independently by Third World Cinema and was subsequently financed by Phillip Morris, Inc.); the display and sale of signed lithographs of the image on the mint's poster, "Morning of the Rooster"; the issuing of the Mint exhibition catalogue (the greatest single expense of the retrospective) including essays by Albert Murray, Dore Ashton, and a section containing the most thorough listing of Bearden works yet published. And of course the exhibit.

The show was a blockbuster. It included the 1970 *Patchwork Quilt* and two versions of *The Block*—the 1971 version owned by The Metropolitan Museum of Art as well as *Block II* (1972, Collection Bearden). Then there were four huge collages (up to 56 x 46″) from the 1973 Cordier & Ekstrom *Prevalence of Ritual* miniseries, six collages from the 1975 *Of the Blues* series, including *Carolina Shout*, four of the *Odysseus Collages*, and eight collages from "Profile / Part I: The Twenties." Interspersed chronologically were other works, often first exhibited at the Ross Gallery, on themes of the South and jazz.

After closing at the Mint on January 4, 1981, the retrospective traveled over the course of a year to the Mississippi Museum of Art in Jackson, the Baltimore Museum of Art, the Virginia Museum of Fine Arts in Richmond, and finally to The Brooklyn Museum. Its reception was universally very good. One example, from the *Washington Post* review of the retrospective's Baltimore opening in late April, is a microcosm of the critical response. "He is usually referred to as one of America's best black artists," Paul Richard wrote. "One of America's best artists is closer to the mark." Bearden's art is one of integration, the review continued: "So layered are its messages, so numerous its sources, that his 10-year retrospective . . . in the end affirms the irrelevance of race. The finest of his pictures—most of them are small, and the best of them are masterful—easily acknowledge a dozen art traditions." Among these, Richard cited that of the African wood-carver, the improvisatory spirit of black music, immersion in European painting from the Dutch Masters through Matisse, and a light bulb out of Picasso's *Guernica* in several of the works. "Yet the citing of such masters—like the citing of the blues, the Madonna or Odysseus—never seems to undermine the originality of Romare Bearden's art."[25]

With the 1980 retrospective, Bearden had brushed his signature indelibly on the national canvas. As if to underscore this impression, he had not only shown the twenty *Jazz Collages* in Birmingham, Michigan, in April 1980, but was also given his first one-artist exhibition on the West Coast (consisting of twenty-eight watercolors and collages) at The Art Garden, Venice, California, from May 16 through June 15. Cordier & Ekstrom gave Bearden two exhibitions in 1981, beginning with "Profile / Part II: The Thirties." Then, as the retrospective was completing its tour at The Brooklyn Museum from September 26 to November 29, 1981, Cordier & Ekstrom exhibited *In 4/4 Time*, a series of oils and collage on paper, from October 1 through November 7. Nationally, 1980–81 represented a mountain Bearden had scaled. From its top, had he been so minded, he could rest and look back with satisfaction over the *oeuvre* of a decade. But he went right on working in St. Martin. From the porch of his studio on the hillside, where he did his watercolors, he could look down on a landscape he had compared to one painted on a Japanese fan: "To the left, a row of hills descends gracefully to large l'Embouchure pond, and in the center, flat sandy ground overgrown with reeds enclose the pond. On the right, the deep blue Atlantic with white threads of surf breaks over coral reefs, with Anguilla and Flat Island visible in the distance."[26]

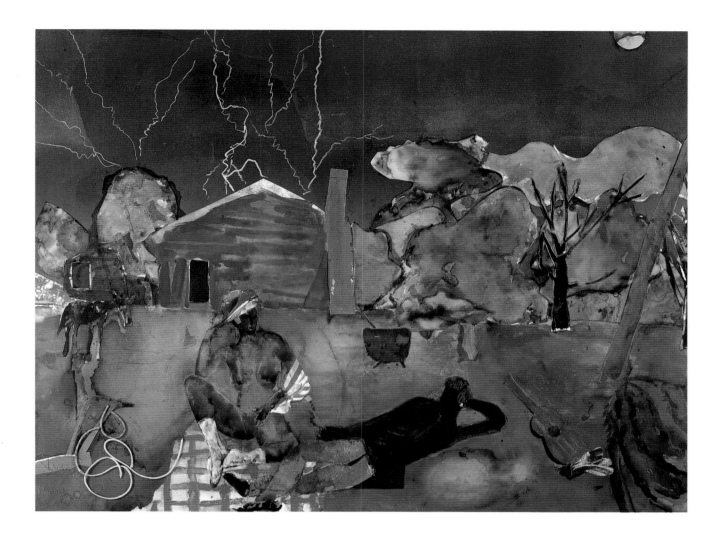

MECKLENBURG AUTUMN

Late in 1983, Bearden exhibited a series of twelve oil paintings with collage at Cordier & Ekstrom. Working on a large scale (roughly 30 x 40″) Bearden now used the medium to evoke a freer, more painterly quality. With age and experience, he told Calvin Tomkins, who wrote the catalogue introduction, "Whatever intelligence you have goes into your hand." *Mecklenburg Autumn* included the wonderful *Morning* (an egg-gatherer with chickens, a rooster, and the morning sun), *The Piano Lesson,* and *Autumn Lamp* (with its smiling guitar player at rest, his instrument leaning against his knee). In addition, Bearden created a suite of four landscapes, his first pure landscapes in collage. For Tomkins, they "come as close to abstraction as the artist ever gets, but the effect they create is not at all abstract. 'September: Sky and Morning' strikes me as being absolutely specific to the light and atmosphere of that time of year in that place, rural Mecklenburg County in the years when Bearden saw it with nine-year-old eyes. . . . Bearden remembers being taken by his great-grandmother, along dirt roads, to see the reservation where the Cherokees still

Heat Lightning Eastward. 1983. From the *Mecklenburg Autumn* series. Oil with collage on board, 31 x 40″. Private collection

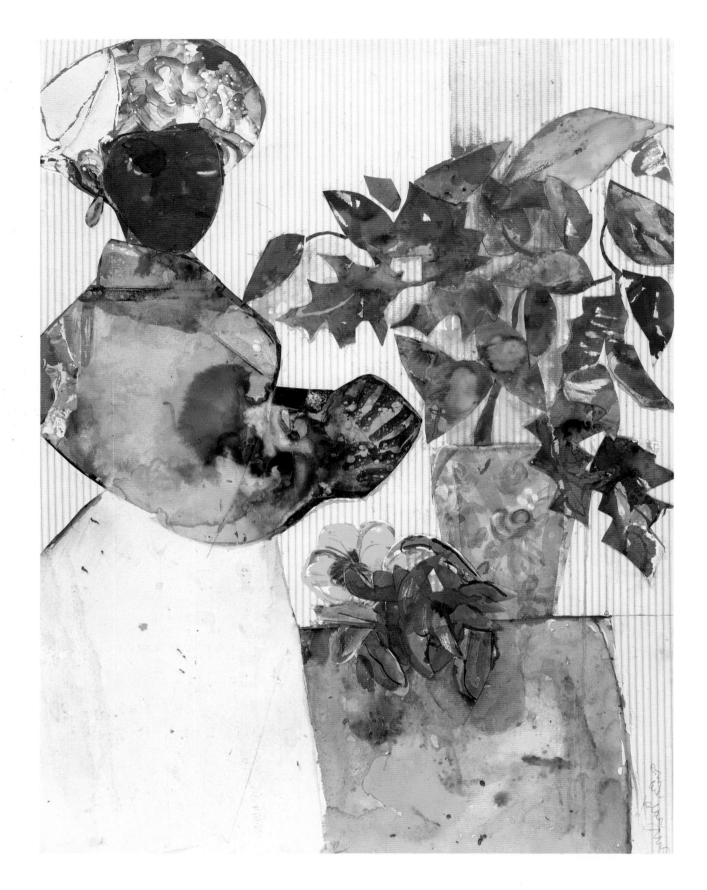

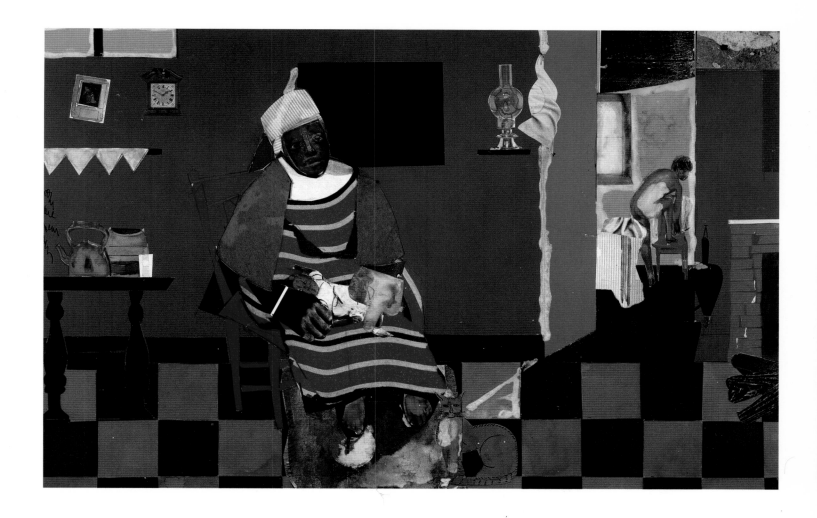

lived as a separate nation, with their own schools and their own newspaper."[27] The suite of months from September on (*October: Toward Paw Creek*; *November: Early Frost—Cherokee Lands*; *December: Time of the Marsh Hawk*) symbolizes the strong, deeply felt music of Bearden's own autumn.

 The almost gravitational pull toward early memories of Mecklenburg had focused much of Bearden's collage work since 1978. Late in 1982, at the Malcolm Brown Gallery (Shaker Heights, Ohio), he had shown a group of seventeen atmosphere, time and season-specific collages. Generally set forth on a much smaller scale (roughly 10 x 8″ or 12 x 9″) than *Mecklenburg Autumn*, the works bore such titles as *The Return of Maudell Sleet*, *Maudell's Morning Bed*, *Liza with Hyacinths*, and *Deep Pool Mecklenburg*. Two of the works, *Autumn of the Red Hat* and *Evening of the Gray Cat*, were conceived on the large (30 x 40″) scale of the 1983 Cordier & Ekstrom exhibition. *Autumn of the Red Hat* contains the classic Bearden iconography of Mecklenburg. A nude is dressing at an armoire with a grandmother figure in attendance, a guitar on the floor at her feet, and a rooster watching with erect attention. Rectangles of door and window open out onto discrete Southern rural landscapes.

Above: *The Grey Cat*. 1979. Collage on board, 15¾ x 24″. Collection Jeff Louis Licht

Opposite: *Mrs. Blanton's October Table*. 1983. From the *Mecklenburg Autumn* series. Oil with collage on board, 40 x 30″. Private collection

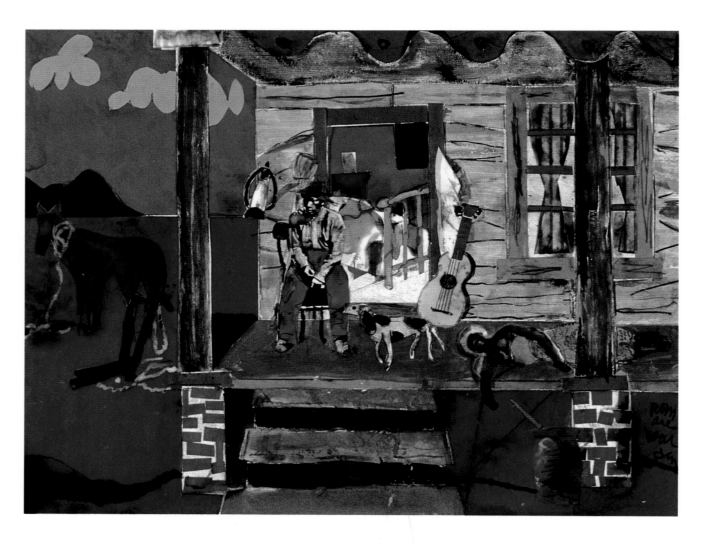

During this period, he by no means confined himself to Mecklenburg, or to collage, for that matter. In 1982, the Alvin Ailey American Dance Theater adapted a Bearden work, *The Bridge,* as a scrim for the world premiere of choreographer Talley Beatty's *The Stack-Up.* It is a dance of two lovers and a displaced junkie in a Harlem juke-joint. Beatty, who was best known prior to that for *The Road of the Phoebe Snow,* went on to choreograph work for the Nanette Bearden Dance Company.

In 1983, The Limited Editions Club published Derek Walcott's *Poems of the Caribbean,* accompanied by Bearden watercolors. It was in the truest sense a collaboration, as Bearden put it to me, for his watercolors were in no way illustrations of any specific poems. Yet the effect of the whole was harmonious, and greater than the sum of its two independent parts.

The years 1983 and 1984 were replete with unveilings of Bearden murals. Just as Delacroix was said to have been prepared to fill the ceilings and public halls of Paris with his art, so Bearden now seemed ready to fill transit systems and college halls down the East Coast with his murals. In May 1983, Bearden's *Baltimore Uproar,* a mosaic mural executed by Cravatto

Mosaics (Italy) according to Bearden's specifications on the basis of a maquette (a collage 16 x 19″) was unveiled in Baltimore in the Laurens Street Subway Station near Billie Holiday's birthplace. It shows a band stomping the blues behind a singer (in whose hair there sits a flower). Four months later, in August, a Bearden mural was unveiled at the new Chambers Street site of Manhattan Community College of The City University of New York. The mural occupies an entire wall opposite the recital hall. It is a variation on a work entitled *Spring Way* of the 1964 Projections depicting, in this instance, a young woman prominent in the window of an apartment while, on the gridwork of a walk, a young man strides along with a book under his arm. The following year, a Bearden mural was installed in Pittsburgh for the Allegheny County Light Transit Authority. (The maquette stood in Bearden's studio, in one place or another, over the years of our interviews.) Much longer than it is high, the work depicts the history of the city, with its two rivers meeting at "The Point," establishing the structure and flow of a panorama of Indian tribes, founding fathers, and the steel mills Bearden remembered from his childhood.

By contrast, Bearden had made the Caribbean his study in winter and summer, 1984. In particular, he had been permitted to watch rites of initiation among the Obeah of St. Martin. In September, he exhibited a series of Caribbean watercolors at the Ross Gallery in Michigan. Then, in October, he exhibited *Rituals of the Obeah*, a striking series of eighteen watercolors, at Cordier & Ekstrom. He had painted each piece using a volatile mixture of watercolor cut with benzine, which dried on the paper within minutes. The subject matter of the series, coming at that time, seemed a radical departure to those expecting the Bearden of Mecklenburg memories. This suggests again that Bearden had been ready to switch up, to regain the element of surprise within himself, to go to the edge.

Reviewing the series, *New York Times* critic Michael Brenson focused on two key elements of Bearden's work: his handling of the paper and his improvisatory spirit. In various works of the series, Bearden had used the silence of the unpainted surface "to light a fire within the paper," the white of the paper in one work "transformed into dappled rays of sunlight on the clothing and face of a man bewitched." In Brenson's view, "If the Obeah holds such an attraction for Bearden, it is because its mixture of rules, improvisation, trust and sacrifice is characteristic of art-making itself."[28]

In November, Bearden was one of six New Yorkers honored for their lifetime achievements in the arts. In a ceremony at Gracie Mansion presided over by Mayor Edward Koch, Bearden was in good New York multi-ethnic, superbly talented company.[29] Honored with him were Ming Cho Lee, set designer; Twyla Tharp, choreographer; Mario Bauza, Afro-Cuban jazz musician; Martha Hill, director of dance at the Juilliard School; and Ada Louise Huxtable, architecture critic and writer.

Also in November, prior to his departure for St. Martin, Bearden began a number of Mecklenburg collages. This time, instead of confining himself to work in watercolor, he sent lighter boards with framed backings to the island so that he could continue to work in both mediums. He was

primed for a productive winter vacation.

At Romare's invitation, I, my wife, and my son visited St. Martin (declining his gracious offer to stay with him and Nanette, we stayed on the Dutch side) in January 1985. Romare put a car at my disposal so that I could get to the house and studio on the island's French side each day.

For five memorable days, I got into the car alone each morning and drove around narrow mountainside curves and through small French-Caribbean towns, trying to avoid oncoming trucks. Finally I would reach the gate just down the steep hillside driveway leading to Romare and Nanette's to share a late breakfast. Game cocks strutted outside the glass-enclosed dining room, the cats eyeing them warily. But just beyond there was another world suffused with Caribbean light, the bay, islands in the distance, birds seemingly suspended between sky and sea. Then Romare and I would ascend the long set of stone steps (there were at least a hundred) up to the studio. If I arrived late, Romare was up there waiting for me. Unlike the Long Island City studio, which he did not reach until 10:30 A.M., this studio was only a five-minute climb away, and he began painting *early* here in St. Martin. The watercolors were already drying in pools on the paper by the time I arrived. We talked for hours, about Harlem, the Apollo, the Kootz gallery. I came to understand why Bearden felt so strange painting any Harlem or Storyville scene in that setting.

It was another world, a way of coming at another truth. Bearden had ended an article with a description of how, one day, he had watched stonemasons building a wall in St. Martin. Rather than split the rocks with powerful swings of their hammers, the workmen tapped at the sides of the rocks, "and at a certain point the rocks would crack into smaller pieces." When Bearden asked one of the men how this was done, "he explained that by tapping the rock the men were listening for its truth. When they discovered that vein of truth, only a few firm taps were needed."[30] By now, Bearden had learned to sound the Caribbean for a new vein of truth himself. His collages that January were set in Mecklenburg, but a Mecklenburg suffused by a constantly changing Caribbean light.

SOUNDS, RHYTHMS, COLORS, AND SILENCES

One day in 1986, master percussionist Max Roach, Bearden, and I sat at lunch near the Long Island City studio. Both men were born in North Carolina, Max in Dismal Swamp, whose topography is like New Orleans's. (The water table shifts so constantly, Max said, that "We bury 'em in the air"—in above-ground mausoleums). Amid lots of banter, Max took a careful look at Romare's face and remarked on the lightness of his features. Bearden answered that he had Cherokee blood on his great-grandmother's side.

Our luncheon had come about as a result of the decision made a year earlier to interview Max Roach about the interrelationship of rhythm and art. Who better, I thought, since Max not only had devoted his life to percussion, but had a love of art and architecture. To help focus the heart of the matter in the interview, Romare had given me three visuals to bring to it. He had taken a watercolor sketch of a St. Martin woman and a postcard-sized

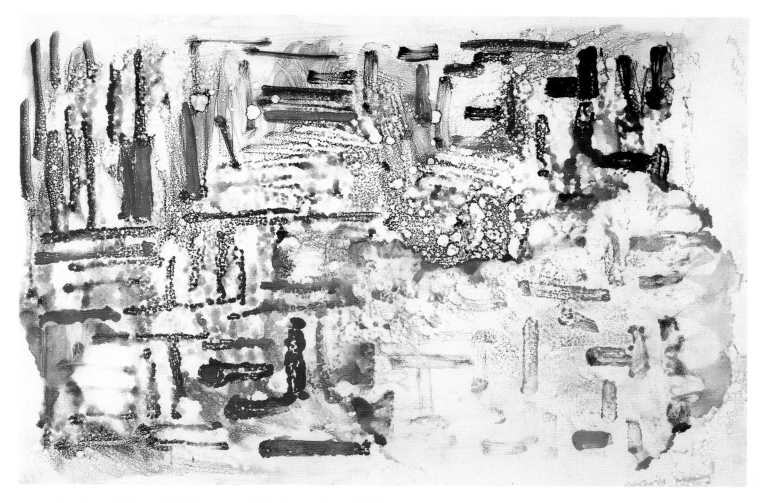

reproduction of Picasso's *Pierrot and Harlequin* (1919) down from his studio wall and employed the Cubist rhythms of the Picasso to make a rapid line drawing of the St. Martin woman in Cubist fashion. At Max's apartment, I set out these three pieces before us at the outset, and asked Max for his response, vis-à-vis music. He didn't answer that question for an hour. In the meanwhile, he spoke about the collage-like uniqueness of the American jazz drum:

A Portrait of Max: In Sounds, Rhythms, Colors and Silences. 1985. Oil on paper (monoprint), 28 x 42″. Collection Max Roach, New York

The jazz drum [taken cumulatively] is unique in that it's one of the original instruments indigenous to the United States. In all other societies, the percussion section is traditionally composed of three or four people. In African societies, there are those who play hand drums; somebody who plays the big drum, which is a lower drum; the middle drums; and the smaller drums, which are higher toned. But here, the drummer is charged to play with all four limbs, so he's playing the cymbal with one foot, the bass drum with another foot, and his hands are playing the cymbals and snares, flying all over the place!

So that's kind of Beardenish. There's something uniquely U.S.A.-American about Romare Bearden. And a jazz drum set is something like that. That's the unique thing about us here. We had to invent it. We had to invent a way of communicating with everybody.

Bearden and Max Roach in the
artist's Long Island City
studio, 1986

Then Max came to the essential point: "My approach to
rhythms, to answer the question you asked earlier, is the use of space, of
silence. It's not that there's necessarily *nothing* going on. There's always a
pulse there. But there are times when there's nothing *but* the pulse. We used to
discuss this up on 52nd Street with Charlie Parker and Miles Davis: the whole
[question] of time. His basic quarter note, his *time* was there: that's why Miles
was so profound, because he *worked* at that. It didn't take a lot; the rhythm was
there even though you didn't have a rhythm section. Some of the horns, like
Lester [Young] and Bird [Charlie Parker], had a built-in rhythm section. They
didn't need a drum or a bass player. When they played, you felt the pulse. So
that allowed the drummer to do colors. It *freed* us. With these people, it was
always there: the silence, the meter. The pulse was there, in the silence.
Bearden's paintings are like that. There's the rhythm I see here."[31] Then Max
sang the rhythms in the work before us.

What Max had said about pulse and silence had strong reso-
nance for Romare. "I was thinking the other day," Bearden said, "of taking
one of those [Greek] vase designs and just tracing it out for a collage of mine,
where nothing is, just the empty space; just put something in there and seeing
what happens." But there was a finished work at hand to illustrate the point,
and he invited me over to see it. In his studio there stood the maquette
for *Quilting Time*, a collage roughly 20 x 32″ (its corner was later cut to 28½″)
which by September 1986 would become a mosaic-glass mural 113¹¹⁄₁₆ x

167½″ unveiled at the opening of the Bearden retrospective "Origins and Progressions" and now part of the permanent collection of the Detroit Institute of Arts.

Quilting Time contains eight figures. A group of five figures on the left is focused on the brightly colored quilts covering the laps of two seated women. One woman seated in profile with a quilt on her lap looks directly toward a guitar player, who is also in profile. This second group of three is completed by a woman holding a baby. Altogether, the figures form an arc with the sun's disk left of center. Off to the right, above a gray fence, a white songbird is set off by tropical foliage. "I've concocted a nice quilt," Bearden said. "Everything else is gray. . . . And the little white bird picks up the white needed at that spot. Then you've got the man's sleeve; the girl in the middle, with her white, and then the white of the dress of the big lady on the right, with the white curtain. The white is carrying right across."

Bearden made a line drawing to illustrate this movement and wrote a commentary next to it: "In a work of a long format, such as *Quilting Time*—the "whites" or very light accents, moving across the picture plane can (1) give an expansion to the work—as the eyes of the onlooker move from one light area to the next—(2) aid in uniting all the elements in the painting."

In a second line drawing, Bearden identified the linear rhythms moving throughout the work: "These are the principal lines of force again attempting to unify the painting. The movements go in and out of the garmented figures—so everything in the painting—figures, foliage and objects [is] conceived as a continuum."

Bearden then made a third and final line drawing that focused on the three figures around the quilt. It demonstrates the integration of several figures in a single unified design. He wrote this commentary: "The 2 ladies working on the quilts are so conceived in the work, that if the quilts were not there, the quilts, so to speak, could be the dresses of both women. The lady I marked "A" has a quilt that touches the young girl in gray, and I made a dark blue area in her dress carrying through the rhythm of the quilt and in addition giving body and credence to the woman quilting." As if to sum up this integration, Bearden said, "Everything is part of something else. So this is what you get from the music."

Clearly Max's words had inspired him, but Bearden had also been listening to the music for a long while. He explained that recently, at Robert Blackburn's printmaking workshop, a recording made by Max and Clifford Brown had come over the radio: "And I just took a brush and painted the sounds, the color rhythms, and the silences on a big sheet of plastic using a volatile benzine medium which dries within four or five minutes. Then I pressed the paper over it and made this oil-on-paper."[32] Bearden called it *A Portrait of Max: in Sounds, Rhythms, Colors and Silences* and made Max a gift of the work.

This was a jazz-filled period for Bearden. In his studio, I saw the maquette of a mural intended for Howard University depicting Duke Ellington, Bessie Smith, and Louis Armstrong. Bearden unrolled huge sheets of

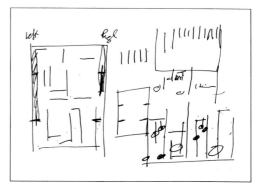

Top: Sketch for Roach interview of St. Martin woman holding basket, abstracted to show the intervals. Ink on paper
Above: Sketch for Roach interview showing intervals in Picasso's *Pierrot and Harlequin*. On right of page, intervals are shown as varied musical notes. Ink on paper

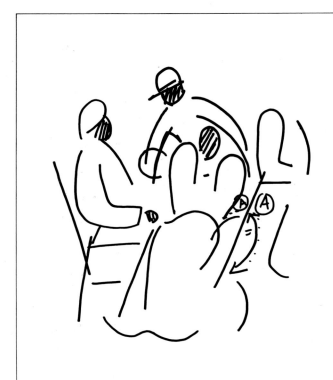

The 2 ladies working on the quilts, are so conceived in the work, that if the quilts were not there the quilts, so to speak, could be the creases of the both women. The lady, I marked "A" - has a quilt that touches the young girl in gray & I made a dark blue area in her dress carrying thru the rhythm of the quilt & in addition giving body & credence to the woman quilting.

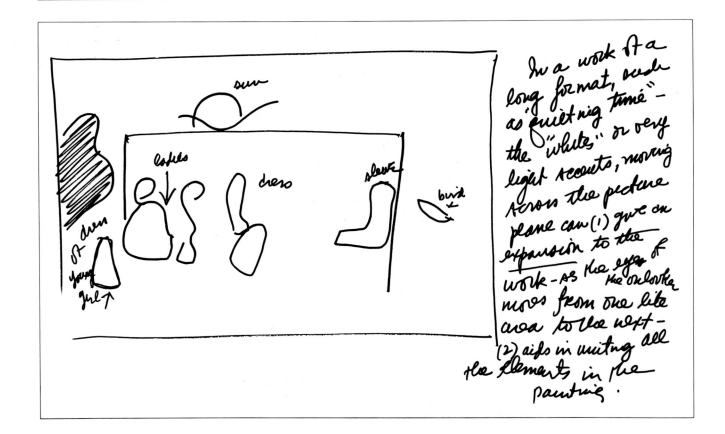

In a work of a long format, such as "quilting time" - the "whites" or very light accents, moving across the picture plane can (1) give an expansion to the work - as the eyes of the onlooker moves from one lite area to the next - (2) aids in uniting all the elements in the painting.

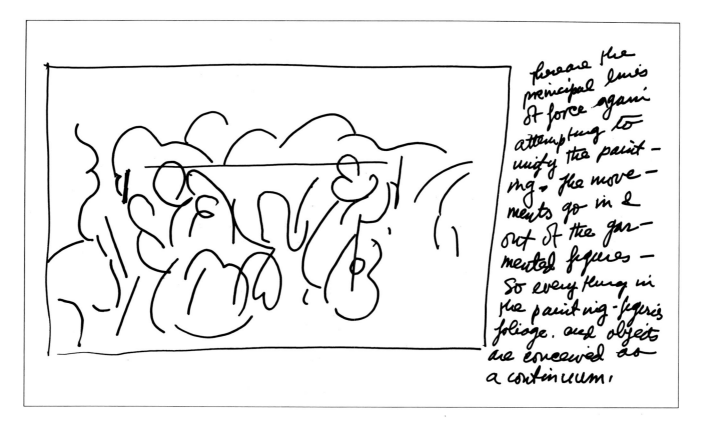

Here are the principal lines of force again attempting to unify the painting. The movements go in & out of the garmented figures — So everything in the painting - figures foliage. and objects are conceived as a continuum.

various trigonometric curves in order to demonstrate how he had used them as a point of departure in thinking about the overall rhythms of the work. Just as there is a precise, almost mathematical structure hidden within much of the best jazz, so there was a rigorous training in higher mathematics underlying Bearden's freest, most improvisatory tributes to the music.

On May 4, 1986, Bearden and the alto saxophonist Jackie McLean performed "Sound Collages and Visual Improvisations" together at the Hartford Atheneum in conjunction with an exhibition of eighteen Bearden works on jazz themes at the nearby Artworks Gallery. McLean, who had made his reputation by the time he was in his early twenties recording with Miles Davis, Charles Mingus, and Art Blakey, had also become a member of Julian Beck's Living Theater and appeared as a musician in Jack Gelber's play *The Connection*. By 1971, with the help of Hartford bassist Paul Brown, Jackie and his wife, Dolly, made their home in Hartford, where he had become a professor at the University of Hartford's Hartt College of Music.

The performance was a provocative and toe-tapping inter-penetration of music, talk, and art. For McLean, it was a lifelong dream real-ized to be on the same stage as Bearden. He played African percussion instruments, piano, and saxophone. Then Romare spoke about his art and asked Jackie to accompany him on the piano while, with his characteristic nonchalance (Bearden could always rivet an audience), he drew with markers what turned out to be a jazz portrait of Jackie at the piano with the name "Dolly" as part of the design. It was perfect.

Three diagrammatic drawings made by Bearden to illustrate the compositional elements of *Quilting Time*, 1985

DECEMBER: TIME OF THE MARSH HAWK

The marsh hawk is a harrier: cruising slowly as low as six or eight feet from the ground, it attacks from mid-flight, dependent on the element of surprise. Sometimes it seems to come to a dead stop in mid-air, hover momentarily, and do a figure-8 split before it plummets onto its unsuspecting quarry, killing it on the ground.[33]

In *December: Time of the Marsh Hawk*, the last in Bearden's suite of autumn months, a deep, wintry blue moves across a landscape of green, orange, and the brown of bare trees. At the left, an area of ice-blue and white fixes the eye on a marsh hawk, its three-and-one-half-foot wingspan spread full, gliding along slowly in search of prey.

Bearden himself was particularly sensitive to winter's cold. He could remember vividly how the joints of his back and neck stiffened after the landlord removed the radiators in his first studio. Forty-six years later, it seemed that health problems were beginning with back colds. In January 1986, Bearden wrote me from St. Martin that the night cold had been getting to him: "My *back* is stiff a bit—But I'm *back* working. The weather hasn't been the really hot kind, I need. There is a chill wind, especially up here & I have some *cold* in my body. But it ain't the 1 degree chill."[34]

During the winters and summers of the mid-1980s, St. Martin was no longer his haven. Once he fell out of bed in the middle of the night and had considerable difficulty bending on his return to New York. Another time he had been unable to go out to the beach: As he wrote to Arne Ekstrom, "While I was reading in the evening, one of those small high intensity lamps fell on my shoulder right about there [a sketch is inset in the letter]. So I have a circle O brand. Now, I'll know to whom I belong at Roundup Time." Bearden ended his letter lyrically, but with a further allusion to the cycle of apprehension and restored confidence: "The day opened fine, but we just had a fine misty shower, and over the hill is a beautiful rainbow with a long arc. Blake wrote—there is a moment in each day that Satan cannot find—for the moment I'm safe."[35]

With preparations well underway for the opening of his retrospective "Romare Bearden: Origins and Progressions" at the Detroit Institute of Arts in September 1986, a great deal of Bearden's time was taken up in helping to select and identify works of the 1950s, many of which had been stored for decades. Works on rice paper in particular were in desperate need of restoration. He also helped in a variety of other ways. Lowery S. Sims of The Metropolitan Museum of Art, interviewed him in late December in preparation for her catalogue essay; Davira S. Taragin, the curator of twentieth-century decorative arts and design at the Detroit Institute of Arts, interviewed him in March for her editing of Bearden's journal of 1947 and 1949, excerpts of which were published for the first time in the exhibition catalogue.[36] Additionally, Bearden was always ready to help answer the hundreds of questions that arise when any major museum retrospective nears completion.

In the spring of 1986, he began work on a series of Mecklen-

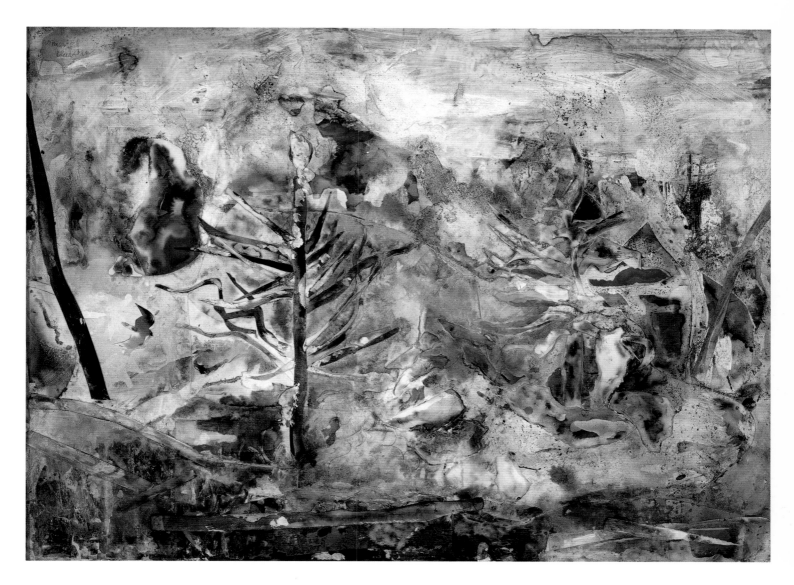

burg collages that were to be exhibited at Cordier & Ekstrom shortly after the Detroit retrospective opened. Further plans were underway for an exhibition of collages at the Sheldon Ross Gallery in Birmingham, also in tandem with the retrospective. The intense activity was, in a sense, an act of sheer will for Bearden. His body was refusing to cooperate.

On Canal Street, the Beardens had acquired and furnished a second-floor apartment in the same building. It had its own bedroom, kitchen, and living room area. He would no longer need to climb the additional three flights of stairs to the fifth-floor apartment on a daily basis. Still, he was having trouble not only with his back but also with his legs, and even a single flight of stairs could be difficult to negotiate. With great apprehension, he sought to restore his health by visits to a chiropractor and gave serious thought to acupuncture. His friend Russell Goings, who had played football for the Buffalo Bills in the early 1960s, brought over small barbells and started Bearden on a

December: Time of the Marsh Hawk. 1983. From the *Mecklenburg Autumn* series. Oil with collage, 30 x 40". Private collection

regimen of exercises to build up his arm muscles. Before driving him to Long Island City, Goings would massage Bearden's back, then rub down his legs, which were too thin and frail for the weight they had to support. Usually, when Bearden had completed his day's work, Goings would drive Bearden back home to Canal Street and help him up the long flight of stairs. That summer, the Beardens stayed in New York.

An August 1986 letter from Bearden to André Thibault/ Teabo, an artist who had long been Bearden's student and who would soon come to assist him quite closely, lays out the medical situation:

One can't, or shouldn't, look back, but I did wait too long before going to the Real doctors. But the neurological team at NY hospital, I think, did a good job. I was discharged after two weeks—but with a week home, I had to go back to the Hospital, and I caught cold going out to keep a clinic appointment—so 2 more weeks in the Hospital.

But I'm back at Canal St. now—I'm using a walker to get around—then to a cane, and hopefully on to the "2 feet."

Next week I'm going to try & do some small things, here, at Canal St.—watercolors . . .

No need to tell you to keep on with your work—you have made enormous improvement. Just keep trying, as we've discussed, not to paint the objects—but the relations between them. Not this:[sketch]; this[sketch].[37]

Bearden's health did not allow him to attend the dedication of his mosaic mural *Quilting Time*, simultaneous with the opening of "Romare Bearden: Origins and Progressions" on September 13, 1986. He had, however, made a videotape to give visitors to the exhibition a sense of his presence, and to make it clear that he would have been there had the trip been possible. In reality, his presence could be felt in all fifty-seven works on display. I was not alone in wishing that, gracious as the gesture had been, the videotape had not been included. Even for those who saw Bearden frequently, the change was apparent; for those who had not seen him in years his weakened voice and literally diminished physical stature were truly saddening.

The retrospective was excellent. The number of works was almost exactly the same as the Mint's six years earlier, but by definition the comparison ended there; the breadth, focus, and depth of this exhibition were entirely different. Several years' meticulous research had gone into the conception, selection of works, and installation of an exhibition which spanned four decades, from 1945 to 1986. Two-thirds of the selections (thirty-nine works) were devoted to the years 1945–63. The early biblical and literary series of 1945–49 were well represented (six from *The Passion of Christ*, 1945; eight from the Garcia Lorca *Lament for a Bullfighter*, 1946; five from the Rabelais *Gargantua and Pantagruel*, 1946–47; three from *The Iliad*, 1948). Six additional 1940 works were interspersed before the transition to the abstractions of the 1950s and early 1960s.

Ten works, spanning the years 1955–63, constituted the art-historical highlight of the exhibition. In her catalogue introduction, and in

a subsequent article for *ARTnews* adapted from it, Lowery Sims wrote an important analysis which not only placed Bearden's work of 1955–63 in the context of his own evolution toward collage, but also in the context of the prevailing art movements of the era. She argued that such thickly impastoed 1955 works as *Blue Lady* and *A Walk in Paradise Gardens* (not exhibited) could be related to Bearden's stay in Paris and his affinity for the work of Jean Dubuffet. Though Bearden's work from 1956 to 1960 was related to the New York School, it was, in Sims's view, to be distinguished from that of the Abstract Expressionists by virtue of its delicacy and modesty of scale, more French than 1950s-American in its sensibility. Finally, and perhaps most interestingly, Sims noted that in such early 1960s works as *River Mist* (1962) and *Night Sounds* (1963), Bearden had pushed forward earlier experiments involving the tearing away of different layers of rice paper to reveal the underlying surface. "In these works," she wrote, "Bearden cut and rearranged his painterly abstractions into new alignments that resulted in unexpected juxtapositions but that still retain their topographical character. He also added strips of brightly colored tape—red, blue, green and yellow—to frame the periphery of *Night Sounds*, which might be taken as a premonition of the more vibrant palette he would use in future collages."[38]

November: Early Frost: Cherokee Lands. 1983. From the *Mecklenburg Autumn* series. Oil with collage, 30 x 40″. ACA Galleries, New York

The balance of the exhibition contained seventeen works spanning the years 1966 to 1985, skipping the Projections period entirely, and highlighting two decades with superlative samples of Bearden's *oeuvre* in collage (*Carolina Shout, At Connie's Inn,* and *Maudell Sleet's Magic Garden* were set side-by-side, for instance). The installation brought the visitor full circle from a 1945 *Madonna and Child* (oil-on canvas) to a 1970 *Black Mother and Child* (collage). *Quilting Time,* the mosaic tile mural that had been commissioned by the Detroit Institute in celebration of its centennial, was a magnificent summing-up of Bearden's achievement. It is undoubtedly the finest mural executed during Bearden's lifetime.

At the Sheldon Ross Gallery, an exhibition of twenty-one works, "Romare Bearden: Recent Collages," was held from September 12 through October 25. Bearden had done about fourteen of these collages, on the theme of Mecklenburg, in 1985; the earliest of them had been done in 1984, and several had been done in the winter of 1985–86. One of the finest of these is *Evening* (14 x 12″), an interior with a older female figure dressed in green, seated, watching over a nude bending in partial silhouette on a towel before the open door of a bedroom.

These works bear comparison with the sixteen collages exhibited at the Jerald Melberg Gallery in Charlotte a year earlier (May 18– June 29, 1985), for which, following the precedent set by the 1978 "Profile I" at Cordier & Ekstrom, Melberg had asked Bearden to write short narratives on the gallery walls next to the collages. *Before Dawn,* for example, was accompanied by the sentence "Carolina sun sort of eased into houses." All of the collages were based on the theme of Mecklenburg. Bearden had completed a number of them in St. Martin that winter; others were completed on his return in the early spring. They included *Cherokee Anderson,* a fascinating portrait in

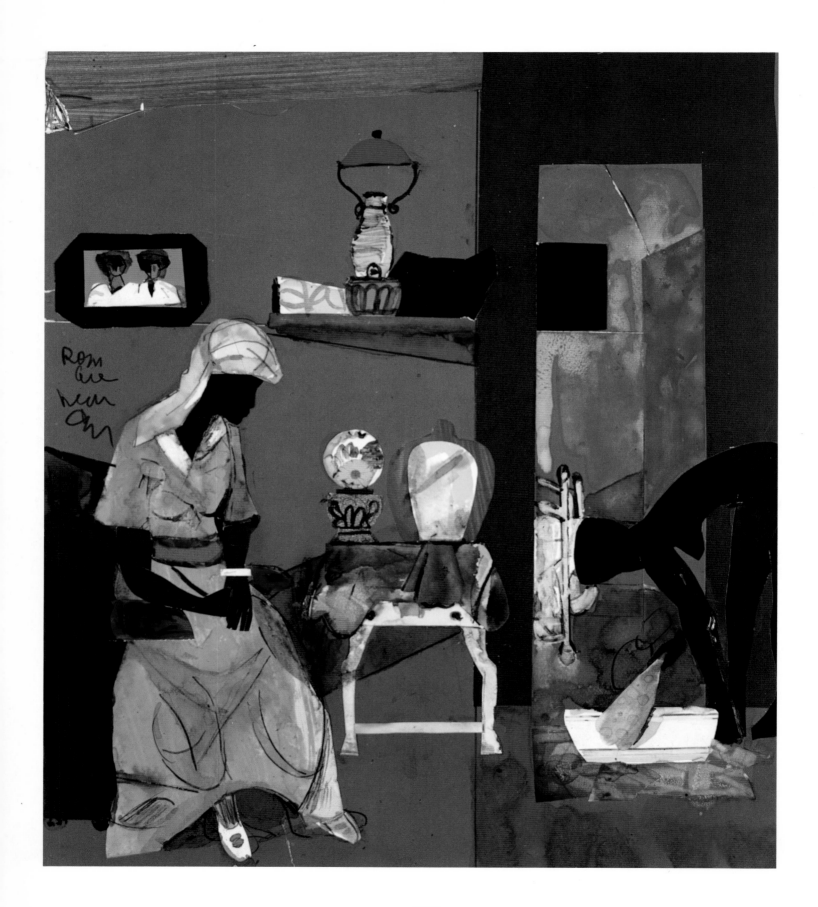

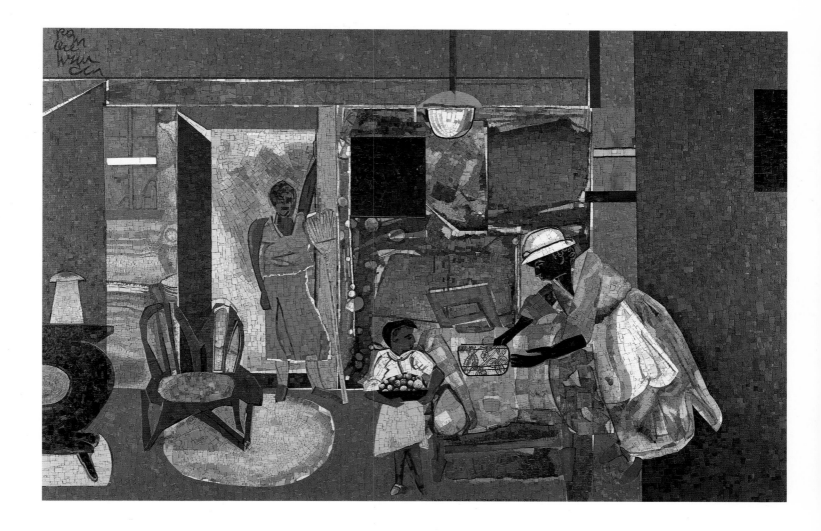

collage, *Blues Man from Up-Country*, and *Evening Church*. As Richard Maschal remarked in his review of the exhibit, "Bearden is leaving things out . . . his work has gotten leaner, and, paradox of art, richer. He seems less interested in the architecture of his collages and more interested in communicating his feelings." I had seen *Evening Church* (a procession led by a little girl, followed by two women and a man holding a lantern which echoes the setting sun) evolve over several weeks in Bearden's studio. It has the painterly quality of the 1983 *Mecklenburg Autumn* series; indeed, for Maschal, "the most remarkable difference [between these and past works] is [that] these works are more painterly."[39]

Bearden's new collages of 1986, *Mecklenburg: Morning and Evening*, were shown at Cordier & Ekstrom from September 23 to November 1. It was the last show Bearden was to have at the gallery. The fourteen works exhibited had all been done on a small scale (the largest were 11 x 14″). Three of these were portraits: *Evening Lamp*, a woman seated, arms folded, facing the viewer; *Jefferson Cooley's Evening Guitar*, a portrait in reds, yellows, deep blues, and white of a guitarist in profile; and *Wednesday Evening*, in which the

Above: *Before Dawn*. 1989.
Glass tile mural, 9′ x 13′6″.
Public Library of Charlotte and
Mecklenburg County

Opposite: *Evening*. 1985.
Collage on board, 14 x 12″.
Private collection

outsize, masklike face of the subject takes up fully a third of the surface. Two nudes in bed, *Cora's Morning* and *Wilhamina's Evening*, counterbalance one another, while a third collage, *Lamplite Evening*, depicts a high-stockinged nude in an interior. *Morning—Grandma and Granddaughter* is counterbalanced by *Sunrise*, Bearden's archetypal grandmother figure attending a nude at the bath. Two outdoor scenes, *Evening: Small Creek, Back Country* and *Evening of the Blue Snake*, are also complementary, one depicting a nude washing clothing in a stream, and the second a nude sleeping in a wooded back-country setting, attended by egret and blue snake. Another group, including *Evening Mail Train* and *Morning: The Broken Wheel*, makes use of the wooden slats of jerry-built homes as a leitmotif of verticals and diagonals.

Throughout, as Nancy Princenthal commented in a review for *Art in America*, "the agility with which Bearden handles collage is undiminished; like his dauntless approach to sentimentality, his control of cut and torn paper recalls Matisse. So does his fluent use of highly saturated color, evident in the increasing application of watercolor as well as the choice of papers."[40] Compared with *Mecklenburg Autumn*, this series seemed less strong and less sustained. In retrospect, however, Bearden was clearly working to the limit of his energy, refusing to succumb to the increasing pain in his back and legs. At least half the works in *Mecklenburg: Morning and Evening* represent Bearden at his best.

The Detroit retrospective showed at the Bronx Museum of the Arts with fifty-five of the original fifty-seven works from December 13, 1986, to March 1, 1987. Bearden attended the New York opening and was happy to see the many friends who came there to honor him and his work. The occasion felt festive. Shortly thereafter, he and Nanette left for St. Martin. The treatments at New York Hospital seemed to have restored him, although, having initially lost a great deal of weight, he had now regained too much.

Reviewing the retrospective in the *New York Times* in January ("A Collagist's Mosaic of God, Literature and His People") Michael Brenson wrote a laudatory and deeply felt article. "Bearden is a great collagist," Brenson said. "He took the medium invented by Picasso and Braque and made it a very particular narrative and expressive tool. Musicians play; eyes accuse or wink; bodies glide across the surface with no more urgency than the procession across Keats's Grecian urn; ancestral shadows illuminate and haunt the present." He characterized the guitar player of *Quilting Time* as "presiding like the sun over the sky and hills. His chair is his throne; the quilting family is his court. Its members, young and old, are kings or queens. They are weaving together disparate moments, present and past. We can hear Bearden's song, and it is about time."[41]

From St. Martin, Bearden wrote Ekstrom: "I'm happy to report that I'm making good progress. In fact, I'm able to negotiate the 109 steps leading up to my studio—with a little help from a cane. Otherwise I walk mostly unaided. And I feel very well. Living down here even when you are inside you are mostly outside; so the constant walking & going, together with the sun, is doing me a lot of good.

"I ran into a lady yesterday, who is a sort of agent for the homes in the lowlands—the rich section on the French side—& she told me that Jasper Johns had a bad fall down here and had injured his back & right arm. He is, or was, in the hospital. I hope his condition isn't serious, as mine was. Only bad angels are supposed to Fall, not artists who need to stand straight."

Bearden closed by telling Ekstrom that he had finally read the *New York Times* article: "He really caught poignantly much of what I try to achieve."[42]

The Beardens returned to New York on March 3, 1987. Two days later, Bearden summoned André Thibault/Teabo to Canal Street to discuss their working together on a new series of collages.[43] His plan was for a series of large collages on the theme of jazz. Thibault was enthusiastic, delighted by the prospect not only of assisting Bearden in such purely mechanical tasks as the preparation of boards, but of learning more than he had ever learned before from his teacher in the process of assisting him.

Thibault set about preparing a number of large boards, of mahogany ply score, glued to a backing of hardwood strips with a middle strip for added stability. Robert Blackburn had supplied Bearden with fine, heavy Arches papers, usually 180-pound stock. With several sizes of boards in hand (20 x 24″, 24 x 36″, 30 x 40″, and 40 x 60″), Bearden and Thibault were nearly ready. They met at Long Island City on the morning of Wednesday, March 18. On that day and the days following, Thibault continued preparing the boards, while he and Bearden set up the studio for work. With all in readiness, Thibault left for a week, returning the last day of March. On April 1, he began assisting Bearden on *Storyville Mirror*, a collage and watercolor 32 x 40″ depicting an odalisque seated on a sofa in a Storyville parlor. She is watching a jazz band, which is reflected in the mirror on the wall behind her. By week's end, Bearden was working on a smaller collage at one table while Thibault continued to lay down the elements on *Storyville Mirror*. Work on the large collage was completed by Friday, April 10, and new boards were coated for the following week.

The next week was again a productive one. Bearden worked on two smaller Mecklenburg collages, probably *Evening Guitar* and *Gospel Morning*. *Evening Guitar* depicts a young woman undressing for bed in a Mecklenburg interior, a Bearden microcosm of infinite variations on a theme now pared down to its essentials.

While Bearden worked at his table, Thibault adhered the elements that Bearden had placed on a larger collage (36 x 24″) of a saxophone player, *All the Things You Are*. At the beginning of the following week, Bearden gave Thibault a lesson in how to place the dyes on the large collage. Laying in the dyes was the result of many years' experience; for Thibault it was a revelation to watch his teacher work. By midweek, the large collage was complete. Bearden was satisfied with it; Thibault returned home at the end of a good day exhausted and exhilarated. By April 23, Thibault recorded the completion of eight works, and at the end of the month, Bearden's manager, June

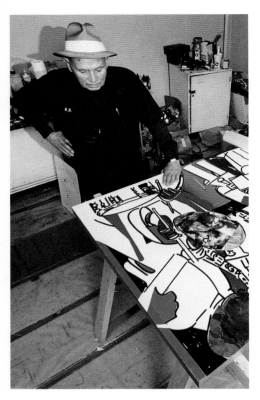

Bearden in studio with 1987 collage *Opening at the Savoy*, 1987. Photograph by Bill Davis, *Newsday*.

Kelly, stopped by the studio to tell Bearden that arrangements had been confirmed for the series to be exhibited at the Thomas Segal Gallery in Boston.

By the time I accompanied Albert Murray to Long Island City on May 27, some eight collages had been completed, another two were in progress, and wooden backings had been prepared for still others. Bearden also showed us a number of completed watercolors, several on jazz themes. The first collage we saw was nearly completed: it depicted a pianist in profile at an upright piano, his large left hand with a wristwatch displayed prominently, a derby cocked down over his head, a cigar in his mouth, a bow-tie, and ornate vest. There was nothing "nice" about the look of this man. His face was almost a mask, and his entire bearing suggested that when he sat down at the piano, he meant business.

To Murray, he recalled the early masters of the stride piano, whose imperial bearing as they entered a room and approached the piano was part and parcel of their music. Murray went on to talk about the three second-generation masters, Duke Ellington, Count Basie, and Fats Waller, pointing out that one of the most obvious influences of the stridemen on Ellington was the emphasis Duke placed on a unique signature opening chord. Bearden liked the idea of the first chord. Murray then refined that, playing around with possible subtitles such as "Uptown Manhattan, 1924" and a title as deliberately ambiguous as "The Statement." By then they had it, a synthesis of the opening chord and the idea of the pianist's playful elegance and bearing as a total statement: hence *Opening Statement*.

Murray then turned to looking for a pattern in the work before us. He suggested placing them in groups moving from jazz soloists to duets, quartets, quintets, and ensembles. Along the way, he suggested names for several individual works—*Fancy Sticks*, for instance, for a collage with watercolor (24 x 36″) depicting a drummer with both drumsticks flying, each stick splayed out in a multicolored swirl. Bearden followed Murray's individual title suggestions, as well as the idea for the overall format. For Bearden and Murray, it had been one last interplay, a joyous one.[44]

Early in June, work began on the large (30 x 40″) collage with watercolor, *Blues Singer from the Delta*. This Storyville scene is quite interesting conceptually by virtue of the manner in which a piano player seated at the right, his back to the singer and his head bent introspectively over the keyboard, is intermeshed with the blues singer's torso. It is impossible to tell whether she stands in front of him or just behind him; her hand seems to protrude from his back, and the brooch beneath her necklace seems to ornament his shoulder. They are discrete, yet the music unites them.

On Friday, June 12, Les Payne came to the studio with a photographer to interview Bearden for a *Newsday* Sunday magazine cover story that was published seven months later in January 1988.[45] While the interview took place, Thibault finished work on *Blues Singer from the Delta*. Among many photographs taken that day, one shows Bearden posing next to the saxophone player collage *All the Things You Are* (which was selected for the cover) and another shows him at his worktable drawing the outlines of the musicians

in the largest of the collages, *Opening at the Savoy* (40 x 60").

The following week, the Beardens traveled to Washington, D.C., where Romare was presented with the National Medal of Arts by President Ronald Reagan. (It was awarded that year to seven artists and four patrons of the arts.)[46] Les Payne met Bearden in Washington and continued his interview there. Bearden was photographed with his arm around Ella Fitzgerald, a fellow recipient. There was luncheon at the White House, followed by a dinner given by Frank Hodsell, chairman of the National Endowment for the Arts, and a Congressional reception given by Senator Edward M. Kennedy.[47] There was a down-home touch to the outdoor dinner on the evening before the White House ceremony, as Bearden stole away with Ella for some *real* food—Southern fried chicken.

By July 3, Romare wrapped up work for the moment and prepared to leave with Nanette for St. Martin. It would be Bearden's last journey to the Caribbean.

On the island, Bearden worked energetically to help organize the festivities for the annual Carnaval, and was interviewed in August by Charles Rowell, editor of the journal *Callaloo*.[48] Upon the Beardens' return to New York in September, the pieces for the Segal show were all but ready. Romare had cut short his stay in St. Martin in order to visit his physicians at New York Hospital. When he did so, about September 14, Bearden was admitted to the hospital, where he stayed for two weeks.

By the second week of October, Bearden and Thibault were back at work at the studio. Bearden was in pain, and work was going much more slowly. It was clear by this time that the marsh hawk had ripped its talons into Bearden's back. On October 16, a day on which the work had felt particularly difficult, Bearden told Thibault that he had cancer. Against all odds, the two continued to work. Bearden laid down the design of two collages, *Blue Morning Rain* and *Moonlite Prelude*. The following Monday, alone at the studio, Thibault received a telephone call from Russell Goings, who told him that Bearden would be returning to the hospital for three or four days. Thibault picked up work on *Blue Morning Rain* from Bearden's initial design. When he called Romare later on in the day, Bearden was happy: he had just learned that Robert Blackburn had prepared new papers for them, using a ground of watercolors rather than oils in rainbow-like sequence. Bearden entered the hospital on October 20, and Thibault took a week's break.

At the beginning of November, Bearden and Thibault met again at the studio and resumed work on *Blue Morning Rain*. It is a large collage (30 x 40") using much of the iconography of Bearden's Mecklenburg. Inside, a woman stands in profile at the breakfast table beneath a lamp opposite a seated man dressed in coveralls, hat on his head, drinking his morning coffee. The glowing embers of a potbellied stove are behind him. The ubiquitous rooster stands before an open door, through which the rays of the rising sun shine through the morning rain, flooding the floorboards with sunlight. Outside, a nude stands in a basin holding a towel, her back to the viewer, set against a landscape of hills, rich foliage, and a field across which a train

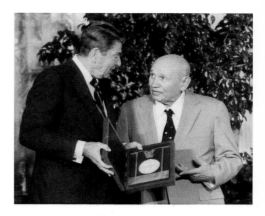

President Ronald Reagan awarding Bearden the National Medal of Art, 1987

Bearden and Thibault with 1987
collage *Storyville Mirror*

steams in the distance. The piece was completed on November 3.

They then resumed work on *Moonlite Prelude*, a striking collage 20 x 28″ depicting a locomotive streaming across a long, high trestle, its engine's light piercing the night sky. In the foreground, at the bottom of the collage, a guitar player, a cigarette in his mouth, plays next to a nude lying on a blanket, her back to a viewer. According to Thibault, Bearden remained dissatisfied with the placement of the trestle until the fourth attempt; it had to be sanded down to the board again and again. At one point, dismayed when Bearden directed him to sand down the trestle again, Thibault told Bearden he felt beaten by the piece. Bearden's response was that the piece "needed to get whipped, instead of whipping us." After that, as Thibault remembers it, "we beat *it*." By November 18, they temporarily suspended work on *Moonlite Prelude;* the opening of the Boston show was upon them.[49]

In all, Bearden and Thibault had completed eleven collages with watercolor for the exhibition, which (simultaneous with another show) inaugurated the new gallery space of the Thomas Segal Gallery, 207 South Street, Boston, from November 21 through late December 1987, and from January 5 to 9, 1988. Although he had caught a cold on November 19 just before making the trip by train to Boston, Bearden's doctors had told him that he was well enough to attend the opening. The exhibition contained seventeen works in all, six jazz watercolors by Bearden alone, and the eleven collages with watercolor. Three of the collages—*Mecklenburg Gospel Morning, Evening Guitar,* and *Gospel Morning*—were on Mecklenburg themes. The others were on jazz and Storyville themes.

Reviews of the Segal show in the *Boston Globe* and *Boston Phoenix* praised the watercolors highly. The *Phoenix* reviewer went so far as to write that "the hit of the show is not the collages at all but a suite of watercolors on jazz themes. . . . In these pieces Bearden lays his ordinarily high-keyed and dynamic colors on clean white paper, and the colors sing." Of the collages with watercolor, neither reviewer cared for *Storyville Mirror*. But *Evening Guitar* and *Gospel Morning* received special praise by the *Phoenix*. The *Boston Globe* reviewer liked *Fancy Sticks*: "Both paint and image are generally on the move: . . . a drummer's two sticks multiply in red, yellow and green to suggest the blur of quick movement."[50]

It is premature to attempt to assess the quality of this work in the perspective of Bearden's lifetime achievement in collage. Such a judgment is bound to be more balanced with the passage of time and in a setting such as a retrospective, when a selection of the work of Bearden's last year can be placed side by side with his total *oeuvre*. One element that complicates its assessment is an evaluation of the precise nature of the working relationship between Bearden and Thibault as it emerged in the completed collages. There is much doubt that Bearden would have been capable of creating alone a collage series on a scale of up to 40 x 60″.

It is important to note that, in some respects, the two had very different techniques of working in collage. Bearden used scissors to cut the paper, for instance, while Thibault used an X-acto knife. Bearden had

always used a roller to press down the cut and glued papers, while Thibault had developed the technique of using a small blue scraper for adhering the elements to the board. Bearden liked this, because it eliminated all air bubbles. The dissimilar techniques affected the overall look and texture of the finished collages. If, for example, Bearden were dissatisfied with the look of a particular part of a collage which had already adhered to the board, he could no longer simply pull it up as he had done in the past; as was the case with *Moonlite Prelude*, Thibault had to use a sander to take that portion of the work back down to the bare board.

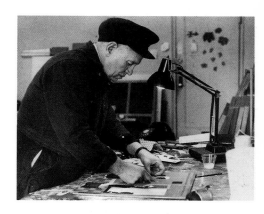

Bearden in his Long Island City studio, 1980. Photograph by Manu Sassoonian

Considering the vast differences in artistic sensibility, experience, and technical means employed by teacher and assistant, how successful was the finished collage in any given instance? It seems fair to say that as the two continued to work together over the months, the overall cohesiveness of the finished collages evolved, especially when they were not racing to meet the deadline for an exhibition. Indeed, their best collages seem to have been created in November and December 1987, and early January 1988, well after work for the Segal exhibition was ready. This is linked to the final complication in evaluating the work: Bearden's capacity to create did not simply deteriorate over the months. He seems to have responded, at least temporarily, to treatment and to have sustained hope. This element was crucial to his creative energy; in the final analysis, Bearden literally lived for his art.

The beginning of December found Bearden in much better spirits. On December 1, the finishing touches were made on *Moonlite Prelude*. The following day, he and Thibault began a collage and watercolor entitled *Autumn* (36 x 24″), which depicted a seated, masked conjur woman whose ornate, flowered hat echoed the flowered ornamentation on her sleeves. Work was going very well, but that Friday, two days later, Bearden developed a cold and was unable to get out of bed. It took him five or six days to get over it. When he returned to the studio on December 10, they completed *Autumn*. The following day, Bearden signed the work: "Romare Bearden & T."

On December 14, Bearden and Thibault began work on the first of two complementary collages with watercolor. *Eden Noon* (which they first called "The hundred-animal piece") depicts a nude bathing in a pool surrounded by a playful, fantasy-landscape composed of egrets, a blue dove, a gigantic bullfrog, and various fish. From one day to the next, Bearden's health varied; he was under sedation for the pain. Christmastime was replete with old friends visiting at the studio. Just after the holiday, on December 28, as they were putting the finishing touches on *Eden Noon*, Dr. Katarina Winnekes, curator for Kunst-Station St. Peter in Köln, paid Bearden a call to discuss the idea of a European show.[51] This buoyed his spirits tremendously. In the days following, Bearden talked with Thibault about work they could exhibit in Europe, leaning toward the idea of Storyville portraits and collages on jazz themes. In addition, they could include *Eden Noon* and its companion piece, which they began working on immediately.

Eden Midnight again depicts a nude bathing in a stream, a waterfall, a twinkling star in the night sky, and a landscape filled with other

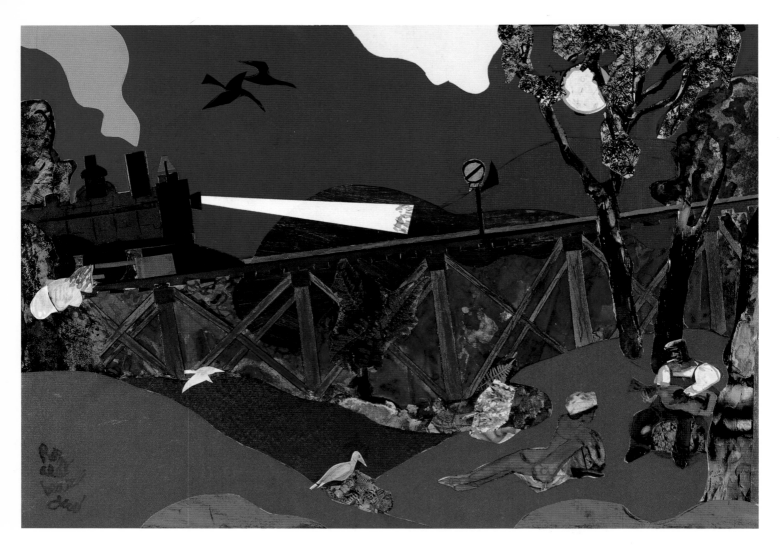

Moonlite Prelude. 1987. Collage on mahogany board, 20 x 28″. Collection Emily and Zach Smith, Charlotte, N.C.

mythological, perhaps prehistoric creatures—a gigantic butterfly, an alligator, and a dinosaur. Bearden worked at this piece (which had first been called "Enchanted Places") through the first two weeks of January, despite increasing pain. Some days he could not even get to the studio. On January 13, *Eden Midnight* was complete. Nanette, who had been coming out to the studio fairly regularly since mid-October, accompanied Romare. Thibault took a picture of the Beardens seated behind the completed work. Taken together, *Eden Noon* and *Eden Midnight* are extraordinary pieces, especially the latter work, whose subject matter combines elements found in many previous Beardens (the nude bathing, the stream, and the waterfall) with a mythological, fantastic element that had never appeared in his work before.

Bearden continued to surprise: it was as if he were trying to outpaint death. On January 14, he arrived at the studio very early and began work on the collage of a guitar player on 30 x 22″ masonite board. That Sunday, January 17, the Sunday *Newsday* article appeared, and as usual when a major article on him appeared, Bearden was deluged with congratulatory telephone

calls from friends. The next week, Bearden continued to work in pain on the guitar player. The following day, Tuesday, while Thibault continued work on the guitar player, Bearden started to make a collage alone. Working with great concentration, he began work on *At Low Tide*, a 20 x 16" collage depicting a white nude surrounded by birds and tropical foliage. He completed work on the collage two days later, on January 21, signed it on front and back and gave it to Thibault. Then he returned to work on the guitar player. The next day, Thibault saw Bearden for the last time. He was in considerable pain, using a walker to get around the studio. (He left early that day, concerned that Thibault might miss his train.)

The last time I saw him at the studio, Bearden had remarked, "Great poets always write poems about the spring, because each year, people forget how beautiful spring is." Hemingway had said as much in *A Moveable Feast*: "Part of you died each year when the leaves fell from the trees and their branches were bare against the wind and the cold, wintry light. But you knew there would always be the spring, as you knew the river would flow again after it was frozen. When the cold rains kept on and killed the spring, it was as though a young person had died for no reason.

"In those days, though, the spring always came finally but it was frightening that it had nearly failed."[52]

Spring came finally for Bearden in 1988. He kept on painting until four days before entering the hospital for the last time. On January 26, Russell Goings drove Romare and Nanette to New York Hospital. Inside the hospital, Bearden thanked Goings for all he had done and told him that there were some things in life that one had to do alone. The following day, Bearden suffered a seizure and went into a coma. He died some six weeks later, around 1:00 A.M. on Saturday, March 12. He was seventy-six years old.

Many moving tributes to Bearden were delivered at the memorial service held April 6, 1988, at the Cathedral Church of Saint John the Divine—in prayer, speech, dance, and music. Among them, Jackie McLean played an unaccompanied alto saxophone solo. Filling the cathedral's silence, the horn, by turns wailing, stomping, and chanting, called and recalled the sounds of a long blues odyssey: from the whistles of gunmetal-blue locomotives steaming at dawn through the North Carolina countryside, to steel-mill whistles screaming lunch break at Pittsburgh mills; from the smokestack horns of ocean-bound Atlantic liners sailing toward Le Havre, to big bands at the Savoy and quintets at Minton's in Harlem round midnight. The series of spontaneous inventions resolved finally into the pure melodic line of Bearden's song "Seabreeze," celebrating the spirit of one of America's most extraordinary masters of collage, an artist for all seasons and for all humankind.

ACKNOWLEDGMENTS

Without the help of the late Romare H. Bearden, who in addition to giving so generously of his time over a period of years, made available virtually anything I needed, this record of his life and art would have been impossible for me to write, and I will always be grateful to him. I also wish to thank Mrs. Nanette Rohan Bearden and the Romare Bearden Foundation on behalf of the Estate of Romare Bearden for their cooperation.

Thanks to Albert Murray, Richard Maschal, David C. Levy, Herbert Gentry, June Kelly, C. David Heymann, Ingrid Sischy, Bryan Sterling, Jean Steinberg, and William L. Coakley for their many valuable suggestions at various stages of research and manuscript preparation; to Gwen Wells for her skilled editorial assistance; and to Jack Ludwig, Louis Casotta, James Halpern, Myron Cohen, Adolphus Ealey, David Englander, Andrew Lavender, Judith Mallin, John A. Williams, Janet Levy, Martin M. Stevens and Michael Vartabedian for wise advice and counsel.

I am especially indebted to Rousmanière Alston and Aida Winters, whose memories of Charlotte were accurate and caring, as were those of Mrs. Aurelia Tate Henderson, Annie Mae Wilkins, and Mrs. Ellington, archivist of the (now roving) Church of St. Michael and All Angels. Thanks also to Dan Morrill, Director of the Charlotte-Mecklenburg Historic Properties Commission, and Joseph Thomas, who shared his knowledge of the Obeah.

For their memories of Bearden in the 1930s and 40s, I am indebted to Sam Shaw, Edward Morrow, Jacob Lawrence, Mr. and Mrs. Leonard Bates, Harry Henderson, Barrie Stavis, Robert Blackburn, Maxwell T. Cohen, Aubré de L. Maynard, M.D., Marvin and Morgan Smith, Laura Glasner, and Mrs. Eleanor Falk Quirt.

For their memories of Bearden's Paris days and afterward, I am grateful to Albert Murray, Marvin Smith, Samuel Menasch, Herbert Gentry, Larry Rivers, and Fred Norman, ASCAP. Thanks to Billie Allen Henderson, who described the production and filming of "Bearden Plays Bearden."

I am immensely grateful to Max Roach for his help in bridging the worlds of jazz percussion and Romare Bearden's art. I owe a debt of gratitude to André Thibault/Teabo for helping to establish the record of Bearden's last year's work in art. Thanks are also due Russell Goings for his insights into Bearden as a friend.

Mr. Arne Ekstrom was most gracious, patient, and unstinting with his help when I set out to research and document the twenty-nine year history of Bearden's affiliation with the Cordier & Ekstrom gallery. Without his openness and generosity, I could not have established a full account of Bearden's art of the 1960s and 1970s in particular. I am also grateful to Mrs.

Dorothy Kramer at C&E for her care and thoroughness in helping me assemble the record of that affiliation.

I thank also Sheldon Ross of the Ross Gallery, Birmingham, Michigan, who has been indefatigable in helping me over the years; Jerald Melberg of the Melberg Gallery in Charlotte, for his ready assistance and great candor; Mr. Thomas Segal of the Segal Gallery, Boston, for his prompt and thorough assistance in documenting Bearden's last exhibition; and ACA Galleries, New York, for their cooperation.

Many library and museum staffs aided me in my research. I am grateful to the staff of the Archives of American Art, in Washington, D.C., and to Jemison Hammond in the New York office, as well as the staffs of the Barnett Aden Collection, the Anacostia Neighborhood Museum and the Hirshhorn Museum of the Smithsonian Institution. In New York, I am grateful to Lowery Sims, Associate Curator, The Metropolitan Museum of Art; Deirdre Bibby and Malcolm Sweet, Art and Artifacts Division, the Schomburg Center for Research in Black Culture; the staffs at the Whitney Museum of American Art archives, the Studio Museum in Harlem, New York University Bobst Library Archives, Columbia University, Parsons School of Design, Bernard M. Baruch College, and the Graduate Center of the City University of New York. In Detroit, thanks to Mary-Ann Wilkinson at the Detroit Institute of Art. I am grateful also to the staff at the Carolina Room of the Charlotte-Mecklenburg Branch Library; the St. Louis Art Museum; the Newark Art Museum; and to Mrs. Roundtree, librarian at Salisbury College's Carnegie Library, North Carolina. Thanks to the Cooperstown Baseball Hall of Fame library. Thanks also to the staff of the main branch of the Chicago library for records of the *Chicago Defender*, as well as newspaper staffs at the *Charlotte Observer*, the *Baltimore Afro-American*, and *Newsday*.

I must thank my wife, Judith, and son, Max, for their patience and forebearance during the years of this project, and my mother and father for their enduring encouragement. It was only because my wife's parents, the late Dr. Paul and Miriam Halberstadt, so admired Bearden's art that I came to know of it in the first place.

The research for this book was funded in part by a grant-in-aid from the American Council of Learned Societies, a grant from the PSC/CUNY Research Foundation, and an NEH summer seminar at the CUNY Graduate Center led by Morris Dickstein. I am grateful to these institutions and individuals, whose help came when it was most needed.

Parts of this book have appeared, in different form, in *Artforum*, *Bulletin of Research in the Humanities* (New York Public Library), and *Callaloo*.

Edythea Ginis Selman is an extraordinarily bright, tenacious, and gifted woman who, as my agent, kept me laughing when laughter was in short supply. Thanks to her, both we and the book came through.

At Harry N. Abrams, Inc., thanks to Beverly Fazio, my editor, and to Margaret Donovan, Ray Hooper, and Neil Hoos. My special thanks to Paul Gottlieb, a tiger.

NOTES

INTRODUCTION

1. The parcel Kennedy purchased ran 193 feet southward on Graham from the intersection of Graham and Second and 50 feet eastward to a stake on Second Street. On April 28, 1884, Kennedy bought an additional piece of property contiguous with the Graham Street parcel and adjoining lands of the Atlantic, Tennessee & Ohio Railroad for $100 from Sidney and Emma Justice. By means of successive indentures on the property from 1888 to 1894, amounting to about $1,200, Kennedy expanded the business, and in March 1895 he purchased a triangular piece of property for $100 on the other side of Graham Street adjoining the railroad tracks on the hypotenuse of the triangle. In the thirty years between 1888 and 1928, Kennedy borrowed some $11,000 on the property, an enormous sum of money for the time. When he died at eighty-seven years of age in 1932 at the home of his granddaughter Anna in Greensboro, the white-owned *Charlotte Observer* ran a front-page obituary in the local section.
2. The other two sponsor/witnesses were William H. Perry and A. Myron Cochran. A male child had two male sponsors, one female.
3. Primus P. Alston married Anna Lilla ca. 1895. They had three children who survived infancy: Wendell (born in 1898), Rousmanière, and Charles. The Rev. Alston died in 1910, and his widow subsequently married Romare Bearden's uncle, Harry Bearden, about 1913. Their daughter, Aida, was born in 1917.
4. Jeanette Thomas Greenwood, *The Black Experience in Charlotte—Mecklenburg 1850–1920* (Charlotte, N.C.: Charlotte–Mecklenburg Historic Properties Commission, 1984), "Blacks in Politics, 1867–1900." Additional information about the role of blacks in Charlotte's political history is drawn from author's interview with Dan Morrill, Chairman, Charlotte–Mecklenburg Historic Properties Commission, Charlotte, N.C., April 10, 1985.
5. Quotations and recollections attributed to Rousmanière Alston throughout this chapter are excerpted from the author's interviews with Rousmanière Alston and Aida Winters, New York, May and August 1984.
6. Romare Bearden Papers, Archives of American Art, Smithsonian Institution, Washington, D.C. (hereafter AAA), roll 3196. Romare Bearden, interview with Henri Ghent, June 29, 1968, AAA pp. 5–6.
7. A compilation of Bearden anecdotes from several sources: Bearden, interview with Henri Ghent, AAA, transcript p. 20. Romare Bearden Papers, AAA, roll 3196; single typescript page, Romare Bearden Papers, AAA (unfilmed at time of author's research); also author's interview with Romare Bearden.
8. Drawn from Bearden's own description, Romare Bearden Papers, AAA (unfilmed at time of author's research).
9. Romare Bearden Papers, AAA (unfilmed at time of author's research).

CHAPTER 1—MILL HAND'S LUNCH BUCKET

1. Quoted by Avis Berman, "Romare Bearden: 'I paint out of the tradition of the blues,' " *ARTnews*, Dec. 1980, p. 65.
2. Bearden's journal is a holograph manuscript in ink, some 77 pages in length, with the handwriting double-spaced in a lined ledger book. The first entry is dated August 14, 1947. It continues with almost daily regularity through January 3, 1948, but in the middle of this entry, in a slightly different hand, Bearden wrote: "And I have skipped a whole year's entries." The remainder of the journal is undated. The entry quoted here is dated September 8 [1947].
3. This, and all Bearden quotations not otherwise noted, is attributable to a series of weekly author's interviews with Bearden in 1983 and 1984.
4. The man's massive strength derived from his work in the puddling mill. In the article "The Negro in 'Little Steel' " he wrote for *Opportunity* (Vol. XV, No. 12, Dec. 1937), Bearden described such a mill in Tarentum, Pa., whose chief product was a bolt used in the linings of engines called the "Lewis Straybolt." His description makes clear the back-breaking nature of the process: "The mill is one of the few old 'puddling mills' that are still operated. Most of these mills have been replaced by those mills using the blast and open-hearth furnaces. . . . Pig iron billets are heated in small furnaces by crews of two or three men under the charge of one man who is called a puddler. The iron is constantly turned by the men, who work before the withering heat of the furnaces with long iron rods. The white hot iron is worked until it is roughly the shape of a large ball. When the puddler feels that the iron is sufficiently heated, it is taken out of the furnaces with a big clamp. Then it is rushed along a stationary dripping hot iron and slag all the while, while it is pushed into the rollers. The rollers are a series of cylinders in constant motion. When the iron strikes the rollers it is pressed out like biscuit dough. After its trip through the rollers, the iron is passed out into the yard in the desired shape. In this case, strips averaging eighteen feet in length, six inches in width, and half an inch in thickness were the result. When the strips are cooled they are sent to the finishing mill. Here the iron is reheated to rid it of imperfections and sent through another set of rollers. But, at this point, the iron is finished in long, round strips to be cut into bolt forms." Bearden's point in this section of his article is that a process resulting in a highly respected product employed black workers in skilled capacities.
5. Author's interview with Sam Shaw, Oct. 1986.
6. Recounted in Calvin Tomkins, "Profiles: Putting Something Over Something Else," *New Yorker*, Nov. 28, 1977, pp. 53–58 ff.
7. *Ibid.*, p. 55.
8. Bearden, "The Negro in 'Little Steel.' "

CHAPTER 2—THE EAGLE FLIES ON FRIDAY

1. Author's interview, March 1983.
2. Milton W. Brown, *The Modern Spirit: American Painting 1908–1935*, exh. cat. Arts Council of Great Britain, 1977. See esp. pp. 67–71, "The Thirties." Quotes attributed to Brown in pages following are from the same source.
3. Study by Norman V. O'Connor, cited by Norman Barr in his Statement, *New York City WPA Art, Then 1934–1943 and Now 1960–1977*, exh. cat. Parsons School of Design, 1977, p. xiv.
4. Figure cited by Brown, *The Modern Spirit*.
5. Bearden, "The Negro in 'Little Steel,' " pp. 362–65 ff.
6. *New York Times*, Sept. 17, 1943, p. 21. Information relating to Bessye Bearden's introduction of Eleanor Roosevelt and Mary McLeod Bethune is from the same source.
7. Author's interview with Dr. Maynard, June 1988. Subsequent quotations attributed to Dr. Maynard are from the same interview.
8. Author's interview with Edward Morrow, May 1985.
9. Information relating to Bearden's brief stint as a pitcher is compiled from Tomkins, "Putting Something Over Something Else," as well as from interviews with Sam Shaw, Edward Morrow, and Bearden.
10. Bearden, interview with Henri Ghent, AAA, transcript p. 1. Bearden Papers, roll 3196.
11. See *Artists Against War and Fascism: Papers of the First American Artists' Congress*, Intro. by Matthew Baigell and Julia Williams (New Brunswick: Rutgers Univ. Press, 1986), pp. 9–15.
12. See Daniel Aaron, *Writers on the Left* (New York: Harcourt, Brace & World, 1961), pp. 275–76.
13. *Artists Against War and Fascism*, "Signers of the Call," pp. 49–52.
14. *Artists Against War and Fascism*, Aaron Douglas speech, "The Negro in American Culture," pp. 78–84.
15. Dierdre L. Bibby, "Augusta Savage and the Art Schools of Harlem," *Augusta Savage and the Art Schools of Harlem* (New York: Schomburg Center for Research in Black Culture, New York Public Library, 1988), pp. 8, 10.
16. *Norman Lewis: From the Harlem Renaissance to Abstraction*, exh. cat. (New York: Kenkeleba Gallery, 1989), Chronology, p. 59.
17. Author's interview with Morgan and Marvin Smith, 1987.
18. Ellen Harkins Wheat, *Jacob Lawrence: American Painter* (Seattle: Univ. of Washington Press, 1986), pp. 29–30.
19. Author's interviews with Mr. and Mrs. Leonard Bates, 1987, 1988.
20. Author's interview with Romare Bearden, April 1985.
21. Ralph Ellison, Catalogue introduction to *Romare Bearden: Paintings and Projections* (Albany: Art Gallery, State Univ. of New York at Albany, 1968).
22. Author's interview with Jacob Lawrence, March 1985 (by telephone).
23. Author's interview with Romare Bearden, April 1985.
24. Author's interview with Jacob Lawrence, March 1985 (by telephone).
25. Author's interview with Romare Bearden, April 1985.

26. Ann Gibson, "Norman Lewis in the Forties," *Norman Lewis: From the Harlem Renaissance to Abstraction*, exh. cat. (New York: Kenkeleba Gallery, 1989), p. 10.

27. Wheat, *Jacob Lawrence: American Painter*, pp. 35–36.

28. Jervis Anderson, *This Was Harlem: A Cultural Portrait 1900–1950* (New York: Farrar, Straus & Giroux, 1981), pp. 310–11.

29. Author's interviews with Romare Bearden.

30. Anderson, *This Was Harlem*, p. 241.

31. Author's interview with Romare Bearden, 1984.

32. "(They) Call It Stormy Monday," by Aron T. ("T-Bone") Walker, © 1948, 1976 Gregmark Music Inc., Tarzana, Calif.

CHAPTER 3—RITES OF SPRING

1. Romare Bearden, *Journal*, Oct. 1, 1947.

2. Artist's Statement in *Romare Bearden*, exh. cat. (New York: "306," 1940).

3. Bearden, interview with Henri Ghent, AAA, transcript p. 2. Romare Bearden Papers, AAA, roll 3196.

4. Author's interview with Morgan and Marvin Smith, 1989.

5. Tomkins, "Profiles: Putting Something over Something Else," p. 58.

6. Bearden, interview with Henri Ghent, AAA, transcript, p. 2. Romare Bearden Papers, AAA, roll 3196.

7. Edith Gregor Halpert, Foreword in *American Negro Art*, exh. cat. (New York: Downtown Gallery, 1941).

8. Bearden to Walter Quirt, Jan. 20, 1942. Courtesy family of Walter Quirt.

9. Gibson, "Norman Lewis in the Forties," p. 16.

10. Wheat, *Jacob Lawrence: American Painter*, p. 69.

11. *Norman Lewis: From the Harlem Renaissance to Abstraction*, Chronology, p. 60.

12. Romare Bearden to Bessye Bearden, postmarked Camp Davis, N.C., Nov. 29, 1942. Bessye J. Bearden papers, Manuscripts and Archives, Schomburg Center for Research in Black Culture, The New York Public Library. To my knowledge, this is the sole surviving letter from Bearden to his mother in any archive.

13. A. D. Emmart, "Art Notes," *The Baltimore Sun*, May 21, 1944.

14. Bearden to Quirt, letter headed "351 West 114 St., N.Y.C.," n.d. Bearden mentions in the letter that his second show at Caresse Crosby's G Place Gallery had opened "last Sunday," so the letter can be dated June 1945. Courtesy family of Walter Quirt.

15. Bearden to Quirt, dated July 10, 1945. Courtesy family of Walter Quirt. Bearden's letter goes on to give an interesting account of his relation to other artists at the time, as well as to his own circumstances:

> Last night I came to the conclusion, as you say, that I best remain close to myself in relation to the artists that are here. Spink [Charles Alston], for instance, came by last night—and I showed him the drawings I did for you and told him I did them in an hour or so. This, he claimed, was physically impossible, and if you can do things that easily you'd better watch yourself. Therefore, you can see how I miss your not being here; because these guys remain on such safe, conservative, petty levels—I'm tired of "can not," "you shouldn't," "you ought," "reflect," "not so fast," "that's impossible"—What is painting but to dare, but to try and control your madness. . . .
>
> I ought to tell you that I'm back on the job at the Dep't of Welfare. I thought that I could get started in cartooning, but I found that the cartoons hurt my painting. You will see in the little drawings I sent you that the least wrong adjustment would make a cartoon-like figure.
>
> Isn't this true Walter? I remember once I read that Picasso said, "I don't care anything about Van Gogh the painter, but Van Gogh the man is great." I didn't understand such a statement then, what had the man's life to do with Picasso's liking or not liking the paintings. But now I'm beginning to see that this art is a way of life. Dishonesty, pettiness, all those things will crop out in your work. So with my father out of work (ill) I went back—will continue to paint what I want—and, since I've started down this lonely road I'd just as well keep going.
>
> I notice a diverse group has begun to visit me at the studio. In this way, I've begun to build up more and more people who have begun to speak about the paintings. It's surprised me, but I've had a call from a concern to illustrate a book of spirituals—and people I don't know have heard of me. But this is wearing, so now I'm retiring and working hard. People say now, I'm this and that, adolescence, etc, because I haven't followed leads that have been suggested to me—but I really feel it's other things that I want. If by chance a worldly success comes—well and good, but to seek it yourself, under this system, you have to be a

combination of business man, press agent, and phoney—all not appealing to me.

16. Author's interview with Maxwell T. Cohen, Nov. 22, 1984.

17. Author's interview with Barrie Stavis, Oct. 2, 1984.

18. Romare Bearden, "The Negro Artist's Dilemma," *Critique*, Nov. 1946, pp. 16–22.

19. Nora Holt, *The Amsterdam News*, Oct. 27, 1945. Almost certainly, the same artist's statement accompanied Bearden's G Place Gallery exhibition several months earlier. That exhibition, however, contained a number of different works, at least four of which had been sold by the time Bearden wrote Quirt about it.

20. "The Whitney Scene," *Newsweek*, Dec. 10, 1945.

21. Ben Wolf, "Bearden Abstracts Drama of the Bull-Ring," *Art Digest*, April 1, 1946.

22. "Romare Bearden Bull-Fight Inspiration," *Artnews*, April 1, 1946.

23. Ben Wolf, "Abstract Artists Pay Homage to Jazz," *Art Digest*, Dec. 1, 1946.

24. Bearden to Holty, n.d., Carl Holty Papers, AAA, roll 670, frames 403–22. Bearden's handwritten letters to Holty are headed only by a day of the week and occasionally, the address of his studio. Sequencing and approximate dating done by author on the basis of internal evidence.

25. Holty to Bearden, Oct. 2, 1948, Holty Papers, AAA, roll 670, frames 501–507.

26. Bearden to Holty, n.d., Holty Papers, AAA, roll 670, frames 447–53; see esp. frame 452, reproduced here.

27. Holty to Bearden, Dec. 22, 1948, Holty Papers, AAA, roll 670, frames 516–21.

28. Bearden to Holty, n.d., Holty Papers, AAA, roll 670, frames 439–46.

29. Holty to Bearden, Jan. 29, 1949, Holty Papers, AAA, roll 670, frames 522–27.

30. See also Holty to Bearden of Feb. 12, 1949, Holty Papers, AAA, roll 670, frames 528–35, esp. frame 530.

31. Holty to Bearden, Jan. 29, 1949, Holty Papers, AAA, roll 670, frames 522–27.

32. Bearden to Holty, n.d. Courtesy Romare Bearden.

33. Bearden to Holty, n.d., Holty Papers, AAA, roll 670, frames 454–59.

34. Holty to Bearden, May 14, 1949, Holty Papers, AAA, roll 670, frames 536–39.

CHAPTER 4—SEABREEZE

1. Mallarmé, "Brise Marine," trans. by Gwendolyn Wells.

2. Author's interview with Herbert Gentry, Dec. 1983.

3. Bearden to Holty, postmarked March 9, 1950, headed 5 rue des Feuillantines, Holty Papers, AAA, roll 670, frames 547–50.

4. Bearden to Charles Alston, postmarked March 23, 1950. Courtesy Rousmanière Alston.

5. Author's interview with Romare Bearden, 1983.

6. Bearden to Holty, ca. April 1, 1950, continued and dated April 3 on p. 6 of letter. Holty Papers, AAA, roll 670, frames 551–56.

7. Avis Berman, "Romare Bearden: 'I Paint Out of the Tradition of the Blues'" *ARTnews*, Dec. 1980, p. 66.

8. Bearden to author, with accompanying sketch of Hélion's studio. Postmarked in St. Martin, 24 Jan., 1986.

9. Berman, "Romare Bearden," p. 66.

10. Tomkins, "Putting Something over Something Else," p. 61.

11. Author's interview with Herbert Gentry, Dec. 1983.

12. Bearden to Holty, ca. late April–May, 1950, Holty Papers, AAA, roll 670, frames 468–74.

13. Author's interview with Larry Rivers, June 1984.

14. Bearden to Holty, dated May 28 on Cunard Line—RMS "Queen Mary" stationery. Holty Papers, AAA, roll 670, frames 491–94.

15. Tomkins, "Putting Something over Something Else," p. 62.

16. Mallarmé, "Brise Marine," trans. by Wells.

17. "Who Can Say?" by Larry Douglas, Fred Norman, and Romare Bearden, copyright Laerteas Music Co., 1954. Lyrics quoted by permission, courtesy Fred Norman.

18. Quoted in Serge Guilbaut, *How New York Stole the Idea of Modern Art* (Chicago: Univ. of Chicago Press, 1983), p. 178.

19. April J. Paul, "Introduction à la Peinture Moderne Americaine: Six Young Painters of the Samuel Kootz Gallery: An Inferiority Complex in Par-

is," *Arts* 60:6 (Feb. 1986), pp. 65–71.

20. Guilbaut, *How New York Stole the Idea of Modern Art*, p. 179.

21. Holty to Bearden, Feb. 27, 1953. Holty Papers, AAA, Roll 670, frames 588–91.

22. Quoted by Greta Berman, "Byron Browne: Builder of American Art," *Arts* (Dec. 1978), p. 98.

23. Author's interview with Romare Bearden, 1986.

24. Author's interview with Fred Norman, 1986. "Seabreeze" by Larry Douglas, Fred Norman, and Romare Bearden, copyright Laerteas Music Co., 1954. Lyrics quoted by permission, courtesy Fred Norman.

25. Bearden to Holty, dated Tuesday, April 1, Holty Papers, AAA, roll 670, frames 499–500.

26. Bearden to Holty, c. Nov. 8, 1952, headed "Wednesday" and opening with the words "I have decided to write you the day after 'the old order changeth.' " Holty Papers, AAA, roll 670. Also in manuscript in the Bearden Papers, AAA.

27. Bearden to Holty, c. 1954, headed "Tuesday" and opening with the words "I saw Freddie during the past week." Holty Papers, AAA, roll 670. Also in manuscript in the Bearden Papers, AAA.

28. Author's interviews with Nanette Rohan Bearden, 1985 and 1986.

29. Romare Bearden, interview with Henri Ghent, AAA, transcript pp. 13–14. Bearden Papers, AAA, roll 3196.

30. Bearden interview with Ghent, AAA, transcript p. 20.

31. Letter from Bearden to a young artist-in-residence, ca. 1983, courtesy Romare Bearden.

32. Bearden interview with Ghent, AAA, transcript p. 4.

33. *New York Times*, Nov. 5, Nov. 8, 1955.

34. Author's interview with Romare Bearden, 1984.

35. Bearden to Holty, ca. mid-Nov. 1952, headed "Sunday" and opening with the words [Harry] "Salpeter asked me to do an oil for his Xmas show." Holty Papers, AAA, roll 670, frames 434 ff. Also in holograph manuscript in Bearden Papers, AAA.

36. Author's interview with Romare Bearden, 1986.

CHAPTER 5—REINVENTING COLLAGE

1. Bearden, "Rectangular Structure in My Montage Paintings," *Leonardo*, Vol. 2 (Jan. 1969), p. 18.

2. Author's interview with Arne Ekstrom, July 1988.

3. Carlyle Burrows, "Bearden's Return," *New York Herald Tribune*, Jan. 24, 1960.

4. *New York Times*, Jan. 23, 1960.

5. "Kennedy to Arrive Here Today; Pre-Inaugural Suite Prepared," *New York Times*, Jan. 4, 1961. "Bearden Painting in Presidential Suite," *Amsterdam News*, Jan. 7, 1961.

6. Brian O'Doherty, "Art: O'Keeffe Exhibition . . . Bearden and Resnick Works on View," *New York Times*, c. April 17, 1961.

7. V.R., "Romare Bearden," *Arts*, April 1961.

8. O'Doherty, "Art."

9. Bearden to Ekstrom, June 1961. Courtesy Arne Ekstrom.

10. Author's interview with Arne Ekstrom, July 1988.

11. Bearden interview with Henri Ghent, Bearden Papers, AAA, roll 3196.

12. *First Group Showing (Works in Black and White)*, exh. cat., (New York: Spiral Gallery, 1965), Foreword.

13. Emma Amos, quoted in *Romare Bearden: A Memorial Exhibition*, exh. cat. (New York: ACA Gallery, 1989), p. 29.

14. Author's interview with Albert Murray, Sept. 1978.

15. Excerpt from a letter written by Arne Ekstrom [copy], dated Sept. 25, 1964. Courtesy Arne Ekstrom.

16. Charles Childs, "Bearden: Identification and Identity," *Artnews*, Oct. 1964, pp. 24–25 ff.

17. Dore Ashton, "Romare Bearden: Projections," *Quadrum* (Brussels), p. 110.

18. Romare Bearden holograph manuscript [copy]: plan of *Projections* exhibition by title. Courtesy Cordier & Ekstrom.

19. Michael Gibson, *International Herald Tribune*. Letter from Bearden dated June 15, 1975 [copy], Bearden Papers, AAA.

20. Bearden interview with Henri Ghent, AAA, transcript p. 24. Bearden Papers, AAA, roll 3196.

21. Bearden, "Rectangular Structure in My Montage Paintings," p. 14.

22. *Fortune*, Vol. LXXVII, No. 1 (Jan. 1968), cover.

23. Author's interview with Romare Bearden, 1985.

24. Grace Glueck, "A Brueghel from Harlem," *New York Times*, Feb. 22, 1970.

25. Bearden to Ekstrom, headed "Summer 1973, Sunday." Courtesy Arne Ekstrom.

26. Author's interview with Lowery Sims, March 1983.

27. *Artnews*, March 1976, p. 132.

CHAPTER 6—THE VOYAGER RETURNS

1. Marsha Miro, *Detroit Free Press*, Dec. 20, 1979.

2. Albert Murray, "The Visual Equivalent of the Blues," in *Romare Bearden: 1970–1980*, exh. cat. Edited by Jerald L. Melberg and Milton J. Bloch, essays by Albert Murray and Dore Ashton (Charlotte, N.C.: Mint Museum, 1980), p. 26.

3. Dore Ashton, "Romare Bearden," in *Romare Bearden 1970–1980*, p. 33.

4. Patricia Krebs and Gloria Anderson, "Artist Seeks Childhood Scenes in Charlotte," *Charlotte Observer*, May 7, 1976.

5. Lew Powell, "Exhibit Rolls Mint onto National Stage," *Charlotte Observer*, Oct. 5, 1980.

6. Richard Maschal, "Acclaimed Artist Celebrates Charlotte Roots," *Charlotte Observer*, Oct. 5, 1980.

7. Berman, "Romare Bearden," p. 62.

8. Author's telephone conversation with Bearden, Dec. 1983.

9. Maryanne Conheim, *Philadelphia Inquirer*, May 6, 1982.

10. *New York Times*, April 8, 1977, Op-ed page.

11. John Russell, "Art: Bearden from Homer to Henri," *New York Times*, April 29, 1977.

12. Letter from Edward Morrow to Bearden, May 5, 1977, Bearden Papers, AAA.

13. Anna Kisselgoff, "The Dance: 'Ancestral Voices' " *New York Times*, May 14, 1977.

14. Berman, "Romare Bearden," p. 62.

15. Hilton Kramer, "Bearden's 'Patchwork Cubism' " *New York Times*, Dec. 3, 1978.

16. Myron Schwartzman, "Romare Bearden's Collaboration with Albert Murray," *Bulletin of Research in the Humanities* (Summer 1983), pp. 158–59.

17. The late Samuel Shore was owner of Shorewood Publishers, Inc., an art/graphics house. A 1971 announcement describes the Shorewood graphic workshop in Long Island as "a multi-faceted complex where the world's great artists are producing original graphics and multiples." The only instance in which Bearden produced multiple collages was with Shorewood graphics, ca. 1972. See Mint Retrospective exh. cat. *Listing of Works 1970–1980*, compiled by Jane McKinnon, no. 643, p. 119: "This series of six collages entitled RITUAL BAYOU was produced in an edition of 39. The collages were hand cut and assembled by Bearden at the Shorewood Graphics Workshop, New York." In fact, Bearden may have stopped at the thirtieth or thirty-second set. Two other planned sets of six collages each, made "after" the maquettes, never came to fruition. They were entitled *Time of the Gingham Rooster* and *Suzannah and the Bath*; the complete projected work, entitled *Trilogy*, totaled three sets of six collages each. Sheldon Ross's 1972 show included one of the *Ritual Bayou* sets, the only part of the projected trilogy Bearden completed. According to Sheldon Ross (Ross to author, July 20, 1989): "Bearden employed one or two helpers to put the first six collages together. It was complicated and very time consuming; after the first 20 or 22 sets were done he [told] Sam Shore that it was an impossible task. . . . Bearden only agreed to do a few more if the sales picked up and more sets were needed. Evidently, he and his assistants did do a few more sets in the next year or two because Bearden told me that he thought about 27 or 28 sets were completed. After that he told Sam Shore he would do more. (However, a few years later, Sam Shore in a telephone conversation, told me that he thought that 30–32 sets were done)."

18. Some of these collectors, including Ross himself, had acquired a taste for Bearden's work in the late 1960s, when they saw it installed at the J. L. Hudson gallery, situated in Detroit's largest department store. Arne Ekstrom had consigned the gallery its Bearden works at the request of its new director, Oscar Piagentini, in 1967 for the gallery's only formal Bearden

exhibition. That exhibition had followed the 1967 Cordier & Ekstrom show, which had sold out, and was composed of entirely different Beardens. Those that did not sell immediately were sold off slowly over the years until the Hudson gallery's closing in the mid-1970s.

19. Richard Oppel, "Honored Guest Nearly Canceled," *Charlotte Observer*, Oct. 19, 1980.

20. Richard Maschal, "Artist Romare Bearden Found His Roots Under City's Concrete," *Charlotte Observer*, Oct. 12, 1980.

21. Powell, "Exhibit Rolls Mint onto National Stage."

22. Miriam Apperson, "Philip Morris's Gift Was Key to Getting Show Together," *Charlotte Observer*, Oct. 5, 1980.

23. Lew Powell, "Mint Museum Put up a Fight for Doing Show Its Own Way," *Charlotte Observer*, Oct. 5, 1980.

24. Oppel, "Honored Guest Nearly Canceled." In this signed follow-up column, Oppel, editor of the *Observer*, made it clear that urgent entreaties had been undertaken to get Bearden to relent, including a telephone call to Bearden from Oppel, at Milton Bloch's request. Oppel called, "not to apologize, for we were happy with the effort, but to explain our intent to celebrate his homecoming with the coverage." On the telephone, Bearden told Oppel that he had changed his mind: "Yes, I went out today and bought a Brooks Brothers suit." An interesting sidelight, Oppel wrote, was the action of Bearden's associates, who "seemed determined to keep waters roiled" even after Bearden's own anger had passed. June Kelly, Bearden's publicist, demanded that neither Melberg nor Powell attend exhibit functions. (But "at a later reception," Oppel wrote, "the publicist pleasingly asked me, 'Is Mr. Powell going to be here? I look forward to seeing him.' ")

25. Paul Richard, "The Integrated Art of Romare Bearden," *The Washington Post*, April 26, 1981, pp. H1, H5.

26. Romare Bearden, "An Artist's Renewal in the Sun," *New York Times* Sunday Magazine, Oct. 2, 1983, pp. 46–48, 52.

27. Calvin Tomkins, "The Intelligent Hand," from *Romare Bearden: Mecklenburg Autumn* exh. cat., (New York: Cordier & Ekstrom, 1983).

28. Michael Brenson, "Art: Romare Bearden, 'Rituals of the Obeah' " *New York Times*, Nov. 30, 1984.

29. "Koch Honors 6 in the Arts With Awards," *New York Times*, Nov. 28, 1984.

30. Bearden, "An Artist's Renewal in the Sun," p. 52.

31. Author's interview with Max Roach, 1985.

32. Author's interview with Bearden, 1985.

33. Thanks to John Behler, Curator of Reptiles, Bronx Zoological Society, for information on the marsh hawk.

34. Letter from Bearden to author postmarked 24 Jan, 1986.

35. Letter from Bearden to Arne Ekstrom, n.d. Courtesy Arne Ekstrom.

36. Bearden, Artist's Statement, in *Romare Bearden: Origins and Progressions* exh. cat., (Detroit: Detroit Institute of Arts, 1986); Lowery S. Sims, "Romare Bearden: An Artist's Odyssey"; *The Journal of Romare Bearden*, Davira S. Taragin, ed., 48 pp.

37. Letter from Bearden to André Thibault/Teabo, postmarked Aug. 31, 1986. Courtesy André Thibault/Teabo.

38. Lowery S. Sims, "The Unknown Romare Bearden," *Artnews*, Oct. 1986, pp. 117–20. The focus of the article was Bearden's earlier lyrical abstractions, which had "been overshadowed by the popularity of his later work"; however, many readers, especially those thoroughly familiar with Bearden, considered the title unfortunate and vulnerable to a complete misreading.

39. Richard Maschal, "New Bearden Works Leaner, Richer" *Charlotte Observer*, June 2, 1985.

40. Nancy Princenthal, "Romare Bearden at Cordier & Ekstrom," *Art in America* (Feb. 1987).

41. Michael Brenson, "A Collagist's Mosaic of God, Literature and His People," *New York Times*, Jan. 11, 1987.

42. Bearden to Arne Ekstrom, Jan. 14, 1987. Courtesy Arne Ekstrom.

43. Dates of work on specific collages and descriptions of work at the studio are based primarily on author's interviews with André Thibault/Teabo, Feb. 1988, March 1988, April 1988, and Aug. 1989.

44. Myron Schwartzman, "A Bearden-Murray Interplay: One Last Time," *Callaloo: A Journal of Afro-American and African Arts and Letters*, Vol. 11, No. 3 (Summer 1988), pp. 410–15.

45. Les Payne, "America's Greatest (Overlooked) Artist," *Newsday Magazine*, Jan. 17, 1988. Cover, pp. 6–11, 18–20. The title tended to buttress the false impression that even near the end of his life, Bearden was strug-

gling for recognition. Bearden had been widely recognized since the mid-1960s.

46. "National Medal of Arts Awarded to 11 by Reagan," *New York Times*, June 11, 1987. In addition to Bearden and Fitzgerald, recipients included J.W. Fisher, opera patron; Dr. Armand Hammer, art patron; Sydney and Frances Lewis, art patrons; Howard Nemerov, writer and scholar; Alwin Nikolais, choreographer; Isamu Noguchi, sculptor; William Schuman, composer; and Robert Penn Warren, poet and novelist.

47. Payne, "America's Greatest (Overlooked) Artist."

48. *Callaloo, A Journal of Afro-American and African Arts and Letters*, Vol. 11, No. 3 (Summer 1988), "In Memoriam: Romare Bearden," pp. 401–46. Cover art: Bearden, *Opening Statement*. Charles Rowell's " 'Inscription at the City of Brass': An Interview with Romare Bearden," pp. 428–46 (dated Aug. 11, 1987) was, to my knowledge, the last interview conducted with Bearden.

49. Astonishingly, and through no fault of Bearden's, Ekstrom was kept in the dark about plans for the Segal Show in Boston. According to Judith Goldman, director of the Thomas Segal Gallery, "It was a show that was really done through . . . June Kelly. We did not really have a choice of the works" (Telephone conversation with the author, July 1989).

50. *The Boston Globe*, Nov. 28, 1987. *Boston Phoenix*, Dec. 18, 1987.

51. Reportedly, the idea was for an exhibition in Frankfurt.

52. Ernest Hemingway, "People of the Seine," in *A Moveable Feast* (New York: Charles Scribner's Sons, 1964), p. 45.

BIBLIOGRAPHY

By the Artist: Statements and Writings arranged chronologically.

"The Negro Artist and Modern Art." *Opportunity*, December 1934, pp. 371–72.

"The Negro Artist's Dilemma." *Critique*, November 1946, pp. 16–22.

"Romare Bearden–biography." In exhibition catalogue *Romare Bearden Projections*. Cordier & Ekstrom, Inc., New York, October 6–24, 1964.

"From far off . . .". In exhibition catalogue *Romare Bearden: Six Panels on a Southern Theme*. Bundy Art Gallery, Waitsfield, Vermont, April 2–May 29, 1967.

"The Black Artist in America: A Symposium." *Metropolitan Museum of Art Bulletin*. New York, January 1969, pp. 245–60.

"The Artist Responds." *Harvard Art Review*. Summer 1969, pp. 31–32.

"Rectangular Structure in My Montage Paintings." *Leonardo*, January 1969, pp. 11–19.

"Black Art: What Is It?" *The Art Gallery*, April 1970, pp. 32–35.

[Book Review]. In *Leonardo*, April 1970, pp. 241–43, of *American Negro Art* by Cedric Dover.

[Book Review]. In *Leonardo*, July 1970, pp. 361–62, of *Theories of Modern Art: A Source Book by Artists and Critics* by Herschel B. Chipp.

"The Poetics of Collage." *Art Now: New York*, vol. 4, 1970 (illus.).

"A Painter in His Fifties." *Arts*, April 1974, pp. 36–37.

"Horace Pippin." Essay in *Horace Pippin* exhibition catalogue of the Phillips Collection, Washington, D.C., February 1977.

"Eating at Ma Chance's." *Essence*, April 1978, pp. 112–14.

"Farewell to Aaron Douglass." *Crisis*, May 1979, pp. 164–66.

"An Artist's Renewal in the Sun." *New York Times* Sunday Magazine, October 2, 1983, pp. 46–48, 52.

"Clouds in the Living Room." *New York Times* Sunday Magazine, Part 2, Oct. 6, 1985, pp. 80–81.

Bearden, Romare, and Henderson, Harry. *Six Black Masters of American Art*. Garden City, N.Y.: Zenith Books, Doubleday, 1972.

Bearden, Romare, and Holty, Carl. *The Painter's Mind*. New York: Crown Publishers, 1969.

On the artist: Arranged alphabetically.

ABA: A Journal of the Affairs of Black Artists. "Important Notes: Black Artists to be Shown at the Modern." 1971.

Aldridge, Cathy. "Bearden's Collages Sold Though Exhibit Goes On." *New York Amsterdam News*, November 4, 1967, p. 23.

Allen, Charles. "Have the Walls Come Tumbling Down?" *New York Times*, April 11, 1971.

Andre, Michael. "New York Reviews: Romare Bearden." *Art News*, May 1975, p. 95.

"Art News International: Artists In the Art News." *Art News*, March 1972, p. 7.

Ashton, Dore. "About Art and Artists." *New York Times*, November 3, 1955.

———. "Response to Crisis in American Art." *Art in America*, January–February 1969, pp. 24–35 (illus.).

———. "Romare Bearden: Projections." *Quadrum* (Brussels), 1964, p. 110+.

Bandler, Michael J. "Black Artists: Growing Impact On American Consciousness." United States Information Service Feature, August 1971, No. N–7/71–F–195, pp. 1–2, 4–5.

Bell, Jane. "Arts Reviews: Romare Bearden." *Arts*, April 1975, p. 5 (illus.).

Black Art: An International Quarterly. Winter 1976, p. 16 (illus.).

Boston Globe, November 28, 1987 [Review].

Boston Phoenix, December 18, 1987 [Review].

Brenson, Michael. "Art: Romare Bearden, 'Rituals of the Obeah.'" *New York Times*, November 30, 1984.

———. "A Collagist's Mosaic of God, Literature and His People." *New York Times*, January 11, 1987.

Brewer, Sherry. "Contemporary Living." *Essence*, February 1978, p. 94.

Brommer, Gerald F. *The Art of Collage*. Massachusetts: Dover Publications, Inc., 1978, pp. 1, 12, 95.

——— and Horn, George F. *Art in Your World*. Worcester, Mass.: Davis Publishers, 1977.

Brown, Marion E. "The Negro in the Fine Arts." *The American Negro Reference Book*. Ed. John Preston Davis. Englewood Cliffs, New Jersey: Prentice-Hall, 1966, pp. 736, 742.

———. "The Negro in the Fine Arts." *The American Negro Reference Book*. Ed. John Preston Davis. vol. 2, Negro Heritage Library. Yonkers, New York: Educational Heritage, 1966, pp. 743, 768 (illus.).

Burnside, Madeleine. "New York Reviews: Romare Bearden." *Artnews*, February 1979, pp. 172–73.

Caldwell, Bill. "Romare Bearden." *Essence*, May 1975, pp. 70–73 (illus.).

Callaloo, A Journal of Afro-American and African Arts and Letters, vol. 11, no. 3, Summer 1988, pp. 401–46.

Campbell, Lawrence. "Reviews and Previews: Romare Bearden." *Artnews*, February 1970, p. 10.

Campbell, Mary Schmidt. "Romare Bearden: A Case Study in Problems and Modern Iconography." Ph.D. Dissertation, Syracuse University, 1981.

Canaday, John. "Art: Bearden, Graffiti, and Life All Over the Place." *New York Times*, August 13, 1972.

———. "The Art of Romare Bearden." *Contact*, Spring 1974.

———. "Art: Themes and the Usual Variations." *New York Times*, September 30, 1967, p. 29.

———. "Romare Bearden Focuses on the Negro." *New York Times*, October 14, 1967.

Cederholm, Theresa Dickason. *Afro-American Artists: A Bio-bibliographical Directory*. Boston: Trustees of the Boston Public Library, 1973, pp. 19–21.

Childs, Charles. "Bearden: Identification and Identity." *Art News*, October 1964, pp. 24–25+ (illus.).

Coker, Gylbert. "Romare Bearden's Sentimental Journey." *New York Amsterdam News*, January 6, 1979, p. D6.

Colby, Joy Hakanson. "Jazz In Shapes and Colors." *The Detroit News*, April 13, 1980, p. 4G.

Coleman, Floyd. "African Influences on Black American Art." *Black Art: An International Quarterly*, Fall 1976, p. 9.

Conroy, William T., Jr. "Columbian Collage: American Art of Assembly." *Arts*, December 1977, pp. 86–87.

Coyne, Richard S. "Expressions of Depression." *Communication Arts*, no. 130, March-April 1978, pp. 56–61 (illus.).

Davis, Douglas. "Putting Things Together." *Newsweek*, April 5, 1971, pp. 52–53.

Diamonstein, Barbaralee. *Inside the New York Art World*. New York: Rizzoli Pub., 1980.

Doar, Harriet. "'Carolina Shout' Comes Back to Its Roots." *The Charlotte Observer*, April 20, 1975.

———. "Charlotte Native Is In New York Art World Spotlight." *The Charlotte Observer*, November 12, 1967, p. G-2 (illus.).

Douglas, Carlyle C. "Romare Bearden." *Ebony*, November 1975, pp. 116–18+.

Driskoll, David. *Two Centuries of Black American Art*. Los Angeles: Los Angeles County Museum and New York: Knopf, 1976, pp. 63, 67–68, 73, 78, 107, 174, 175, 177.

Ellison, Ralph. "Bearden." *Callaloo*, vol. 11, no. 3, Summer 1988, pp. 416–19.

———. "Romare Bearden: Paintings and Projections." *Crisis*, March 1970, pp. 80–86.

Fax, Elton Clay. *Seventeen Black Artists*. New York: Dodd, Mead, 1971, pp. 12, 47, 128–45, 146, 147, 158, 178.

Feldman, Edmund Burke. *Becoming Human Through Art*. Englewood Cliffs, New Jersey: Prentice-Hall, 1970, pp. 226–28.

ffrench-frazier, Nina. "New York Reviews." *Art News*, October 1977, pp. 141–42 (illus.).

Fine, Elsa Honig. *The Afro-American Artist: Search for Identity*. New York: Holt, Rinehart and Winston, 1973, pp. 92, 104, 141, 151, 156–59, 164, 188, 190, 193, 195, 197, 281 (illus.).

Ghent, Henri. "And So It Is." *School Arts*, April 1969, pp. 21–23 (illus.).

———. "Notes to the Young Black Artists: Evolution or Revolution?" *Art International*, June 20, 1971, pp. 33–35.

———. Recorded Interview with Romare Bearden. Archives of American Art, Smithsonian Institution, Washington, D.C., June 29, 1968.

Glueck, Grace. "A Brueghel from Harlem." *New York Times*, February 22, 1970, p. 29.

———. "Minority Artist Finds a Welcome in a New Showcase." *New York Times*, December 23, 1969, p. 22.

———. "Negro Art from 1800 to 1950 Is On Display at City College." *New York Times*, October 16, 1967, pp. 47–48.

———. "Negroes' Art Is What's In Just Now." *New York Times*, February 27, 1969, p. 34.

———. "New York Gallery Notes." *Art in Amer-

ica, September–October 1967, p. 111.

———. "New York Gallery Notes: Think Up a Brand New Name." Art in America, September–October 1967, p. 108+.

———. "1930's Show at Whitney Picketed by Negro Artists Who Call It Incomplete." New York Times, November 18, 1968, p. 31.

Goldstein, Rhoda L., ed. "Is Black Art About Color?" Black Life and Culture in the United States. New York: Crowell, 1971, p. 318.

Greene, Carroll. "The Afro-American Artist." The Art Gallery, April 1968, pp. 12–25.

———. "Afro-American Artists: Yesterday and Now." The Humble Way, Fall 1968, pp. 10–15 (illus.).

———. "Perspective: The Black Artist in America." The Art Gallery, April 1970, pp. 1–29 (illus.).

Henry, Gerrit. "Reviews and Previews: Romare Bearden." Artnews, May, 1973, p. 87.

Howe, Susan, "Essay on Bearden." Survivor's Box. St. Petersburg, Florida: Possum Press, 1977, pp. 42–50.

———. "Review of Exhibitions: Romare Bearden at Cordier and Ekstrom." Art in America, November–December 1976, p. 122 (illus.).

Igoe, Lynn. Artis, Bearden and Burke: A Bibliography and Illustrations List. Museum of Art, North Carolina Central University, 1977, pp. 1, 7–41.

Jacobs, Jay. "Two Afro-American Artists." Art Gallery, April 1968, pp. 26–31 (illus.).

Jodido, Philip. "Romare Bearden: Les Experiences d'un Peintre Noir Américain." Connaissance des Arts, November 1978, pp. 114–19.

Johnson, Herschel. "Romare Bearden Rediscovers Himself." Soho News, December 7, 1978.

"In Memoriam: Romare Bearden." Callaloo, vol. 11, no. 3, Summer 1988, pp. 401–446.

Kramer, Hilton. "Art: Drawings with Graphic Subtlety." New York Times, March 31, 1973.

———. "Art: Intimacy and the 'Indefinite.'" New York Times, June 22, 1974.

———. "Art View: Bearden's 'Patchwork Cubism'." New York Times, December 3, 1978.

———. "'Black Art' and Expedient Politics." New York Times, June 7, 1970, p. 19.

———. "Black Experiences and Modern Art." New York Times, February 14, 1970, p. 23 (illus.).

Marr, Warren, II. "Black Artist Illumined." Crisis, March 1974, p. 106.

Maschal, Richard. "New Bearden Works Leaner, Richer." The Charlotte Observer, June 2, 1985.

Miesel, Victor H. "Art." The Americana Annual 1971. New York: Americana Corp., pp. 110–14.

Miro, Marsha. "Recreating the Feelings of His People and Their Places." Detroit Free Press, December 20, 1979.

Muchnic, Suzanne. "An Artist's Garden of Memories." Los Angeles Times, May 28, 1980.

Murray, Alma and Thomas, Robert, eds. Black Perspectives. The Scholastic Black Literature Services. New York: Scholastic Book Services, 1971, cover and pp. 206–7 (illus.).

"Music to the Eyes." Village Voice, March 10, 1975.

Myers, Bernard S. "Bearden, Romare." Dictionary of 20th Century Art. Ed. Bernard S. and Shirley D. Myers. New York: McGraw-Hill, 1974, pp. 26–27.

"The Negro Artist Comes of Age." Artnews, February 1–14, 1945, pp. 16, 29–30 (illus.).

"Negro Artists: Their Work Wins Top Honors." Life, July 22, 1946, pp. 62–64 (illus.).

Neugass, Fritz. "Foto-Montagen und Collagen erzielen hohe Preise." Foto Magazine (Munich), February 1964, p. 42 (illus.).

O'Doherty, Brian. "Art: Year-End Review." New York Times, December 16, 1961.

Payne, Les. "America's Greatest (Overlooked) Artist." Newsday, January 17, 1988, cover, pp. 6–11, 18–20.

"People in the News." Encore American, December 4, 1978, pp. 42–43.

Pomeroy, Ralph. "Black Persephone." Art News, October 1967, pp. 44–45+ (illus.).

Porter, James Amos. Modern Negro Art. New York: Dryden Press, 1943, pp. 130, 243.

Princenthal, Nancy. "Romare Bearden at Cordier & Ekstrom." Art in America, February 1987.

Purdie, James. "Gallery Review." The Globe and Mail (Toronto), September 1, 1979.

Raynor, Vivien. "State Museum Shows Work of 'Six Black Americans'." New York Times, March 2, 1980.

Reed, Judith Kaye. "Art of Christmas Along Fifty-Seventh Street: In Abstract Idiom." Art Digest, December 1, 1945, p. 15.

———. "Moderns of Large Area." Art Digest, June 1, 1946, p. 10.

Riley, Clayton. "Romare Bearden—of the Blues." Contact, Spring 1975.

Robbins, Eugenia S., ed. "Art News from Colleges and Elsewhere." Art Journal, Spring 1972, pp. 324–26+.

Roberts, Lucille. "The Gallery of Eight." Topic, no. 5, 1966, pp. 21–25 (illus.).

"Romare Bearden." Time, October 16, 1964, p. NY 2 [10].

Rowell, Charles. "Inscription at the City of Brass: An Interview with Romare Bearden." Callaloo, vol. 11, no. 3, Summer 1988, pp. 428–46.

Russell, John. "Art: Bearden from Homer to Henri." New York Times, April 29, 1977.

Scarborough, Ellen. "Bearden Exhibit Will Put Mint on Cultural Map." The Charlotte Observer, March 16, 1980.

Schwartz, Sanford. "New York Letter." Art International, Summer 1973, pp. 83–85+.

Schwartzman, Myron. "A Bearden-Murray Interplay: One Last Time." Callaloo, vol. 11, no. 3, Summer 1988, pp. 410–15.

Shapiro, David. "Reviews and Previews: Group Shows: Cordier & Ekstrom's 'Bestiary'." Artnews, February 1972, p. 208.

Sharp, Marnell. "Fifty-Seventh Street in Review: Bearden Paints 'The Iliad'." Art Digest, November 15, 1948, pp. 32–33 (illus.).

Shepley, James R. "A Letter from the Publishers." Time, November 1, 1968, cover by Bearden.

Shirey, David L. "An Afro-American Show That Isn't." New York Times, August 1, 1971.

Siegel, Jeanne. "Why Spiral?" Art News, September 1966, pp. 48–51+ (illus.).

Sims, Lowery S. "Black Americans in the Visual Arts: A Survey of Bibliographic Material and Research Sources." Artforum, November 1973, pp. 66–79.

———. "The Unknown Romare Bearden." Artnews, October 1986, pp. 117–20.

Staats, Margaret and Mattheissen. "Genetics of Art—Part 2." Quest/77, August 1977, pp. 38–43.

"Ten Black Artists Honored at White House." New York Times, April 3, 1980.

Tomkins, Calvin. "Profiles: Putting Something Over Something Else." New Yorker, November 28, 1977, pp. 53–58+.

Toppman, Lawrence. "Charlotte Artist Coming Home for Celebration." Charlotte News, May 1, 1980.

"Tormented Faces." Newsweek, October 19, 1964, p. 105.

"Touching at the Core." Time, October 27, 1967, pp. 64–65.

Turner, Norman. "Arts Reviews: Romare Bearden." Arts, September 1977, p. 29 (illus.).

"The 'Vasari Diary': Straphanger Art." Artnews, February 1977, p. 30 (illus.).

Washington, M. Bunch. The Art of Romare Bearden: The Prevalence of Ritual. Introduction by John A. Williams. New York: Abrams, 1973.

Wolf, Ben. "Abstract Artists Pay Homage to Jazz." Art Digest, December 1, 1946, p. 15 (illus.).

———. "Bearden Abstracts Drama of the Bull-Ring." Art Digest, April 1, 1946, p. 13 (illus.).

———. "Bearden—He Wrestles With Angels." Art Digest, October 1, 1945, p. 16 (illus.).

———. "Bearden Sings of the Cup that Cheers." Art Digest, March 1, 1947, p. 19 (illus.).

———. "With Modern Accent." Art Digest, May 15, 1946, p. 17.

INDEX

PHOTOGRAPH CREDITS

Rousmanière Alston and Aida Winters: 14, 15 top and middle, 16, 79, 80, 177 bottom, 178. A/P Wide World Photos: 301. © 1980 The Charlotte Observer: 13, 278 top and bottom; 279 top and bottom. Geoffrey Clements: 101, 231. Cordier & Ekstrom Gallery, New York: 19, 20, 22 top, 23 bottom, 29, 31, 33 left and right, 37 bottom, 40, 45, 50, 60, 81, 83 top, 85, 86, 87, 89, 90, 93, 94 top, 95, 109, 115, 170 top and bottom, 171 (photo—Geoffrey Clements), 181, 203 (photo—Taylor & Dull), 207 (photo—Taylor & Dull), 210, 211 (photo—Geoffrey Clements), 214, 219 (photo—Geoffrey Clements), 222 (photo—Geoffrey Clements), 223 (photo—Geoffrey Clements), 224, 226, 227, 229, 232, 233, 234, 235, 236 bottom, 239, 242, 246 left and right, 247, 251 (photo—eeva inkeri), 254, 255, 257, 259, 260, 261 (photo—Geoffrey Clements), 262, 263, 264, 265, 266, 267 top and bottom, 268, 270, 271, 272, 273, 281, 282, 295. Pierre Dupuy: 293. Jerald Melberg Gallery, Charlotte, NC: 11; 21, 22 right, 237, 284, 304 (photos by Bill Moretz). Bill Moretz: 297. Port Authority of Allegheny County: 61. Sheldon Ross Gallery, Birmingham, MI: 23 top, 25, 51, 54, 57, 118, 174, 175, 192, 213, 216, 220, 221, 236 top, 238, 250, 274, 275, 276, 277, 283, 296 (all photos by Eric Smith). Myron Schwartzman: 288. Frank Stewart: 98. Jim Strong, Inc.: 36, 37 top, 63, 83 bottom, 92, 94 bottom, 119 top and bottom right, 134, 142 top and bottom, 150, 180, 184, 185, 209, 287. André Thibault/Teabo: 302.